LEONARDO ON PAINTING

LEONARDO ON PAINTING

*An anthology of writings by
Leonardo da Vinci with a
selection of documents relating to
his career as an artist*

Edited by
MARTIN KEMP

Selected and translated by
MARTIN KEMP and MARGARET WALKER

YALE UNIVERSITY PRESS · NEW HAVEN AND LONDON · 1989

PHOTOGRAPHIC ACKNOWLEDGEMENTS

Figs. 2, 5, 7, 8, 11, 12, 72, 81, 100–2, 110, 135, 144–5, 147, 151–2, 162 and 172, Windsor Castle, Royal Library, © 1988 Her Majesty The Queen. Fig. 165, The Metropolitan Museum of Art, Rogers Fund, 1917 (17.142.2v), all rights reserved. Figs. 3, 42, 103, reproduced by courtesy of the Trustees, The National Gallery, London. Figs. 153, 170, reproduced with the permission of the Trustees of the British Museum. Figs. 153–4, reproduced with the permission of the Governing Body, Christ Church, Oxford. All other figures are credited in their accompanying captions.

Set in Compugraphic Bembo

Typeset, printed and bound in Great Britain by The Bath Press, Avon

Library of Congress Catalog Card Number 88-51825

ISBN 0-300-04542-5 Cloth
ISBN 0-300-04509-3 Paper

CONTENTS

Acknowledgements vii
Notes to this edition viii
Editor's Introduction I

PREFACE: KNOWLEDGE, LEARNING AND EXPERIENCE 9

PART I GENERAL PRINCIPLES II

The Science of Art 13
The Works of the Eye and Ear Compared 20

PART II THE SCIENCE OF VISION IN PAINTING 47

The Eye and Light 49
Introduction to Perspective 51
Perspective of Size 52
Colour and the Perspective of Colour 70
Perspective of Disappearance 85
Light and Shade 88

PART III THE HUMAN BODY 117

Proportions 119
Anatomy and Motion 130
Posture, Expression and Decorum 144
Draperies 153

PART IV THE DEPICTION OF NATURE 159

Light in the Countryside 161
Distances, Atmosphere and Smoke 165
Water 169
Horizons 172

Mountains 173
Trees 176
Trees seen in Landscapes 185

PART V THE PAINTER'S PRACTICE 191

Ethics for the Painter 194
Judging Works 196
Advice for the Young Painter 197
Criteria and Judgements 200
The Life of the Painter 205
How Effects Should be Achieved 208
The Studio and Painters' Aids 214
Wall Painting and Illusion 217
The Invention and Composition of
 Narratives 220
Examples of Compositions 227
Examples of Allegories and Emblems:
 'Fictions that Signify Great Things' 238

PART VI LEONARDO'S ARTISTIC CAREER 249

Letters from Leonardo 251
Memoranda 263
Contracts and Documents Regarding
 Commissions 268
The End of Leonardo's Life 275

Manuscript Sources and Notes 281
Concordances 297
Glossary of Problematical Terms 311
Bibliography and Abbreviations 317
Index 321

ACKNOWLEDGEMENTS

The idea for the present anthology came from observing the difficulties of students and general readers who wanted to read Leonardo's own thoughts on art but found that the existing anthologies did not present a coherent expression of his views. It remains surprising that no one has previously attempted to edit Leonardo's notes on painting into a systematic treatise, which, if not the work that he himself would have produced, would at least be recognisable to him and would respect his intentions. I was delighted when Margaret Walker, a former student of art history in Glasgow, a qualified art librarian and the indexer of my Leonardo monograph, agreed to bring her systematic skills and knowledge of Italian to the project. She has provided valued assistance on all aspects of the editorial process, though the ultimate responsibility for the form of the anthology (including any shortcomings) should be laid at my door. We have assumed an undivided responsibility for the translation.

I have subsequently received much encouragement for this new kind of anthology from Leonardo enthusiasts of all kinds, and most particularly from Jack Wasserman, who had begun to think along similar if not identical lines. John Nicoll of Yale University Press has offered characteristic support and patience in the face of a schedule for publication made extremely tight by the delayed production of our typescript, and Elaine Collins has provided valuable assistance in realising the work in its final form. Vital help was given by Kathryn Smith at the Institute of Fine Arts, New York University, and Gordon Beamish at the University of St Andrews, who uncomplainingly undertook the unexciting work which laid the foundation for the concordance of manuscript sources. At an important stage in the translation, Clare Farago was kind enough to send me a copy of the doctoral thesis she had completed for the University of Virginia, which consisted of a critical edition, commentary and translation of Leonardo's *paragone*. Although the present translation aims to fulfil a different function from Dr Farago's, I derived great benefit from her insights. Richard Schofield and Janice Shell provided useful comments on the highly problematical 'Lista' for Leonardo's work on the altarpiece which was to house his *Virgin of the Rocks*. Finally, any editor of Leonardo's writings

cannot but feel a profound debt to his predecessors, most notably amongst present-day scholars, Carlo Pedretti and Augusto Marinoni.

M.K. October 1988

I am privileged to have first been taught art history in Glasgow by Martin Kemp in the early Seventies, and I remain indebted to him for the support and encouragement he has subsequently provided in various projects, not least a blessing on an extended period of residence in Florence at a critical point in my career.

Michael Doran, Book Librarian at The Courtauld Institute of Art, generously allowed me time off from my library duties to work on parts of this translation. Laura Mardon enthusiastically discussed grammatical puzzles with me. In what little spare time he had in a demanding professional schedule, my husband, Brian Hannan, uncomplainingly typed the drafts of my translation. It is to him, wholeheartedly, that I dedicate my contribution to the present anthology.

M.W. October 1988

NOTES TO THIS EDITION

All titles and subtitles for the major parts and subdivisions (printed in capital letters) are those of the editor and co-translator. All topic headings for the thematic sections are taken from Leonardo's manuscripts, with the exception of those denoted by square brackets, thus [...].

Other editorial interpolations are also denoted by square brackets.

Sections of text omitted within a section drawn from a single source are denoted by three dots, thus ...

Footnote numbers,[1,2] etc., refer to the key to manuscript sources at the end of the main text. Generally accepted abbreviations are used and are listed in the bibliography of sources.

* or † or ‡ or § indicates that an interpretative note is to be found under the number referring to the manuscript source at the end of the main text. The notes are not intended to provide a running commentary, but to indicate some of Leonardo's direct sources and to surmount the main obstacles in the way of understanding his meaning for the modern reader.

The diagrammatic illustrations are transcribed from the Codex Urbinas and from the manuscript sources. Those from the manuscript sources have been transcribed in the style of the Codex Urbinas illustrations for the sake of consistency. They are intended to be functional rather than to illustrate the quality of Leonardo's original drawings (which are lost in the case of the majority of the transcriptions in the Codex Urbinas). The labelling of the diagrams has occasionally been adjusted to bring it into line with Leonardo's text, and vice versa.

EDITOR'S INTRODUCTION

A treatise on painting by Leonardo?

This will be a collection without order drawn from many pages which I have copied here, hoping to put them in order in their places, according to the subjects with which they will deal, and I believe that before I am at an end of this, I will have to repeat the same thing many times. (BL 1r)

As far as Leonardo's projected treatise 'On Painting' is concerned, we know that he never did reach the 'end of this'. Indeed, it is unlikely that any of his many projected books – 'On Water', 'On the Elements of Machines', 'On the Human Body', 'On the Flight of Birds' and so on – ever reached completion. What remained after his death in 1519 was a magnificent legacy of personal manuscripts, consisting of large-scale notebooks, small pocket-books, compendia of miscellaneous sheets (some extracted from dismembered codices), and collections of separate pages, including those containing drawings for works of art. The greater part of Leonardo's literary legacy became the treasured property of Leonardo's favourite pupil and heir, Francesco Melzi, who, as the son of a noble family in Lombardy, was well enough educated to make sense of his master's notes. During the centuries following Melzi's death, his collection of drawings and manuscripts was dispersed and many of the items disappeared.

Melzi himself took the first important steps in editing Leonardo's disorderly notes with a view to having them published. He went through the notebooks in his possession to extract passages for a treatise on painting, presumably with some direct knowledge of what Leonardo himself had intended. The result was the manuscript anthology in the Vatican, known as the Codex Urbinas, the title-page of which announces that is the 'Book on Painting by M. Leonardo da Vinci, Florentine Painter and Sculptor'. Melzi's work was not only important as the first attempt to put Leonardo's writings in order but is also invaluable in that it preserves passages from manuscripts that are now lost. Of the thousand or so passages transcribed by Melzi, only a quarter come from manuscript sources still available to us. This provides some rough measure of the extent of the losses from Leonardo's legacy. If we allow that those of his manuscripts which were

concerned with artistic matters were at least as likely to survive as those concerned with science and technology, the extant manuscripts probably represent no more than a quarter of the total remaining at Leonardo's death.

Whilst we must be eternally grateful for Melzi's pious labours, we should also recognise that his ordering and editing of Leonardo's notes is very rough and incomplete. He made no effort to deal with the repetitions and occasional contradictions in the passages he transcribed. He appears not to have consulted all the manuscripts, while at the same time drawing on others in such a comprehensive manner as to unbalance the picture of Leonardo's interests. He drew very little, for instance, upon the writings on optics and perspective, possibly because of his reluctance to deal with technical matters, or more probably because perspective was to be the subject of a treatise in its own right. There is evidence to suggest that a treatise (or at least a notebook) on perspective by Leonardo was known in the sixteenth century. On the other hand, he included almost one hundred passages on trees, giving a false impression that trees held a dominant position in Leonardo's views on the imitation of nature.

It was through Melzi's compilation that Leonardo's views on painting entered general currency. Manuscript copies of an abridged version of the Codex Urbinas circulated quite widely in Italy in the sixteenth and early seventeenth centuries, and it was one or more of these, accompanied by a set of illustrations by the great French painter, Nicolas Poussin, that provided the basis for the first printed editions of Leonardo's writings, published simultaneously in Italian and French in Paris in 1651. The nature of the published compilation attracted criticism from the first, not least from Poussin himself. A later English translator of the 'Treatise on Painting' was not far wrong when he described the printed editions as 'a chaos of intelligence'.

Subsequently the Codex Urbinas has itself been published and translated in an accessible manner, though a modern critical edition is much needed. Leonardo's other writings, as preserved in his autograph manuscripts, have been progressively published from the end of the nineteenth century onwards in facsimiles, transcriptions and in part in English translations. Various anthologies have been made of this manuscript material, of which the most notable English language versions are Jean Paul Richter's important but misleadingly entitled *The Literary Works of Leonardo da Vinci* (which originally appeared in 1883 and has subsequently been republished with Carlo Pedretti's valuable *Commentary*), and Edward MacCurdy's *The Notebooks of Leonardo da Vinci*, which gives greater prominence to the scientific writings than Richter's selection. Both anthologies group the selections from the manuscripts under broad subject headings, but neither attempts to solve the inherent problems posed by the disorderly,

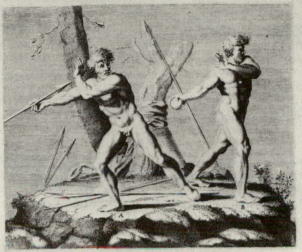

Des attitudes, & des mouuemens, & de leurs membres.
C h a p. CLXXXIII.

Qv'on ne voye point la mesme action repetée dans vne mesme figure, soit
en ses principaux membres, ou en ses mains, ou aux doigts; ny encore la mes-
me attitude ou position de figure plusieurs fois en vne histoire : & si le sujet de
l'histoire estoit si vaste qu'il obligeast à vn tres grand nombre de figures, com-
me pourroit estre vne bataille ou quelque carnage de gladiateurs, au mestier
desquels il n'y a que trois manieres de frapper, c'est à sçauoir, ou de poin-
te, ou de reuers, ou d'estramasson; en ce cas il faut faire en sorte par vostre
inuention que tous les estramassons soient donnez diuersement, comme si
l'vn se tourne en arriere, vn autre soit veu de costé, vn autre en deuant, &
ainsi diuersifier les mesmes actions par diuers aspects; & pour cela nous ap-
pellerons tous les autres, participans de ces principaux : mais dans les batail-
les, les mouuemens composez sont d'vne inuention tres-artificieuse, fort spi-
ritueux, & de tres-grande expression, & on nomme composez ceux-là qui en
vne seule figure monstrent le deuant des jambes & vne partie du corps par le
profil des espaules; & cette espece de figure composée sera décrite en son lieu.

Des jointures des membres. C h a p. CLXXXIV.

Dans les jointures des membres & la varieté de leurs plis, on doit pren-
dre garde de quelle sorte la chair croissant d'vn costé elle vient à se retirer de
l'autre; & cela se doit rechercher dans l'encolleure des animaux, parce que

1. Figures in the act of throwing, engraving based on Nicolas Poussin's illustration for
Leonardo's text (Urb. 106r), from Leonardo da Vinci, *Traité de la peinture*, ed. R. du
Fresne, Paris, 1651 (compare fig. 98).

repetitious, inconsistent and fragmentary nature of the source material. Anyone who goes to the anthologies by Richter or Mac-Curdy – or to any other of the editions of his writings – hoping to read and understand Leonardo's views in a sequential and cumulative manner, as we would expect when reading a finished book or treatise, will be disappointed. The present edition is designed to overcome this problem – at least as far as it can be overcome, given the character of the sources.

Leonardo himself undoubtedly intended to compile a treatise 'On Painting', and a number of his notes were specifically given this heading. There are also some indications of the way in which he intended to group his material, including a list of thirty-one optical topics under the heading '*dellappittura*' on a folio in the large compilation of manuscript material in the Biblioteca Ambrosiana in Milan (Codice atlantico, fol. 360/1004r). However, it is to be doubted whether the plans for his treatise reached the point where its scope and organisation were fully resolved, and it is certainly impossible to arrange the material that has survived precisely in accordance with those hints he has left. Not only have the losses been too severe, but it is also clear that the elasticity of Leonardo's views on what should be included under the heading 'On Painting' rendered even his own schemes unworkable. In a sense, there was no aspect of knowledge about causes and effects in the visible world which could not be legitimately said to lie within the painter's compass. There is no obvious reason why systems of branching in plants should be included (as they are in the Codex Urbinas) while the detailed accounts of the bones, tendons and muscles of the human hand should be omitted. It seems likely that some of the relevant topics, such as perspective and descriptive anatomy, grew to such proportions that Leonardo decided they could best be treated in separate treatises. Yet the three kinds of perspective remained central to the optical foundations of painting, just as the treatment of motion and expression provided central tenets for his instructions to the painter of narratives.

The present edition follows Leonardo's intentions and procedures in the general sense that the progress within the treatise as a whole and within the individual sections is from general principles and basic tenets to the detailed illustration of effects in nature and in the practice of painting. There are also particular sections, such as those devoted to the three kinds of perspective – of size, of colour and of disappearance – in which it has been possible to follow Leonardo's own classification quite closely. The way the text is laid out is also broadly in keeping with the kind of book Leonardo was planning, which in its turn was based upon the format of late medieval and early Renaissance treatises, particularly those on aspects of natural philosophy, such as John Pecham's *Perspectiva communis*, the standard

textbook on optics. Thus, the text that follows is organised as a series of chapters or 'books', with systematic subdivisions, within which thematic sections of text of varied length are each introduced by a heading in the form of a proposition or question. Each of the detailed headings, except where noted, are Leonardo's own, while the 'book' and subdivision titles have been provided by the editor and co-translator.

In these respects, the selection and editing corresponds uncontroversially both to Leonardo's own intentions and to the character of the sources as they have survived. With respect to the detailed assembly of the actual texts, the editorial procedures have been far more radical and involve some measure of conscious violence towards the original sources. Leonardo's notebooks often contain numerous analyses of the same topic, sometimes with repeated redrafting of a particular passage and not infrequently with changes of mind, either at one time or over a number of years. Any attempt to weld such passages into a coherent whole – as Leonardo himself would have needed to accomplish if he were to have published his text – involves a series of decisions about the strongest draft, about which diversions and asides are to be omitted, about which alternative view is to be favoured, and so on. In some instances, a single passage on a particular topic has been compiled from as many as half a dozen separate sources. Making and ordering the selections on such a radical basis places the editors in the position of trying to work creatively with Leonardo, without, it is hoped, violating the character of his thought through the anachronistic imposition of modern ideas about what a treatise on painting should be like.

The best any anthology can hope to accomplish is to play selectively towards certain strengths inherent in its criteria, whilst acknowledging their inevitable disadvantages. The strength of the present method is to present a coherent, cumulative picture of Leonardo's aspirations for his beloved science of painting, bringing out the consistent inner core and style of his beliefs, however much his detailed opinions on particular topics may have changed over his lifetime. There are two main disadvantages resulting from the principles of organisation adopted here. The first is that there is no sense of what may be called the 'archaeology' of Leonardo's manuscripts – in other words, the detailed study of the original manuscripts to see how they were compiled. The second is that the development of Leonardo's ideas is masked rather than clarified. The earliest passages included here date from the late 1480s, while others originate from almost thirty years later. Occasionally, and most notably with his writings on the vagaries of perspective, the accompanying notes emphasise where the drift of his theories changed direction significantly, but the selection as a whole leads away from a chronological consideration of his thought.

Both of these largely excluded topics – codicology and chronology – are unquestionably important to the student who wishes to obtain a rounded and detailed understanding of Leonardo's thought and its relationship to his art, but these are properly the subjects for separate studies and of other anthologies, which would themselves possess sets of strengths and limitations of their own particular kind.

Even by the lights of its own criteria, this anthology has involved the omission of a large quantity of relevant material in order to provide a treatise of manageable length. The percentage of material omitted varies from section to section. In the early section on the *paragone*, the comparison of the arts, large sections of text which largely repeat or work variations on the same theme have been excluded. By comparison, the number of surviving texts on linear perspective is small in relation to the subject's importance for Leonardo and for Renaissance theorists in general, and the take-up rate has accordingly been higher. In other sections, such as those on atmosphere, light and shade, human motion, proportions and trees, the most important passages on general principles have been included, together with sufficient of the case studies of individual effects to give a fair idea of the type of considerations in Leonardo's mind when he laid down his requirements for good painting.

Perhaps the severest problem Leonardo himself experienced in bringing his writings to completion was knowing when he had accumulated enough examples of the particular effects of general causes. The present selection certainly does not go as far as he intended in detailing every conceivable circumstance or 'accident' (to use his own term), but in this respect at least we would be unwise to emulate Leonardo. In the case of descriptive anatomy, his own fairly frequent hints that this simply could not be encompassed within a book on painting have been followed, though the arguments for the importance of anatomy for the painter are well represented. Nothing has been included on sculpture or architecture, beyond the *paragone*, since his surviving writings on these arts in their own right are too fragmentary to do anything other than disrupt the coherence of his views on painting.

The inclusion, after the main text, of a selection of letters, memoranda and other primary sources for his career is intended to provide another first-hand dimension to the Leonardo who emerges from the treatise. Each kind of document operates within its own conventions, as does the treatise, but behind their formalities the primary sources as a whole convey a vivid sense of the man himself, his impact upon contemporaries and the framework within which he pursued his career.

It is hardly possible to quote a few lines of Leonardo's writings without gaining some sense of an extraordinary mind at work, a mind which can bewilder and frustrate the reader as much as it can beguile

and enlighten – though it is to be hoped that the present edition will result in fewer of the former problems and more of the latter delights. Perhaps we might borrow a passage from his writings about the 'Elements of Machines' as a fitting literary epitaph for his extraordinary achievement:

> Study me reader, if you find delight in me, because on very few occasions shall I return to the world, and because the patience for this profession is found in very few, and only in those who wish to compose things anew. Come, O men, to see the miracles that such studies will disclose in nature. (Codex Madrid I 6r)

The translation

The process of translation, like the processes of selection and editing, involves a choice between a series of options, each of which has particular merits and particular shortcomings. The translation of writings by any historical figure not only involves the obvious difficulties of finding English words and phrases that will convey the sense of the original Italian but also necessitates the handling of terms which are now obsolete or whose meaning has changed significantly. This latter problem is particularly apparent with the terminology Leonardo adopted from late medieval science, which too many translations unwittingly update in the light of modern scientific vocabulary. Terms like 'percussion', 'impetus', 'chords' (for nerves, tendons and ligaments) and 'common sense' possessed meanings for Leonardo in his historical context different from those implied by the same words today. There are also a number of individual terms which were used by Leonardo in a variety of senses and which correspond to different words in today's English. His usages of *grossezza* (size), *corpo* (body) and *figura* (shape) are cases in point. On the other hand, he used various separate words for a term covered by only one in present-day English; for example, *simulacro*, *spetie* and *similitudine* can all be translated as 'image', but in fact reflect a very different framework of optical theories from those in operation today. The accompanying notes signal the most severe of such difficulties, and the glossary of Italian terms should help explain the nature of the choices made.

Within the possible spectrum from literal translation to free literary rendering, the present translation tends towards the literal side. Its purpose is to convey Leonardo's meaning in the kind of language he used, giving what is to be hoped is a clear sense of the tone of his own voice and reflecting the often idiosyncratic way he structured his discussions. His word order and punctuation – generally a lack of the latter – have been diplomatically adjusted where necessary, but we

have not tried to iron out some of the difficulties of the texts purely
for literary effect. Leonardo tended to string ideas together with chains
of 'which's, 'and's, 'because's, 'hence's and so on, often with sustained
asides and sometimes without clearly returning to the home base of
the discussion. He frequently mixed tenses and switched from plural
to singular and back again. Although some of the structures he used
became so tangled as to obscure his meaning, and therefore require
reworking, the courses he plotted through his extended sentences have
generally been followed, even though they do not always make for
easy reading. In all this we should remember that, with the exception
of some of the *paragone* sections and early drafts on perspective, few
of the passages extracted from his notebooks can be regarded as fin-
ished statements. Most represent work in progress.

Leonardo's original notes pose considerable problems of legibility.
He wrote in mirror image from right to left – probably as his own in-
dividualist way of coping with his left-handedness – and used what is,
broadly speaking, a notarial hand in the late medieval style, with many
abbreviations and variable spellings. Successive scholars have done
much to ensure that accurate transcriptions are available, but many of
the Codex Urbinas passages cannot be found in the surviving
manuscripts, and the transcriptions of the sixteenth-century compiler
cannot therefore be checked. Where they can be compared to the
originals, they are encouragingly accurate, but it is necessary in
various instances to reconstruct how an obvious mistake may have oc-
curred. The Codex Urbinas itself is written in an attractive humanist
script (the ancestor of our 'italic') and presents relatively few problems
of legibility. The researches of earlier scholars and of Carlo Pedretti
in particular have proved invaluable in such textual matters.

PREFACE:
KNOWLEDGE, LEARNING AND EXPERIENCE

Good men possess a natural desire to know*

I know that many will say that this is a useless work, and these people
will be those of whom Demetrius† said that he took no more account
of the wind from their mouths, which caused their words, than of the
wind which issued from their lower regions. These men possess a
desire only for material wealth and are entirely devoid of the desire for
wisdom, which is the sustenance and truly dependable wealth of the
mind.

I know well that, not being a man of letters, it will appear to some
presumptuous people that they can reasonably belabour me with the
allegation that I am a man without learning. Foolish people! Do they
not know that I might reply as Marius‡ did to the Roman patricians
by saying that they who adorn themselves with the labours of others
do not wish to concede to me my own; they will say that since I do
not have literary learning I cannot possibly express the things I wish
to treat, but they do not grasp that my concerns are better handled
through experience rather than bookishness.[1] Though I may not
know, like them, how to cite from the authors, I will cite something
far more worthy, quoting experience, mistress of their masters. These
very people go about inflated and pompous, clothed and adorned not
with their own labours but with those of others. If they disparage me
as an inventor, how much more they, who never invented anything
but are trumpeters and reciters of the works of others, are open to
criticism. Moreover those men who are inventors are interpreters of
nature, and when those men are compared to the reciters and
trumpeters of the works of others, they should be judged and ap-
praised in relation to each other in no other way than the object in
front of a mirror may be judged to surpass its reflection, for the former
is actually something and the other nothing. People who are little
reliant upon nature are dressed in borrowed clothes, without which I
would rank them with the herds of beasts.[2]

Anyone who argues on the basis of authority does not exploit his
insight but his memory. Good writing is born of a good natural
understanding, and since the cause is to be praised rather than the
effect, you should praise natural understanding without bookish
learning rather than bookish learning without understanding.[3]

Many will believe that they can reasonably reproach me, alleging that my proofs go against the authority of those men held in greatest reverence by those of inexpert judgement, not considering that my works are born of simple and pure experience, which is the true mistress. This gives the rules by which you are able to distinguish the true from the false, and enable men to strive towards what is possible with more discrimination, and not to wrap themselves up in ignorance. If the rules are not put into effect, you will in despair give yourself up to melancholy.[4]

These rules will enable you to possess a free and good judgement, since good judgement is born of good understanding, and good understanding derives from reason expounded through good rules, and good rules are the daughters of good experience – the common mother of all the sciences and arts.[5] Experience does not err, but rather your judgements err when they hope to exact effects that are not within her power. Men wrongly complain of experience, which with great abuse they accuse of falsity, but let experience be, and turn such complaints against your own ignorance which causes you to be carried away by vain and foolish desires.[6] They say that knowledge born of experience is mechanical but that knowledge born and ending in the mind is scientific, and that knowledge born in science and ending in manual operations is semi-mechanical, but to me it appears that those sciences are vain and full of error that have not been born of experience, mother of every certainty and which do not likewise end in experience; that is to say, those that have neither at their beginning, middle or end passed through any of the five senses.[7]

True sciences are those which have penetrated through the senses as a result of experience and thus silencing the tongues of disputants, not feeding investigators on dreams but always proceeding successively from primary truths and established principles, in a proper order towards the conclusion. This may be witnessed in the principles of mathematics, that is to say, number and measure – termed arithmetic and geometry – which deal with discontinuous and continuous quantities with the utmost truth. Here no one hazards guesses as to whether two threes make more or less than six, or whether the angles of a triangle are less than two right angles. Here all guesswork remains destroyed in eternal silence, and these sciences are enjoyed by their devotees in peace, which is not possible with the delusory sciences of a wholly cerebral kind.[8]

Part I:

GENERAL PRINCIPLES

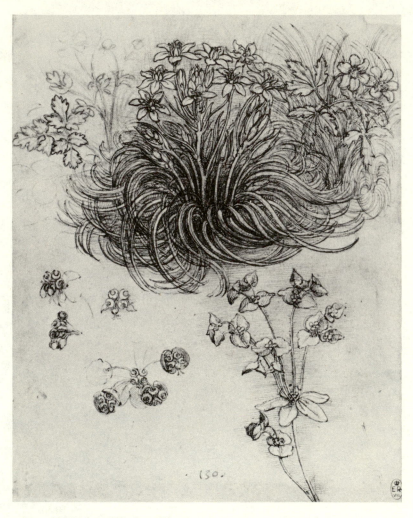

2. Star of Bethlehem, Windsor, RL 12424.
'Painting . . . with philosophical and subtle speculation considers all manners of forms:
sea, land, trees, animals, grasses, flowers . . .'

THE SCIENCE OF ART

He who despises painting loves neither philosophy nor nature

If you scorn painting, which is the sole imitator of all the manifest works of nature, you will certainly be scorning a subtle invention, which with philosophical and subtle speculation considers all manner of forms: sea, land, trees, animals, grasses, flowers, all of which are enveloped in light and shade. Truly this is science, the legitimate daughter of nature, because painting is born of that nature; but to be more correct, we should say the granddaughter of nature, because all visible things have been brought forth by nature and it is among these that painting is born. Therefore we may justly speak of it as the granddaughter of nature and as the kin of god.[9]

Why painting is not numbered amongst the sciences

Because writers had no access to definitions of the science of painting, they were not able to describe its rank and constituent elements. Since painting does not achieve its ends through words, it is placed below the . . . sciences through ignorance, but it does not on this account lose its divinity. And in truth it is not difficult to understand why it has not been accorded nobility, because it possesses nobility in itself without the help of the tongues of others – no less than do the excellent works of nature. If the painters have not described and codified their art as science, it is not the fault of painting, and it is none the less noble for that. Few painters make a profession of writing since their life is too short for its cultivation. Would we similarly deny the existence of the particular qualities of herbs, stones or plants because men were not acquainted with them? Certainly not. We should say that these herbs retained their instrinsic nobility, without the help of human language or writings.[10]

Whether painting is a science or not

That mental discourse that originates in first principles is termed science. Nothing can be found in nature that is not part of science, like

continuous quantity, that is to say, geometry, which, commencing
with the surfaces of bodies, is found to have its origins in lines, the
boundary of these surfaces. Yet we do not remain satisfied with this,
in that we know that line has its conclusion in a point, and nothing
can be smaller than that which is a point. Therefore the point is the
first principle of geometry, and no other thing can be found either in
nature or in the human mind that can give rise to the point.*

If you were to say that the contact made on a surface by the very
tip of the point of a pen would create a point, this is not true. Rather,
we would say that such contact as this would actually be a surface
around a centre and that centre is the location of the point. And such
a point is not of the material of the surface. If all the points that are
potentially in the universe were to be united – should such a union be
possible – neither they nor a single point would compose any part of
a surface. And given, if you were to so imagine it, a whole composed
of a thousand points, and dividing some part of this quantity by one
thousand, it may fairly be said that this part will be equal to the whole.
This may be demonstrated by zero or nothing, that is to say, the tenth
figure in arithmetic, which is represented by an '0', which is in itself
nothing, but if it is placed after the unit it will make ten, and if you
should put two after the unit it will make one hundred, and so on
infinitely – the number to which it is joined always growing by ten
times. But in themselves the noughts do not have any value other than
nought, and all the noughts in the universe are equal to a single nought
with respect to substance and value.

No human investigation may claim to be a true science if it has not
passed through mathematical demonstrations, and if you say that the
sciences that begin and end in the mind exhibit truth, this cannot be
allowed, but must be denied for many reasons, above all because such
mental discourses do not involve experience, without which nothing
can be achieved with certainty.[11]

Those sciences are termed mathematical which, passing through the
senses, are certain to the highest degree, and these are only two in
number. The first is arithmetic and the second geometry, one dealing
with discontinuous quantity and the other with continuous quantity.
From these is born perspective, devoted to all the functions of the eye
and to its delight with various speculations. From these three,
arithmetic, geometry and perspective – and if one of them is missing
nothing can be accomplished – astronomy arises by means of the
visual rays. With number and measure it calculates the distances and
dimensions of the heavenly bodies, as well as the terrestrial ones. Next
comes music, which is born of continuous and discrete quantities and
which is dedicated to the ear, a sense less noble than the eye. Through
the ear, music sends the various harmonies of diverse instruments to
the *sensus communis*＊ Next follows smell, which satisfies the *sensus*

communis with various odours, but although these odours give rise to fragrance, a harmony similar to music, none the less it is not in man's power to make a science out of it. The same applies to taste and touch.[12]

[Principle of the science of painting]

The principle of the science of painting is the point; second is the line; third is the surface; fourth is the body which is enclosed by these surfaces. And this is just what it is to be represented, that is to say, the body which is represented, since in truth the scope of painting does not extend beyond the representation of the solid body or the shape of all the things that are visible.[13]

Point is said to be that which cannot be divided into any part. Line is said to be made by moving the point along. Therefore line will be divisible in its length, but its breadth will be completely indivisible. Surface is said to be like extending the line into breadth, so that it will be possible to divide it in length and breadth. But it has no depth. But body I affirm as arising when length and breadth acquire depth and are divisible. Body I call that which is covered by surfaces, the appearance of which becomes visible with light. Surface I call the outer skin of a body, which defines the forms of a body and its boundary.* Boundary I call the surrounding edge of each seen surface, the termination of which marks the division [between one body and another].[14]

The second principle of the science of painting

The second principle of the science of painting is the shadow of bodies, by which they can be represented. We shall give the principles of shadow, with which we must proceed if we wish to model in three dimensions on the aforesaid surface.[15]

What is the first intentional aim of the painter?

The first intention of the painter is to make a flat surface display a body as if modelled and separated from this plane, and he who most surpasses others in this skill deserves most praise. This accomplishment, with which the science of painting is crowned, arises from light and shade, or we may say *chiaroscuro*.* Therefore, whoever fights shy of shadow fights shy of the glory of art as recognised by noble intellects, but acquires glory according to the ignorant masses, who require

nothing of painting other than beauty of colour, totally forgetting the beauty and wonder of a flat surface displaying relief.[16]

There are two principal parts into which painting is divided: firstly the outlines which surround the shapes of solid bodies – and these outlines require draughtsmanship; and secondly what is called shading. But draughtsmanship is of such excellence that it not only investigates the works of nature but also infinitely more than those made by nature . . . On this account we should conclude that it is not only a science but a goddess which should be duly accorded that title. This deity repeats all the visible works of almighty God.[17]

Of the ten functions of the eye, all appertaining to painting

Painting embraces all the ten functions of the eye; that is to say, darkness, light, body and colour, shape and location, distance and closeness, motion and rest.* My little work will comprise an interweaving of these functions, reminding the painter of the rules and methods by which he may imitate with his art all these things – the works by which nature adorns the world.[18]

How painting includes all the surfaces of bodies...[19]

The science of painting includes all the colours of surfaces and the shapes of the enclosed bodies, and their closeness and distance, with their due degree of diminution according to their degrees of remoteness. And this science is the mother of perspective, that is to say, visual rays. Perspective is divided into three parts, of which the first is concerned solely with the outlines of the bodies; the second in the diminution of colours at varying distances; the third in the loss of definition of bodies at various distances. Now, the first, which only embraces the outlines and contours of bodies, is called drawing, that is to say, the figuration of any solid body. From this arises another science, which embraces light and shade, or we may wish to say *chiaroscuro*, a science of complex exposition. From the visual rays, the science of astronomy has arisen, which is merely perspective, since it consists of visual lines and intersected pyramids.[20]

There is no part of astronomy which is not a function of visual rays and perspective – the daughter of painting – because it is the painter through the requirements of his art who has given birth to perspective, in that he cannot manage without the outlines that enclose the varied

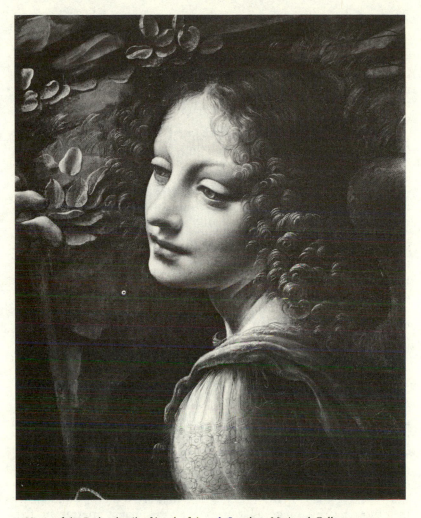

3. *Virgin of the Rocks*, detail of head of Angel, London, National Gallery.
'The first intention of the painter is to make a flat surface display a body as if modelled
and separated from this plane. ... This accomplishment ... arises from light and shade'

shapes of the bodies generated by nature – without which the art of the geometer is blind. The geometer analyses every surface circumscribed by lines using the figure of a square and every solid using the figure of a cube, and the arithmetician does similarly with his cubic and square roots. But their two sciences do not extend beyond the consideration of continuous and discontinuous quantities. The quality they cannot express is the beauty of the works of nature and the adornments of the world.[21]

Painting only extends to the surfaces of bodies, and its perspective extends to the increase and decrease in size of the bodies and of their colours, because anything as it is removed from the eye loses degrees of size and colour according to the extent of its remoteness. Therefore painting is philosophy, because philosophy deals with augmented and diminished motion... Or inversely we may say that the object seen by the eye gains such size and clarity and colour as the space interposed between it and the eye diminishes... Painting can be shown to be philosophy because it deals with the motions of bodies in the briskness of their actions, and philosophy too extends to motion.[22] Philosophy penetrates within these bodies, considering what comprises their distinctive essences, but it does not remain satisfied with its truth as does the painter with his, which comprises the primary truth of the bodies, because the eye deludes itself less.[23]

How the eye is less easily deluded in its workings than any other sense

The eye deludes itself less than any of the other senses, because it sees by none other than the straight lines which compose a pyramid, the base of which is the object, and the lines conduct the object to the eye, as I intend to show. But the ear is strongly subject to delusions about the location and distance of its objects because the images [of sound] do not reach it in straight lines, like those of the eye, but by tortuous and reflexive lines. Many times things that are remote sound closer than those nearby, on account of the way the images are transmitted; although the sound of the echo is referred to the ear only by means of straight lines. The sense of smell is even less able to locate the source of an odour. Taste and touch, which come into contact with their objects, can only gain knowledge from this direct contact.[24]

Which science is most useful, and in what does its utility consist?

That science is most useful whose fruits are most communicable, and thus conversely that which is less communicable is less useful. The end results of painting are communicable to all the generations in the universe, because its results are a matter for the visual faculty. And they are not transmitted by the ear to the *sensus communis* in the same manner as things are transmitted by the eye. Therefore the eye has no need for translators from various languages, as have words, and it gives immediate satisfaction to human beings in no other way than the things produced by nature herself – and not only to human beings but also to other animals, as is shown in a picture representing the father of a family, which little children tried to caress even in their swaddling clothes, and similarly the dog and cat in the same household. It was an amazing display to behold.

Painting represents the works of nature to its sense with greater truth and certitude than do words and letters, but letters represent words to its sense with greater truth than does painting. But we declare the science representing the works of nature to be more marvellous than that science which represents the works of the worker, that is to say, the products of man, which words are, as in poetry and other similar things which are expressed through human language.

Of the imitable sciences

Those sciences that are imitable are of such a kind that through them the disciple can equal the master and produce comparable results. These sciences are useful for the imitator, but they are not of such excellence as those that cannot be passed down in this way as if they are heritable goods. Amongst these, painting has first place. It cannot be taught to someone not endowed with it by nature, as can be done with mathematics in which the pupil takes in as much as the master gives out. It cannot be copied as can writing, in which the copy has as much worth as the original. It cannot be reproduced as can sculpture, in which the cast shares with the original the essential merits of the piece. It cannot produce infinite offspring, like printed books. Painting alone retains its nobility, bringing honours singularly to its author and remaining precious and unique. It never gives rise to offspring equal to itself, and such singularity gives it greater excellence than those things that are spread abroad. Do we not even now see the greatest kings of the Orient going out veiled and concealed, believing their fame to be diminished by showing themselves publicly and divulging their

presence? Do we not see pictures representing the divine beings constantly kept under coverlets of the greatest price? And whenever they are unveiled there is first great ecclesiastical solemnity with much hymn singing, and then at the moment of unveiling the great multitude of people who have gathered there immediately throw themselves to the ground, worshipping and praying to the deity, who is represented in the picture, for the repairing of their lost health and for their eternal salvation, exactly as if this goddess were there as a living presence. This does not happen with any other science or other works of man, and if you claim that this is not due to the power of the painter but to the inherent power of the thing represented, it may be replied that in this case the minds of the men would be satisfied were they to remain in their beds rather than going to wearisome and dangerous places on pilgrimages, as may be continually witnessed. But since such pilgrimages continue to take place, what causes their inessential travels? Certainly you will concede that it is the visual image. All the writings could not do this, by representing so potently the form and spirit of this deity. Accordingly it would seem that the deity loves this painting and loves those who love and revere it, and takes delight in being adored in this way rather than in any other form of imitation, and thus bestows grace and gifts of salvation in accordance with the faith of those who gather in that location.[25]

THE WORKS OF THE EYE AND EAR COMPARED

How painting surpasses all the works of man on account of the subtle speculations with which it is concerned

The eye, which is said to be the window of the soul, is the primary means by which the *sensus communis*⋆ of the brain may most fully and magnificently contemplate the infinite works of nature, and the ear is the second, acquiring nobility through the recounting of things which the eye has seen. If you, historians or poets or mathematicians, had not seen things through your eyes, you would only be able to report them feebly in your writings. And you, poet, should you wish to depict a story as if painting with your pen, the painter with his brush will more likely succeed and will be understood less laboriously. If you assert that painting is dumb poetry,† then the painter may call poetry blind painting.[26] It may be said, therefore, that poetry is the science that serves as the pre-eminent medium for the blind, and painting does the same for the deaf. But painting remains the worthier in as much as it serves the nobler sense[27] and remakes the forms and figures of nature

with greater truth than the poet. And the works of nature are far more worthy than words, which are the products of man, because there is the same relationship between the works of man and those of nature as between man and god. Therefore, it is nobler to imitate things in nature, which are in fact the real images, than to imitate, in words, the words and deeds of man.[28]

Now, do you not see that the eye embraces the beauty of all the world? The eye is the commander of astronomy; it makes cosmography; it guides and rectifies all the human arts; it conducts man to the various regions of this world; it is the prince of mathematics; its sciences are most certain; it has measured the height and size of the stars; it has disclosed the elements and their distributions; it has made predictions of future events by means of the course of the stars; it has generated architecture, perspective and divine painting. Oh excellent above all other things created by God! What manner of praises could match your nobility? What races, what languages would they be that could describe in full your functions...? Using the eye, human industry has discovered fire, by which means it is able to regain what darkness had previously taken away. It has graced nature with agriculture and delectable gardens.

But what need is there for me to expand into an elevated and lengthy discourse? What is there that cannot be accomplished by the eye? It allows men to move from east to west. It has discovered navigation. And it triumphs over nature, in that the constituent parts of nature are finite, but the works which the eye commands of the hands are infinite, as is demonstrated by the painter in his rendering of numberless forms of animals, grasses, trees and places.[29]

Which is the greater deprivation for man: to lose sight or hearing?[30]

The eye, in which the beauty of the world is mirrored for spectators, is of such excellence that whoever consents to its loss deprives himself of access to all the works of nature. The soul is reconciled to stay in its human prison on account of its vision of these works through the eyes – by means of which all the varieties of objects in nature are presented to the soul. But he who loses his eyes leaves his soul in a dark prison in which every hope is lost of seeing again the sun, the light of the world. And how many are those for whom the shades of night are hardly bearable, though they be but short-lived. What would they do if such shades were to be their companions for life?

Certainly, there is no one who would not choose to lose hearing and smell rather than sight. By consenting to the loss of hearing, a man surrenders all those sciences which achieve their ends by words and

he would only do this in order not to lose the beauty of the world which consists of the surfaces of bodies, with their visual effects and actual forms as reflected in the human eye.[31] A deaf man only foregoes the sound made by the movement of the percussed air, which is the least matter in the world.[32] He who loses sight loses the spectacle and beauty of the universe, and comes to resemble someone who has been buried alive in a tomb in which he can move and survive.[33]

Animals receive worse injury by the loss of vision rather than hearing, for many reasons: firstly, by means of sight, they find food with which to nourish themselves, as is necessary for all animals; secondly, through sight, they can appreciate the beauty of all created things, most especially those that arouse love. One born blind is never able to make good this deficiency through hearing, because he would never be able to judge whatever might be beautiful. For him there remains only hearing, through which he is only able to hear voices and human speech, contained in which are the names of all things to which names are assigned. Without the knowledge of these names it is possible to live contentedly, as is seen in those born deaf, namely the mutes, most of whom are able to find pleasure in the practice of drawing.

If you say that sight provides an impediment to sharp and subtle mental reasoning, through which insight is achieved into divine sciences, and that this kind of impediment led a philospher to deprive himself of sight,* the answer to this is that the eye, lord of the senses, does its duty by obstructing all the confusions and lies which arise not in sciences but in those discourses undertaken with great commotion and gesticulation. Hearing, which remains most offended by them, should do the same, since it seeks an accord in which all the senses tally. If this philosopher plucked out his eyes to remove the impediment to his discourse, you may well consider that such an act fittingly accompanied his mind and reasoning, since they were equally insane. Could he not have closed his eyes when he entered such a frenzied state and kept them thus closed until his fury had abated? But the man was mad, and his ideas were mad, and none more so than the plucking out of his eyes.[34]

The difference between painting and poetry[35]

The imagination cannot see with such excellence as the eye, because the eye receives and gives the images or rather the semblances of the objects to the *imprensiva*,* and from this *imprensiva* to the *sensus communis*, where it is interpreted, but the imagination is unable to exist outside the *sensus communis*, unless it passes to the memory where it terminates and dies if the thing imagined is not of great excellence. Poetry arises in the mind and imagination of the poet, who desires to

depict the same things as the painter. He wishes to parallel the painter, but in truth he is far removed . . . Therefore, with respect to representation, we may justly claim that the difference between the science of painting and poetry is equivalent to that between a body and its cast shadow. And yet the difference is even greater than this, because the shadow of the body at least enters the *sensus communis* through the eye, while the imagined form of the body does not enter through this sense, but is born in the darkness of the inner eye. Oh! what a difference there is between the imaginary quality of such light in the dark inner eye and actually seeing it outside this darkness![36]

Painting immediately presents to you the demonstrations which its maker has intended and gives as much pleasure to the greatest of senses as anything created by nature. And in this case, the poet who sends the same thing to the *sensus communis* via hearing, a lesser sense, cannot give any greater pleasure to the eye than if you were listening to something spoken. Now, see what difference there is between hearing an extended account of something that pleases the eye and seeing it instantaneously, just as natural things are seen. Yet the works of the poets must be read over a long span of time. Often there are occasions when they are not understood and it is necessary to compose various commentaries, and very rarely do the commentators understand what was intended by the mind the poet. And many times authors do not read out any more than a small part of their work through lack of time. But the work of the painter is instantaneously accessible to his spectators.[37]

Painting presents its essence to you in one moment through the faculty of vision by the same means as the *imprensiva* receives the objects in nature, and thus it simultaneously conveys the proportional harmony of which the parts of the whole are composed, and delights the senses. Poetry presents the same thing but by a less noble means than by the eye, conveying it more confusedly to the *imprensiva* and describing the configurations of the particular objects more slowly than is accomplished by the eye. The eye is the true intermediary between the objects and the *imprensiva*, which immediately transmits with the highest fidelity the true surfaces and shapes of whatever is in front of it. And from these is born the proportionality called harmony, which delights the sense with sweet concord, no differently from the proportionality made by different musical notes to the sense of hearing. And yet hearing is less noble than sight, in that as it is born so it dies, and it is as fleeting in its death as it is in its birth. This cannot apply to the sense of sight, because if you represent to the eye a human beauty composed of proportionately beautiful parts, this beauty will not be so impermanent or rapidly destroyed as that made by music. On the contrary, it has great permanence and allows you to see and contemplate it, and does not need to be reborn in numerous

performances like music, nor will it induce boredom in you. Rather, human beauty will stimulate love in you, and will make all your senses envious, as if they wished to emulate the eye – as if the mouth would wish to suck it into the body, as if the ear would seek its pleasure from being able to hear visual beauty, as if the sense of touch would wish it to be infused through the pores, and as if the nose would wish to inhale it with the air that it continually exhales.[38]

If you were to say that poetry is more enduring, I would reply that the works of a coppersmith are even more enduring, because time conserves them better than the works of both of us. Nevertheless, the coppersmith requires little imagination. And by painting with enamels on copper, pictures can be made more durable.[39] Time will destroy the harmony of human beauty in a few years, but this does not occur with such beauty imitated by the painter, because time will long preserve it. And the eye, in keeping with its function, will derive as much true pleasure from depicted beauty as from the living beauty denied to it ... In this case, the painted imitation can provide a surrogate in large measure – a form of substitution that the poet cannot effect. In such matters the poet may wish to rival the painter, but he does not allow for the fact that the words with which he delineates the elements of beauty are separated from one another by time, which leaves voids between them and dismembers the proportions. He cannot delineate them without excessive wordiness, and not being able to depict them, he cannot compose the proportional harmonies that are produced by divine proportions. During the very time that it takes to embrace the contemplation of painted beauty it is not possible to accomplish a beautiful description, and it is a sin against nature to send via the ear those things that should be sent via the eye. Let the effects of music enter through the ear, but do not send the science of painting that way, since it is the true imitator of the natural shapes of all things.[40]

A poem, which has to accomplish the representation of a given beauty by means of the representation of each of those parts which would comprise the same harmony in a painting, does not achieve any more grace than music would produce if each note were to be heard on its own at various intervals, failing to produce any harmony – just as if you wished to show a face part by part, always covering the section previously shown. In such a demonstration, the concealment does not allow the composition of any proportional harmony because the eye cannot embrace all of it within its faculty of vision simultaneously.[41]

[Reply of King Mathias to a poet who vied with a painter]

On King Mathias's* birthday, a poet had brought him a work made to commemorate the day on which the King was gifted to the world, when

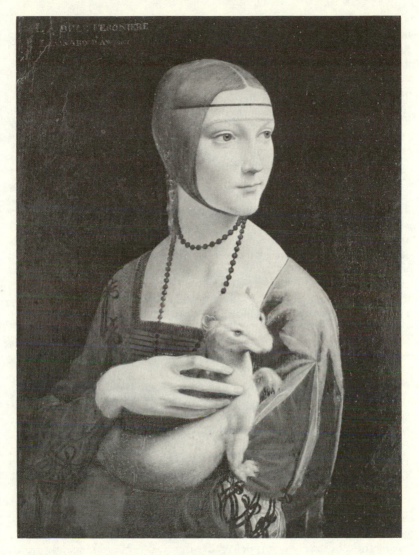

4. *Cecilia Gallerani*, Cracow, Czartoryski Museum.
'a painter presented [the King] with a portrait of his beloved lady. Immediately the King closed the book of the poet and turned to the picture, fixing his gaze upon it with great admiration'

a painter presented him with a portrait of his beloved lady. Immediately the King closed the book of the poet and turned to the picture, fixing his gaze upon it with great admiration. Whereupon the poet very indignantly said, 'Read, O King! Read and you will discover something of greater consequence than a dumb painting'. The King, on hearing the accusation that he was giving credence to dumb objects said, 'Be silent, O poet. You do not know what you are saying. This picture serves a greater sense than yours, which is for the blind. Give me something I can see and touch, and not only hear, and do not criticise my decision to tuck your work under my arm, while I take up that of the painter in both hands to place it before my eyes, because my hands acted spontaneously in serving the nobler sense – and this is not hearing. For my part I judge that there is an equivalent relationship between the science of the painter and that of the poet as there is between the senses to which they are subject. Do you not know that our soul is composed of harmony, and that harmony cannot be generated other than when the proportions of the form are seen and heard instantaneously? Can you not see that in your science, proportionality is not created in an instant, but each part is born successively after the other, and the succeeding one is not born if the previous one has not died? From this I judge that your invention is markedly inferior to that of the painter, solely because it cannot compose a proportional harmony. It does not satisfy the mind of the listener or viewer in the same way as the proportionality of the very beautiful parts composing the divine beauty of this face before me, and which by contrast are conjoined instantaneously, giving me such delight with their divine proportions. I judge that there is nothing on earth made by man which can rank higher.'[42]

The arguments of the poet and the painter, and what difference there is between poetry and painting[43]

If the poet says that he can inflame men with love, which is the central aim in all animal species, the painter has the power to do the same, and to an even greater degree, in that he can place in front of the lover the true likeness of that which is beloved, often making him kiss and speak to it. This would never happen with the same beauties set before him by the writer. So much greater is the power of a painting over a man's mind that he may be enchanted and enraptured by a painting that does not represent any living woman. It previously happened to me that I made a picture representing a holy subject, which was bought by someone who loved it and who wished to remove the attributes of its divinity in order that he might kiss it without guilt. But finally his conscience overcame his sighs and lust, and he was forced to banish

5. Infernal destruction, Windsor, RL 12388
'I will describe hell or paradise, or other delights and terrors'

it from his house. Now, poet, attempt to describe a beauty, without basing your depiction on an actual person, and arouse men to such desires with it.

If you say, 'I will describe hell or paradise, or other delights and terrors', the painter will surpass you because he will place things before you which will silently tell of such delights or terrify you or turn your mind to flight.[44]

If you, poet, were to portray a bloody battle you would write about the dark and murky air amid the smoke of fearful and deadly engines of war, mixed with all the filthy dust that fouls the air, and about the fearful flight of wretches terrified by awful death. In this case, the painter will surpass you, because your pen will be worn out before you have fully described something that the painter may present to you instantaneously using his science. And your tongue will be impeded by thirst and your body by sleep and hunger, before you could show in words what the painter may display in an instant. In such a picture nothing is lacking except the souls of depicted beings. And in each body the integration of its parts is demonstrated from a single viewpoint. It would be a long and tedious thing in poetry to portray all the movements of the participants in such a war, with all the components and members of their bodies and their accoutrements. The painter can accomplish this and place it before you with great immediacy and truth, and such a display lacks only the noise of the weapons, the shouts of the terrifying victors and the screams and cries of those terrified. And the poet, too, is unable to represent these things to the sense of hearing.[45]

The painter disputes with the poet[46]

Painting moves the senses more rapidly than poetry . . . A painter made a figure so that anyone who saw it immediately yawned and continued to repeat this behaviour for as long as his eyes remained on the picture in which the yawning was actually portrayed. Others have painted such libidinous and wanton acts that they incited spectators to indulge in these same activities, which poetry cannot accomplish. And if you were to describe the image of some deities, such writing would never be venerated in the same way as a painted goddess, since votive offerings and various prayers will continually be made to such a picture. Many generations from diverse regions and across the eastern seas will flock to it, and they will beg succour from such a painting but not from writing.[47]

What moves you, O man, to abandon your own houses in the cities and to leave relatives and friends and to go into the countryside through mountains and valleys, if not the natural beauty of the world,

6. Warriors's head for the *Battle of Anghiari*, Budapest, Museum of Fine Arts.
'the shouts of the terrifying victors'

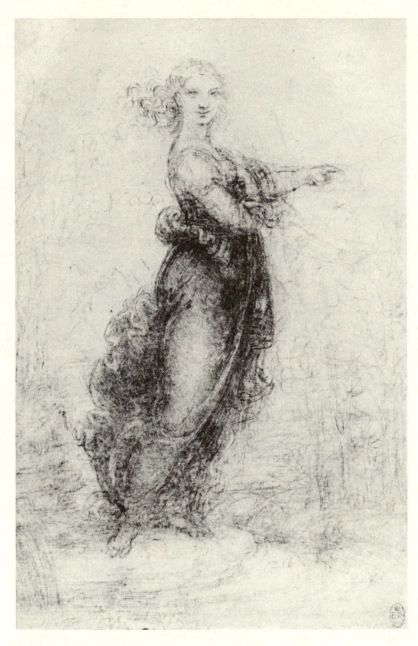

7. Pointing lady in a landscape, Windsor, RL 12581.
'you will be able to picture yourself as a lover with your beloved in flowery meadows,
beneath the sweet shade of verdant trees'

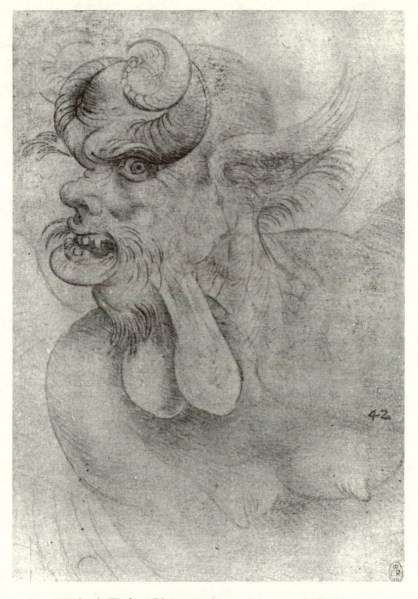

8. Monster's head, Windsor, RL 12371.
'if the painter wishes to see ... monstrous things which might terrify or which would
be buffoonish and laughable or truly pitiable, he is their lord and god'

which, if you think carefully about it, can only be appreciated by the sense of sight? And if in this respect the poet also wishes to call himself a painter, why do you not take up the descriptions of such places by the poet, and stay at home without subjecting yourself to the excessive heat of the sun? Would that not be more convenient and less arduous for you, because it could be accomplished in the cool and without travel or danger of sickness? But your soul would not enjoy the benefits provided by the eyes, windows of its dwelling, and it would not receive the images of pleasant locations; it would not see the shady valleys irrigated by the play of winding rivers; it would not see the various flowers, which with their colours make a harmony for the eye, and likewise all the other things that may be presented to the eye. But, if a painter in the cold and harsh wintertime set before you the same or similar landscapes as those in which you once took your pleasures beside a spring, you will be able to picture yourself again as a lover with your beloved in flowery meadows, beneath the sweet shade of verdant trees. Will you not obtain a different pleasure than from hearing the poet's description of such effects?[48]

How the painter is lord of every kind of person and of all things

If the painter wishes to see beauties that would enrapture him, he is master of their production, and if he wishes to see monstrous things which might terrify or which would be buffoonish and laughable or truly pitiable, he is their lord and god. And if he wishes to produce places or deserts, or shady and cool spots in hot weather, he can depict them, and similarly warm places in cold weather. If he seeks valleys, if he wants to disclose great expanses of countryside from the summits of high mountains, and if he subsequently wishes to see the horizon of the sea, he is lord of them, or if from low valleys he wishes to see high mountains, or from high mountains see low valleys and beaches. In fact, therefore, whatever there is in the universe through essence, presence or imagination, he has it first in his mind and then in his hands, and these are of such excellence that they can generate a proportional harmony in the time equivalent to a single glance, just as real things do.[49]

An argument of the poet against the painter[50]

You say that a science is correspondingly more noble to the extent that it embraces a more worthy subject, and accordingly, that a spurious speculation about the nature of god is more valuable than one

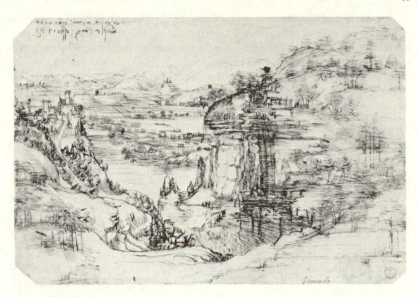

9. Landscape, the 'Val d'Arno', Florence, Uffizi.
'if he wants to disclose great expanses of countryside from the summits of high mountains'

concerned with something less elevated. In reply we will state that painting, which embraces only the works of God, is more worthy than poetry, which only embraces the lying fictions of the works of man.[51]

The poet may say, 'I will make a story which signifies great things'. The painter can do the same, as when Apelles painted the *Calumny*.*[52] The poet says that his science consists of invention and measure, and this is the main substance of poetry – invention of the subject-matter and measurement in metre – which is subsequently dressed up in all the other sciences. The painter responds that he has the same obligations in the science of painting, that is, invention and measure – invention of the subject that he must depict and measurement of the things painted, so that they should not be ill-proportioned.[53]

Painting does not dress itself up in the three other sciences. On the contrary, these others dress themselves up largely by means of painting, as does astronomy,* which can achieve nothing without perspective, the principal element of painting – I mean mathematical astronomy, not that false prophecy which is (if you will forgive me for saying so) the means by which fools live.[54]

If poetry embraces moral philosophy, painting is natural philosophy. If poetry describes the operation of the mind, painting considers the action of the mind in bodily motions. If poetry terrifies people with fictional hells, painting can do likewise by presenting in reality the same thing. Supposing that the poet, like the painter, depicts beauty, fierceness, an evil or ugly thing, or something monstruous, by transforming objects in whatever manner he wishes, then the painter will give greater satisfaction. Have we not seen painting which had such a conformity with the imitated object that they have deceived both men and animals?[55]

I once saw a painting which deceived a dog by means of the likeness of the painting to its master. The dog made a great fuss of it. And in a similar way I have seen dogs barking and trying to bite painted dogs, and a monkey did an infinite number of stupid things in front of a painted monkey.* I have seen swallows fly and perch on iron bars which have been painted as if they are projecting in front of the windows of buildings.[56]

Here the poet answers, and concedes the above arguments, but adds that he is superior to the painter because he can make men talk and argue about diverse fictions in which he depicts things that do not exist; because he can induce men to take up arms; because he will describe the heavens, the stars, nature and the arts and everything. To this one replies that none of these things of which he speaks belongs within his real profession. But if he wishes to make speeches and orations, he must be persuaded that he will be conquered by the orator, and that if he wishes to speak of astronomy, he has stolen it from the astronomer, and philosophy from the philosopher.[57] The only true office of the poet is to invent words for people who talk to each other. Only these words can he represent naturally to the sense of hearing, because they are in themselves the natural things that are created by the human voice. But in all other respects he is bettered by the painter.[58]

How music may be called the younger sister of painting

Music is not to be regarded as other than the sister of painting, in as much as she is dependent on hearing, second sense behind that of sight. She composes harmony from the conjunction of her proportional parts, which make their effect instantaneously, being constrained to arise and die in one or more harmonic intervals. These intervals may be said to circumscribe the proportionality of the component parts of which such harmony is composed – no differently from the linear contours of the limbs from which human beauty is generated.[59]

Although the objects in front of the eye touch each other as if hand

in hand, I shall none the less found my rule on a scale of 20 for 20 *braccia*, just as the musician has done with notes.★ Although the notes are united and attached to each other, he has none the less recognised small intervals between note and note, designating them as first, second, third, fourth and fifth, and in this manner from interval to interval has given names to the varieties of raised and lowered notes.[60]

But painting excels and is superior in rank to music, because it does not perish immediately after its creation, as happens with unfortunate music. Rather painting endures and displays as lifelike something that is in fact on a single surface.[61] The painter makes his work permanent for very many years, and of such excellence that it keeps alive the harmony of those proportional parts which nature, for all her powers, cannot manage to preserve. How many paintings have preserved the image of a divine beauty which in its natural manifestation has been rapidly overtaken by time or death. Thus, the work of the painter is nobler than that of nature, its mistress![62]

O marvellous science, you keep alive the transient beauty of mortals and you have greater permanence than the works of nature, which continuously change over a period of time, leading remorselessly to old age. And, this science has the same relation to divine nature as its works have to the works of nature, and on this account is to be revered.[63]

With painting images of gods are made, around which religious cults arise, in the service of which music is used as an adornment; semblances of those who inspire love are provided for lovers; beauty, which time and nature renders fleeting, will be preserved; and we are able to preserve the likenesses of famous men. If you should say that music lasts for ever by being written down, we are doing the same here with letters.[64] Yet words are less noble than deeds; and you, writer on sciences, do you not copy with your hand, rendering what is in your mind, just like the painter? . . .

If you, O musician, should say that painting is mechanical because it is carried out by excercise of the hands, I say that music is produced by the mouth, which is a human organ – not dedicated in this instance to the sense of taste any more than the hands are to the sense of touch.[65] If you say that sciences are not mechanical but cerebral, I say to you that painting is cerebral, and that, just like music and geometry, it considers the proportions of continuous quantities, while arithmetic considers discontinuous quantities. Painting deals with all the continuous quantities and the qualities of shade and light and distance through the science of perspective.[66]

That thing is most worthy that satisfies the highest sense. Therefore painting, satisfying the sense of sight, is more noble than music, which only satisfies hearing . . . That thing which is in itself most universal and various in its subjects will be said to possess the most excellence.

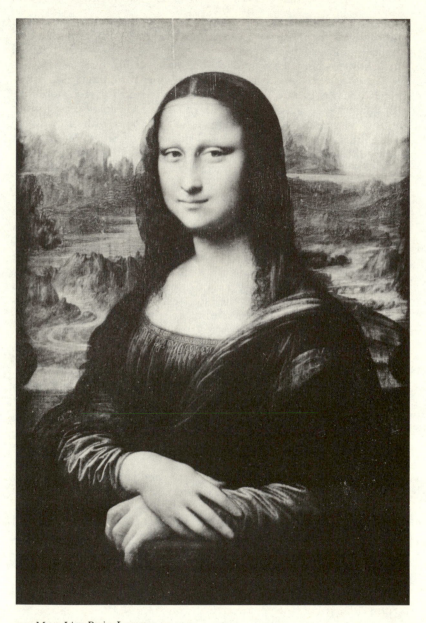

10. *Mona Lisa*, Paris, Louvre.
'O marvellous science, you keep alive the transient beauty of mortals and you have greater permanence than the works of nature'

Therefore painting is to be preferred to all other occupations, because it embraces all the forms that are and are not found in nature. It is to be more praised and exalted than music, which is only concerned with pitch ... Therefore, seeing that you have placed music amongst the liberal arts,* either you should place painting there or remove music. And if you say that vile men can make use of paintings, music can be similarly corrupted by those who do not understand it.[67]

Concluding arguments of the poet, painter and musician

There is the same difference between the representation of corporeal things by the poet and painter as between dismembered and intact bodies, because the poet in describing the beauty or ugliness of any figure shows it to you bit by bit and over the course of time, while the painter will permit it to be completely seen in an instant. The poet is not able to present in words the true configuration of the elements which make up the whole, unlike the painter, who can set them before you with the same truth as is possible with nature. The poet may be regarded as equivalent to a musician who sings by himself a song composed for four choristers, singing first the soprano, then the tenor, and following with the contralto and then the bass. Such singing cannot result in that grace of proportioned harmony which is contained within harmonic intervals. Alternatively, something made by the poet may be likened to a beautiful face which is shown to you feature by feature, and, being made in this way, cannot ever satisfactorily convince you of its beauty, which alone resides in the divine proportionality of the said features in combination. Only when taken together do the features compose that divine harmony which often captivates the viewer.

Yet music, in its harmonic intervals, makes its suave melodies, which are composed from varied notes. The poet is deprived of this harmonic option, and although poetry enters the seat of judgement through the sense of hearing, like music, the poet is unable to describe the harmony of music, because he has not the power to say different things at the same time. However, the harmonic proportionality of painting is composed simultaneously from various components, the sweetness of which may be judged instantaneously, both in its general and in its particular effects – in general according to the dictates of the composition; in particular according to the dictates of the component parts from which the totality is composed. And on account of this the poet remains far behind the painter with respect to the representation of corporeal things, and, with respect to invisible things, he remains behind the musician.

But if the poet borrows assistance from the other sciences, he may

be compared to those merchants at fairs who stock varied items made by different manufacturers. The poet does this when he borrows from other sciences, such as those of the orator, philosopher, cosmographer and suchlike, whose sciences are completely separate from that of the poet. Thus the poet becomes a broker, who gathers various persons together to conclude a deal. If you wish to discover the true office of the poet, you will find that he is nothing other than an accumulator of things stolen from various sciences, with which he fabricates a deceitful composition – or we may more fairly say a fictional composition. And in that he is free to make such fictions the poet parallels the painter,* although this is the weakest part of painting.[68]

Introduction on sculpture and whether it is a science or not[69]

Applying myself to sculpture no less than to painting, and practised in both to the same degree, it seems to me that I am able to form a judgement about them with little prejudice, indicating which of these two is of greater insight,* difficulty and perfection.[70]

Sculpture is not a science but a very mechanical art, because it causes its executant sweat and bodily fatigue. A sculptor only need know the simple measurements of the limbs and the nature of movements and postures. With this knowledge he can complete his works, demonstrating to the eye whatever it is, and not inherently giving any other cause for admiration in the spectator, unlike painting, which on a flat surface uses the power of its science to display the greatest landscapes with their distant horizons.[71]

There is no comparison between the innate talent,* skill and learning within painting and within sculpture, inasmuch as spatial definition in sculpture arises from the nature of the medium and not from the artifice of the maker.[72]

The difference between painting and sculpture

... The sculptor undertakes his work with greater bodily exertion than the painter, and the painter undertakes his work with greater mental exertion. The truth of this is evident in that the sculptor when making his work uses the strength of his arm in hammering, to remove the superfluous marble or other stone which surrounds the figure embedded within the stone. This is an extremely mechanical operation, generally accompanied by great sweat which mingles with dust and becomes converted into mud. His face becomes plastered and powdered all over with marble dust, which makes him look like a

baker, and he becomes covered in minute chips of marble, which makes him look as if he is covered in snow. His house is in a mess and covered in chips and dust from the stone.

The painter's position is quite contrary to this (speaking of painters and sculptors of the highest ability), because the painter sits before his work at the greatest of ease, well dressed and applying delicate colours with his light brush, and he may dress himself in whatever clothes he pleases. His residence is clean and adorned with delightful pictures, and he often enjoys the accompaniment of music or the company of the authors of various fine works that can be heard with great pleasure without the crashing of hammers and other confused noises.

Moreover, the sculptor, in bringing his work to completion, has to make each figure in the round with many contours so that the figure will look graceful from all viewpoints. These contours cannot be made if the raised and lowered areas are not apparent, and they cannot be realised accurately without turning the form to see its profiles; namely, the contours of the concave and convex parts seen against their abutment with the air which touches them. But in truth this requirement cannot be said to rebound to the credit of the sculptor, considering that he shares with the painter the need to pay attention to the contours of forms seen from every aspect. This consideration is implicit in painting, just as it is in sculpture.[73]

The sculptor says that he cannot make one figure without making an infinite number, on account of the infinite number of contours possessed by any continuous quantity. It may be replied that the infinite contours of such a figure can be reduced to two half figures, that is, one half from the middle backwards and one half from the middle forwards, which, if correctly proportioned, will combine to make a figure in the round. These half figures, exhibiting the due relief in all their parts, will embody in themselves without additional assistance all the infinite figures which the sculptor claims he must make. The same claim may be made by someone who has to make a vase on a wheel since he must inspect the vase from an infinite number of aspects.[74]

The sculptor, wishing to carve in such a way as to render the intervals between the muscles and to permit the prominences of the muscles to stand out, cannot produce the required figure, other than in terms of its length and breadth, if he does not move around it, stooping or rising in such a way as to see the true elevations of the muscles and the true gaps between them. These features can be judged by the sculptor in this situation, and by such means the contours are recognised, otherwise he would never capture the profiles or true shapes of his sculptures. In this is said to reside the mental effort of sculpture, because he does not otherwise require anything more than physical exertion. He does not need any measure of mental activity – or we may say judgement – unless in rectifying the profiles of the

limbs when the muscles are too prominent. And this is the proper pro-
cedure by which the sculptor brings his works to completion.[75]

If you make a figure in half relief, to be seen from the front, you will
not have to achieve more in your demonstration than the painter has
to accomplish in a figure seen from the equivalent viewpoint – and the
same applies to a back view of the figure.

But low relief entails incomparably more intellectual considerations
than sculpture in the round, and it approaches painting with respect
to its intellectual considerations, because it is indebted to perspective.
And sculpture in the round incorporates nothing of such knowledge,
because it simply adopts those measurements that are found in the live
model, and, on this account, the painter learns sculpture more rapidly
than the sculptor learns painting. But to return to the subject of low
relief, I say that it involves less physical exertion than sculpture in the
round but much more research, in that you must consider the propor-
tional distances between the parts of objects that come first in sequence
and those that come second, and between the second and third, and
so on. And, given this, you will as a perpsectivist not find a single
work in low relief that is not full of errors with respect to the lower
and higher relief through which the parts of objects recede, according
to whether they are more or less close to the eye.[76]

How sculpture requires less talent than painting and lacks many natural characteristics[77]

Painting involves greater mental deliberation and is of greater artifice
and wonder than sculpture, in that necessity requires the mind of the
painter to transmute itself into nature's own mind and to become the
interpreter between nature and art, showing how the causes of her
effects are dependent on laws and in what way the semblances of the
objects surrounding the eye converge on the pupil of the eye, as true
images of the objects. It will be demonstrated how, amongst objects
of equal size, some may appear larger to the eye; and of equal colours
it will be shown how some will appear more or less dark or more or
less light; and of objects placed equally low, it will be demonstrated
how some will appear more or less low; and of those placed equally
high, it will be demonstrated how some appear more or less high; and
of equal objects placed at various distances, it will be shown how some
will be less distinct than others.

The art of painting embraces and contains within itself all visible
things. It is the poverty of sculpture that it cannot do this; namely,
show the colours of everything and their diminution with distance.
Painting shows transparent objects, but the sculptor shows you the
things of nature without the painter's artistry. The painter shows to

11. Study of the chest and shoulders of an infant from front and rear, Windsor, RL 12567. 'the infinite contours of . . . a figure can be reduced to two half figures, that is one half from the middle backwards and one half from the middle forwards'

you different distances and the variations of colour arising from the air interposed between the objects and the eye; also the mists, through which the images of the objects penetrate with difficulty; also the rains, behind which can be discerned the cloudy mountains and valleys; also the dust, through which can be discerned the warriors who set it in motion; also the rivers of greater or lesser transparency, in which can be seen fishes playing between the surface of the water and the bed; also the polished pebbles of various hues, deposited on the washed sand of the river's bed and surrounded by the verdant plants under the surface of the water; also the stars at their various altitudes above us; and also innumerable other effects to which sculpture cannot aspire.[78]

The sculptor is not able to achieve diversity using the various types of colours. With respect to these, painting is not deficient in any way. The perspective used by sculptors [in reliefs] never appears correct, whereas the painter can make a distance of one hundred miles appear in his work. Aerial perspective is absent from the sculptors' work. They cannot depict transparent bodies, nor can they represent luminous sources, nor reflected rays, nor shiny bodies such as mirrors and similar lustrous things, nor mists, nor dreary weather – nor endless other things, which I will not list in order to avoid monotony.[79]

The sculptor says that low relief is a form of painting. This may be in part conceded as far as drawing is concerned, because it participates in perspective. As far as light and shade are concerned low relief fails both as sculpture and as painting, because the shadows correspond to the low nature of the relief, as for example in the shadows of foreshortened objects, which will not exhibit the depth of those in painting or in sculpture in the round. Rather, the art of low relief is a mixture of painting and sculpture.[80]

Next we may look at the arch-enemy of sculpture. Whether fully in the round or in low relief, sculptures are of no consequence unless they are provided with appropriate illumination, comparable to that under which they were made. Accordingly, if they are illuminated from below, the sculptor's works will look notably monstrous, particularly in the case of low reliefs, which are almost wiped out and appear in reverse.[81]

Sculpture is nothing other than it appears to be, that is to say, a modelled form surrounded by air and clothed in shaded and illuminated surfaces as are other natural objects; and this art is produced by two masters, namely nature and man, but the work of nature is the greater. If she did not render assistance to the work with shadows of greater or lesser darkness and lights of greater or lesser brightness, the whole undertaking would exhibit a colour of uniform lightness and darkness, like a flat surface. In addition to this, nature contributes

12. Storm over a valley, Windsor, RL 12409.
'the painter shows to you different distances ... [with] rains, behind which can be discerned the cloudy mountains and valleys'

perspective, which by foreshortening helps round off the surfaces of the muscles on various sides, according to whether one muscle or another is in action to a greater or lesser extent. Here the sculptor replies and argues that 'if I did not make these muscles, perspective could not foreshorten them for me'. To which it may be answered that were it not for the assistance of light and shade you would not have been able to make the muscles, because you would not have seen them. The sculptor responds that 'it is I who give rise to the light and shade when I remove material in sculpting'. It is answered that it is not he but nature who makes shadow, nor is it his art. If he worked in the gloom he could not see anything because it could not be distinguished. Equally, if the material to be sculpted were to be surrounded with a mist of uniform brightness, he would see nothing other than the outlines of the material to be sculpted where they abut against the edges of the mist.

I wish to ask, sculptor, why you cannot bring your work to completion out of doors, surrounded by the universally diffused light of the air, in the same way as you can under a specific source of illumination which descends on your work from above. If you originate shadow as you please by removing material, why cannot you give rise to this effect in material sculpted under diffused light, rather than under specific illumination? Certainly you deceive yourself, in that your shadows and lights are made by another master to whom you are only the servant – preparing the medium on which the visual effects are imprinted. Therefore do not glorify yourself through the labours of someone else.[82]

The major cause of wonder that arises in painting is the appearance of something detached from the wall or other flat surface, deceiving subtle judgements with this effect, as it is not separated from the surface of the wall. In this respect the sculptor makes his works so that they appear to be what they are... The second major consideration essential for the painter is the subtle investigation which concerns the placing of the true quality and quantity of the shade and light, which nature produces by herself in the works of the sculptor. Perspective, an investigation and invention of the greatest subtlety in mathematical studies, uses the power of lines to make that which is near appear distant and that which is large appear small. In this respect the sculptor is helped by nature without any invention of his own.[83]

The excuse of the sculptor

The sculptor says that if he removes more marble than he should, he cannot rectify his error as can the painter. To this it is replied that someone who removes more than he should is not a master, because a

master is required to understand the true science of his profession.[84] If he is in command of measurements, he will not remove what he should not, and therefore we may say that this fault arises from the executant and not from the material.[85] It is a poor argument to try to prove that the irreparability of lapses makes a work more noble. But I would certainly say that it will be more difficult to retain the credibility of the talent of the master who makes such mistakes than it will be to repair the work that has been ruined.[86] We well know that someone with practised skill will not make such errors. Rather, obeying good rules, he will proceed by removing so little at any time that he takes his work along smoothly. Moreover, the sculptor working in clay or wax can take away and add on, and when it is finished it can be readily cast in bronze. This is the final process and results in the most permanent sculpture, since that which is only in marble is susceptible to damage, which is not the case with bronze.[87]

Modelling is the sister of painting, as was affirmed by the ancients, being an art of less crashing and labour than the working of stone. It was acclaimed as mother by sculpture, in order that her works should serve as examples and guides. Sculpture avails itself of clay models, which come closer to our imagination. These are then measured with compasses, and can thereby insinuate figures of men, horses and whatever you wish into the marble. From this it is concluded that we are able to characterise sculpture as nothing other than a laboured imitation of modelling, involving the practice of carving marble with care and much time, and that it will be more elevated and perfectly realised the closer it approaches modelling. This is because it does not in itself lack draughtmanship, composing muscles and disposing contours, although not using foreshortening. All properties that are possessed by painting. Thus painting is held to be sister to modelling, from which it follows that painting is aunt to sculpture... Accordingly it has always given me much pleasure and delight, as can be seen by my various complete horses, and limbs and heads, and also human heads representing Our Lady, and complete youthful Christs and fragments, and heads of old men in good number.[88]*

[Conclusion]

The divinity of the science of painting considers works both human and divine, which are bounded by surfaces, that is to say the boundary lines of bodies, with which she dictates to the sculptor the way to perfect his statues. Through her principle, that is to say, draughtsmanship, she teaches the architect how to make his buildings convey pleasure to the eye; she teaches the potters about the varieties of vases, and also the goldsmiths, the weavers and the embroiderers. She has

invented the characters in which the various languages are expressed; she has given numerals to the mathematicians; she has taught the drawing of figures to the geometrician; she has taught the students of optics, the technicians and the engineers.[89]

You have placed painting amongst the mechanical arts. Certainly if painters were capable of praising their works in writing, as poets have done, I do not believe that painting would have been given such a bad name.[90] Painting does not speak, but is self-evident through its finished product, while poetry ends in words, with which it vigorously praises itself.[91] If you call painting mechanical because it is primarily manual, in that the hands depict what is found in the imagination, you writers draft with your hand what is found in your mind.[92] With justified complaints painting laments that it has been excluded from the number of the liberal arts, since she is the true daughter of nature and acts through the noblest sense. Therefore it was wrong, O writers, to have left her outside the number of the liberal arts, since she embraces not only the works of nature but also an infinite number that nature never created.[93]

Part II:

THE SCIENCE OF VISION IN PAINTING

THE EYE AND LIGHT

Painting and its divisions and components

Light, shade, colour, body, shape, position, distance, nearness, motion and rest – of these ten parts of the functions of sight, painting has seven, of which the first is light, then shade, colour, shape, position, distance and nearness. I omit body and motion and rest. Light and shade are included, or we may wish to say shadow and illumination, or lightness and darkness. I do not include body because painting in itself is a thing of surface, and surface has no body as is defined in geometry.[94]

Amongst all the studies of natural phenomena, light most delights its students. Amongst the great things of mathematics, the certainty of its demonstrations most conspicuously elevates the minds of investigators. Perspective must therefore be preferred to all the human discourses and disciplines. In this field of study, the radiant lines are enumerated by means of demonstrations in which are found not only the glories of mathematics but also of physics, each being adorned with the blossoms of the other. Analysis of these has been conducted with great circumlocutions, but I will constrain myself with decisive brevity, treating them according to the nature of the material and its mathematical demonstrations. Sometimes I will deduce effects from causes and at other times causes from effects, adding also my own conclusions, some of which do not arise in this way but may nonetheless be formulated – if the Lord, light of all beings, deigns to illuminate my discourse on light.[95]★

Introduction to perspective, that is to say, the function of the eye

Now, take note reader, something about which we cannot believe our ancient predecessors, who have wished to define the nature of the soul and life – things beyond proof – whereas those things which at any time can be clearly known and proved by experience have for so many centuries been unknown or falsely conceived. The eye, the function of which is thus clearly shown by experience, has, until my own time,

been defined by innumerable writers in one way; I find by experience that it is different.[96]

In the eye the shapes, the colours, all the images of the parts of the universe are reduced to a point, and this point is such a marvellous thing! O wonderful, O marvellous necessity, you constrain with your laws all the effects to participate in their causes in the most economical manner! These are miracles ... In so small a space the image may be recreated and recomposed through its expansion. In this way, clear and immediate effects can arise from confused origins, like the images which have passed through the aforesaid natural point. Describe in your anatomy what ratios exist between the diameters of all the spheres of the eye and what distance there is between them and the crystalline sphere.*[97]

In what way the eye sees things placed in front of it[98]

The eye sees in no other way than by a pyramid.[99]

13. Visual pyramids emanating from an object, based on MS BN 2038 6v.

The body of the air is full of an infinite number of radiant pyramids caused by the objects located in it. These pyramids intersect and interweave without interfering with each other during their independent passage throughout the air in which they are infused. They are of equal power, and all can be equal to each and each equal to all. The semblance of a body is carried by them as a whole into all parts of the air, and each smallest part receives into itself the image that has been caused.*[100]

Immediately the air is illuminated it is filled with an infinite number of images which are caused by various bodies and colours located within it. The eye becomes the target and the magnet of these images.[101] It is impossible that the eye should send the power of vision outside itself through visual rays, because, on opening that front part of the eye which would have to be the source of their departure, the power of vision could not reach out to the object without a lapse of time. This being so, it could not climb in a month to the height of the sun, when the eye wished to see it.*[102]

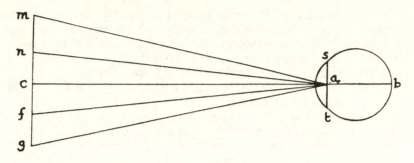

14. Optical system of the eye, based on CA 337rn/85va.

Let us suppose that the ball represented here is the sphere of the eye and that the lesser portion of the eye is divided by the line *st* in its transparent area,★ and that all the things impinging on the middle of the surface of this transparent part immediately pass through and go to the pupil, passing via a certain crystalline humour which does not interfere in the pupil with the thing displayed to this transparent part. And the pupil, having received the things from this part immediately refers them and transmits them to the intellect along the line *ab*. And you must know that the pupil does not transmit anything with such perfection to the intellect or *sensus communis*† as when the things sent to it via the transparent area are directed along the line *ab*, as for example the line *ca*. Although the lines from *m*, *n*, *f* and *g* will be visible within the pupil, they are not taken into account because they are not directed along the line *ab*. And the proof is this: if the eye described above wishes to count the letters placed in front of it, it will be granted that the eye must truly turn from letter to letter, because it will not discriminate between each letter unless along the axis *ab*, in the manner of *ac*. All the seen objects reach the eye by pyramidal lines, and the apex of the said pyramid terminates and finishes in the middle of the pupil as described above.★[103]

INTRODUCTION TO PERSPECTIVE

On the errors of those who rely on practice without science[104]

It is a very great vice found in many painters that they make the houses of men and other surrounding buildings in such a way that the gates

of the city do not come up to the knees of the inhabitants even though they are closer to the eye of the observer than the man who indicates that he wishes to enter therein. We have seen porticos laden down with men, and the supporting column like a thin cane in the fist of the man who leans on it. Other similar things are to be disdained.[105]

Those who are in love with practice without science are like the sailor who boards a ship without rudder and compass, who is never certain where he is going. Practice must always be built on sound theory, of which perspective is the signpost and gateway, and without perspective nothing can be done well in the matter of painting.[106] The painter who copies* by practice and judgement of eye, without rules, is like a mirror which imitates within itself all the things placed before it without any understanding of them.[107]

Discourse on painting

Perspective, with respect to painting, is divided into three principle parts, of which the first is the diminution in the size of bodies at various distances; the second part is that which deals with the diminution in colour of these bodies; the third is the diminution in distinctness of the shapes and boundaries which the bodies exhibit at various distances.[108] Of these three perspectives, the first has its foundation in the eye, while the other two are derived from the air interposed between the eye and the objects seen by the eye.[109]*

Their rules will permit you to acquire an unfettered and good judgement, since good judgement is born of good understanding, and good understanding derives from rationality – drawn from good rules – and good rules are the daughters of good experience, common mother of all the sciences and arts. Hence, once you have my precepts in your mind, your rectified judgement will on its own enable you to judge and recognise every ill-proportioned work, whether with respect to perspective or figures or anything else.[110]

PERSPECTIVE OF SIZE

Perspective is a rational demonstration by which experience confirms that all things send their semblances to the eye by pyramidal lines. Bodies of equal size will make greater or lesser angles with their pyramids according to the distances between one and the other. By

15. Standard perspective construction of a tiled floor (with confirming diagonal, *ab*), based on MS A 54Ir.

pyramidal lines I mean those which depart from the surface edges of bodies and travelling over a distance are drawn together towards a single point.[111]

All the instances of perspective are expounded through the five terms of the mathematicians, namely point, line, angle, surface and body. The point is unique of its kind: the point has neither height nor breadth nor length or depth, and, hence, it is to be concluded that it is indivisible and occupies no space. Line is of three types, namely straight, curved and sinuous, and has neither breadth nor height or depth, and, hence, is indivisible except in its length; its ends are two points. Angle is the termination of two lines at a point.[112] The surface is the boundary ... and the boundary of a body is not part of that body ... and the boundary of one body is the start of another.[113]

The boundaries of bodies are the least of all things. This proposition is proved to be true because the boundary of a thing is a surface, which is not part of the body clothed in that surface, nor is it part of the air surrounding these bodies, but it is the division interposed between the air and the body, as is proved in the right place. But the lateral boundaries of these bodies is the boundary line of the surface, which as a line is indivisible. Therefore, painter, do not surround your bodies with drawn lines, above all when representing objects smaller than they are in nature. Not only will these objects not exhibit their lateral boundaries, but their component parts will not be visible from a distance.[114]

The principle of perspective

All things send their semblances to the eye by means of pyramids. The image of the original object will be smaller to the extent that the pyramid is intersected nearer the eye. Therefore you may cut the pyramid with an intersection that touches the base of the pyramid as is demonstrated by the intersection *an*.

16. Pyramid of vision and the intersection, based on MS A 36v.

The eye f and the eye t are one and the same thing; but the eye f denotes the distance, that is to say how far away you are when looking at the object, and the eye t demonstrates the orientation, that is to say whether you are situated centrally or to the side or at an angle to the thing you are looking at. Remember that the eye f and the eye t should always be placed at the same height as each other. For example, if you lower or raise the eye f, which denotes the distance, you must do the same with the eye t, which denotes the orientation. The point f shows how far the eye is distant from the square plane and does not show in which way it is orientated, and similarly the point t provides this orientation and does not show the distance. Therefore, to know both distance and orientation, you must identify the eyes with each other, so that they may be the same thing.

If the eye f looks at a perfect square, in which all the sides are equal to the length between s and c, and if at the base of the side which is towards the eye is placed a staff or other straight object which stands perpendicularly, as is shown by rs, I say that if you look at the side of the square which is nearest to you it will appear at the base of the intersection rs. And if you look at the second side, opposite, it will appear higher up on the intersection at point n. Therefore, by this

17. A square viewed in perspective, based on MS A 36v.

demonstration, you can understand that if the eye is above an infinite number of things placed on a plane one behind the other they will accordingly be located progressively higher, as far as the point which denotes the height of the eye. But they will appear no higher, providing the objects are placed on the plane on which your feet are located and the plane is flat. Even if this plane extends infinitely, it will never pass higher than the eye, because the eye has in itself that point towards which are directed and towards which converge all the pyramids that carry the images of the objects to the eye. And this point

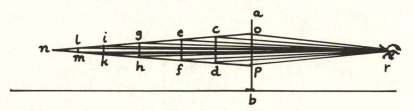

18. Points of the visual pyramid and the pyramid of diminution, based on MS A 37r.

always coincides with the point of diminution that appears at the limit of everything we see ... In the figure above, let *ab* be the intersection, *r* the point of the pyramids ending in the eye, *n* the point of diminution. This point is always seen by the visual point in the eye along a straight axis and always moves with it, just as when a rod is moved its shadow moves and travels with it, no differently from the way a shadow travels with a solid body. And both points are the vertices of the pyramids that make a common base on the intervening intersection. Although their bases are equal, they make different angles, because the point of diminution is the apex of a smaller angle than that of the eye. If you should ask me, by what experience can you demonstrate these points to me, I will say to you that the extent to which the point of diminution travels with you will be apparent when you walk beside a ploughed plot of land with straight furrows, the ends of which reach down to the road on which you are walking. You will always see each pair of furrows in such a way that it seems to you that they are trying to press inwards and join together at their distant ends.[115]

If the eye is in the middle between the tracks of two horses which are running towards their goal along parallel tracks, it will seem to you that they are running to meet each other. This happens because the images of the horses which impress themselves on the eye are moving towards the centre of its surface, that is, the pupil of the eye.[116]

With respect to the point in the eye, this will be more easily understood as follows: if you look at someone's eye, you will see your image reflected; now if you imagine two lines starting from your ears and running to the ears of the semblance of yourself that you see in the other person's eye, you will understand that these lines are arranged in such a way that a little behind your reflected image they would subsequently come together in a point. And if you want to measure the diminution of the pyramid in the air which is to be found between the thing seen and the eye, you can do so in the manner of the diagram below. Let *mn* be a tower, and *ef* a rod which you move backwards

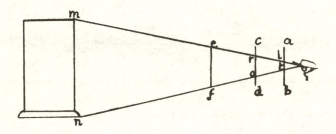

19. Perspective of a tower demonstrated by a rod, based on MS A 37v.

and forwards until its ends coincide with the limits of the tower. Then bring it nearer the eye at *cd*, and you will see that the image of the tower seems smaller, as *ro*. Next bring it closer to the eye and you will see the rod extend far beyond the image of the tower at *al* and *tb*, and thus you will deduce that a little further on the lines will converge to a point.[117]

20. Draughtsman using a perspective frame to draw an armillary sphere, CA 1ra/5.
'the intersection ... should be made to serve the same function as a pane of glass through which are seen various objects which you draw on it'

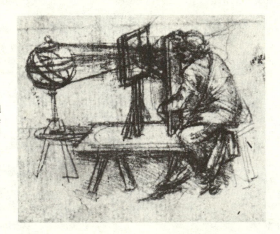

The intersection is a vertical line which is imagined in front of the common point at which the courses of all the pyramids are conjoined. This intersection with the said point should be made to serve the same function as a pane of glass through which are seen various objects which you draw on it. And the drawn objects would be so much smaller than the originals to the extent that the space between the glass and the eye becomes smaller than that between the glass and the objects.[118]

Linear perspective embraces all the functions of the visual lines, proving by measurement how much smaller the second object is than the nearest, and how much the third is smaller than the second, and so on by degrees, as far as the objects can be seen. I have found by experiment that when the second object is as far from the first as the first is from the eye that, although they are the same size, the second will appear as half as small as the first. And if the third object is of equal size to the second, and the third is as far distant from the second as the second is from the eye, it will appear half the size of the second, and so on by degrees. At equal distances the second will always diminish by a half compared to the first, and so on.[119]

If you place the intersection at one *braccio* from the eye, the first object, situated at a distance from your eye of four *braccia*, will diminish by three-quarters of its size on the intersection; and if it is eight *braccia* from the eye, by seven-eighths; and if it is at a distance of sixteen, by fifteen-sixteenths of its height, and so on from stage to stage. As the space doubles so the diminution doubles.[120]

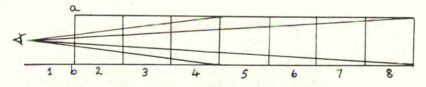

21. Ratios of size on the intersection, based on MS A 8v.

If two similar and equal things are placed one behind the other at a given distance, they will demonstrate a greater difference between their sizes when they are nearer to the eye which sees them. And thus conversely they will demonstrate less divergence in size between themselves when they are more remote from the designated eye. This is proved by the ratios between their distances. It follows that if these two bodies are located so that the distance from the eye to the first is the same as that from the first to the second, a proportion of two to one will arise, since if the first is one *braccio* distant from the eye and the second two *braccio* distant, and accordingly, two being double one,

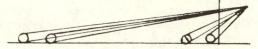

22. Perspective of two bodies
at different distances, based on
MS G 29v.

the first body will be shown double the size of the second. And if you
remove the first to one hundred *braccia* from you, and the second to
one hundred and one, you will discover the first to be larger than the
second only to the extent that one hundred is less than one hundred
and one.[121]

To demonstrate that the pyramid of perspective encompasses in-
finite space, we will imagine an eye at *ab* which demarcates the degrees
of distance to infinity *d, n, m, o, p* ..., and its visual lines intersect the
section *cd*. These visual lines at every degree of distance from the start
gain height on the plane *cd,* but they will never reach the height of the
eye. And since the plane *cd* is a continuous quantity, it is infinitely
divisible, and will never be filled up with visual lines, even if the
length of the ultimate line were to be infinitely distant.[122]

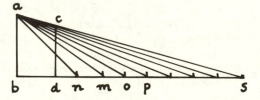

23. Perspective objects on the
intersection, based on Urb
283v.

[Problems of natural and accidental perspective]

Perspective comes into action when judgement is lacking with respect
to things that diminish. The eye can never be a true judge for deter-
mining with certainty the closeness of one thing compared to
something else when the top of the second thing appears to the eye
of the observer to be placed at the same level, unless by the use of the
intersection, mistress and guide of perspective. Let *n* be the eye and
ef be the intersection mentioned above, and *a, b, c, d,* will denote the

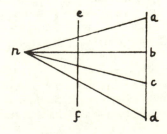

24. Problems of perspective from
a close viewing distance, based on
MS C 27v.

three parts that are one above the other. If the lines *an* and *cn* are of a given length and the eye is centrally placed, *ab* will appear the same size as *bc*. However, *cd* is lower and more distant from *n* and appears smaller. The same thing happens in the three divisions of the face, when the eye of the portrait painter is on a level with the eye of the person he is portraying.[123]

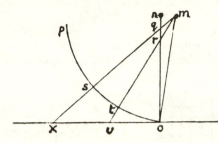

25. Perspective and the viewing position, based on MS A 38r.

The eye *m*, looking at the spaces *o–v–x*, will see almost no difference between them, and this arises because of the proximity of the eye to them. But if you produce these spaces on the intersection at *n–o*, the space *o–v* appears on the intersection as *o–r*, and similarly the space *v–x* appears as *r–q*. And if you did this in a work in some place in which you are able to move around, it will appear to be discordant, on account of the great variation that exists between *o–r* and *r–q*. This comes about because the eye is so adjacent to the intersection that the intersection is foreshortened. Hence if you wanted to put it into operation in any work, you must ensure that this perspective is only viewed through a single aperture, which is located at *m*, or indeed you must retreat to a distance at least three times the height of the thing you see. The intersection *op*, being always equidistant from the eye is one way of rendering things well, so that they may be viewed from a number of places.[124]

The practice of perspective is divided into [two] parts. The first represents all the objects to the eye at their distances and shows how the eye sees them diminished. The observer is not obliged to remain in one place rather than another, providing that the wall on which it is represented does not foreshorten it a second time. But the second practice is a mixture of perspective made in part by art and in part by nature, and a work undertaken according to this rule does not exhibit any elements that are not subject to a mixture of natural perspective and accidental perspective. By natural perspective I mean that in which the perspectival projection is produced on a flat intersection, and on this intersection, although it has parallel horizontal and upright sides, we are required to diminish the remoter parts more than the

nearest, and this conforms to the first of the divisions mentioned above, in which the diminution of objects will be natural.

Accidental perspective, that is to say, that made by art, acts in a contrary manner, because the size of bodies that are in themselves equal appears larger on the foreshortened intersection to the extent that the eye is naturally closer to the intersection and to the extent that some parts of the intersection on which it is represented are more distant from the eye.

Let the intersection be *de* on which are represented three equal circles, which are behind *de*, that is to say the circles *a b c*. Now you can see that the eye *h* will see the intersections of the images on the

26. Problems of natural and artificial perspective, based on MS E 16v.

rectilinear intersection as larger at greater distances or smaller when closer. But this invention requires that the observer should situate himself with his eye at a small aperture, and then through this hole the perspective will be well displayed. But because many spectators will strive to see at the same time the one work made in this manner – and as only one can see well how such perspective functions – all these other people will find it confusing.* It is well therefore to avoid such compound perspective and to limit yourself to simple perspective, which does not see the intersection as itself foreshortened, but as much in its actual shape as is possible. In this simple perspective, the intersection cuts across the pyramids carrying the images to the eye at equal distances from the seat of vision, and these images are experienced on the curved surface of the transparent part of the eye, on which these pyramids are intersected at equal distances from the seat of vision.[125]

The cause of accidental perspective lies with the wall on which the demonstration is performed, which is at unequal distances from the eye at various places along its length. The diminution of the wall arises naturally, but the perspective represented on it is accidental, because in no part does it accord with the actual diminution of the aforesaid wall. Thus it comes about that when the eye is removed from the station point for viewing the perspective, all the objects represented

27. Problems of perspective distortion, based on BL 62r.

appear monstrous ... Let us say that the four-sided body *abcd* represented above is a foreshortened square, seen by the eye located opposite the middle of the side which is at the front. Accidental perspective mixed with natural perspective will be found in the four-sided body known as a parallelogram, that is to say *efgh*, which must appear to the eye looking at it as similar to *abcd* when the eye remains fixed at its original place in relation to *cd*; and this will be seen to good effect, because the natural perspective arising from the wall will conceal the defects of this monstrous form.[126]

A painting ought to be viewed from a single aperture, as appears in the case of bodies made thus: 0 [an ovoid shape]. If you wish to make a round ball at a height it is necessary to make it elongated, as in this image, and to situate yourself at such a distance away that it is foreshortened and appears round.[127]

[A problem of perspective]

A perspectivally diminished work should be viewed from the same distance and height and direction as the point at which your eye is placed, otherwise your science will not make a good effect.

And if you will not or cannot adopt this principle, for the reason that the wall on which you are painting is to be viewed by several persons, place yourself at a distance of at least ten times the size of the thing to be represented. The least of the errors which you can make in this case is to set down all the nearest objects in their true shape, and from whatever place you take up, the seen objects will diminish on their own account, except that the spaces which exist between

28. Problems of artificial perspective with a row of columns, based on MS A 41r.

them will not be in keeping with reason. For, if you take up position opposite the middle of a straight row of columns and look at a series of them arranged in a line, you will see, beyond a few of the intervals between these columns, that the columns touch each other, and after touching they overlap each other in such a way that the last column appears but little beyond the penultimate one. Accordingly the intervals that exist between the columns are entirely lost. And if your method of perspective is good, it will produce this very effect. This effect arises from standing close to the line along which the columns are placed. And this method will be disagreeable if the work is not viewed through a small hole at the centre of which is located your point of sight, and if you do it thus, your work will be perfect and will deceive the spectators, and they will see the columns portrayed in the manner represented here. In this diagram the eye is in the middle at point *a* and is close to the columns.

If you cannot ensure that the people who look at your work stand at a single point, draw your viewing point backwards, when arranging your work, to at least twenty times the greatest height or width of your work, and this will ensure that there will be so little variation when the eye of the spectator is moved that it will barely be noticed, and it will be well worthy of praise.

29. Problems of artificial perspective with three objects equidistant from the eye, based on MS A 41v.

If the viewing point is at *f*, you could make the figures on the circle at *d*, *b*, and *e*, all of the same size, each of them being in the same relationship to the point *f*. Consider the diagram . . . and you will see why this is not so, and why I shall make *b* smaller than *d* and *e*. It can clearly be seen that where two things equal to each other are set down, one at three *braccia* will seem smaller than one at two *braccia*. This is more a matter for theoretical debate than practice, because [in this demonstration] you are close [to the seen objects]. [In practice] render all the foreground objects exactly as they are, large or small as they may be. If you see them from a distance, they will appear as they

ought, and if you see them at close quarters, they will diminish automatically.[128]

[A further problem of perspective]

Whether a rectangular wall of four sides and four angles and of extended length will display itself to the eye with its upper and lower edges straight or curvilinear; these parallel sides will display themselves as a hexagonal shape, that is to say, of six sides and six angles. And this is proved by the ... proposition that states: of objects of equal size the more remote will be seen so much smaller as they are removed to a greater distance. Thus the height of the wall *rtop* appears smaller at *op* than the height at *ab*, to the extent that the line *pf* is longer than the line *bf*, in that *pf* exceeds *bf* by the interval *pm*, which amounts to a third of *pf*. Therefore *op* will be correspondingly smaller than *ab*, that is to say, by a proportion of one third, and *vice versa*, because increasing distance makes the seen object seem smaller, and decreasing distance increases the size of the seen object ... Thus it is proved that if an eye is located opposite the middle of a rectangular wall of four straight sides and four right angles, the wall is seen with six straight sides and six angles, of which two are obtuse and four right

30. Lateral diminution in a wall, based on MS E 4r.

angles.[129] The aforementioned obtuse angle is not the largest of such angles, because the angle will increase to the extent that the eye which sees it is placed further from it, and the angles will correspondingly diminish to the extent that the eye is placed closer. Hence it has been concluded that if the eye is placed directly opposite parallels, these parallels will display themselves as a biangular body with curved sides, but in truth this figure possesses four angles of which the two are in the middle – that is to say, above and below each other – and the other two are at the two other opposite ends.[130]

Why objects portrayed perfectly from nature do not appear to possess the same relief as appears in an object in nature

It is impossible that a picture copying outlines, shade, light and colour with the highest perfection can appear to possess the same relief as that

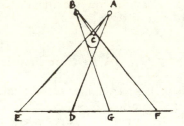

31. Binocular vision of an object, based on Urb 155v.

which appears in an object in nature, unless this natural object is look-ed at over the long distance and with a single eye. This is proved as follows: let the eyes be *a* and *b*, looking at an object *c*, with the con-verging central axes of the eyes as *ac* and *bc*, which converge on the object at the point *o*. The other axes, lateral to the central one, see the space *gd* behind the object, and the eye *a* sees all the space *fd*, and the eye *b* sees all the space *ge*. Hence the two eyes see behind the object and all the space *fe*. On this account, this object *c* acts as if transparent, by the definition of transparency, according to which nothing behind it is concealed. This cannot happen with someone who looks at an ob-ject with one eye, if the object is bigger than the eye, although the same does not apply when this eye sees an object somewhat smaller than its pupil, as is demonstrated in the diagram. And from what has been said we can arrive at a conclusion to this question, because something painted interrupts our view of all the space behind it, and in no way is it possible to see any part of the background behind it within the circumferential outline of the object.[131]

Why, of two objects of equivalent size, the painted one appears larger than the one in full relief

The reason for this cannot be demonstrated as readily as with many other questions, but I shall none the less strive to reach a satisfactory understanding, if not completely, at least as far as I am able ... The visual lines which pass between the object and the eye, when they ex-tend to the surface of a painting, all terminate at the same intersection, while the visual lines which pass between the eye and a piece of sculpture have different terminations and lengths. That line will be longer that extends towards a limb more distant than the others, and so that limb appears smaller. Since many lines are longer than others, and because many details are at different distances from each other ... it follows that they appear smaller, and, appearing smaller, manage by their diminution to make the object smaller in its entirety, and this

does not occur with a painting, in which all the lines end at the same distance. It follows that they are without diminution. Hence the details do not diminish and reduce the whole object, and for this reason the painting does not diminish as does a piece of sculpture.[132]

Why does a painted object, while coming to the eye at an angle of the same size as from an object more distant from it, not appear as distant as it does in nature? Let us say that I paint on the intersection *bc* something which is required to appear a mile away, and I place it

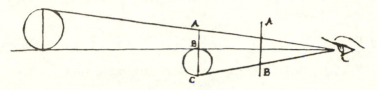

32. Size of an object as painted and as seen in nature, based on Urb 152v.

beside an object which is at that real distance of one mile, and the two things are arranged such that the intersection *ac* cuts the pyramids at equal widths. Notwithstanding this, they will never appear to be at the same distance to two eyes.[133]

[More problems of perspective and vision]

If all the images which reach the eye converge at a single angle, by the definition of an angle they would converge on a mathematical point, which is proved to be indivisible. Therefore all the things seen in the universe would appear one and indivisible and there would not be any space between one star and another that could be judged at such an angle. And since experience shows us that everything is divided by proportional and intelligible space, the seat of vision, on which the images of things are imprinted, must be divisible into as many larger and smaller parts as are the images of the seen objects. We conclude, therefore, that the sense takes the images which impinge on the surface of the eye and then judges them within.[134] It is true that every part of the pupil possess the visual power, and this power is not reduced to a point as the perspectivists require.[135]

The eye will never be capable of seeing the true boundary of the shapes of any body seen against a background in the far distance. This may be proved: let *ab* be the pupil of the eye and *cp* the body placed opposite to the eye of which it will be noted that *c* is the upper edge, and let *nm* be the background against which this edge ought to be seen

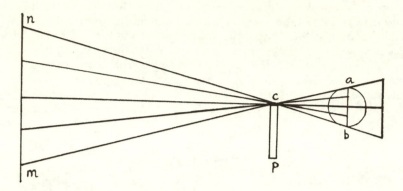

33. The edge of an object seen against a distant background, based on MS D 10v.

by the eye. I say that it will not be ascertained on what part of this background the edge of this body terminates ... [because] the seat of vision is not in a point as the painter-perspectivists wish, but is throughout all the pupil into which the images of the objects penetrate, and within the eye in a larger space than that occupied by the pupil.★ The images are more clearly to be discerned to the extent that they are closer to the centre of the seat of vision.[136]

An object smaller than the pupil placed before the eye will not cover up for this pupil any distant object.[137]

Experience proves that sheets of canvas made out of coarse horsehair and placed in front of the eyes do not cover anything behind them and conceal it less to the extent that they are closer to the eye.[138]

All objects in front of the eye that are brought too close to it will have their edges discerned confusedly, as happens with objects close to a light, which make a large and indistinct shadow, and the eye makes a corresponding effect in judging objects in front of it.[139]

The further that a spherical body is from the eye, the more of it you will see.★[140]

If you look with the eyes a and b at the spot c, it will appear to you that this spot c is at d and f [with respect to the background]. And if you look only with the eye g, h will appear to you at point m. And painting can never contain in itself these two varieties of looking.[141]

If you are situated under water and look at something within the air, you will see this thing out of its position, and the same occurs with a thing within the water seen from the air.[142]

That rod or chord which is in rapid vibration appears to be doubled. This happens when a knife is fixed and the top of it is pulled forcibly

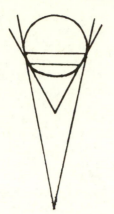

34. A spherical body seen from different distances, based on MS A
10v.

35. Binocular and monocular vision, based on Turin 38v.

to one side and released, causing it to shake back and forth many times. And the same thing happens with the chord of a lute when one tests it to see if it is good.[143]

Actual motion made with rapid impetus will never obstruct from the eye the object which is behind the body that is moving, providing it is near to the eye and not too much larger than this eye – as happens with the motion of certain instruments worked by women, made for the purpose of gathering their threads together ... For these by their circular motion are so swift that through being perforated they do not obstruct to the eye anything behind them.[144]

Every object that moves with speed seems to tinge its path with the semblance of its colour. This proposition is seen from experience, in that when the lightning moves among the dark clouds the speed of its sinuous flight makes its whole course appear in the form of a luminous snake. And similarly if you move a lighted brand with a circular motion it will appear that its whole course is a flaming circle. This is because the *imprensiva*★ is quicker [in responding] than the judgement.[145]

Among objects of equal size and at equal distances from the eye, that

will show itself to be larger that is more white in colour, and thus conversely will appear smaller if darker.[146]

If the eye looks at the light of a candle at a distance of four hundred *braccia*, this light will appear to the eye of the spectator increased a hundred times its true quantity ... This error comes from the eye which takes in the luminous images not only from the point of its light but also from the whole of this light [as radiated].[147]

That luminous body which loses more of its radiance will be shown of less size at the same distance. This is shown by an iron rod heated along part of its length when in a dark place. Although it is of uniform thickness, it appears considerably bigger in the heated part, and the more so as it is more heated.[148]

Amongst objects of equal darkness, size, shape and distance from the eye, those will be displayed as smaller which are seen against a background of the greatest radiance or whiteness. This is shown when the sun is seen behind trees without leaves, in which all their branches are situated against the body of the sun and are so diminished that they remain invisible. The same happens with a rod interposed between the eye and the body of the sun ... Objects seen at a distance are disproportionate, and this arises because the brightest part sends its image to the eye with a more vigorous ray than the dark part is able to do. And I have seen a woman dressed in black with a white cloth headdress, which made her head look entirely as large as the width of her shoulders, which were dressed in black.[149]

This may [also] be seen in the height of buildings at night, when lightning flashes behind them, and it immediately appears that the effect of the lightning diminishes the height of the building. From this also arises the effect that buildings appear larger when in fog or at night than when the air is clear and luminous.[150]

[The pupil]

1st. The pupil of the eye contracts in size to the extent that the light impinging on it grows in quantity.

2nd. The pupil of the eye enlarges to the extent that the brightness of the daylight or other light which impinges on it diminishes.

3rd. The eye sees and comprehends the things that serve as its objects more intensely to the extent that the pupil is more dilated, and this can be proved by means of the nocturnal animals, such as cats and some birds, like the owl and similar things, in which the pupil undergoes variations from huge to tiny etc., when in the dark or in the light.

4th. The eye located in a luminous ambience sees darkness behind the windows of light dwellings.

5th. All colours placed in shady locations appear of equal darkness beside each other.

6th. But all colours placed in bright locations will never vary in their essential natures.[151]

The pupil of the eye increases and diminishes in size slowly when looking at dark or luminous things

Why does the eye located in a bright place see darkness inside each dwelling, when on moving inside it seems bright enough? The answer to this resides in the fact that the outdoor light offers such an excess of light that the pupil contracts and diminishes in size in order that it can bear the radiance of the air, the radiance being reduced in the eye. From this it follows that in looking within these dwellings with an eye adapted in this way, they will appear to be gloomy, because if the strongly luminous ambience has been made less bright in the eye, anything lacking this degree of brightness will seem to be character-ised by shade.[152]

The eye, in the act of seeing things converging on it, retains a certain amount of the images. This conclusion is proved by observed effects, because our sight on seeing a light experiences a certain amount of fear.* Moreover, after staring at the image of an intensely bright ob-ject, it is retained in the eye, and makes a less bright place appear shady, until the eye has cast off the last vestiges of the impression of the greater light.[153]

The pupil which becomes largest will see objects largest

This is shown in looking at luminous bodies, above all those in the heavens. When the eye emerges from darkness and suddenly looks up at these bodies, they appear larger and then diminish. And if you were to look at these bodies through a small aperture, they would appear smaller because a smaller part of the pupil would be able to exercise its function.[154] Every visible object will appear larger at midnight than at midday, and larger in the morning than at midday. This hap-pens because the pupil of the eye is considerably smaller at midday than at any other time.[155]

COLOUR AND THE PERSPECTIVE OF COLOUR

On the intersection of images in the pupil of the eye

At the intersection of the images on entering the pupil, the images do not become fused with each other in that place where their crossing brings them together. This can be demonstrated in that if the rays of the sun pass through two panes of glass which are in contact with each other, and one glass is blue and the other yellow, then the rays penetrating it are tinged with neither blue nor yellow but with a beautiful green, and if the same thing should occur in the eye, the images of the colours yellow and blue* should fuse with each other when they cross on entering the pupil, but this does not occur, and no mixture results.

The direct lines of the rays, which carry the shape and colour of bodies in the air through which they proceed, do not colour the air with themselves, nor do they subsequently colour each other by contact when they intersect, but only colour that place at which they cease their existence, because that place is visible to the source of the rays and vice versa, and no other object which surrounds that source may be seen at the place where the ray is intersected and destroyed, depositing there the captive form it has transported.[156]

[On colours]

The simple colours are [six], of which the first is white, although some philosophers do not accept white or black amongst the number of the colours, because the one is the cause of the colours and the other is the absence of them. However, because the painter cannot do without them, we add them to the number of the others, and we say that, in this order, white is the first among the simple colours, and yellow the second, green the third of them, blue is the fourth, and red is the fifth, and black is the sixth. And white is given by light, without which no colour may be seen, yellow by earth, green by water, blue by air and red by fire, and black by darkness which stands above the element of fire, because there is no substance or density on which the rays are able to percuss and accordingly to illuminate it.*

If you wish to see readily the variety of all the compound colours, take some coloured pieces of glass and look through them at all the colours of the countryside that can be seen behind them, and thus you will be able to see that all the colours of the things behind the glass appear

to be mixed with the colour of that particular glass, and you will be able to see whether the colour is enhanced or weakened by this mixture.

If the particular glass is yellow, I say that the images of the objects which pass to the eye through this colour can be as easily impaired as improved. The impairment with glass of this colour will occur above all with blue, and with black and white before the others. The enhancement occurs with yellow and green above all the others. In this way you will make sense for the eye of the colours which are infinite in number, and by this means you will be able to avail yourself of mixed and compound colours of new invention. You will do the same with two glasses of different colour placed before the eye, and you will be able to proceed accordingly.

Blue and green are not in themselves simple colours because blue is compounded from light and shade as with the colour of the air which arises from the deepest black and brightest white.[157]

When a transparent colour lies over another colour differing from it, a compound colour is composed which differs from each of the simple colours from which it is compounded. This is seen in the smoke coming out of chimneys, which when seen against the blackness of the chimney makes a blue colour, and when it rises to be seen against the blue of the air appears grey or reddish. Similarly, purple placed over blue makes the colour of violet, and when blue is placed above yellow it will make green, and saffron above white will make yellow, and brightness above darkness makes a blue which will be of greater beauty to the extent that the brightness and darkness are most intense.[158]

For those colours which you wish to be beautiful, always first prepare a pure white ground. I say this in regard to colours which are transparent, because those which are not transparent do not benefit from a light ground. An example of this is shown by coloured pieces of glass which, when interposed between the eye and the luminous air, reveal themselves as exceedingly beautiful and this they cannot do when they have behind them a shadowy air or other darkness.[159]

There are many birds in various regions of the world, on whose feathers can be seen the most beautiful colours produced as they make their varied motions, as we see in our own region in the feathers of peacocks or in the necks of ducks or doves – similarly on the surfaces of ancient glasses found underground, and in the roots of turnips left for a long time at the bottom of wells or other stagnant water, in which each root is surrounded by a rainbow similar to the celestial bow. This may be seen in oil spread on top of water, and again in the solar rays reflected from the surface of diamond or beryl; again any dark object bordering the air or other light object, seen through a facet of beryl, is surrounded by a rainbow interposed between the air and the dark object. And there are many such occurrences, which I will leave aside, because these are enough for my purpose.[160]

Of the mixture of one colour with another, extending towards infinity

While the mixtures of the colours with each other extend towards infinity, I will not on this account be deterred from writing a small discourse, at first setting down certain simple colours and with each of these mixing each of the others: one with one, and then two with two, and three and three, and so on proceeding towards the goal of the entire number of colours ...

I call simple colours those which are not compounded and cannot be compounded by means of a mixture of other colours ... After black and white come blue and yellow, then green and tan, that is to say, tawny, or if you wish to say ochre, and then deep purple and red. These are the eight colours and there are no more in nature, and with these I begin the process of mixing, first with black and white, and then with black and yellow, black and red, then yellow and black, yellow and red [and so on].[161]

How the beauty of colours is bound to exist in light

Since we see that the quality of colours is revealed by means of light, it is to be deduced that where there is more light will be seen more of the true quality of the illuminated colour; and where there is more shadow, the colour will be tinged with this shadow. Hence, painter, remember to display the true qualities of colour in the illuminated parts.[162]

It must be noted in what situation the same colour looks most beautiful in nature ... Black possesses beauty in shadow, and white in light, and blue and green and tawny in middle shadow, and yellow and red in light, and gold in reflected light, and lake in middle shadow.[163]

That surface shows less of its true colour which is more polished and shiny. We see this in the grass of meadows and in the leaves of trees, which having shiny and lustrous surfaces, take on the lustre of the reflected sun or of the air which illuminates them, and accordingly in the lustrous parts are deprived of their natural colour.[164]

Of combining colours with each other in such a way that one gives grace to the other

If you wish to ensure that the proximity of one colour should give grace to another colour which ends beside it, apply that rule which can

be seen in the rays of the sun in the composition of the celestial rainbow, otherwise called the iris.[165]

Of colours of equal whiteness that will look brightest which is against the darkest background. And black will display itself at its darkest against a background of greatest whiteness. And red will look most fierce against the yellowest background, and accordingly all the colours will do this surrounded by their directly contrary colour.[166] A direct contrary is a pale colour with a red, black with white (although neither of these is a colour), blue with a yellow such as gold, green and red.[167] The colours which go well together are green with red or purple or mauve, and yellow with blue.*[168]

That part of white will appear most pure that most closely borders upon black, and correspondingly appears less white the further it is from the black. That part of black appears darkest that is closest to a white, and correspondingly will appear to lack darkness the more remote it is from this white.[169]

Black clothing makes the flesh of images of people appear whiter than it is, and white clothing makes the flesh appear darker, and yellow draperies make it appear more colourful, and red clothes make it display paleness.[170]

Remember, painter, to dress your figures in lighter colours, in that darker colours will make lesser relief and be little apparent from a distance. And this is because the shadows of all things are dark and if you make a garment dark, there will be little variety between the lights and darks, while with light colours there will be greater variety.[171]

On the colours in shadow and to what extent they are darkened

Just as all the colours are tinged with the darkness of the shadows of night, so the shadow of any colour ends in that darkness. Therefore, painter, do not make it the practice that in your final shadows you are able to discern the colours which border on one another, because if nature does not let this happen and you make claims to be an imitator of nature, as far as art allows, do not make it seem that you intend to rectify her errors, because there is no error in her, but you should understand that the error is in you.[172]

Colours situated in shadow show less variety amongst each other to the extent that the shadow in which they are situated is darker. This is evident when we look from squares into the doorways of shady temples, in which pictures adorned with various colours appear to be covered with darkness.[173] We see, when we are inside a house, that all the colours on the surfaces of the walls are clearly and immediately visible when the windows of this house are open; but if we were to

go outside the house and look through the windows from a little distance to see again the pictures executed on the walls, rather than these pictures we would see an unrelieved darkness.[174]

Of the colours of simple cast shadows[175]

36. Shadows produced by blue and yellow lights, based on CA 45v.

The shadow is not exposed to the source that casts it, because the shadows are formed by the light that encompasses or surrounds them. The shadow formed by the light e, which is yellow, will tend towards blue, because the shadow of the body a is formed on the floor at b, where it is exposed to the blue light, and accordingly the shadow made by the light d, which is blue, will be yellow at the location c, because it is exposed to the yellow light. The ground surrounding the shadow bc, in addition to its natural colour, will be tinted with a mixed colour of yellow and blue, because it is exposed to and illuminated by yellow light and blue light at the same time.[176]

Any shadow formed on an opaque body smaller than the light source, sends out a derivative shadow that is tinted with the colour of the source.[177]

Of lights and shadows and their colours

No body is ever shown wholly in its natural colour.*

This proposition may be explained through two different causes, of which the first occurs with the intervention of the medium which is placed between the object and the eye. The second is when the object which illuminates the aforesaid body possesses in itself the quality of some colour. That part of a body will be shown with its natural colour that is illuminated by a light without colour and when the illumination does not come from an object other than that making the aforesaid light. This cannot occur and is never seen other than in a blue colour situated on a plane facing the sky on top of the highest mountain, so that in this place it is not exposed to any other object – and if the setting sun is obscured by low clouds and the canvas is of the colour of the air. But in this case I remind myself that pink will also be increased in beauty when the sun which illuminates it turns reddish in the west, together with the clouds that intervene, although in this case it may be accepted as true that a pink illuminated by a rosy light displays

beauty more here than elsewhere, which indicates that lights of other colours than red will take away its natural beauty ...

The surface of every opaque body takes on the colour of its source. The painter must pay great attention in situating his bodies amongst objects which possess various strengths of light and various lit colours, inasmuch as every body which is so surrounded never shows itself wholly in its true colour.[178]

If you should place a spherical body in the middle of various objects, such that one side is illuminated by the sun, and on the opposite side is a wall illuminated by the sun, which is green or another colour, while the surface on which it is placed is red, on the two portions affected by shadow you will see the natural colour of the said body partaking of the colour of the objects opposite. The most powerful will be the luminous source, the second will be that of the illuminated wall; the third that of the shadows.[179]

The colours of illuminated objects are impressed on the surfaces of each other in various parts as there is a variety of the locations for these objects. O is an illuminated blue object which is visible without any supplementation across the space *bc* on the white sphere *abcdef*, and it tinges this space with a blue colour. M is a yellow object, which illuminates the space *ab* in company with the blue body *o*, and tinges it with the colour green.[180]

37. Body illuminated by lights of different colours, based on CA 181r.

The surface of every opaque body takes on the colour of an object opposite, and it does this to a greater or lesser degree according to whether the object is closer or further away.[181] The colour will be more discernible on the surface to the extent that the surface of the body is whiter.[182]

That object will most tinge the surfaces of white bodies with its likeness which is farthest removed in nature from white. That which shows itself to be furthest from white is black and it is this that will colour the surface of an opaque white more than any other colour[183]

If you see a woman dressed in white in the countryside, that part of her which is exposed to the sun will be bright in such a way that it will in part irritate our vision like the sun. That part of the woman which is exposed to the air – which is luminous through the rays of the sun interweaving and interpenetrating within it – and is seen through the air, will take on a blue colour because the air is blue. If on the surface of the earth nearby there are fields, and if the woman finds herself within a field illuminated by the sun, you will see the parts of the folds that are facing the sun tinged by reflected rays with the colour of this field. Thus the dress continues to transform itself

in response to the luminous and non-luminous colours of adjacent objects.[184]

The lit colour of faces, having opposite them an object of black colour, will acquire black shadows, and this will happen correspondingly with yellow, green, and blue and every other colour placed opposite it.[185] Wet streets are more yellowish than dry ones, and those parts of the face that are turned towards these streets are tinted with the yellowness and darkness of the streets situated opposite them.[186]

Shadows generated by the redness of the sun close to the horizon will generally be blue ... Since the whiteness of the wall is deprived of any other colour, it is tinged with the colour of objects opposite.

38. Blue shadows on a white wall at sunset, based on Urb 148v.

The objects are in this instance the sun and sky. Because the sun reddens towards the evening, and the sky shows its blueness ... the cast shadow strikes the white wall with a blue colour, and the area around the shadow is exposed to the redness of the sun and takes on the colour red.[187]

I once saw green shadows made by the ropes, masts and yards on the surface of a white wall when the sun was setting, and this occurred because those parts of the surface of this wall which were not coloured by the light of the sun were coloured by the hue of the sea which was the object opposite it.[188]

You should pay the greatest attention to the things surrounding the bodies you wish to portray ... in that the surface of every opaque body takes on the colour of an object opposite. But you should skilfully arrange things so that you can ensure that the shadows of green bodies impinge upon green things such as meadows and on other suitable things, so that the shadows share in the colour of the object opposite and do not degenerate and appear to be the shadow of a body other than green, because if you place an illuminated red so that it impinges upon a shadow that is in itself green, the reddish shadow will compound a shadow which will be very ugly and very different from the true shadow of the green. And what is said about this colour also applies to the others.[189]

[The perspective of colour]

Ensure that the perspective of colour does not come into conflict with the sizes of the things depicted; that is to say, the colours should be diminished in natural strength to the extent that bodies are diminished in their natural size at different distances.[190] However, it is indeed true that in nature the perspective of colours never breaks its laws,

while the perspective of size is free, because a small hill may be found close to the eye, and a very great mountain at a distance, and similarly with trees and buildings.[191]

Among colours of the same nature, the one which is least removed from the eye varies least. This is proved because the air which is interposed between the eye and the seen object obscures the object to some extent, and if the interposed air is of considerable quantity, then the seen object will be strongly tinged with the colour of this air, and if the air is of a thinner quantity, then the object will be interfered with less.[192]

The nearest colours should be simple, and the degrees of their diminution should be consistent with the degrees of distance; that is to say, the size of things should partake more of the nature of the point of diminution the more they approach that point, and the colours have to partake more of the colour of the horizon to the extent that they come closer to it.[193]

The varieties of distance at which the colours of objects are lost vary according to the times of day, and according to the variety of density and thinness of the air through which the images of the colours of the aforementioned objects penetrate to the eye.[194]

That thing which is brightest will be most apparent at a distance, and the reverse occurs with something darker.[195] That colour will be visible at a more distant location that is most removed from black.[196]

Among the colours of a group of bodies the one will be visible at a greater distance that is of the most brilliant white. Accordingly, something of greater darkness will be visible at a lesser distance. Of a group of bodies of equal whiteness and distance from the eye the one will show itself most pure that is surrounded by the strongest darkness, and, conversely, that darkness will appear most deep that is seen within the purest whiteness.[197]

Objects darker than the air will show themselves less dark when they are more distant, and things lighter than the air will show themselves of lesser whiteness when they are more distant from the eye.[198] There are many who make figures in the open countryside so much darker as they are more distant from the eye. The contrary occurs, unless the thing to be imitated is white.[199]

In shadows no colour in the second plane is of the same brightness as that in the first.[200] All distant colours that are in shadow are undiscerned, because something not touched by the principal light is not strong enough to transmit its image to the eye through air of greater luminosity, since the lesser light is overcome by the greater.[201]

How the painter ought to put into practice
perspective of colour

If you want to put into practice this perspective of variation and loss, or rather diminution of the intrinsic quality of colours, take things positioned throughout the countryside at intervals of one hundred *braccia*, such as trees, houses, men and particular locations. Then in front of the first tree, with a well-steadied plate of glass and a correspondingly fixed eyepoint, draw a tree on the said glass over the shape of the real one. Then move the glass far enough to one side so that the real one is aligned close to the side of the one you have drawn. Then colour your drawing in such a way that, with respect to colour and form, it is so alike the real one that both, if you close one eye, might seem to be painted on the aforementioned glass at one and the same distance. And by this same method paint the second and third trees, with one hundred *braccia* between each. And these will serve as a standard and guide if you consistently make use of them in your works wherever they are applicable, and they will speed the progress of the work. I have found as a rule that the second diminishes by four-fifths compared to the first at a distance of twenty *braccia* from it.[202]

With a single colour placed at various distances and heights, its brightness will be in proportion to the distances of each of these colours to the eye which sees them. The proof is as follows: let e, b, c, d, be the same colour, and the first, e, is placed at two intervals of

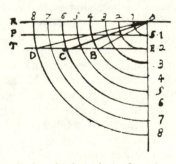

39. A colour seen through various
densities of air, based on Urb 65r.

distance from the eye a, and the second, which is b, is four intervals distant, and the third, which is c, will be at six intervals, and the fourth, which is d, will be at eight intervals, as indicated by the circles that intersect the lines, as is seen above the line ar. Then $arsp$ is the thin air; *spet* is a layer of denser air. It follows that the first colour, e, passes to the eye through one interval of dense air, es, and through one interval of less dense air, sa; and the colour b sends its image to the eye through two intervals of dense air and by two of the less dense; and c sends it by three of the dense and three of the less dense; and the colour d

through four of the dense and four of the less dense. Accordingly it is proved that the diminution of the colours, or should we wish to say their loss, will be in proportion to the distance from the eye which sees them; but this only occurs with colours which are of equal height, in that those that are of unequal height will not obey the same rule, because they are in air of varying density, which variously interferes with these colours.[203]

On colour which does not display differences in various densities of air

It is possible that the same colour will not be modified at various distances, and this arises when the proportions of the density of the air and the proportional distances of the colours from the eye are similar but inverse. This is proved as follows: let *a* be the eye; *h* will be whatever colour you wish placed at one interval of distance from the eye and in air of four degrees of density. But because the second

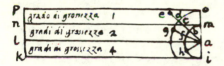

40. A colour appearing the same at different distances, based on Urb 64r.

interval above *amnl* has air thinner by half, containing within it the same colour, it is necessary that such colour will be twice as remote from the eye as it was at first. Therefore we put it at two intervals, *af* and *fg*, away from the eye, and this will be the colour *g*. This is then raised to the level where the thinness is double that of the second, *manl*, namely to the level *ompn*. It will be necessary that it is placed at the height *e*, and will be at a distance from the eye along the line *ae*, which can be shown to possess a density of air of the same value as that of the distance *ag*. And it is proved thus: if *ag* is the depth of the same air interposed between the eye, and the colour occupies two and a half intervals, this distance is sufficient to ensure that the colour *g* raised to *e* does not vary in its strength, because the interval *ab* and the interval *af*, being of the same density of air, are similar and equal, and the interval *bd*, although it will be equal in length to the interval *fg*, is not similar in density of air, because half of it is in air of double density to the air above. Half an interval of distance below obscures as much of the colour as is done by one complete interval of the air above, which is twice as thin as the air which surrounds it below.

Therefore, calculating first the density of the air and then the distance, you will see that the colours, varying in location, have not changed in their beauty. We say this because of the calculation of the

density of the air: the colour *h* is placed in four degrees of density of
air. The colour *g* is placed in air of two degrees of density; colour *e*
is found in air of one degree of density.

Now let us see if the distances are in equal but in inverse proportion:
colour *e* is found two and a half intervals distant from the eye, *a*; *g* is
at two intervals, and *h* at one interval. This distance does not corres-
pond to the proportion of density. But it is necessary to make a third
calculation, and this is what I must tell you: the interval *ab*, as was said
above, is similar and equal to the interval *af*, and the half interval *cb*
is similar but not equal to the interval *dc*, because half an interval of
length below is equal to a complete degree of the air above ...
Therefore the calculation made satisfies this proportion, because *ab*
equals two degrees of the density of the air above, and the half degree
cb is equal to a complete one in the air above, which makes a value for
ac equivalent to three degrees of the density above, and one more is
included, that is *ce*, which makes four. It follows that *ah* has four
degrees of density of air; *ag* also has four, that is to say *af* has two of
them, and *fg* two more, which makes four. *Ae* also has four of them,
because *ab* possesses two and one, *cb*, which is the half of *ac* of the same
density of air, and one complete one is above in the thin air, which
makes four in total. Thus, if the distance *ae* is not twice the distance
ag, nor four times the distance *ah*, it is rectified by *cb*, half a degree of
dense air, which is equal to a complete interval of thinner air which
is above. Thus is concluded our proposition, that the colour *h*, *g*, *e*, is
not different at different distances.[204]

On aerial perspective

41. Buildings seen over
a wall, based on Urb
78r.

There is another perspective which we call
aerial, because through variations in the air we
are made aware of the different distances of
various buildings whose bases apparently arise
from a single line, as might be seen with many
buildings beyond a wall, all of which appear the
same size over the top of the said wall. And if
you wish in painting to make one appear more
distant than the other, you should represent the
air as rather dense. You know that in such air the furthest things seen
in it – as in the case of mountains, when great quantities of air are
found between your eye and the mountains – appear blue, almost the
colour of the air when the sun is in the east. Therefore make the first
building above the said wall of its own colour; the next most distant
make less outlined and more blue; that which you wish to show at yet
another distance, make bluer yet again; and that which is five times

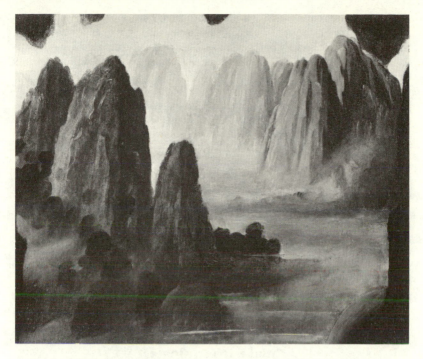

42. *Virgin of the Rocks*, detail of distant mountains, London, National Gallery.
'the blue of the sky arises from the density of the mass of illuminated air interposed
between the upper darkness and the earth'

more distant make five times more blue. This rule ensures that when
buildings appear of equal size above a line, it will be clearly discerned
which is more distant and larger than the other.[205]

How the blue of the air arises

The blue of the sky arises from the density of the mass of illuminated
air interposed between the upper darkness and the earth. The air in
itself has neither the qualities of smell, taste or colour, but takes within
itself the images of things which are located beyond it; and it will be
a more beautiful blue to the extent that it has behind it the strongest
shadow, providing there is neither too great a space or too dense a
humidity. It is seen that mountains which have more shadow are a
more beautiful blue at greater distances, while where they are more il-
luminated they display more of the colour of the mountain than of the
blue acquired from the air interposed between them and the eye.[206]

The air will assume less of a blue colour to the extent that it is closer to the horizon, and will be deeper to the extent that it is more remote from this horizon ... That body will be least illuminated by the sun that is most rare in quality, therefore the element of fire which clothes the air, being in itself more rare and more thin than the air, is over-whelmed by the darkness above it, and consequently the air, a body less rare than fire, is more illuminated by the solar rays which pass through it, illuminating the infinity of atoms of which it is constituted and rendering it bright to our eyes. Hence, penetrating through the air, the images of the aforementioned shadow necessarily make the whiteness of the air appear blue.[207]

Shadows of distant objects partake so much more of the colour blue inasmuch as they are in themselves darker and more distant.[208]

Amongst colours that are not blue, the one will partake most of blue which is closest in nature to black, and thus, conversely, the one will retain its own colour over a longer distance that is most dissimilar to the said black. Therefore the green of meadows will be transmuted in-to blue more than will occur with yellow or white, and thus converse-ly yellow and white will transmute themselves to a lesser degree than green and red.[209]

How the air ought to be made lighter the lower you make it terminate

Because the air is denser nearer the earth, and so much rarer the higher it is, when the sun is in the east and you look westwards, taking in the south-west and the north-west, you will see that the dense air receives more light from the sun than does the rarer, because the rays encounter more resistance. If the sky in your vista ends in a low plain, the lowest part of the sky will be seen through denser and whiter air, which adulterates the truth of the colour which is seen through the medium, and it will appear to you that this sky is whiter than that above you, where the visual axis passes through a lesser quantity of air corrupted by the dense humours. But if you look towards the east the air appears darker to the extent that it is lower, because the luminous rays are less able to pass through the said air.[210]

Of the lights and shades which colour the surfaces of the countryside

The shadows and lights of the countryside take on the colour of their sources, because the darkness which originates from the opaqueness of the clouds, combined with the absence of direct sunlight, tinges what-

ever it impinges upon, while the surrounding air, beyond the clouds and shadows, exposes itself to and illuminates the same location and leads it to assume a blue colour. And the air, penetrated by the solar rays which are found between the darkness of the said shadows on the ground and the eye which sees them, further colours this location with the colour blue. This is proved by the origination of the blueness of the air from light and shade. That part of the countryside illuminated by the sun takes on the colour of the air and of the sun, but it takes on more thoroughly that of the air, because the air exercises the greater impact since it is nearer, and covers an area equivalent to innumerable suns with respect to the eye. The countryside takes on so much more of blue as it is more remote from the eye, and this blue is rendered so much brighter as it is raised above the horizon, and this happens because of the humid vapours.[211]

On the colour of mountains

That mountain distant from the eye will show itself as the most beautiful blue that is in itself the darkest, and that will be darkest that is highest and most wooded, because such woods show their trees from the underside since they are mightily high and the undersides are dark because they are not exposed to the sky. Also the wild vegetation of the woods is darker in itself than cultivated vegetation. Oak, beech, fir, cypress and pine are much darker than olives and other fruit trees.

The translucent brightness which is interposed between the eye and the blackness, when it is thinner at its great peak, makes this black into a blue of greater beauty, and thus conversely.[212]

Winter landscapes should not exhibit mountains as blue as one sees the mountains in summer ... When the trees have shed their leaves they will be seen as a greyish colour while with their leaves they are green, and to the extent that green is darker than grey, the green will display more blue than the grey.[213]

It is clearly seen that the air which borders most closely on the plain of the earth is more dense than the other air, and to the extent that it is higher it is thinner and more transparent. Things which are tall and large, whose bases are distant from you will be little seen, because the visual axis passes through the denser air surrounding them. The summits of these heights are known to be seen by an axis which, although it begins close to the eye in dense air and terminates at the top of the thing seen, none the less reaches its destination in much thinner air than can occur at the bottom. For this reason, this axis, as it moves more distant from you, always changes its quality from point to point within air of varied thinness. Therefore painter, when you make mountains, ensure that from hill to hill the bases are always lighter

than the summits, and when you make one more distant than another make the bases increasingly light, and when they are raised up higher show more of their true form and colour.[214]

I continue by saying that although the spaces between the mountains *o, p, q* are equal in proportion, one to the other, the colours of

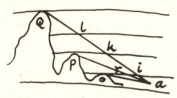

the summits of these mountains, *o, p, q,* do not obey the same proportion in their brightness as they would if they were of the same height, because if they were of the same height their extremities would be in air of equal density.[215] The summit *o* is wholly in the dense air and is strongly whitened by this air; *p* is seen by the eye *a* through less of the dense air, as *ra*, and through

43. Summits of mountains seen through different densities of air, based on Urb 233v.

the thinner air, across *pr*. Therefore it is almost as white as *o*. Q is seen through the denser air, across *ia*, and in the thinner, *ki*, and in the even thinner, *lk*. Q is lighter than *o*, but not to the extent that is expected at this distance.[216]

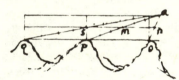

When the eye sees the summits of mountains of equal distances and heights below itself, it will not see the colours of the summits of these mountains diminish in colour in the same proportions as the given distances, because they pass to the eye through various densities of air. This is proved as follows: let *o, p, q,* be the summits of three mountains that are in themselves of the same colour and of the same

44. Summits of mountains not diminishing in distinctness in accordance with their distance, based on Urb 233r.

distances from one to the other. Let *a* be the eye which sees them and which is higher than these summits. I say that the proportional ratios of the distances which there are between the summits of these mountains will not be one and the same as the proportions of the diminution of colour in the summits of these mountains. This arises because *ao* is two units, *ap* four, and *aq* six, while the proportion of the equivalent aerial value of *no* is not in a ratio of 1:2 to the air *mp*, but 1:3, while the space of the eye *ao* is in a 1:2 ratio to the space *ap* and a 1:4 ratio to the space *sq* – according to which the space of the mountain should be 1:3.[217]

PERSPECTIVE OF DISAPPEARANCE

How objects will be less discerned the more they are removed from the eye

That thing will be less evident that is furthest removed from the eye. This occurs because those parts are lost first that are the minutest, and the next less minute are lost at a greater distance, and thus it successively follows little by little. Since the parts are consumed, the appearance of the remote object is consumed in such a way that all the parts are lost, together with the whole object.[218]

This happens because the images of small things at the same distance are sent to the eye at a narrower angle than the larger ones, and our perception of distant objects will be so much less distinct as they are of lesser size. It therefore follows that when an object of larger size comes to the eye from a long distance by a very tiny angle, and it almost ceases to be discernible, any perception of the lesser quantity will be entirely lacking.[219]

Of the perspectival diminution of opaque bodies

Amongst opaque bodies of equal size the diminution of the appearance of their shapes will be in proportion to their distance from the eye which sees them, but such proportion is inverse, because when the distance is greater the opaque body will be less apparent, and when the distance is less this body will be more apparent. And from this is born linear perspective, and it teaches as its second lesson that every body over a long distance first loses those parts that are in themselves most thin. To give an example: in a horse, one would lose its legs before its head, because the legs are thinner than the head; and one would lose the neck before the torso, for the same reason as is given. Hence it follows that the last discernible part of the horse left for the eye will be the torso, reshaped as an oval form, or rather translated into a cylinder, and of this one would lose its breadth before its length.[220]

If you see a man close to you, you will discern the character of his bulk, the character of his shape and similarly of his colour; and, if he goes a certain distance away from you, you will not recognise who he is, because the character of his shape will be lacking; if he moves still further away, you will not be able to discern his colour, rather he appears to you as a dark object, and from even further he will appear as a very small, rounded body. He acquires this rounded dark appearance

because the distance diminishes all the details of the limbs, so that nothing appears other than the main bulk. The reason is this: we know clearly that the images of things enter the *imprensiva*★ via the small aperture of the eye. Hence if a whole horizon ... enters via such an aperture, and given that a certain body ... is a minimal part of this horizon, what space can it occupy within this tiny representation of such a great hemisphere?[221]

If you look at a man who is placed at the distance of a crossbow shot, and you hold the eye of a little needle close to your eye, you will be able to see through it many men, transmitting their images to the eye, and they can all be perceived at the same time in this opening. Therefore, if the man at the distance of a crossbow shot sends to the eye his image and it occupies a small part of the eye of a needle, how can you distinguish or see his nose or mouth or any detail of his body? Not being able to see them, you will not be able to recognise the man, because he does not exhibit those parts that give each man his distinct appearance.[222]

What I should remind you about faces is that you should consider how at different distances different degrees of shadow are lost, only leaving those primary patches, that is to say, in the orbit of the eye and other comparable places, and ultimately the face is left obscure, in that the lights are consumed, being small things by comparison to the intermediate shadows, and on this account the quality and quantity of the principal lights and shadows are consumed in the long run, and every quality is mixed together as a medium shadow. This is the reason why trees and all objects are made to look darker at a certain distance.[223]

Perspective of disappearance occurring with the edges of opaque bodies

If the true edges of opaque bodies are invisible at even a tiny distance, they will be invisible to an even greater extent at long distances. And if it is by outlines that the true shape of every opaque body is known, and we lack overall knowledge of it over a distance, the discernment of its parts and outlines will be more greatly lacking.[224]

The boundaries of things in the second plane will not be discerned like those in the first. Therefore, painter, do not produce boundaries between the fourth and fifth things like those between the first and the second, because the boundary of one object and another is of the nature of a mathematical line but not an actual line, in that the boundary of one colour is the start of another colour and is not to be accorded the status of an actual line, because nothing intervenes between the boundary of one colour which is placed against another ...

Therefore, painter, do not make the boundaries pronounced at a distance.[225]

In the distance the boundaries of bodies which are of similar colour are the first to be lost, when the boundary of one is on top of the other, like that of the boundary of one oak tree on top of another similar oak. At the next stage of distance the boundaries of bodies of moderately different colour are lost when one above the other, such as green, that is to say, trees, against cultivated land or walls or broken mountains or stones. Finally are lost the boundaries of bodies which have borders of dark against light or light against dark.[226]

[Of the effects of light] on surfaces that are first lost as opaque bodies move further away

The first aspect that colours lose over distance is lustre, the least part of them and the highlight of an illuminated area. Secondarily is lost the illuminated area, because it is smaller than the shadow, and thirdly the primary shadow, and there finally remains only a dull and blurred obscurity.[227]

Precepts for painting

That object, or rather its shape, is shown with more distinct and sharp boundaries which is nearer to the eye. And on this account, painter, when in the name of dexterity you represent the view of a head seen at a short distance with abrupt brushstrokes and rough and harsh handling, you should realise that you are deceiving yourself, because at whatever distance you represent your shape, it will always have a finished appearance appropriate to the degree of distance at which it is found. Although at a long distance the definition of the boundaries is lost, you should not on this account neglect to observe that a smokey finish is to be seen, and not boundaries and profiles that are sharp and harsh. Thus it is to be concluded that in a work to which the eye of the observer can approach closely, the parts of the picture should be finished with the greatest diligence at all degrees of distance, and in addition to this the nearest objects will be bounded by evident and sharp boundaries against the background, while those more distant will be highly finished but with more smokey boundaries, that is to say more blurred, or we may say less evident. It is to be observed at successively greater distances ... that firstly the boundaries are less evident, then the component parts and finally the whole object is less evident in shape and colour.[228]

How many are those who in representing cities or other things distant from the eye make the outlines of the buildings very evident, as if they were at the closest proximity! This is impossible in nature because there is no visual potency that in such close proximity can see the said outlines with true certainty, because the boundaries of these bodies are demarcated by their surfaces and the boundaries of surfaces are lines, which are not part of the extension of that surface nor yet of the air, in which such surfaces are clothed. Hence that which is not part of anything is invisible, as is proved in geometry. If you, painter, make these boundaries sharp and evident, as is customary, the building will not be represented as if at a great distance, because such a defect does not even arise at very close distances. Also, the edges at the angles of buildings in distant cities should not be depicted [as lines], because they are impossible to discern nearby, in that the edges of these angles arise from the junction of two lines at a point, and a point has no dimension and is therefore invisible.[229]

LIGHT AND SHADE

On lights and darks

Lights and darks, together with foreshortening, comprise the excellence of the science of painting ... Lights and darks, that is to say, illumination and shadow, have an intermediate quality that cannot be called light or dark, but partakes equally of light and dark. And at certain times it is equally removed from both light and dark and at other times closer to one or the other.[230]

Shadows and lights are the most certain means by which the shape of any body comes to be known, because a colour of equal lightness or darkness will not display any relief but gives the effect of a flat surface which, with all its parts at equal distance, will seem equally distant from the brightness that illuminates it.[231] Objects seen in light and shade will be displayed in greater relief than those which are wholly in light or in shade.[232]

There are four principal parts which must be considered in painting; that is to say, quality, quantity, position and shape. By quality I mean that shadow or that part of a shadow which is more or less dark; quantity concerns the extent of the size of such shadow with respect to others nearby; position concerns in what way they are located and on which part of the elements of a form they are attached; shape concerns the shape that the shadow will have – whether it is to be described as triangular or as partaking of roundness or squareness.[233]

45. Study of a woman's head for the Angel in the *Virgin of the Rocks*, Turin, Biblioteca Reale.
'Shadows and lights are the most certain means by which the shape of any body comes to be known'

For all visible objects, three things are to be considered; that is to say, the location of the eye which sees; and the location of the seen object; and the light – the location of the light which illuminates this body.[234]

On lights

The lights which illuminate opaque bodies are of four kinds; that is to say, universal, like that of air which lies within our horizon; and specific, like that of the sun or a window or a door or other source; the third is reflected light; the fourth is that which passes through translucent things like linen or paper or similar things, but not transparent things such as glass or crystal or other bodies which have the same effect as if there were nothing interposed between the opaque body and the light that illuminates it ... Illumination arises from the presence of light, and lustre is the reflection of this light.[235]

A specific light source is the means of providing greater relief in opaque bodies than universal light, as may be seen by the comparison of one section of a landscape illuminated by the sun with another section overshadowed by clouds, which is only illuminated by the universal light of the sun.[236]

What are shadow and light?

Shadow is the absence of light and only arises from the opposition of dense bodies, when opposed to luminous rays. Shadow is of the nature of darkness and illumination is of the nature of light. The one conceals and the other reveals. They are always joined together in company on bodies, and shadow is of greater power than light, because it banishes and completely deprives bodies of light, and light can never wholly chase away the shadows of bodies, that is to say of dense bodies.[237]

Shadow derives from two things that are dissimilar to each other, because one is corporeal and the other immaterial. The corporeal one is the opaque body and the immaterial is the light. Thus light and body are the causes of shadow.[238]

Shadow is a mixture of darkness with light and it will be of greater or lesser depth according to whether the light that is mixed with it is of greater or lesser strength.[239]

On what surface is found true and equal light[240]

That part of an illuminated object will be more illuminated that is closest to the origin of its light.[241]

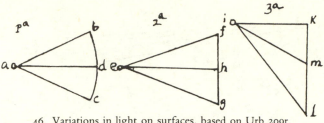

46. Variations in light on surfaces, based on Urb 209r.

That surface will be equally illuminated which is equally distant from the body that illuminates it, as with the light *a*, which illuminates the surface *bdc* and from which equal lines may be drawn to this surface. In accordance with the definition of the circle, this surface will be equally illuminated in every part; while if this surface were to be flat, as is shown in the second diagram as *efgh*, then, if the edges of the surface are equally distant from such a light, the middle *h* will be the part closest to this light and will be so much more illuminated to the extent that these edges are closer to the said light *e*. But if the edges of such a flat surface are removed at unequal distances from such a light, as is shown in the third figure as *iklm*, then the closer part and the most distant will have such proportion between their lights as that between their distances from the body which illuminates them.[242]

Rule for putting the proper shadows and proper lights on a figure or faceted body[243]

If *a* is the light and the head serves as the object which it illuminates, that part of the head that receives the ray on to itself at equal angles will be most illuminated, and that part which receives rays at less equal angles will be less illuminated. This light performs its function in a similar way to a blow, since the blow that falls at equal angles will have the first degree of power, and when it falls at unequal angles it will be of less power than the first to the extent that the angle is more slanted. For example, if you throw a ball against a wall, the extremities of which are equally distant from you, the blow will fall at equal angles, while if you throw the ball at the said wall standing at one of its extremities, the ball hits at unequal angles and will not make such an impact ...

Since it has been proved that every definite light has – or appears to have – its origins in a single point, that feature illuminated by it will have that portion more illuminated on to which the radiant lines fall

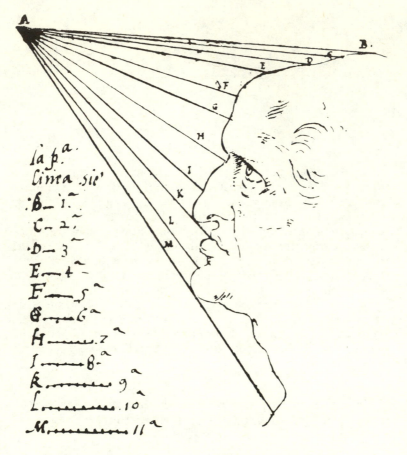

47. Intensities of light on a face, based on Urb 219r.

at equal angles, as is shown above with the line *ag* and also *ah*, and
similarly *la*. That portion of the illuminated feature will be less illu-
minated on to which the incident lines make two angles of greater
dissimilarity, as appears at *b*, *c*, *d*, and *e*. By this means you will also
be able to determine the parts deprived of light, as appears at *m* and
k.[244]

A greater or lesser darkness of shadow or greater or lesser
brightness of light will fall on the faces of a faceted body according
to whether a greater or smaller angle is described between the central
line of the illumination which strikes the centre of the illuminated facet
and the surface of that illuminated facet. For example, if the illumi-
nated body is an octagonal column, the front of which is shown here

48. Intensities of light on a faceted
body, based on Urb 223v.

... and one central line is *ra*, which extends from the centre of the light
source *r* to the centre of the side *cs*, and another central line is *rd*, which
extends from the centre of this light source to the centre of the side
cf, I say that there will be such proportion between the light received
by the side *sc* from this light source and that received by the side *cf*
from this light source as there is between the size of the angle *bac* and
the size of the angle *cdf*.[245]

What part of a body will be more illuminated by a light of even quality

That part of a body illuminated by an even light will be of more in-
tense brightness that is struck by the greatest luminous angle. The
proof is as follows: let the hemisphere be *rmc*, which illuminates the
house *kdof*. I say that the part of the house that will be more illu-
minated will be that struck by the greatest angle arising from a light
of even quality. Thus at *f*, which is struck at the angle *nfc*, the light
will be more intensely bright than at that part struck by the angle *ebc*,
and the proportion of the lights will be the same as that between the

49. Light and shade on a house, based on Urb 201r.

angles, and the proportion of the angles will be the same as that between their bases, *nc* and *ec*, of which the greater exceeds the lesser by the whole part *ne*. Thus at *a*, under the eaves of the roof of this house, there will be so much lesser light than at *d* to the extent that the base *bc* of this angle *bac* is less than the base *ec*; and thus it always follows on proportionately, providing that the light is of even quality.

And the same rule as given above may be confirmed with any body illuminated by the light of our hemisphere, and here it is shown in the portion of a spherical object under the hemisphere *kf*. The point *b* is illuminated by all the section from *a* to *c*, and the point *d* by the hemisphere *ef*, and at *o* by *gf*, and at *n* by *mf*, and at *h* by *sf*, and accordingly we can discern where is the highest degree of light and the highest degree of shadow in any such body.[246]

50. Light and shade on a sphere, based on Urb 201v.

That part of an opaque body will be more luminous that is illuminated by the greater amount of light

Thus, taking as the opaque body the object *abc*, and *dfn* as the luminous body, that is to say the illuminated hemisphere, the portion *c* has half as much light again as the portion *b* and three-quarters as much again as at *a*, because *c* is illuminated by the sky from *dgfe*, and *b* by the sky from *df*, which is half less than *de*, and the portion *a* will only be illuminated by a quarter part of *de*, that is to say *gd*.[247]

51. The extent of light on a sphere, based on Urb 201v.

That part of an illuminated sphere will be of more intense brightness that is accompanied by the lesser quantity of shadowed images

The proof is as follows: let *fno* be the opaque spherical body and *abc* the luminous hemisphere and the plane *ac* the darkness of the earth. I say therefore that the portion of the sphere *fn* will be of more intense brightness because it is not exposed to any part of the earth *ac*, and it is in itself of equal brightness, for it is illuminated by equal arcs of the hemisphere *abc*; that is to say, the arc *are* is equal to the arc *rbs* and the

52. The extent of shadow on a sphere, based on Urb 220v.

arc *bsc*. And according to the precept which says that when two things are equal to a third, they are also equal. Therefore *p*, *f*, and *n* are equal in brightness.[248]

Here the adversary says that he does not want so much science and that it suffices to practice copying things from nature. To this it is replied that nothing more deludes us than to place faith in our own judgement without any other reasoning, as may be proved by the way in which experience is always the enemy of alchemists, necromancers and other simple minds.[249]

On illumination and lustre

Illumination partakes of light, and lustre is the reflection of this light.[250] Lustre is always more powerful than light [on a body] and light is of larger quantity than lustre.[251] Lights which are generated on the smooth surfaces of opaque bodies will be immobile on

immobile bodies even if the eye of its spectator is moved; but the lustres on the same bodies will be in as many locations on the surface as there are places to which the eye is moved ... Opaque bodies which have dense and rough surfaces will never generate lustre at any place in their illuminated portions.[252] When the eye and the object are without motion, the lustre is moved on the object in conjunction with the light which causes it.[253]

Of the lustres generated on spheres equally distant from the eye, that will be of smaller dimensions which is generated on a sphere of lesser size. We see on granules of quicksilver, which are of almost invisible size, that the lustres are of equal size to these grains, and this arises because the visual power of the pupil is of greater dimension than each grain and on this account surrounds it.[254] Universal lights surrounding polished bodies give universal brightness to the surfaces of these bodies.[255]

Among lustres of equal power that will be displayed as of greater radiance that is generated on a surface of greater whiteness.[256]

Among lustres on bodies of equal smoothness that will appear to have greatest contrast with its background that is generated on the blackest surface, and this arises because the lustres which are generated by polished surfaces are virtually of the nature of mirrors, passing on to the eye that which it received from its source. Thus every mirror that has the sun as its source renders the sun as the same colour, and the sun will appear more powerful against a dark background than against a light background ...

That part of an opaque body that is illuminated will appear to be of so much less luminosity that is closer to its lustre, and this is caused by the great variation that there is between them at their borders, with the result that the less luminous part appears dark at its borders, and the luminous part of the lustre appears brighter. But the surfaces that receive the said impressions are of the nature of uneven mirrors, which confusedly take up the images of the sun and of the sky which makes its background, and similarly with the light of a window and the darkness of the wall, in which this window has been made.[257]

Lustre partakes somewhat more of the colour of the light that illuminates the body which shines than of the colour of this body ... The lustre of many opaque bodies is entirely the colour of the illuminated body, as is the case with burnished gold and silver and other metals and similar bodies. The lustre of sheets of glass and gems partakes little of the colour of the body on which it arises, and somewhat more of the colour of the object that illuminates it. The lustre made in the depths of transparent, dense objects is of the first degree of beauty for this colour, as is seen within cut ruby and glass and similar things. This occurs because the natural colour of the transparent body is interposed between the eye and this lustre. The reflected lights on

dense and lustrous bodies are of much greater beauty than the natural colour of these bodies, as is seen in the opening of folds in fabric of spun gold and in other similar bodies, in which one surface reverberates against the other that is opposite it, and the latter reverberates against the former, and thus they do this successively towards infinity. No lustrous and transparent body may display on itself a cast shadow from any object, as is seen in the bridges of rivers, which are never seen unless on muddy waters, and they are not apparent in clear waters.[258]

[An introduction to shadow]

Shadow is the privation of light. Shadows appear to me to be supremely necessary in perspective, since without them opaque and solid bodies will be ill defined. Those features that are located within their boundaries – and their boundaries themselves – will be ill defined if they do not end against a background of a colour different from that of the body. And on this account I propound my first proposition on shadows: I state in this manner that every opaque body will be encircled and its surfaces clothed in shadows and lights, and on this basis I will found my first book. In addition to this, these shadows are in themselves of varying degrees of darkness because they represent the loss of varying quantities of luminous rays, and these I term original shadows, because, being the first shadows, they clothe the bodies to which they are attached; and on this I will found my second book. From these original shadows there arise shadowy rays which are transmitted throughout the air, and these are of a quality corresponding to the variety of the original shadows from which they are derived. And on this account I will call these shadows derived shadows, because they have their origins in other shadows; and on this I will compose my third book. Again, these derived shadows, where they strike other things, make varied effects in accordance with the places at which they make their impact; this topic comprises the fourth book. And because the place of impact of the derived shadow is always surrounded by the impact of luminous rays, which by reflected transmission are projected back towards the source of the original shadow, they mix with this shadow and modify it, altering its nature to some extent; and on this I will found my fifth book. In addition to this, I will compose a sixth book, in which will be enumerated the many wide diversities in the transmission of the reflected rays, which modify the original shadow with varied colours corresponding to the various places from which these luminous reflected rays derive. Furthermore, I will compose a seventh section on the various distances between the

impact of the reflected rays and the places from which they originate, and the extent to which the images of the colours vary in their impact as they impinge on an opaque body.[259]*

Of the nature of shadow itself

Shadow shares the nature of universal things, which are all more powerful at their beginning and become enfeebled towards their end. When I speak about the beginning of every form and quality, discernible or indiscernible, I do not refer to things arising from small beginnings that become greatly enlarged over a period of time, as will happen with a great oak which has a modest start in a little acorn. Rather, I mean that the oak is strongest at the point at which it arises from the earth, that is to say, where it has its greatest thickness. Correspondingly, darkness is the first degree of shadow and light is the last. Therefore, painter, make your shadow darker close to its origin, and at its end show it being transformed into light, that is to say, so that it appears to have no termination.[260]

On shadow and its division[261]

Primitive shadow is that which is attached to shaded bodies; derivative shadow is that which is dispatched from shaded bodies and flows through the air; cast shadow is that which is surrounded by a luminous plane.[262] Primitive shadow is unique and single and is never varied. Its boundaries are exposed to the boundaries of the luminous body and [abut] the boundaries of the illuminated portion of the body to which it is joined.[263]

What is the difference between shadow joined to bodies and a separate shadow?

An integral shadow is that which never leaves the illuminated body, as will occur with a ball placed in light, which will always have part of itself occupied by shadow, which never separates itself from the ball, whatever its change in position. Separate shadow might be or might not be created by the body. Let us place this ball at a distance of one *braccio* from a wall, with a light on the opposite side of it. The said light will send to the said wall a shadow of precisely the same dimensions as that which is found on the part of the ball that faces this

53. Primary and cast shadows when the source and the object are the same size, based on MS BN 203822r.

wall. This portion of the separate shadow will not be apparent when the light is beneath the ball, so that the shadow travels towards the sky, and, not encountering any resistance to its course, it is lost.[264]

Which body is it that approaching the light increases its shaded portion?

When the luminous body is smaller than the body illuminated by it, the shadow of the illuminated body will increase to the extent that it is brought closer to the luminous body. Let *a* be the luminous body, smaller than the opaque body *rsgl*. It illuminates all the portion *rsg*, which is encompassed by its luminous rays, *an* and *am*. Thus the

54. Spherical body at different distances from a light, based on Urb 210v.

shaded portion – as is inevitable with these rays – comprises the whole of the shadow *rlg*. Subsequently, I bring the opaque body closer to the same luminous source, and it will be as *dpeo*, which is enclosed within the straight lines of the luminous rays *ab* and *ac*, and is touched by these rays at the point *d* and the point *e*. And the line *de* divides the shaded from the illuminated portions – *dpe* from *doe*. The shaded portion is necessarily larger than the shaded portion of the remoter body *rlg*. All this is occasioned by the luminous rays, which, being straight, are so much more removed from the central line of such an opaque body to the extent that this body is closer to the light.[265]

When the opaque body and the luminous source are the same size as each other, then no lesser or greater distance that can be placed between them has the power to diminish or increase their shaded or illuminated portions.[266]

On the location of the eye which sees more or less shadow, depending on the motion which it makes around the opaque body

The intermediate shadow will be displayed as having a greater quantity to the extent that the eye which sees it is more in line with the centre of its magnitude. By intermediate shadow I mean that which colours the surfaces of opaque bodies beyond the principal shadow, and contains within itself the reflected light. It will be so much darker or lighter to the extent that it is closer to or further from this principal shadow. *Mn* is the darkest shadow. The remainder is continuously lightened as far as the point *o* . . .

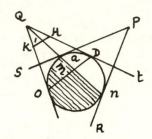

55. Looking at an illuminated body, based on Urb 199r.

The proportions of the quantities which the shaded and illuminated parts of opaque bodies exhibit in relation to each other will be varied to the extent that there are various locations for the eye that sees them. This is proved as follows: let *ano*[*m*] be the opaque body; *p* will be the light that embraces *pr* and *ps* with its visual rays, illuminating the portion *mdn*. The remainder, *nom*, remains dark; and the eye which sees this body will be *q*, which with its visual rays embraces this opaque body and sees all of *dmo*. From this viewpoint it sees *dm*, the illuminated portion, as somewhat smaller than *mo*, the shaded portion, as is demonstrated by the pyramid *dqo*, cut at *kh*, equally distant from its base and divided at the point *i*. And similarly therefore, in such ways, the quantity of the light and shade will be varied for the eye that sees them to the extent that there will be a variety of locations for the said eye . . .

An eye which is located within the reflected pyramid of the luminous images of an opaque body will never see any shaded portion of this body . . . But when the eye is more distant from a shaded sphere than the body which illuminates it, then it is impossible to find a location from which the eye is completely deprived of the shaded images of this body.[267]

On the human body which turns round without change of location and receives the same light from various directions and is infinitely varied

The shadows which, accompanied by lights, clothe an irregular body will be of such varied darkness and such varied shapes as correspond to the various positions adopted by this body in its rotating motion. Turning the body round while the light remains stationary is just the same as turning the light around an immobile body. This is proved as follows: let *en* be the immobile body, and the mobile light be *b*, which is moved from *a* to *b*. I say that when the light is at *b*, the shadow of the protruberance *d* will be extended from *d* to *f*, which, on moving the light from *b* to *a* is transposed to *e*, and thus the said shadow is transformed in quantity and shape because the location at which it is found is not of the same configuration as the place from which it has been detached. Such transformation of shape and quantity is infinitely variable, because if the entire location occupied by the shadow is continually changeable and of continuous quantity* – and every continuous quantity is infinitely divisible – therefore it is concluded that the quantity of the shadow and its shape is infinitely variable.[268]

56. An irregular body seen under illumination, based on Urb 238v.

How bodies accompanied by shadow and light differentiate their boundaries from the colour and light of that which abuts on their surface

If you see a body, the illuminated part of which is set against and terminates on a dark background, that part of this light appears of greater brightness that terminates on the dark background... And if the said illuminated part is surrounded by a bright background, it will appear less bright than formerly... The same occurs with the shadow, in that the boundary of that part of a shaded body that is set against a bright place... appears much darker... and if the said shadow terminates on a dark background, it will appear brighter than formerly.[269]

Whether the primitive shadow is darker than the derivative shadow

The primitive shadow is always darker than the derivative shadow, providing it is not corrupted by the impact of light reflected from the

57. Relative darkness of the primitive and derivative shadows, based on Urb 184v.

background on which the derivative shadow makes its impact.[270] [However] the derivative shadow which is surrounded in whole or in part by a luminous background will always be darker than the primitive shadow. Let the light on a flat surface be *a*, and the object which forms the primitive shadow be *bc*. The wall *de* is the surface on which the derivative shadow is received at the place *nm*. The remainder, *dn* and *me*, continues to be illuminated by *a*, and the light from *dn* is reflected in the primitive shadow *bc*, and the light from *me* does the same. Thus the derivative shadow *nm*, which is not exposed to the light *a*, remains dark, while the primitive shadow is illuminated by the lit background which surrounds the derivative shadow. Therefore the derivative is darker than the primitive.[271]

58. Derivative shadows, based on MS C 21r.

To the extent that a derivative shadow travels further from the primitive shadow it will partake increasingly of lightness

There will be the same proportion between the diameter of the derivative shadow as will be found between the darkness of the primitive shadow and that of the derivative shadow. Let *ab* be the diameter of the primitive shadow, and *cd* that of the derivative shadow. I say that, since it is apparent that *ab* goes three times into *dc*, the shadow *dc* will be three times lighter than that of *ab*.[272]

The darkness of derivative shadows is infinitely variable, with such greater or lesser power as corresponds to the greater or lesser distances at which the impacts of the derivative shadows are occasioned.[273]

The boundaries of a derived shadow will be most distinct when it makes its impact closest to the primitive shadow.[274] To the extent that the derived shadow is further removed from the primitive, it will increasingly vary from the primitive in its boundaries.[275]

If a spherical opaque body is illuminated by a luminous source of elongated shape, the shadow which is generated by the longer part of this source will have less discernible boundaries than that which is generated by the breadth of the same light... That shadow will have less discernible boundaries that is created by a larger luminous source, and, conversely, that shadow will have more discernible boundaries that is illuminated by a smaller source.[276]

That opaque body that is placed between equal lights will cast shadows according to the quantities of the lights

The shadows of one will be so much darker than the other to the degree that the light which is opposite one side is closer to this body than the one on the other side. That opaque body that is situated at equal distances between two lights will cast two shadows in such a way that one will be darker than the other to the extent that the light causing it is stronger than the other.[277]

On a derivative shadow generated on another derivative shadow

A derivative shadow arising from the sun can be made on top of a shadow generated by the air. The proof is as follows: the shadow of

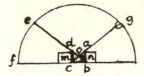

59. Derivative shadows cast on derivative shadows, based on Urb 187v.

the object *m* is generated by the air *ef* in the space *dcb*, and let the object *n* make the shadow *abc* by means of the sun *g*, and the remainder of the shadow of *m* is not exposed to the air *ef* at this place; neither is it exposed to the sun. Therefore the shadow is double, because it is generated by two objects, that is to say, *n* and *m*.[278]

What is augmented shadow?

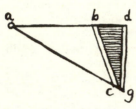

60. Augmented shadow, based on Urb 180v.

Augmented shadow is that in which is reflected its derivative shadow. *A* is the source of light; *bc* is the primitive or original shadow; and *dg* will be the shadow that is produced.[279] Among objects of equal darkness, shape and size, the one that is closest will augment most the darkness of the shadow facing it.[280] That part of the same shadow will be displayed darker that has opposite it the darker objects. It will be displayed less dark when it is exposed to a lighter object. And the bright object which is largest will lighten it most.[281]

Of how many configurations are the derived shadows?[282]

There are three configurations for shadows. In so far as the material object which casts the shadow is equal in size to the light, the shadow resembles a column, without any termination. If the material object is larger than the light, its shadow is similar to a truncated and reversed

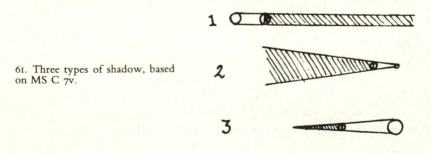

61. Three types of shadow, based on MS C 7v.

pyramid, and its length is without termination. But if the material object is smaller than the light, the shadow will be similar to a pyramid.[283] And if you say that such a shadow must end at the angle of the junction of its sides and does not proceed further, this is denied, because... I have proved that something is entirely terminated only when no part of it goes beyond its boundaries, whereas in such a shadow we see the contrary, inasmuch as during the course of the production of the derived shadow, there manifestly arises a configuration

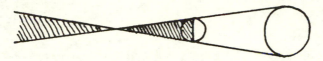

62. Pyramids of shadow, based on MS E 32r.

of two shadowy pyramids, which are joined at their apexes.[284] After the first pyramid has reached its intersection, an infinite pyramid is generated in a contrary orientation to the finite pyramid, should it find infinite space.[285]

On the shapes of derived shadows

A shadow will never form a true image of the contours of the body from which it arises, even if it is spherical, unless the light is the same shape as the opaque body.

If the light is of a long shape, and its length is extended upwards, the shadows of the bodies which it illuminates will be extended laterally.

If the length of the light is transverse, the shadow of a spherical body will be longer in an upwards direction; and, thus, in whatever direction the length of the light occurs, the shadow will always have its length in the contrary direction, intersecting the length of the light in the manner of a cross.

If the light is wider and shorter than the opaque body, the impact of the derivative shadow will be longer and thinner than the primitive shadow.

If the light is thinner and longer than the opaque body, the impact of the derivative shadow will be wider and shorter than the primitive shadow.

If the length and breadth of the luminous source is equal in length and breadth to the opaque body, then the derivative shadow on impact will make boundaries of the same shape as the primitive shadow.[286]

The impact of derivative shadows if of two kinds; that is to say, straight and oblique. The straight is always smaller in quantity than the oblique, which may be extended towards infinity.[287]

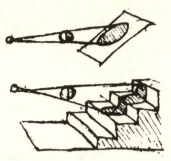

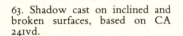
63. Shadow cast on inclined and broken surfaces, based on CA 241vd.

Even though an opaque body and the source of light are of a spherical roundness and of the same size, none the less its derivative shadow will not resemble the roundness of the body from which it arises, but rather will be of an elongated shape if it falls at unequal angles.[288]

Amongst bodies of equal size, that which is illuminated by the larger light will have a shadow of lesser extension

Those bodies which are closer to or more distant from their light source will make derivative shadows or greater or lesser brevity.

In this experiment the above proposition is confirmed by the following reasoning: the body *mn* is embraced by a greater part of the light than the body *pq*, as is demonstrated here. Let us say that *vcabdx* is the sky which provides the source of illumination, and that *st* is a window through which the emanations of the light enter. Furthermore, *mn* and *pq* are the bodies placed on the other side from the said light. *Mn* will have a smaller derivative shadow because its primary shadow is smaller, and its derived light will be large because the source of light *cd* is large. *Pq* will have a larger derivative shadow, since its primary shadow will be greater and its derivative light will be smaller than those of the body *mn*, because that part of the hemisphere, *ab*, which illuminates it is lesser than the hemisphere at *cd*, which illuminates the body *mn*.[289]

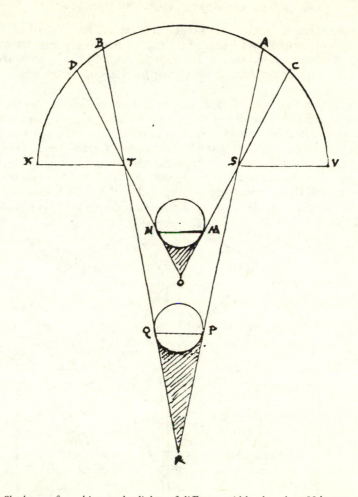

64. Shadows of an object under lights of different widths, based on Urb 211v.

Scattered bodies situated in a dwelling illuminated by a single window will make more or less short derivative shadows according to whether they are more or less directly opposite this window

The reason that opaque bodies which are to be found situated more in line with the middle of the window make shorter shadows than those situated in a lateral position is that the window is seen in its proper shape, while the lateral bodies see it foreshortened. The window appears larger to the body in the middle, and smaller to the lateral ones. That in the middle is exposed to the large hemisphere, that is to say *ef*, and those at the side are exposed to the small hemisphere, that is to say *qr* is exposed to *ab*, and correspondingly *mn* is exposed to *cd*.

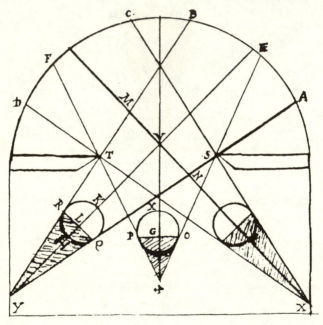

65. Shadows on three objects illuminated through a window, based on Urb 212r.

The body at the centre, because it receives a greater quantity of light than those at the side is illuminated somewhat lower down than its centre, and therefore the shadow is much shorter. And by the number of times that *ab* will go into *ef*, so the pyramid *g4* will go precisely into *ly*.

The centre of every derivative shadow lies in line with the centre of the primary shadow and with the centre of every opaque body and

with that of the derivative light and with the middle of the window
and ultimately with the middle of that part of the meridian made by
the celestial hemisphere. *Yh* is the middle of the derivative shadow, *lh*
that of the primary shadow. *L* is the middle of the opaque body, *lk* that
of the derivative light. *V* is the middle of the window and *e* is the
ultimate centre of the source of light made by that portion of the
hemisphere of the sky which illuminates the opaque body.[290]

Every opaque body is found between two pyramids, one dark and the other light, one seen and the other not. And this only happens when the light enters through a window

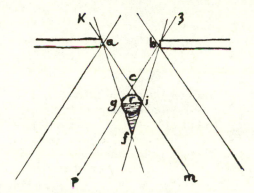

66. An object illuminated through
a window, based on Urb 216r.

Let us take *ab* to be the window and *r* to be the opaque body. The right
hand light, *z*, passes to the left side of the opaque body at *g* and pro-
ceeds to *p*. The left hand light *k* passes to the said body on the right
side at *i* and proceeds to *m*, and these two lines intersect at *c* and make
two pyramids. Then *ab* touches the opaque body at *i* and *g*, and makes
its pyramid at *fig*. F will be dark, because it can never be exposed to
the light *abig*. C will always be light because it is exposed to the
light.[291]

On the compound derivative shadow[292]

The types of shadow are divided into two parts, one of which is called
simple and the other compound. The simple is that which is caused by
a single light and a single body. Compound is that which is generated
by more than one light on the same body, or by more than one light
on more than one body.[293]

Compound lights and compound shadows always surround each other, but the outer boundary of the compound shadow is a simple shadow and the boundary of the compound light is the simple illumination.[294]

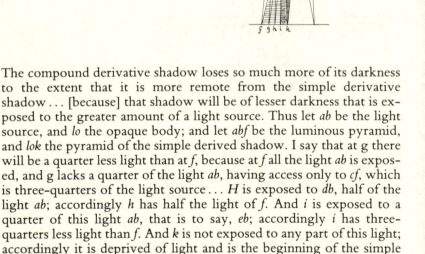

67. Compound derivative shadow, based on Urb 177r.

The compound derivative shadow loses so much more of its darkness to the extent that it is more remote from the simple derivative shadow ... [because] that shadow will be of lesser darkness that is exposed to the greater amount of a light source. Thus let *ab* be the light source, and *lo* the opaque body; and let *abf* be the luminous pyramid, and *lok* the pyramid of the simple derived shadow. I say that at g there will be a quarter less light than at *f*, because at *f* all the light *ab* is exposed, and g lacks a quarter of the light *ab*, having access only to *cf*, which is three-quarters of the light source ... *H* is exposed to *db*, half of the light *ab*; accordingly *h* has half the light of *f*. And *i* is exposed to a quarter of this light *ab*, that is to say, *eb*; accordingly *i* has three-quarters less light than *f*. And *k* is not exposed to any part of this light; accordingly it is deprived of light and is the beginning of the simple derivative shadow. Thus we have defined the compound derivative shadow.[295]

Every shadow made by an opaque body smaller than the source of light casts derivative shadows tinged by the colour of their original shadows

The origin of the shadow *ef* is *n*, and it will be tinged with its colour. The origin of *he* is *o*, and it will be similarly tinged with its colour, and accordingly the colour of *vh* will be tinged with the colour of *p*,

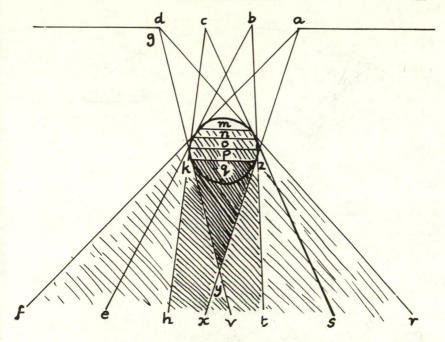

68. Grades of shadow on an object, MS BN 2038 13v.

because it arises from it. And the shadow of the triangle *zky* will be tinged with the colour of *q*, because it derives from this *q*.

Fg is the first degree of light, because there it is illuminated by all the window *ad*, and thus the opaque body at *m* is of similar brightness. *Zky* is a triangle which contains within itself the first degree of shadow, because the light *ad* does not arrive within this triangle. *Xh* is the second degree of shadow, because it is illuminated only by a third of the window, that is to say, *cd*. *He* is the third degree of shadow, because it is exposed to two-thirds of the window at *bd*. *Ef* will be the last degree of shadow, because the maximum degree of light from the window illuminates the position *f*.[296]

Every light which falls on opaque bodies between equal angles produces the first degree of brightness and that will be darker which receives it by less equal angles, and the light and shade both function by means of pyramids

The angle *c* produces the first degree of brightness because it is exposed to the window *ab* and to all the diameter of the sky at *mx*. The

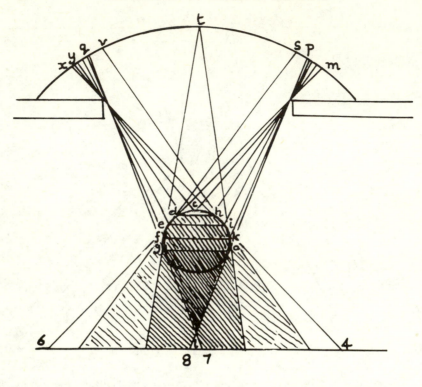

69. Grades of light and shade on an object, MS BN 2038 14r.

angle *d* makes little difference compared to *c*, because the angles they subtend are not of such distorted proportions as the others that are lower down, and *d* is deprived only of that part of the diameter that is between *x* and *y*. Although it acquires as much from the opposite side, nevertheless its line is of little strength because its angle is smaller than the corresponding one. The angles *e* and *i* will be of diminished light, because it is not fully exposed, lacking the light *ms* and the light *vx*, and their angles will be somewhat distorted. The angle *k* and the angle *f* are placed towards the middle of the body, and each makes within itself an angle which is as highly distorted as that of the other, and therefore they will possess little light, because *k* is only exposed to the light *pt*, and *f* is only exposed to *tq*. *Og* will be the minimum degree of light because it is not exposed to any part of the diameter of the light, and these are the lines that on the other side reconstitute a pyramid comparable to the pyramid *c*. In this pyramid *l* is found the first degree of shadow because it also falls between equal angles. The

apexes of these pyramids are aligned and orientated towards each other along a straight line, which passes through the centre of the opaque body and corresponds to the middle of the light of the luminous images propagated between the edges of the windows at the points *a* and *b*. They make a lightness which surrounds the derivative shadow created by the opaque body at the positions *4* and *6*. The images of the shadows are propagated by *og* and finish at *7* and *8*.[297]

On compound and simple shadows

When the intersection of two opaque columnar bodies generate their derived shadows by means of two luminous sources, it necessarily follows that four derived shadows are generated ... and such shadows intersect in four places; and of these intersections there are two that comprise simple shadows and the other two remain compound. And these two simple shadows are generated where the two lights cannot be seen, and the compound shadows are generated at a place illuminated by one of the two lights. But the intersections of the compound shadows are always generated by a single luminous source, and the simple by two luminous sources; and the right intersection of the compound shadow is generated by the left light and the left intersection is generated by the right light; but the intersection of the simple shadows, both the upper and the lower, are generated by the two lights, that is to say, the right light and the left light. This is proved as follows.

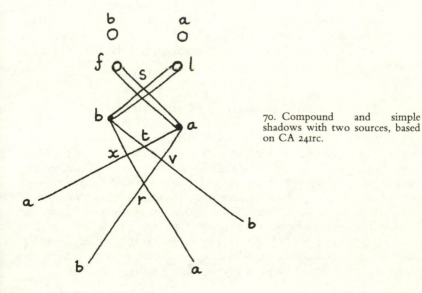

70. Compound and simple shadows with two sources, based on CA 241rc.

Let *s* be the intersection of the two opaque columnar bodies, *af* and *bl*; and the derivative shadows generated by these opaque bodies will be *a* and *b*, originating from the two luminous sources above, *a* and *b*. And the same two lights generate the two other derivative shadows, *bb* and *aa*. But each of the shadows that intersect do not originate from the two lights, and this is evident because, having taken away the light *b*, the shadow *aa* and the shadow *ba* remain, intersecting at the point *x*. And these two shadows, following the taking away of this light, remain simple shadows, being generated by a single luminous source... [in accordance with the rule that] there is no quantity of simple shadows generated by multiple opaque bodies from a single luminous source that can generate intersections amongst themselves if the opaque bodies causing these shadows do not intersect each other. Thus we have demonstrated that the two lateral intersections do not generate a shadow of greater darkness than exists beyond these intersections; and this arises because the shadow is as simple at such an intersection of the opaque bodies as it is beyond the said intersection, because the shadow of the first opaque body is imprinted on top of the second opaque body, with which it is in contact at the intersection, and on this account does not descend to the pavement on which the other derivative shadows are intercepted. And if you should make the cross shape, without it actually touching at the intersection, this cross will be entirely simple, and the derivative shadow will be simple at its intersection, and on this account will not acquire darkness at its intersection etc. But the shadows *bb* and *aa* are duplicated at their two intersections *r* and *t*, and since such shadows are created by the two luminous sources, *a* and *b*, they will lose the two lights at their intersection, and the remainder will only lose one of the two luminous sources. But the intersections *v* and *x* do not lose all of the illumination because each of them is always exposed to one of the two luminous bodies.[298]

On the motions of shadows

The motions of shadows are of five natures, and we will say that the first of them is that in which the derivative shadow moves together with its opaque body and the light causing this shadow remains immobile; and we say that the second is that in which the shadow and the light are moved, but the opaque body is immobile; the third is that in which the opaque body and the luminous source are moved, but the luminous source with greater slowness than the opaque body; in the fourth motion of this shadow the opaque body is moved more swiftly than the luminous source; and in the fifth, the motion of the opaque body and the luminous source are equal to each other.[299]

The motion of a shadow is always faster
than the motion of the body that generates it,
providing the luminous source remains im-
mobile. This is proved as follows. Let *a* be
the luminous source, and *b* the opaque body
and *d* the shadow. I say that at the same time
as the opaque body is moved from *b* to *c*, that
the shadow *d* is moved to *e*; and the propor-
tion between the velocity of one and the
velocity of the other during the same time is
the same as that between the length of the
motion of one to the length of the motion of the other...

71. Shadow of a moving
object, based on MS E
30v.

But if the luminous source is in motion at a velocity equal to that
of the opaque body, then the shadow and the opaque body will be of
equal motion to each other; and if the luminous source has more
velocity than the opaque body, then the motion of the shadow will be
slower than that of the opaque body. But if the motion of the
luminous source is slower than the opaque body, then the shadow will
have more velocity than the opaque body.[300]

Part III:

THE HUMAN BODY

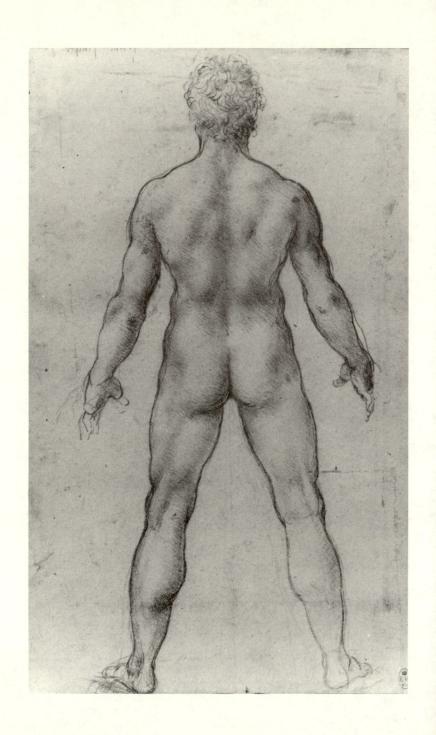

PROPORTIONS

[Principles]

The configuration of bodies is divided into two parts, that is to say, the proportionality of the parts amongst themselves, which will correspond to the whole, and the movement appropriate to the occurrences in the mind of the living being that moves the body... The proportion of the limbs is also divided into two parts, that is to say, quality and motion. By quality I mean that, in addition to making the measurements correspond to the whole, you should not mix limbs of the young with those of the old, nor those of the stout with those of the lean, and besides this you should not make men with feminine limbs, nor mix graceful limbs with clumsy ones. By motion I mean that the gestures or movements of the old should not be made with the same vivacity as is suitable for the movement of a youth, nor that of a small child like that of a youth, nor that of a woman like that of a man.[301]

Every part of the whole must be proportionate to the whole. Thus if a man has a thick and short figure, he must be the same in all his limbs, that is to say, with short and thick arms, with wide, thick hands, and short fingers, with their joints in the aforesaid manner, and so on with the remainder. And I intend to say the same about animals and plants universally, reducing or increasing them proportionately according to their diminution or increase in size.[302] All the parts of any animal will correspond to the whole ... and it is my intention to say the same about trees – those which have not been maimed by man or by winds, because these renew their youth above the old parts and thus disrupt the natural proportionality.[303]

Among the praiseworthy and marvellous things which are apparent in the works of nature, it happens that none of the productions of any species in themselves precisely resemble in any of their details those of any other. Thus, imitator of nature, observe and pay attention to the variety of the lineaments of things. I will be well pleased if you avoid monstruous things, like long legs with short torsos, and narrow

72. *Facing:* Nude man from the rear, Windsor, RL 12596r.
'if a man has a thick short figure he must be the same in all his limbs, that is to say, with short and thick arms, with thick hands...'

chests with long arms. Therefore take the measurements between the joints and you should vary their breadths, which differ considerably. And if you should wish to make your figures according to a single measure, you must know that one cannot be distinguished from another – something which is never observed in nature.[304]

If nature had fixed a single rule for the relationships of the features, all the faces of men would resemble each other in such a way that it would not be possible to distinguish one from the other. But she has varied the five parts of the face in such a way that, although she has made an almost universal rule for their sizes, she has not observed it in the relationships to such a degree that it is impossible to recognise clearly one person from another.[305]

Measure on yourself the proportion of the composition of your limbs, and if you find any discordant part, take note of it and make very sure that you do not adopt it in the figures that are composed by you, because it is a common vice of painters to take delight in making things similar to themselves.[306]* This happens because our judgement is that which directs the hand in the creation of the delineations of figures in various configurations until it is satisfied. Because this judgement is one of the powers of our soul, through which it composes the form of the body in which it lives according to its will, when it has to reproduce with the hands a human body, it willingly reproduces that body of which it was the original inventor, and from this it arises that he who loves will eagerly fall in love with things similar to himself.[307]

On the measurements of the human body[308]

Vitruvius,* the architect, has it in his work on architecture that the measurements of man are arranged by nature in the following manner: four fingers make one palm and four palms make one foot; six palms make a cubit; four cubits make a man, and four cubits make one pace; and twenty-four palms make a man; and these measures are those of his buildings.

If you open your legs so that you lower your head by one-fourteenth of your height, and open and raise your arms so that with your longest fingers you touch the level of the top of your head, you should know that the central point between the extremities of the outstretched limbs will be the navel, and the space which is described by the legs makes an equilateral triangle.

The span to which the man opens his arms is equivalent to his height.

From the start of the hair [i.e., the hairline] to the margin of the bottom of the chin is a tenth of the height of the man; from the bottom

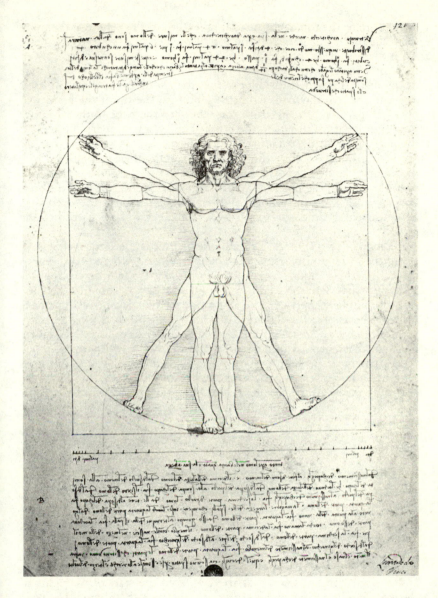

73. Study of human proportions in the manner of Vitruvius, Venice, Accademia.

of the chin to the top of the head is an eighth of the height of the man; from the top of the breast to the top of the head is a sixth of the man; from the top of the breast to the start of the hair is a seventh part of the whole man; from the nipples to the top of the head is a quarter part of the man; the widest distance across the shoulders contains in itself a quarter part of the man; from the elbow to the tip of the hand will be a fifth part of the man; from this elbow to the edge of the shoulder is an eighth part of this man; the whole hand is a tenth part of the man; the penis arises at the middle of the man; the foot is a seventh part of the man; from the sole of the foot to below the knee is a quarter part of the man; from below the knee to the start of the penis is a quarter part of the man; the portions which are to be found between the chin and the nose and between the start of the hair and ... the eyebrows are both spaces similar in themselves to the ear and are a third of the face.[309]

If a man of two *braccia*★ is small, one of four is too large – the mean being the most praiseworthy. Half-way between two and four comes three. Therefore take a man of three *braccia* and determine his measurements with the rule I give you. And if you should say to me that you might make a mistake and judge someone to be well proportioned who is not, I reply on this point that you must look at many men of three *braccia*, of whom the great majority have limbs in conformity with each other. From one of the most graceful of these take your measurements. The length of the hand is a third of a *braccio* and goes nine times into the man; and correspondingly the face, and from the pit of the throat to the shoulder, and from the shoulder to the nipple, and from one nipple to the other, and from each nipple to the pit of the throat.[310]

On the changes in the measurements of man from his birth to the culmination of his growth

Man in his earliest infancy has the width of his shoulders equal to the length of his face and to the space along the arm to the elbow when the arm is bent; and it is similar to the space which there is between the largest finger of the hand [i.e., the thumb] and the said bent elbow, and is similar to the space that there is from the start of the penis to the middle of the knee, and is similar to the space that there is between this joint of the knee to the joint of the foot. But when the man has attained his final height, all the aforesaid spaces are doubled in length, except the length of the face, which, in keeping with the size of the whole head shows little difference. By this means, the man who has attained full size will be well proportioned if he is ten faces high, and

when the width of his shoulders is two of these faces, and similarly all the other lengths given above are of two faces.[311]

Between men and small babies I find a great difference in length from one joint to another; for a man has from the shoulder joint to the elbow – and from the elbow to the tip of the thumb, and from the humerus of one shoulder to the other – two faces per unit, and a baby has one, because nature composes first the mass of the seat of the intellect before that of the bodily spirits.[312]

Little babies are thin in all their joints and the spaces located between the joints are fat, and this happens because the skin over the joints is without any flesh other than that of the nature of sinew, which links and binds the bones together, while a juicy fleshiness is found between one joint and the other, enclosed between the skin and bone. But the bones are thicker at their joints than between the joints, and the flesh, when the man grows, comes to lose that superfluity which was between the skin and bone, and for this reason the skin draws nearer to the bone and leads to the limbs becoming slimmer. The parts above the joints, because there is nothing other than cartilaginous and sinewy skin, cannot lose fluid, and, since they do not dry out, do not become smaller. For this reason small babies are slim at their joints and fat between the joints, as is seen in the joints of fingers, arms and shoulders which are thin with concave dimples, and a man, on the contrary, has thick joints in his fingers, arms and legs. Where small babies have dimples, men have prominences.[313]

On the proportionality of the parts[314]

The space between the slit of the mouth and the base of the nose is one-seventh of the face.

The space from the mouth to below the chin, cd, will be a quarter part of the face, and similar to the width of the mouth.

The space between the chin and below the base of the nose, ef, will be a third part of the face, and similar to the nose and the forehead.

The space between the midpoint of the nose and below the chin, gh, will be half the face.

The space between the upper origin of the nose, where the eyebrows arise, ik, to below the chin will be two-thirds of the face.

The space between the slit of the mouth and above the beginning of the upper part of the chin, that is to say, where the chin ends at its boundary with the lower lip, will be a third part of the space between the parting of the lips and below the chin, and is a twelfth part of the face. From above to below the chin, mn, will be a sixth part of the face, and will be a fifty-fourth part of the man.

From the furthest projection of the chin to the throat, *op*, will be similar to the space between the mouth and below the chin and is a quarter part of the face.

The space from above the throat to its base below, *qr*, will be half the face and the eighteenth part of the man.

From the chin to behind the neck, *st*, is the same as the space between the mouth and the start of the hair, that is to say three-quarters of the head.

From the chin to the jawbone, *vx*, is half the head, and similar to the width of the neck from the side.

The thickness of the neck goes one and three-quarter times into the space from the eyebrows to the nape of the neck.[315]

The distance between the centres of the pupils of the eyes is one-third of the face.

The space between the edges of the eyes towards the ears, that is to say, where the eye ends in the socket which contains it (at its outer corners), will be half the face.

The greatest width which the face has at the level of the eyes will be equivalent to that between the line of the hair at the front and the slit of the mouth.[316]

The nose will make two squares, that is to say, the width of the nose at the nostrils goes twice into the length between the tip of the nose and the start of the eyebrows; and, similarly, in profile the distance between the extreme edge of the nostril – where it joins the cheek – and the tip of the nose is the same size as between one nostril and the other seen from the front. If you divide the whole of the length of the nose into four equal parts, that is to say, from the tip to where it joins the eyebrows, you will find that one of these parts fits into the space from above the nostrils to below the tip of the nose, and the upper part fits into the space between the tear duct in the inner corner of the eye and

74. Proportions of the face in profile, based on Windsor, RL 12304r.

the point where the eyebrows begin; and the two middle parts are of a size equivalent to the eye from the inner to the outer corner.[317]

A-b-c are equal spaces and are similar to the space between the point where the arm is attached to the chest and the point at which the penis is attached; and to the space between the tip of the hand to the

75. Proportions of the face from the front, based on Windsor, RL 19129r.

76. Proportions of the torso and legs, based on Windsor, RL 19130v.

joint of the arm, and from the joint to the midpoint of the chest. And you should know that cb is a third part of the length of the man from his shoulders to the ground. D-e-f are similar spaces to each other and to the widest span of the shoulders.[318]

The hand to the point at which it joins with the bone of the arm goes four times into the space between the tip of the longest finger and the joint at the shoulder.[319]

Ab goes four times into ac, and nine times into am. The greatest thickness of the arm between the elbow and the hand goes six times into am, and is similar to rf. The thickest part of the arm between the shoulder and the elbow goes four times into cm, and is similar to hng.

77. Proportions of the arm, based on Windsor, RL 19134r.

The least thick part of the arm above the elbow, *xy*, is not the base of a square, but is similar to half of the space *hz*, which is found between the inner joint of the arms and the wrist. The width of the arm at the wrist goes twelve times into the whole of the arm, that is to say, from the tip of the fingers to the shoulder joint, that is to say, three times into the hand and nine times into the arm.[320]

Ac is half of the face, and is similar to *db* and to the point of attachment of the five toes, *ef. Dk* diminishes by one sixth in the leg at *gh. Gh* is a third of the face. *Mn* increases by a sixth over *ac*, and is seven-twelfths of the face. *Op* is a tenth less than *dk*, and is six-seventeenths of the face. *A* is the midpoint between *q* and *b*, and is a quarter of the man. *R* is the midpoint between *s* and *b*. The concavity of the knee outside *r* is higher than that of the concavity on the inside, *a*. Half of the size of the leg from the foot, *r*, is found at the midpoint between the protrusion *s* and the ground *b*. *V* is at the midpoint between *t* and *b*. The thickness of the thigh from the front is similar to the greatest width of the front of the face, that is to say, two-thirds of the space between the chin and the top of the head. *Zr* is five-sixths of *7v*. *Mn* is similar to *7v*, and is a quarter of *rb*. *Xy* goes three times into *rb* and into *rs*.[321]

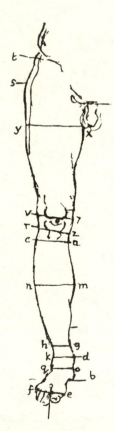

78. Proportions of the leg and foot, based on Windsor, RL 19136–9v.

The big toe is a sixth part of this foot,

taking the measurement in profile on the inside from the point at which this toe arises from the flesh of the ball of the foot as far as the tip of the toe ... and it is similar to the space from the mouth to below the chin. If you show the foot in profile from the outside, make the little toe start at three quarters of the length of this foot.[322]

The foot is as much longer than the hand as the thickness of the wrist at the junction of the hand, that is to say, where the wrist is thinnest, seen from in front. Again you will find the foot to be larger than the hand by the distance between the inner attachment of the little toe to the ultimate extension of the big toe, taking the measurement straight along the foot. The palm of the hand without its fingers goes two times into the foot without its toes ... The width of the heel at its lowest point is similar to the width of the arm where it joins the hand on the inside. It is similar to the leg at the point where it is thinnest from the front.[323]

The whole of the foot fits between the elbow to the hand joint and between the elbow and the inner attachment of the arm towards the breast when the arm is folded. The foot is of a size equal to that of the head of the man, that is to say, from below the chin to the highest point of the head.[324]

On the measurement of the human body and the bending of the limbs

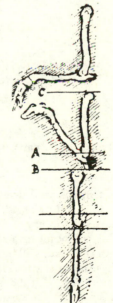

Necessity requires that the painter pay attention to the bones sustaining and supporting the flesh situated at the joints, which enlarge and diminish on bending. On this account the measurement of the extended arm does not correspond to the measurement of the bent arm *c*. The arm increases and diminishes across the range between its furthest extension and bending by an eighth part of its length. The increase and shortening of the arms comes from the bone which advances beyond the joint of the arms, as is seen in the diagram. *Ab* makes the measure from the shoulder to the elbow longer ... The space between the shoulder and the elbow will increase to the extent that the angle at which this elbow is bent becomes smaller than a

79. Proportions of a bent arm, based on Urb 104v.

right angle, and will decrease to the extent that it is greater than a right
angle.[325] The increase is similar to the thickness of the arm at its junc-
tion with the hand when seen in profile.[326] The knee neither increases
nor diminishes on being bent or extended.[327]

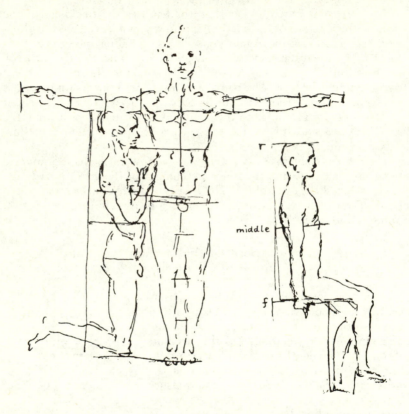

80. Proportions of a man kneeling, standing and seated, based on Windsor, RL 19132r.

If a man kneels down he will lose a quarter of his height. When a
man kneels down with his hands in front of his breasts, the navel will
be at the midpoint of his height and likewise the points of his elbows.
 The midpoint of a seated man, that is to say, from the seat to the
top of the head, will be just below the breasts and below the shoulders.
This seated part, that is to say, from the seat to above the head, will
be more than half the height of the man by the amount of the breadth
and length of the testicles.[328]
 A man lying down obtains only one-ninth of his height.[329]

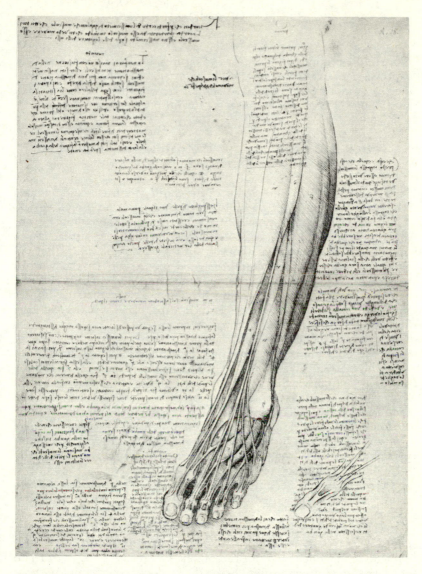

81. Anatomy of the foot and lower leg, Windsor, RL 19017r.
'That painter who has a knowledge of the chords, muscles and tendons will know well
in moving a limb which chord is the cause of its motion'

ANATOMY AND MOTION

Note in the motions and gestures of figures, how the limbs and their expressions are varied, as instanced by the shoulder blades which, during the motions of the arms and shoulders, vary the back somewhat. And you will find all the causes of this in my book on anatomy.[330]

How it is necessary for the painter to know the internal structure of man

That painter who has knowledge of the chords,* muscles and tendons will know well in moving a limb which chord is the cause of its motion, and which muscle in swelling is the cause of the contraction of this chord, and which chord, transformed into thinnest cartilage, surrounds and binds together the said muscle. By these means he will become a varied and comprehensive demonstrator of the various muscles according to their various effects in the figure, and he will not, as many do, render diverse actions in such a way that the figures always display the same features in their arms, backs, breasts and legs. Such things are not to be counted as minor errors.[331]

Remember, painter, that in the movements you depict as being made by your figures to disclose only those muscles which are involved in the motion and action of your figure, and in each case make the most relevant muscle the most apparent, and that which is less relevant less evident, while that which is not involved at all remains slack and limp and is little displayed. And for this reason I urge you to learn the anatomy of the muscles, chords and bones, without attention to which you will accomplish little. If you are drawing from life, perhaps the person you have selected lacks fine muscles in that action which you wish him to adopt, but you do not always have access to good nudes, and nor is it always possible to portray them. It is better for you and more useful to be practised in such variety and to have committed it to memory.[332]

It is necessary ... to know in diverse motions and forces which chord or muscle is the cause of such motion and only to make these evident and swollen, and not the others, like many who, in order to appear as great draughtsmen, make their nudes wooden and without grace, so that they seem to look like a sack of nuts rather than the surface of a human being, or, indeed, a bundle of radishes rather than muscular nudes.[333]

A nude figure represented with all its muscles very evident will be without motion, because it cannot move unless one part of its muscles relax when the opposite muscles tighten, and those which are relaxed

lack definition, and those which tighten disclose themselves strongly and become evident.[334]

O anatomical painter, take care that excessive attention to the bones, chords and muscles does not cause you to become a wooden painter, in your desire that your nude figures should exhibit all their emotions. Therefore, wishing to remedy this, observe in what way the muscles of the old or lean cover or rather clothe their bones, and in addition to this note the rule by which the same muscles fill the superficial spaces which are interposed between them, and which are the muscles that never lose their definition with any degree of fatness, and which are the muscles that lose their definition at their points of contact with even the slightest amount of obesity. Many are the occasions on which several muscles become one through fatness, or in old age one muscle becomes several.[335]

82. Wrong and right ways of portraying skin over muscles, based on Urb 117r.

The concavities interposed between the muscles must not be of such a kind that the skin appears as if it covers two rods placed in contact beside each other, nor yet should they appear like two rods somewhat separated from such contact, with the skin hanging down vacuously in a long curve, as at *f*. Rather it will be as at *i*, placed above the spongy fat interposed between the angles, as in the angle *mno*, which arises from the edges at which the muscles are in contact. So that the skin cannot descend into such an angle, nature has filled this angle with a little quantity of spongy fat – or you might say a viscous substance with minute vesicles full of air – which is condensed within itself or is rarefied according to the expansion or retraction of the substance of the muscles.[336]

The greatest thickness that is acquired by the limbs is in that part of the muscle that is most distant from its anchorage points. The flesh never increases over those parts of the bones which are close to the surfaces of the limbs. At *b, r, d, a, c, e, f*, the increase or diminution of the flesh never makes much difference. Nature has

83. Points of little overlying flesh on the skeleton of a leg, based on Windsor, RL 19141r.

arranged it so that in a man in locomotion all those parts are in front that, when the man bangs into something, need to feel pain. This is felt in the shins of the legs and in the forehead and nose, and this happens for the preservation of man, in that if such pain was not registered in these parts, it is certain that many blows would be received on these parts and would be the cause of their destruction.[337]

Muscular men have thick bones and are short and stocky, and have a dearth of fat, because the fleshiness of the muscles, through their growth, are pressed together, and there is no place for the fat that would otherwise be interposed between them. The muscles in such lean men, being in direct contact with each other, cannot widen, but increase in thickness and grow most in that part which is most distant from their ends, that is to say, towards the middle of their breadth and length ... Whereas fat men are themselves short and stocky, like the aforesaid muscular men, they have slight muscles, but their skin covers much fat sponginess and vacuity, that is to say, it is full of air, and, therefore, these fat men sustain themselves better on water than can the muscular men, whose skin is full inside and who have a lesser quantity of air within it.[338]

All the parts of each creature should be in keeping with its overall age, that is to say, that the limbs of the young should not be contrived with pronounced muscles, chords or blood vessels, as is done by those who, wishing to display artistry and great draughtsmanship, ruin the whole effect through switching limbs, and the same thing is done by others who, lacking draughtsmanship, make old people with young limbs.[339]

Youths have limbs with small muscles and blood vessels, and the surfaces of the body are delicate and rounded and of agreeable colour. In men the limbs will be sinewy and full of muscles. Old men will have rough and wrinkled surfaces, venous and with prominent sinews.[340]

On the movement of man and other animals

... Motions are of three kinds, that is to say motion of place and motion by simple action,* and the third is motion composed of motion by action and motion of place ... Motion of place is when the animal moves from one location to another. Motion by action is the motion that the animal makes in the same place without change of location. Motion of place is of three kinds, that is to say, rising, falling and going on the level. These three are supplemented by two [further properties], namely slowness and speed, and by two others, that is to say, straight motion and twisting motion, and another related one, that is to say, jumping. But motion by action is infinite, together with all the

infinite activities in which man often indulges, not without injury to himself . . . Compound motions are infinite, because amongst them are dancing, fencing, playing, sowing, ploughing, rowing – but rowing is simple motion by action, because the motion by action made by a man in rowing is not mixed with a motion of place which results from the motion of the man but one which results from the motion of the boat.[341]

The movements of man during the course of a single event are infinitely varied in themselves. The proof is as follows. In the case of a man delivering a blow to some object, I say that such a blow occurs in two directions; that is to say, either he is raising the thing which is to descend to create the blow, or he is making the descending

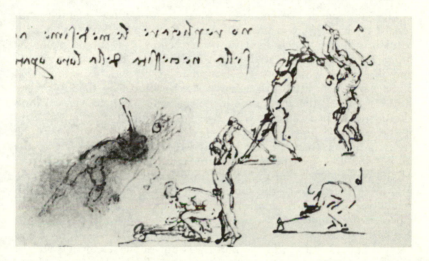

84. Man hammering, detail of Windsor, RL 19149v.

motion. In either of the two instances, it cannot be denied that the motion occurs across space and that the space will be a continuous quantity and every continuous quantity is infinitely divisible.* Hence it is concluded that every motion of something which descends is infinitely variable . . .

One and the same action will [also] show itself as infinitely varied because it may be seen from an infinite number of locations. These locations have continuous quantity and continuous quantity is infinitely divisible. Hence from varied viewpoints each human action is displayed as infinite in itself.[342]

The way to represent the eighteen actions of man

At rest, movement, running; standing upright, leaning, seated, stooping, kneeling, recumbent, hanging; carrying and being carried, pushing, pulling, striking, being struck, weighted down and lifting.[343]

On the balance of figures[344]

A figure which supports itself motionless on its feet maintains an equality of matching weights around the central line of its support.[345]

The components of the body must be gracefully adapted with regard to the effect you wish to make in the figure, and if you wish to make a figure which displays attractiveness, you should make the limbs refined and elongated, without displaying too many muscles, and those few which you are bound to show should be soft, that is to say, with little prominence, with colourless shadows. The limbs, above all the arms, should be relaxed, that is to say, no limb should be aligned directly with the part to which it is joined. And if the hips, the pole of man, are found to be posed such that the right is higher than the left you will ensure that the joint of the higher shoulder falls perpendicularly over the most uppermost part of the hips ... and the pit of the throat will always be above the middle of the angle of the foot on which it is supported. The limb which is not supporting will have its knee lower than the other and close to the other leg.[346]

The navel always lies on the central line of the weight which is located above it, and this ... takes account of the accidental weight of the man as well as his natural weight. This is shown when an arm is extended, for the fist at the extremity of the arm has the same effect as is seen in the counterweight at the end of a crane. Hence as much weight as the accidental weight of the fist is necessarily thrust out to the other side of the navel. It is appropriate that the heel should be raised on the same side as the fist.[347]

If a figure balances above one of its feet, the shoulder on the side on which he rests will always be lower than the other, and the pit of the throat will be above the middle of the leg on which he rests. The same thing will occur along whatever line we look at the figure, providing that the arms do not extend much beyond the figure, or it is without weight on its back, in its hands, or on its shoulders, or it does not extend forwards or backwards the leg on

which it does not stand.[348] If the leg is thrust backward, the pit of the throat goes forwards, and it alters correspondingly for every action.[349]

We see that someone who takes up a weight with one of his arms naturally thrusts the other arm outside himself in an opposite direction, and if this is not sufficient to ensure his equilibrium, he bends so as to impose as much of his weight as suffices to counteract the acquired weight. This is also seen in someone who is about to fall over towards one side who always thrusts out his arm on the other side.[350]

85. Man balanced over one foot, based on Urb 113v.

The distribution of weight or balance in men is divided into two parts, that is to say, simple and compound. Simple balance is that which is effected by a man over his immobile feet ... By compound balance is meant that which a man effects when he bears a weight during various motions. For example, when representing the figure of Hercules who crushes Antaeus,★ whom he suspends above the earth between his chest and arms, you should ensure that Hercules' figure extends as far behind the central line of his feet as the centre of gravity of Antaeus extends in front of these same feet.[351]

86. Hercules and Antaeus and other figures carrying weights, based on Urb 128v.

The shoulder of a man which supports a weight is higher than the shoulder without weight, and this is shown in the figure ... in which the central line passes through the whole of the weight of the man and of the weight he carries. This compound weight, if it were not divided into equal parts above the leg on which he stands, would necessarily collapse, but necessity ensures that as much of the natural weight of the man is thrust towards one side as the quantity of accidental weight is added on the other side, and this could not be accomplished if the man did not bend and if he did not lower his lighter side by bending so that it shares in the accidental weight he is carrying. This cannot happen if the shoulder with the weight is not raised

87. Man carrying a weight on one shoulder, based on Urb 112v.

and the lighter shoulder lowered, and this is the way that ingenious necessity proceeds in this action[352]

A man in bending diminishes on one side to the extent that he increases on the opposite side, and such bending will ultimately make the one side half the extended side.[353]

When the back or backbone is arched, the breasts are always lower than the shoulder-blades of the back. If the breast is arched, the breasts will be higher than the shoulder-blades of the back. If the back is straight the breasts will always be found at the height of these shoulder-blades.[354]

88. Man bending his body, based on Urb 113r.

The furthest a man can twist round will be when he displays the heels straight on and the face straight on, but this is not done without difficulty if he does not bend his leg and lower the shoulder which faces backwards. The cause of this twisting will be demonstrated in the book on anatomy, showing which are the first and last muscles to be moved.[355]

On the joints of the limbs[356]

The flesh which clothes the joints of the bones and other adjacent parts increases and decreases in thickness according to their bending or stretching; that is to say, increasing on the inside part of the angle produced by the bending of the limbs, and becoming thinner and extended on the part on the outside of the exterior angle. And the mid-part, which is inserted between the convex and concave angles, takes part

89. Bent arms, based on Windsor, RL 12614r.

in such increase or diminution, but so much more or less to the extent that it is closer to or more remote from the angle of these bent joints.[357]

This is to be sought in the necks of animals, because their motions are of three kinds, of which two are simple and one is compound, which combines both the simple ones. Of the simple motions one is when the neck is bent towards one or other shoulder or when it raises or lowers the head which is placed on it, and the second is when this neck is turned towards the right or towards the left without curvature, rather remaining straight while the face is turned towards one of the shoulders; and the third motion, which is called compound, is when the bending of the neck is combined with its turning, as when the ear is inclined towards one of the shoulders and the face turns towards the same part or to the opposite shoulder with the face turned towards the sky.[358]

The fingers thicken at their joints from all sides when they are bent, and they are more thickened to the extent that they are more bent, and accordingly diminish to the extent that they are straightened. The same thing happens with the toes, and they will vary more to the extent that they are more fleshy.[359]

90. Straight and bent fingers, based on Urb 113r.

[On the motion of parts of the body]

The principal motions of bending made by the joint of the shoulder are of a simple nature; that is to say, when the arm joined to it is moved higher or lower, or forwards or backwards, although it might be said that such movements are infinite, because if you turn your shoulder at the plane of a wall, you will describe a circular figure with your arm if you make the full motion of which this shoulder is capable. Because every continuous quantity* is infinitely divisible, and such a circle is a continuous quantity ... and since the motion of this arm has passed through every part of this circle, ... the variety in the positions of the shoulder is infinte.[360]

The principle motions of the hand are ten, that is to say inwards, outwards, right and left, revolving, upwards and downwards, closing and opening, spreading or drawing in the fingers.[361] The hand ... passes through a space which is a continuous quantity.[362]

There are [two] principle motions of the fingers, that is to say extending and bending. The extension and bending varies in type; that is to say, sometimes they bend as a unit from the first joint; sometimes they bend or straighten half-way down, at the second joint; and

sometimes they bend themselves completely by bending all three joints at the same time. If the first two joints are prevented from bending, then the third joint will be bent with greater ease than previously. It can never bend on its own if the other joints are unconstrained ... In addition to the aforesaid motions, there are four principle ones, of which two are up and down, and the two others are from side to side, and each of these is made by a single sinew. From these there follow infinite other motions always made by two sinews – one of these sinews slackening and the other reasserting itself.[363]

The attitudes of the head and arms are infinite. Therefore I do not intend to propose any rule, only saying that they should be easy and graceful with varied dispositions and united at the joints as intended, in order that they should not appear like bits of wood.[364]

On motion [of place] made by the disruption of balance

Motion [of place] is created by the disruption of balance, that is to say of equilibrium, in as much as nothing may move of itself which does not depart from its state of balance, and it will move more swiftly when it is more remote from the aforesaid state of balance.[365] Motion of place made by man or another animal will be of so much greater or lesser swiftness to the extent that the centre of its gravity is more remote from or closer to the centre of the foot over which it is supported.[366] That figure will show itself to be progressing fastest that is about to collapse forwards.[367]

91. Man running, based on MS A 28v.

A man in running puts less weight on his legs than when standing still. And in the same way a horse which is running feels less of the weight of the man it bears. Hence many are astonished that a horse in running can support itself on a single foot. Thus it may be stated that a weight in lateral motion will be so much more rapid to the extent that the weight is less perpendicularly above the centre.[368]

92. Figure moving against the wind, based on Urb 137r.

Invariably a figure that is moving against the wind in any direction does not retain the centre of its gravity in its natural distribution above the centre of its support.[369]

When a man wishes to stop running and overcome his impetus, it is necessary that he leans backwards and takes short, quick steps.[370]

A man who climbs any slope finds that he must give himself more weight in front of the higher foot than the rear one, that is to say in front of the axis rather than behind this axis. Hence a man always transfers greater weight towards the point to which he wishes to move than in any other direction. The faster someone runs the more will he lean towards the place to which he is running, and he transfers greater weight in front of his axis than behind. Someone who runs downhill transfers his axis over his heels, and one who runs uphill puts it over the tips of the feet; and someone who runs on the flat puts it first over the heels and then over the tips of the feet.[371] Someone who descends takes little steps, because his weight rests above the rear foot; and someone who climbs takes large steps, because his weight is located over the foot in front.[372]

The first thing a man does in mounting steps is to unload from the leg which he wishes to raise the weight of the trunk which was located above this leg, and in addition to this he loads the opposite leg with all the remaining weight of the man, including the other leg. He then raises the leg and sets his foot on that step on to which he wishes to raise himself. Having done this he restores to the higher foot all the weight of the trunk and other leg, and rests his hand on the thigh and thrusts his head forwards and makes a motion towards the tip of the higher foot, rapidly raising the heel of the lower foot; and with this impetus he lifts himself upwards and at the same time extends the arm which he has rested on his knee. This extending of his arm pushes the torso and the head upwards and thus straightens his curved backbone. To the

93. Man who stops running, based on Windsor, RL 19038v.

94. Man climbing a slope, based on MS A 28v.

95. Man stepping upwards, based on Windsor, RL 19038v.

extent that the step mounted by the man is of greater height, so his head must be further forward than his upper foot.[373]

When a man is sitting on the floor the first thing he does to raise himself is to draw one foot towards him and place his hand on the ground on that side on which he wishes to rise, and he throws his body over the braced arm, and puts his knee on the ground on that side on which he wishes to raise himself.[374]

When a man jumps upwards his head has three times the velocity of the heel of the foot before the tip of the foot leaves the ground, and twice the speed of his hips. This occurs because three angles are opened up at the same time, of which the first is where the trunk joins the thighs in front; the second is where the backs of the thighs are joined with the backs of the shins; the third is where the front of the shins is joined to the foot bone.[375]

Jumpers with their feet together who wish to make a larger leap thrust their fists straight behind them and violently project them forwards in the take-off of their leap, finding that by the motions of their hands the leap becomes greater. To augment such a jump there are many who take up two heavy stones in their two hands, and use these to the same effect as they had previously used their fists alone; the leap is made much further.[376]

On the motions appropriate to the pursuits of men

The motions of your figures must be shown with such degrees of force as correspond to those they are using in various actions; that is to say you should not display the same force in someone who lifts a stick as would be appropriate to lift a beam. Thus make your figures prepare to display force according to the nature of the weights they are handling.[377]

On the motion of figures in pushing or pulling

Pushing and pulling are the same action, in as much as pushing is only an extension of the limbs and pulling is a contraction of these limbs, and to both forces alike is added the weight of the mover against the thing pushed or pulled.[378] In addition to the power of the arms is added the weight of the person, and the force of the back and of the legs, which are extended as required, as would happen with two men at a column, one of whom pushes the column while the other pulls it . . .

96. Pushing and pulling, based on
Urb 120v.

Man has greater power in pulling than in pushing because in pulling
the force of the muscles of the arms is added, and these only come into
action in pulling and not in pushing, because when the arms are
straight the muscles which move the elbow cannot have any role in
pushing in excess of that of the man leaning his shoulders against the
object which he wishes to move from its place – in which only the
sinews which straighten the curved backbone are involved and those
which straighten the bent legs and those which are located under the
thigh and those in the calf behind the shin. Thus it is concluded that
in pulling there is joined together the force of the arms and the power-
ful extension of the back and of the legs, together with the weight of
the man, according to the extent to which he leans; the same things
combine in pushing but without the force of the arms, because
pushing with a straight, immobile arm is equivalent to having a piece
of wood placed between the shoulder and the object which is
pushed.[379]

On the application of force by a man who wishes to
produce a great blow

When a man prepares himself for the creation
of a forceful motion he bends and twists
himself to the greatest extent in a contrary
motion to that in which he wishes to pro-
duce the blow, and thus prepares as much
force as is possible for him, which he then
gathers up and releases on the thing struck
by him, expending the motion.[380]

A man who has to make a great blow with
his weapon prepares himself with all his
power on the contrary side to that side on

97. Man preparing to
throw a spear, based on
Urb 128r.

which the blow is to be made; and this is because something which moves further is rendered more powerful against the thing which impedes this motion.[381]

A man who wishes to throw a spear or a rock or other object with impetuous motion can be portrayed in two principal ways; that is to say, either you must portray him when he prepares to generate the motion, or alternatively when the motion is finished. If you should portray him at the beginning of the motion, the inner side of the foot will lie along the same line as the breast, but will have the opposite shoulder above this foot; that is to say, if the right foot is under the weight of the man, his left shoulder will be above the tip of his right foot.[382]

Someone who in order to plough wishes to push or thrust a blade into the ground, raises his leg on the opposite side to the arm which thrusts, and bends that knee. This puts him in balance over the foot which is placed on the ground. Without such a bending or twisting of his leg he would not be able to do it, nor could he make the thrust if this leg were not extended.[383]

98. Archer preparing to fire an arrow, based on Forster I² 44r.

Someone who wishes to draw back his bow a considerable way must set himself entirely on one foot, lifting the other so much higher than the first that it makes the necessary counterpoise to the weight which is thrown over the first foot. He must not hold his arm completely extended, and in order that he should be able better to bear the strain, he places a piece of wood against the bow, as is used in the stock of a crossbow, going from his hand to his breast, and when he wishes to let go, he suddenly and simultaneously leaps forward and extends his arm and releases the bowstring; and if he dextrously does everything simultaneously, the arrow will go a considerable distance.[384] You should know that the reason for the above is that since the leap forward is swift it gives one increment of fury to the arrow, and the extending of the arm, because it is swifter, gives two increments; the thrusting of the bowstring, being yet faster than the arm, gives three increments. Accordingly, if other arrows are driven by three increments of fury, and if, by dexterity, this arrow is driven by six increments it ought to go double the distance.[385]

On the movements of man

The highest and principal part of art is the inventing of the composition of something. And the second part consists of the movements,

giving due account to the actions that are undertaken with rapidity, according to the degree of motivation, whether apathy or alertness. The vividness of ferocity is the highest degree of action that is required of a participant, as when someone is to cast spears, stones or other similar things, in which the figure demonstrates the highest commitment to this action. The two figures here are shown with different

99. Men preparing to throw, based on Urb 106r.

powers in action, and the first in effectiveness is the figure *a*; the second is the movement *b*. *A* dispatches the thrown object further from himself than *b*, because, although they both show that they wish to cast their weight in the same direction, *a* has orientated his feet in this direction. Having twisted and moved himself towards the other side, where he prepares for the application of his power, he pivots with speed and convenience towards the point at which he wishes to release the stone from his hands; but in this same example the figure *b* has the tips of the feet facing in a direction opposite to the place towards which he wishes to cast his weight. He twists towards this place with great difficulty, and consequently the result is weak, in that the motion shares [the potency of] its cause. The preparation of the force in each movement needs twisting and bending of great violence, and the reflex motion will happen with ease and facility, and thus the operation will have a good effect ...

In a crossbow which is not disposed for violence, the motion of the projectile will be short or nonexistent. Where there is no dispensation of violence, there is no motion, and where there is no violence there can be no destruction, and for this reason a bow which has no violence cannot generate motion if it does not acquire this violence ... Correspondingly, a man who neither twists nor bends himself does not acquire power. Thus when *b* has thrown his spear he finds himself to be contorted and weak on that side towards which he has cast the projectile, and he has acquired only so much power as comes from turning in a contrary direction.[386]

POSTURE, EXPRESSION AND DECORUM

Posture is the first and most noble aspect of figure painting, in that not only is a well-painted figure in a bad posture disagreeable, but also a living figure of the highest quality of beauty loses its reputation when its actions are not adapted to the function they must perform. Certainly and without doubt, posture requires greater deliberation than does the degree of excellence of the painted figure, in that the quality of a figure may be gained by imitation from life, but the movement of such a figure is necessarily engendered by a talent of great discernment.[387]

How the good painter has to paint two things: man and his mind

The good painter has to paint two principal things, that is to say, man and the intention of his mind. The first is easy and the second difficult, because the latter has to be represented through gestures and movements of the limbs – which can be learned from the dumb, who exhibit gestures better than any other kind of man.[388] Do not laugh at me because I propose an instructor without speech, who is to teach you an art of which he is unaware, because he will teach you better through what he actually does than others can through their words. And do not despise such advice, because the dumb are the masters of movements and understand what one says from a distance when one accommodates the motions of the hands to the words.

This opinion has many enemies and many defenders. Therefore, painter, thread a path between one and the other faction. Follow what actually occurs, according to the rank of the people who speak and the nature of the thing under discussion.[389]

How a figure is not praiseworthy if it does not display actions which express the passion of its feelings

That figure is most praiseworthy which best expresses through its actions the passion of its mind.[390]

The movement which is depicted must be appropriate to the mental state of the figure. It must be made with great immediacy, exhibiting in the figure great emotion and fervour, otherwise this figure will be deemed twice dead, inasmuch as it is dead because it is a depiction, and dead yet again in not exhibiting motion either of the mind or of the body.[391] The motions and postures of figures should display the true mental state of the originator of these motions, in such a way that they

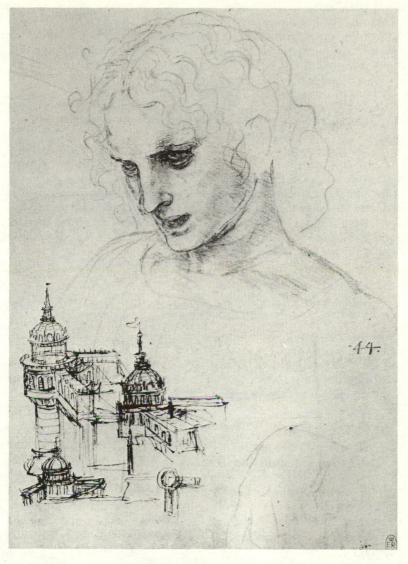

100. Study for St James the Greater in *The Last Supper*, Windsor, RL 12552r.
'That figure is most praiseworthy which best expresses through its actions the passion of its mind'

could not signify anything else.[392] The movements of men should be as required by their dignity or baseness.[393]

Vary the air of faces according to the states of man – in labour, at rest, enraged, weeping, laughing, shouting, fearful, and suchlike. And, in addition, the limbs of the person together with his whole posture should correspond to the altered features.[394]

On motions appropriate to the mind of the mover

There are some mental motions that are without motion of the body and others with motion of the body. The mental motions without motion of the body allow the arms to fall, with the hands and every other part which exhibits life, but mental motions with motion of the body set the body with its limbs in motion as appropriate to the motion of the mind ... And there is a third motion which partakes of both, and a fourth which is neither one nor the other, and these latter ones are those of the foolish or truly insane, and this is to be put in the chapter on madness or on buffoons and their wild dances.[395]

How an angry figure is to be made

Show an angry figure hold someone up by the hair – wrenching that person's head against the ground, with one knee upon the person's ribcage – and raising high the fist of his right arm. The angry figure will have his hair standing on end, his eyebrows lowered and drawn together, and teeth clenched, with the two lateral corners of his mouth arched downwards. His neck will bulge and overlap in creases at the front as he stoops over his enemy.

How a despairing man is to be represented

Give the despairing man a knife and let him have rent his garments with his hands. One of his hands will be tearing at his wound. Show him standing on his feet with his legs somewhat bent, and his body accordingly inclined towards the ground, with his hair torn and bedraggled.[396]

How young children should be represented

Little children must be represented with lively, wriggling actions when they are seated, and when they stand upright with timid and fearful actions.

How old men should be represented

Old men should be made with sluggish and slow movements, and their legs will be bent at the knees when they stand still, both when their feet are together and some distance apart, stooping with their heads tilted forwards and their arms not too extended.

How women should be represented

Women should be represented with demure actions, their legs tightly closed together, their arms held together, their heads lowered and inclined to one side.

How old women should be represented

Old women should be represented as shrewlike and eager, with irascible movements in the manner of the infernal furies, and their movements will be more apparent in their arms and heads than in their legs.[397]

On physiognomy and chiromancy

I will not enlarge upon false physiognomy and chiromancy,* because there is no truth in them, and this is made clear because such chimeras have no scientific foundation. It is true that the signs of faces display in part the nature of men, their vices and their temperaments. If in the face the signs which separate the cheeks from the lips of the mouth and the nostrils of the nose and sockets of the eyes are pronounced, the men are cheerful and often laughing, and those with slight signs are men who engage in thought. And those who have facial features of great relief and depth are bestial and wrathful men of little reason, and those who have strongly pronounced lines between their eyebrows are evidently wrathful, and those who have strongly delineated lines crossing their forehead are men who are full of hidden or overt regrets. And it is possible to discuss many features in this way.[398]

On laughing and crying and the difference between them ...

Do not depict the face of one who weeps with movements equivalent to those who laugh – just because they often resemble each other –

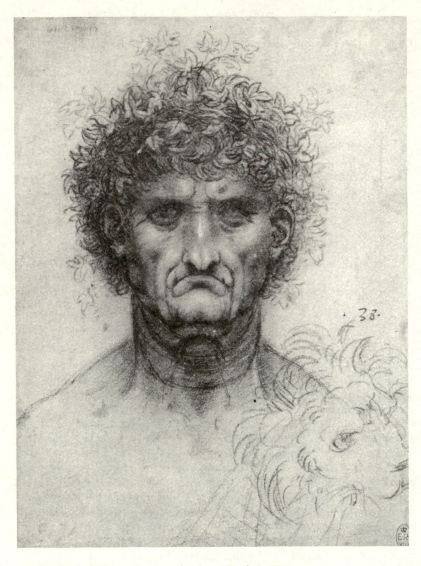

101. Head of a belligerent man with a lion, Windsor, RL 12502.
'Those who have facial features of great relief and depth are bestial and wrathful men of little reason'

because their true appearance is different from each other, in the same way that the state of weeping differs from the state of laughing. For in weeping, the eyebrows and the mouth vary according to the various causes of the weeping, because some weep in anger, some through fear and others through tenderness and joy, others through suspicion and others through pain and torment, and others through pity and grief for lost relatives or friends. Of those who weep, some display despair, others moderation, others only tearfulness, and others screaming; others turn their face towards the sky and lower their hands, wringing their fingers; others are fearful with their shoulders hunched up to their ears – and thus the effects follow on according to the aforesaid causes. He who sheds tears raises his eyebrows where they meet and knits them together, which results in wrinkles above them and towards the centre, and the corners of his mouth are turned down. The person who laughs raises the corners of his mouth, and has eyebrows that are separated and wide apart ... And the person who weeps in addition tears at his garments and hair with his hands, and rips the flesh of his face with his nails – which does not happen with one who laughs[399]

On representing someone who is speaking to many people

When you make someone whom you wish to be speaking to many people, consider the subject on which he must discourse, and adapt his actions so that they are in accordance with the subject. That is to say, if it be a matter of persuasion, then his actions should fit this purpose. If many different arguments are to be expounded, then he who speaks will grasp one of the fingers of his left hand with two from the right, having closed the two smaller fingers, and with his face turned in readiness towards the throng and with his mouth somewhat open, so that he appears to speak. And if he is sitting, let it seem as if he is rising up to some extent, leaning his head forwards. And if you make him standing, make him incline his chest and head somewhat towards the throng, whom you should represent as silent and attentive, all looking the orator in the face and making admiring gestures. And show the mouth of some old man, marvelling at the opinions he has heard, with its corners dragged downwards amid his flabby jowls. His eyebrows will be raised where they meet, making many furrows in his forehead. Some will be seated, with their fingers clasped around their weary knees. Others will be cross-legged, with a hand placed on their knee which cups the elbow of the other arm, whose hand, in turn, might support the chin of some stooped and aged man.[400]

Good orators, when they wish to persuade their listeners of something, use their hands and arms to accompany their words, although some senseless men do not care for such ornamentation and seem in court to be statues of wood, through the mouth of which passes as in a conduit the voice of another man who is concealed within the court.[401]

For affectionate gestures, pointing out things that are nearby in time or space, he should point with the hand not too far from him, and if the aforesaid thing is further away, the hand of he who points should be farther out, and the front of his face turned towards that to which he points.[402]

On the attention of bystanders at a notable event

All the bystanders at an event worthy of note adopt various gestures of admiration when contemplating the occurrence, as when justice punishes wrongdoers. And if the event is of a devotional kind all the onlookers direct their eyes with various expressions of devotion towards the event, as when the host is displayed at the Sacrifice of the Mass and in similar events. And if it is an event that merits laughter or tears, it is not necessary in this instance that all the bystanders turn their eyes towards the event, but with a variety of movements the greater part of them should rejoice or mourn together. And if the event is terrifying the frightened faces of those who run away will make a great show of terror and flight.[403]

Take studious pleasure to observe those who speak together with motions of the hands, if they are persons whom you can approach and hear what causes them to make such movements as they do ... Consider those who laugh and those who cry; take delight in those who shout in anger, and so on for all the states of our minds. Observe decorum and note that it is not suitable, either with respect to place or action, for the lord to behave like the servant, nor should the infant behave like the adolescent but in a way similar to an old man, who can barely support himself. Do not make a rude peasant with an action which is rightly used for a noble man, nor the strong like the weak, nor the actions of a whore like those of an honest women, nor males like females.[404]

On the observation of decorum

The actions of men are to be expressed in keeping with their age and station, and they will vary according to their types, that is to say the types of men and those of women.[405]

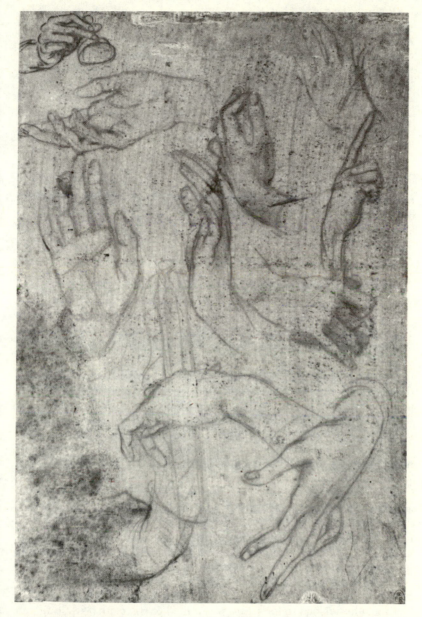

102. Study of hands for the *Adoration of the Magi*, Windsor, RL 12616 (photographed under ultra-violet light).
'Good orators ... use their hands and arms to accompany their words'

Observe decorum, that is to say the suitability of action, clothing, and situation, and have regard to the dignity or baseness of those whom you wish to portray, that is to say the king will be bearded, with dignified demeanour and clothing, and in an ornamented setting, and the bystanders should be respectful and admiring, and clad in garments worthy and fitting for the dignity of a court. And those of a base nature will be unadorned and [shown as] abject dissemblers, and the bystanders should be similar with base and rude actions, and all the elements should correspond to such a composition.[406]

Of the poses of women and girls

In women and girls there must be no actions where the legs are raised or too far apart, because that would indicate boldness and a general lack of shame, while legs closed together indicate the fear of disgrace.[407]

On ways of dressing your figures and various kinds of clothing

The clothing of figures should be accommodated to their age and to decorum, that is to say, the old man should be robed; the young man should be adorned with clothing that omits to extend over the area from the neck to the points of the shoulders, with the exception of those who follow a religious profession. And avoid as much as is possible the dress of your own era – except when the figures coincide with the group mentioned above – and it is only to be used in figures which are likenesses of those who are buried in churches. In this way we may be spared our successors laughing at the mad inventions of men, but rather elicit admiration for their dignity and beauty.

And in my own days I remember in my childhood having seen men, both minor and major, having all the edges of their garments scalloped at every place – on their heads as on their feet and at their sides – and it even appeared such a beautiful invention to that generation that they further scalloped the scallops, and they wore hoods and shoes in the same style, and scalloped cockscombs which extruded from the seams of garments of diverse colours. Next were seen shoes, caps, purses, weapons which were carried for fighting, the collars of garments, the borders of jackets and trains of garments down to the feet, and in effect anyone who wished to look fine was armed to the teeth with long and sharp points.

In another era sleeves began to grow and were of such size that each one by itself was larger than the gown. Then garments began to rise

around the neck, so that in the end they covered the whole head. Then
they began to pare back the clothing to the point where the drapery
could not be supported from the shoulders, because it did not hang
from there. Then the garments began to lengthen, so that men con-
tinually had their arms laden with clothes in order not to tread on
them with their feet. Then they reached such an extreme that they
wore clothing only as far as their hips and elbows, and they were so
tight that they suffered great torment and many of them split
underneath, and the feet were so constricted that their toes were push-
ed over one another and were full of corns.[408]

DRAPERIES

Of draperies which clothe figures

The draperies that clothe figures must show that they are inhabited by
these figures, enveloping them neatly to show the posture and motion
of such figures, and avoiding the confusion of many folds, especially
over the prominent parts, so that these may be evident.[409]

In one drapery you should not create confusion with many folds.
On the contrary, you should show them only when they are held by
the hands or arms. The remainder should fall simply as its nature dic-
tates, and should not cut across the figure with too many contours or
broken folds.

Draperies must be copied from nature, that is to say if you wish to
make woollen cloth, use folds appropriate to that, and should it be silk
or fine cloth or rude cloth or linen or voile, differentiate the folds for
each type, and do not base a garment, as do many, upon models
covered with paper or thin leather, for you would be making a grave
error.[410]

The draperies that clothe figures must have their folds arranged to
gird the limbs clothed by them, in such a way that folds with dark
shadows are not placed in the illuminated portions, and folds of ex-
cessive brightness are not to be made in the shaded portions. The con-
tours of these folds should occur in the part which surrounds the limbs
... but not in such a way that the contours cut across the limbs, nor
should the shadows sink further in than the surface of the clothed
body. And in effect the drapery should be arranged in such a way that
it does not seem uninhabited, that is to say, it does not seem to be a
pile of drapery cast off by man, such as we see made by many artists,
who are so fond of the diverse gatherings of various folds that they
completely cram a figure with them, forgetting the effect for which the

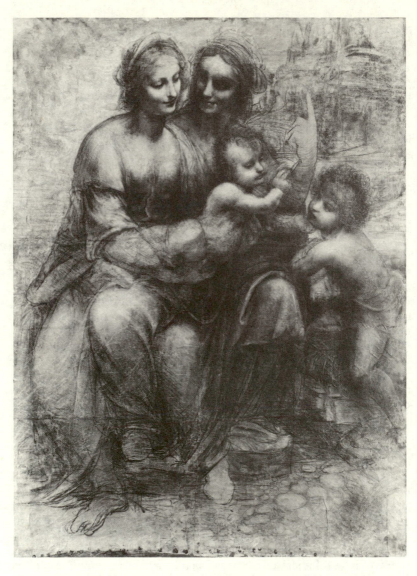

103. *The Virgin and Child with St Anne(?) and St John*, London, National Gallery.
'The draperies that clothe figures should show that they are inhabited by these figures'

drapery is made; that is to say, to clothe and surround gracefully the limbs on which it is placed, and not to stuff the raised and illuminated parts of figures like bellies or inflated bladders. I do not deny that one should make some beautiful pleats, but they should be made in that portion of the figure where this drapery is gathered together and falls down between the limbs and the body.

And above all vary the draperies in narrative compositions, making some folds with faceted breaks – and this is for thick draperies – and some draperies will have soft folds and their sides will not be angular but curved – and this occurs with silks and satins and other thin cloths, like linen, voile and suchlike. Also make some draperies with a few, large folds, as with coarse cloth, like that seen in felt and blankets and other bedcovers.

And I do not give this advice to masters, but to those who do not wish to teach, who certainly are not masters, because he who does not teach is afraid that he will loose his profits [if he does teach], and, esteeming profits, he abandons the study which is contained in the works of nature, the mistress of painters. What they have learned they cast into oblivion, and what they have not yet learned they will never learn later.[411]

On fluttering and static draperies

The draperies with which figures are clothed are of three types, that is to say fine, coarse and medium. The fine ones are more flexible and lively in motion. Therefore when a figure is running consider the motion of this figure, because it bends now to the right, now to the left, and in putting weight on the right foot the drapery of that part rises from the foot, its undulation reflecting the percussion. And at the same time the leg which remains behind behaves similarly with the drapery which lies over it. And the part in front lies wholly in diverse folds over the breast, body, thigh and legs, and behind it wholly drifts away, with the exception of the leg which remains behind. And the medium cloths make lesser movements and the coarse almost none at all, unless a wind contrary to the motion of the figure helps them to move.

The borders of draperies, either the upper or lower ones, move according to the bending of the figure, and the border which is nearest the feet according to whether the drapery hangs down or bends or twists round or strikes against the legs. The borders move nearer to or further from the joints according to whether the figure is walking or running or jumping, or they may even move without any other motion in the figure when the wind itself strikes against them. And

the folds should be accommodated to the nature of the cloths, transparent or opaque ...[412]

The profile of the folds that are tightest around the limbs should be wrinkled on that side of the limb which is shortened by being bent, and should be stretched out on the opposite side.[413]

A figure dressed in a cloak should not show the naked form so much that the cloak seems to be next to the flesh. Certainly you do not want the cloak to be next to the flesh inasmuch as you have to remember that between the cloak and the flesh there are other garments which hinder the disclosure of the limbs under the cloak. And make the form of those limbs that you do disclose of sufficient thickness as to suggest other garments under the cloak, and the true thickness of the limbs should only be disclosed in the case of a nymph or an angel, who are represented as dressed in flimsy garments which the driving winds impress around their limbs. In these and similar figures the shape of their limbs may perfectly well be revealed.[414]

Ensure in your draperies that the part which surrounds the figure

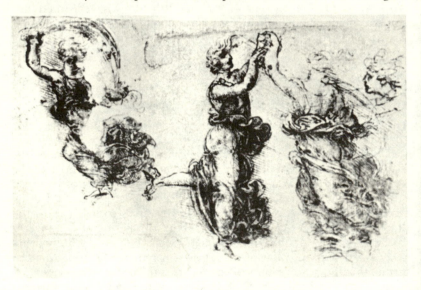

104. Dancing 'Nymphs', Venice, Accademia.
'As much as you can imitate the Greeks and Latins in the way in which the limbs are revealed when the wind presses the draperies over them'

reveals the way in which it is posed, and that part which remains behind it should be ornamented in a fluttering and outspread manner.[415] As much as you can, imitate the Greeks and Latins in the way in which the limbs are revealed when the wind presses the

draperies over them, and make few folds. Only make extra folds for old men of authority who are dressed in robes.[416]

Opinions about draperies and their folds, which are of three natures

There are many who love to make the folding of the layers of drapery with sharp, harsh and abrupt angles, others with almost imperceptible angles, others without any angles but in their stead they make curves of these three kinds; some want coarse draperies with few folds; others

105. Varieties of folds in draperies, based on Urb 168v.

want ones with a great number of folds; others take a middle course. You will adopt these three procedures, placing each kind in your narrative, with the addition of draperies that appear to be old and patched, and new draperies with abundant cloth and others which are wretched, according to the station of whoever you are dressing, and do likewise with their colours.[417]

On the nature of folds in drapery

That part of a fold that is located farthest away from its gathered edges will most completely revert to its natural state. By nature everything has a desire to remain as it is. Drapery being of equal density and thickness both on its reverse and on its right side strives to lie flat, wherefore when it is forced to forsake this flatness by reason of some fold or pleat, observe the nature of the force on that part of it which is most bunched up, and you will find that part which is farthest from

106. Folds in draperies, based on Urb 169r.

these constraints reverts most to its natural state, that is lying spread out and flat.

For example, let *abc* be the fold of the drapery mentioned above. Let *ab* be the place where this folded drapery is gathered. I put it to you that the part of the drapery that is farthest away from the gathered edges reverts most to its natural state. Therefore *b* being furthest away from *ac* is where the fold *abc* will be wider than at any other point.[418]

On the eye which sees the folds of draperies that surround a man

The shadows interposed between the folds of draperies surrounding human bodies will be darker to the extent that they are more directly opposite the eye with respect to the concavities within which such shadows are produced, and this I mean to apply when the eye is located between the shaded and illuminated portions of the aforesaid figure.[419]

107. Folds in draperies foreshortened, based on Urb 169v.

Where the figure is foreshortened ensure that a greater number of folds are seen than where it is not foreshortened, and its limbs should be surrounded with repeated folds revolving around these limbs. Let *A* be the location of the eye; *mn* sends the midpoint of each circular contour at a greater remove from the eye than its edges. *No*, displays them straight because it is situated directly opposite. *Pq* sends them from the opposite side. And use this distinction in the folds that surround the arms, legs and so on.[420]

Part IV:

THE DEPICTION OF NATURE

LIGHT IN THE COUNTRYSIDE

On giving the proper lights to illuminated things, according to their locations

It is necessary to take great care that the lights are appropriate to the things illuminated by them, inasmuch as in the same narrative there will be areas in the countryside illuminated by the universal light of the air and others that are within porticos which are lit by a mixture of specific and universal light, and others in specific lights, that is to say in dwellings which take light from a single window. Of these three kinds of light it is necessary for the first to occupy large expanses ... [according to the principle that] the relative sizes of those parts of the bodies which are illuminated are proportional to the relative sizes of the objects which illuminate them. And furthermore in this case there will be reflections from one body to another where the light enters through the narrow spaces between the bodies illuminated by the universal light, because the lights which penetrate between bodies close to one another behave in the same way as the lights which penetrate through the windows and doors of houses, which we designate as specific lights.[421]

And you, painter, who undertake narrative paintings, ensure that your figures have as much variety in their lights and shadows as there are varieties of source which cause the lights and shadows, and do not treat them in a uniform manner....

The countryside which is illuminated by the light of the sun will have shadows of great darkness on any object, and to someone who sees the object from the opposite side to that which is exposed to the sun it will appear darkest, and things far away will appear close. But when you see things along the direction from which they are exposed to the sun they will be displayed to you without shadows, and things near to you will be made to seem remote and unclear in shape.

Something which is illuminated by the sunless air has its darkest part where it is least exposed to the air, and it will be so much darker to the extent that it is exposed to surroundings of the greatest darkness. Things seen in the countryside [without sun] have little difference between their shadows and their lights, and their shadows will be almost imperceptible and without any boundary, in fact seeming like smoke, which disappears towards its illuminated por-

tions and only becomes darker where it is deprived of the light of the air.

Something seen in places with little illumination or as nightfall commences will also have little difference in its lights and shadows, and if it is fully night-time the difference between light and shade is so imperceptible to the human eye that the shape of everything is wholly lost, and is only apparent to the sharp sight of nocturnal animals.[422]

How to portray landscapes

Landscapes exhibit the most beautiful blue during fine weather when the sun is at noon than at any other period of the day, because the air is purged of vapours. And looking under these conditions you see trees with a beautiful green towards their edges and with dark shadows towards the centre. And at long distances the air which is interposed between you and them becomes most beautiful when something darker is beyond it, and hence the blue is most beautiful.[423]

Wholly cloudy air renders the countryside beneath it lighter or darker according to the greater or lesser thickness of the clouds interposed between the sun and the countryside.

When the thickened air interposed between the sun and the earth is of uniform density you will see little difference between the illuminated and shaded parts of any body.[424]

Landscapes should be portrayed in such a manner that the trees are half illuminated and half shaded, but it is better to make them when the sun is covered by clouds, for then the trees are illuminated by the universal light of the sky and by the universal shade of the earth and these are so much darker in their parts to the extent that these parts are closer to the centre of the tree and to the earth.[425]

That body will exhibit the greatest difference between its shadows and its lights that happens to be seen under the strongest light, like the light of the sun or the light of a fire at night. And this should be little used in painting because the works will remain harsh and disagreeable.

There will be little difference in the lights and shadows in that body which is situated in a moderate light, and this occurs at the onset of evening or when there is cloud, and such works are sweet and every kind of face acquires grace. Thus in all things extremes are blameworthy. Too much light makes for harshness; too much darkness does not allow us to see. The medium is best.[426]

On sun and clouds★

The sun makes a beautiful spectacle when it is in the west, illuminating all the high buildings of a city and castles and the lofty trees of the countryside, and it tinges them with its colour. And all other things below remain in slight relief, because – being only illuminated by the air – there is little difference between their shadows and their lights,

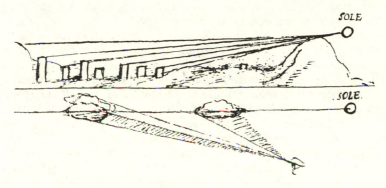

108. Sun in the west colouring buildings and clouds, based on Urb 152r.

and for this reason they do not much stand out. And those objects amongst them that rise highest are touched by the solar rays and, as has been said, are tinted with their colour. Hence you should take the colour with which you make the sun and include it in every bright colour with which you illuminate these objects.[427]

At one hour into the day the atmosphere in the south near to the horizon has a dim haze of rosy clouds, and towards the west it becomes darker, and towards the east the humidity at the horizon is brighter than the air at the horizon, and the white of the houses in the east is hardly discerned, and in the south, the farther distant they are, the more they become shaded by a rosy colour, and even more so in the west. And with the shadows it is to the contrary, for these are consumed before the white.[428]

Although over long distances the perception of the existence of many things is lost, nevertheless those which are illuminated by the sun are rendered more certain in their appearance, and others appear to be enveloped in obscuring mists... The air which is situated between the sun and the earth, when the sun rises or sets, will always cover the things which are behind it more than any other portion of the air...

When the sun turns the clouds red at the horizon, objects which at

a distance are clothed in blue take on such a red colour, whereby a compound between blue and red is made, which renders the countryside very gay and cheerful. And all the things illuminated by this red which are dense will be very conspicuous and reddened, and the air, being transparent, has this redness diffused throughout itself, whereby it displays the colour of lily flowers.[429]

The red colour with which the clouds are tinted to greater or lesser degrees of redness arises when the sun is at the horizon in the evening or morning, because any body which is to some extent transparent is to some extent penetrated by the solar rays when the sun displays itself in the evening or in the morning. And because those parts of the clouds which are nearest the edges of their convexities are more rarefied than in the middle of these convexities, the solar rays penetrate them with a more splendid red than those dense parts which remain dark through being impenetrable to such solar rays. And the clouds are always thinner at the borders of their convexities than in the middle of the clouds, as is proved above, and on this account the red colour of clouds is of various degrees of redness...

What is discussed here about the redness of the clouds refers to when the sun is behind the clouds, but if the sun is in front of the same clouds, then their convexities will be of greater radiance than their internal portions, that is to say, in the centre of the convexities and hollows, but not at the sides of the convexities which are exposed to the darkness of the sky and of the earth.

I say that the eye interposed between the convexities of the clouds and the body of the sun, will see the middle of these convexities as being of greater radiance than any other part, but if the eye is on one side in such a way that the lines which pass from the convexity to the eye and from the sun to the same eye make their convergence under less than a right angle, then the highest illumination of the convexities of the clouds will be at the boundaries of these convexities.[430]

The solar rays penetrating through the small apertures intervening between the various masses and convexities of clouds illuminate all the locations which they intersect, illuminating even the shadows and tingeing all the dark places which are behind the clouds. This darkness is apparent in the intervals between these solar rays.[431]

109. Solar rays penetrating clouds, based on Urb 143v.

Clouds sometimes display their reception of solar rays as if they were themselves illumated in the manner of dense mountains, and at other times they remain very dark without any variation in darkness in any of their parts. And this arises from the shadows which are made by other clouds, interposed between the sun and these darkened clouds, which cut out the solar rays.[432]

DISTANCES, ATMOSPHERE AND SMOKE

How the same area of countryside may sometimes be shown as larger or smaller than it is

Sometimes areas of countryside show themselves as larger or smaller than they are, because of interposed air which is thicker or thinner than is normal and which intervenes between the horizon and the eye which sees it. Amongst the horizons of equal distance from the eye, that will show itself as most distant that is seen through the thickest air and that will show itself nearest that is seen through the thinnest air.

The same thing seen at equal distances will appear larger or smaller according to the extent that the air interposed between the eye and the object is thicker or thinner.

And if the object is seen at a length of a hundred miles through air that is uniform and thin, and then the same object is seen at this same length of a hundred miles and the air is uniform and thick – with a thickness four times that of the former air – without doubt the same thing ... will appear four times larger than in the thinner air.

Unequal objects seen at equal distances will appear equal if the thickness of the air interposed between the eye and these objects is unequal, that is to say, with thick air interposed between the smaller object, and this is proved by means of the perspective of colours.[433]

On the lower contours of distant objects

The lower contours of distant objects will be less discernible than their upper contours, and this occurs especially with mountains and hills, the summits of which have as their background the sides of other mountains which are behind them. And in these, the upper contours are seen more readily than their bases, because the upper contour is darker on account of its being less covered by the thick air which is low-lying, and which indeed obscures the aforesaid contours of the

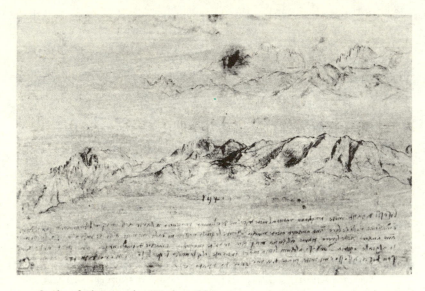

110. Study of Alpine peaks, Windsor, RL 12414.
'the lower contours of distant objects will be less discernible than their upper boun-
daries, and this occurs especially with mountains and hills'

bases of the hills. And the same happens with trees and buildings and
other things which rise into the air. And from this it arises that high
towers seen at a long distance often appear thick at the top and thin
at their bases, because the upper parts display the angular junctions by
which the sides abut the front face, because the thin air does not con-
ceal them from you like the thick ... This happens ... [because] where
the thick air is interposed between the eye and the sun it is more
luminous lower down than higher up, and where the air is whiter it
conceals darker objects from the eye more than if this air were blue.
This is seen in the battlements of fortresses at a long distance. If the
space between each battlement is equal to the width of each battle-
ment, the space appears somewhat larger than the battlement, and at
a greater distance the space occupies and covers all the battlement, and
such a fortress only shows a straight wall, without battlements.[434]

[On smoke and dust]

Smoke seen between the sun and the eye will be lighter and brighter
than any other part of the landscape in which it arises, and the same

applies with dust and mists which will, however, appear dark to you if you are between the sun and them.[435]

Smoke is more transparent and darker towards the edges of its con-vexities than towards their centre...

Clouds of smoke do not make clearly bounded shadows, and their boundaries are so much less definite to the extent that they are more distant from their source, and things placed behind them are so much less evident to the extent that the curls of smoke are denser, and they are so much whiter to the extent that they are closer to their origin and bluer towards their end. And the fire appears so much darker to the extent that a greater quantity of smoke is interposed between the eye and this fire. Where the fire is more distant, things are less con-cealed by it.

Make a landscape with smoke in the manner of a thick mist, so that clouds of smoke are seen in various locations, with the flames at their sources illuminating the more dense convexities of these clouds. And the highest parts of the mountains will be more evident than their bases, as is to be seen with mists...

Smoke moves with greater slant to the extent that the wind that moves it is more powerful.

There are smokes of as many varied colours as there are varieties of things which generate them.[436] That smoke will appear most blue that arises from the driest wood and that is closest to its cause, and that is seen against the darkest background, and has the light of the sun upon it.[437]

Clouds of smoke are seen better and more readily in areas towards the east than towards the west, when the sun is in the east. And this arises from two causes: the first is that the sun shines with its rays on the particles of this smoke and brightens them and makes them evi-dent; the second is that the roofs of houses seen in the east are shadowy at this time, because their inclined surface cannot be illuminated by the sun. And the same happens with dust, and [the cloud of] one is so much more luminous than the other to the extent that it is more dense.[438]

When the sun is situated in the east the smoke from the city will not be seen towards the west, because it is not seen to be penetrated by the solar rays, nor is it seen against a dark background, because the roofs of the houses display to the eye that same side which is exposed to the sun, and against this bright background, such smoke can barely be seen. But dust under similar circumstances is shown as darker than smoke, for the reason that it is of denser material than smoke, which is of vaporous material.[439]

We may also see the difference between the atoms of dust and the atoms of smoke as visible in the solar rays as they pass through the small apertures of the walls into dark rooms, in that one ray appears

the colour of ashes and the other, in the thin smoke, appears a most beautiful blue.[440]

The dust which is raised through the running of some animal is brighter to the extent that it is raised up higher, and correspondingly darker to the extent that it rises less, when it is located between the sun and the eye.[441]

[On rain and wind]

The rain falls through the air, darkening it with a livid tinge and taking up the light of the sun on one of its sides and shadow in the opposite part, as is to be seen in mists. And the earth is darkened by this rain which takes away the radiance of the sun, and the objects seen behind the rain have blurred and unintelligible boundaries, and the objects which are closer to the eye will be more discernible. And things seen in shadowy rain will be more discernible than those in illuminated rain, and this occurs because the objects seen in shadowy rain only lose their principal lights, but the objects which are seen in the luminous rains lose their light and shadows because the luminous parts are mingled with the illuminated air and the shadowy parts are made bright again by the same brightness of the said air which is illuminated.[442]

The colours in the middle of the rainbow are mingled together. The bow in itself is not in the rain nor yet in the eye which sees it, although it is generated from the rain, from the sun and from the eye. The celestial bow is only to be seen when our eyes are interposed between the rain and the body of the sun. Hence, when the sun is situated in the east and the rain in the west, this rainbow will be generated in the rain to the west.[443] When the sun is lower the rainbow has a larger circle, and when it is higher it will happen in the opposite way.[444]

In the depiction of wind, in addition to bending branches and turning back their leaves in the opposite direction to the wind, there should be represented the formation of clouds by the fine dust which is mingled with the murky air.[445] If you are on the side from which the wind blows, you will see the trees looking much lighter than you would see them from the other side. And this occurs because the wind reveals the reverse sides of the leaves, which are all much paler than their right sides, and above all they will be very light if the wind blows from the quarter where the sun is located, towards which you have turned your back.[446]

WATER

The surfaces of rivers are of three colours; that is to say light, medium and dark. The light is generated by the foam; the medium is when the air is reflected; the dark is in the shadows of the waves, and this darkness takes on a green colour. The light part, that is to say the foam, which is submerged by the impetus of its falling, makes the water appear more green above it on account of its whiteness which serves the purpose that the foil does for the jewels... If the water in its lit portions partakes of the blue of the air, and the shadows partake of green, the blue will be somewhat dark... Wet pebbles and sand are darker than the dry. Water in spate is darker, and in the calm places it is of the colour of the air.[447]

When water, by reason of its transparency, lets its bed be seen, the bed will be shown so much more readily to the extent that the water is in slower motion, and this occurs because waters which are in slow motion have surfaces without waves, whereby through their planar surfaces it is possible to see the true shapes of the pebbles and sand located on the bed of these waters. And this cannot occur with water in rapid motion, on account of the waves generated on the surface. The images of the various shapes of the pebbles, having to pass through these waves, cannot be brought to the eye through the various slopes of the sides and fronts of the waves. And their curves and their peaks and troughs transmit the images outside the direct lines of our sight, and twist the

III. Pebbles seen through waves, based on Urb 160r.

straight lines of the images from the pebbles in diverse directions. Their shapes are shown to us confusedly, and this is shown by undulating mirrors, that is to say, mirrors in which flatness, convexity and concavity are combined.[448]

On images reflected in water

Painters often deceive themselves by making the things they wish to be visible [by reflection] on water the same as those seen [directly] by men. But on water the object is seen from one aspect and the man sees it from another, and on many occasions it occurs that the painter sees something from below [when reflected], and, accordingly, the same body is seen back to front and upside down, because the water shows the image of an object in one way and the eye sees it [directly] in another.[449]

Of things reflected in water that will be more similar in colour to the thing being reflected which is reflected in clearer water... Things reflected in disturbed water always take on the colour of that thing which makes this water cloudy.[450]

112. Angles of incidence and reflection on water, based on Urb 71r.

The only air that provides an image of itself on the surface of water is that reflected from the surface of the water to the eye by equal angles, that is to say, when the angle of incidence is equal to the angle of reflection.[451]

The shadows of bridges are never seen [lying directly] on top of their areas of water, if the water has not first lost its property of reflectiveness as a result of turbulence, and this is proved because clear water has a lustrous and polished surface and reflects the bridge in all places at which the eye and the bridge subtend equal angles, and it reflects the air under the bridge at the place where it is shaded by this bridge. This cannot occur with water that is stirred up because it is not reflective but is very receptive to the shadow, as would occur with a dusty road.[452]

113. Bridge seen in reflection, based on Urb 158v.

Of things reflected in running water, the image of that thing will be displayed as more extended and with more muddled contours that is impressed on water whose course is most rapid.[453]

Sea with waves does not have a universal colour, but he who sees it from dry land sees it dark in colour and it will be so much darker to the extent that it is closer to the horizon, [though] he will see there a certain brightness or lustre which moves slowly in the manner of white sheep in flocks. And he who sees the sea from the high seas sees it as blue. And this arises because from the land... you see the waves which reflect the darkness of the land, and from the high seas... you see in the waves the blue air reflected in such waves.[454]

On the foam of water

The foam of water shows itself to be of lesser whiteness the further down it is from the surface of the water, and this is proved [because]... the natural colour of something submerged will be the more transformed into the green colour of the water to the extent that the thing submerged has a greater quantity of water above it.[455]

On bright or dark images which are impressed on shaded or illuminated places located between the surface and bed of clear water

When the images of dark or luminous objects are impressed on the dark and illuminated portions of bodies located between the bed of the water and its surface, then those shaded portions of these bodies will be made darker that are covered by the shadowy images. The luminous portions act in the same way, but if luminous images are

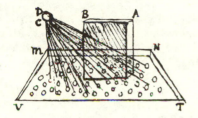

114. Pebbles seen under areas of water in illumination and shadow, based on Urb 139r.

impressed on the shaded and illuminated portions, then the il-luminated portions of the aforesaid bodies will be given greater brightness and their shadows will lose the greater part of their darkness, and these very bodies will show slighter relief than the bodies struck by shadowy images. And this occurs because, as has been said, the shadowy images augment the shadows of opaque bodies. Even though the shadowy images are exposed to the sun which penetrates the surface of the water, they remain with their shadows sharply differentiated from the lights on these bodies, and to the shadow is added the darkness of the shadowy image which is reflected in the surface ['skin'] of the water, and hence the shadow of these bodies is augmented, becoming darker. And although this shadowy image tinges the illuminated portions of such submerged bodies, these portions do not relinquish the brightness which they ac-quire from the impact of the solar rays. Although the brightness will be to some extent affected by this shadowy image, it is little impaired. This is because the shadowy image gives so much assistance to the shaded portions that the submerged bodies have considerably more relief than those affected by the luminous images. Whilst the luminous images add more brightness to the illuminated portions of the bodies, the altered shadows in these shaded portions are nevertheless of such brightness that these submerged bodies in such a situation show slight relief.

Let the pool *nmtu* have pebbles or plants or other opaque bodies on the bed of the clear water, which takes its light from the solar rays which come from the sun, *d*. And let one area of pebbles have over

it the shadowy image which is reflected in the surface of this water, and let one area of the pebbles have over it the image of the air *bcsm*. I say that the pebbles covered by the shadowy image will be more visible than the pebbles that are covered by the brightness of the light image, and the reason is that... the visual power of the eye is overwhelmed and impaired by the illuminated portion of the water in which the air the reflected, and, correspondingly, the visual power is amplified by the dark portion of this water, and in this instance the pupil of the eye does not possess a constant power, because on one hand it is impaired by too much light and on the other is amplified by the darkness.

Thus the effects described above only arise from causes that are remote from the water and the images, because it only arises with the eye★ which is impaired by the glare of the image of the air, and aided on the other hand by the dark image.[456]

HORIZONS

What is the true location of the horizon?

Horizons are at various distances from the eye, so that what is called the horizon, where the brightness of the air borders on the boundary of the earth, is to be seen in as many locations along the same perpendicular to the centre of the earth as there are heights of the eye which sees it, because the eye placed on the surface ['skin'] of the calm sea sees the horizon as close as half a mile or so, and if the man raises himself with his eye up to his full height, the horizon is seen seven miles from him, and thus for every degree of height the horizon becomes more distant from him. Hence it occurs that those who are at the summits of high mountains close to the sea see the arc of the horizon very distant from themselves, but those who are inland do not have a horizon at an equal distance, because the surface of the land is not equally distant from the centre of the earth. Hence it does not have perfect sphericity like the surface of the water, and this is the cause of such variations in the distances between the eye and the horizon.

But the horizon of the sphere of water will never be higher than the soles of the feet of the one who sees it, when he stands with the soles of his feet in contact with the point of contact which the edge of the sea makes with the edge of the land emerging from the water.

The horizon of the sky is very close on some occasions, and above all for someone who finds himself to the side of the summit of mountains, and he sees the horizon as commencing at the termination of this

summit. And turning himself towards the horizon of the sea, he sees
it as very distant.[457]

If the earth is spherical the horizon will never reach the height of
the eye, which will be higher than the surface of the earth. I say that

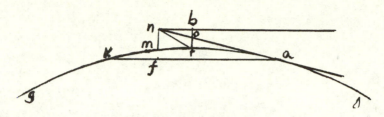

115. The horizon and the earth's curvature, based on Urb 285r.

if the height of the eye is *nm*, and if the line or rather plane of measure-
ment is *br*, and *a* is the horizon, and the line *grh* is the curvature of the
earth, the horizon, corresponding to the straight line *afk*, is then lower
than the feet of the man by the whole of *mf*, and lower in relation to
the curving of the earth by the whole of *bo*.[458]

116. A straight line in relation to
the earth's curvature, based on Urb
285r.

That thing is higher that is more distant from the centre of the earth.
Therefore a straight line lying on the level is not at an even height, and
as a consequence it is not [actually] on the level [with respect to the
earth]. Hence, if you talk of a line of equal height, it is to be
understood that it is none other than curved. If *a* and *b* are two men,
the horizon *n* will be level with their height.[459]

MOUNTAINS

Painting which shows the essential configuration of
the alpine mountains and hills

The shapes of the mountains called 'the chain of the world' are pro-
duced by the courses of the rivers that are born of rain, snow, hail and
ice, melted by the solar rays in the summer. This melting produces the
waters which join together in many small rivulets, running from
various directions into larger streams, growing in magnitude as they

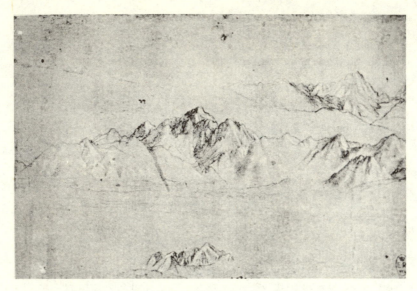

117. Study of peaks of mountains, Windsor, RL 12410.
'the shapes of the mountains called "the chain of the world" are produced by the courses of the rivers that are born of rain, snow, hail and ice'

acquire motion, until they converge on the great oceanic sea, always eroding one of the river banks and building up the other, as long as they go on seeking out the breadth of their valleys. And they do not rest content with this, and consume the bases of the flanking mountains. The mountains, collapsing into the rivers, close the valleys, and, as if wishing to be avenged, prohibit the course of such a river and convert it into a lake in which the slow-moving water appears to be subdued, until such time as the blockage caused by the collapsed mountain is in turn consumed by the course of the aforesaid water.

Thus we shall say that the water that runs most narrowly and the shortest distance least consumes the place through which it passes, and conversely it consumes more where it is widest and deepest. It follows from this that the highest peaks of the mountains have greater constancy of surface than their bases, because they are for most of the time coated with snow, and the rains strike them for a short time, and there are no rivers until such time as the few drops of rain left after their absorption by the arid summit begin to generate the most minute tributaries of the slowest motion, which are too weak to be muddied by any of the particles of earth they have dislodged from among the old roots of tiny plants. At the bases of the mountains, the furious course of the united waters, which is forever unsated by the amount

of earth being carried, removes the hills covered with plants, together with the largest rocks, rolling them over for a long distance, until it has reduced them to small pebbles and ultimately to fine sand...[460]

Because of what has been concluded above, it is necessary to concede that the bases of mountains and hills are continually receding, and, this being so, it cannot be denied that the valleys are being enlarged, and because the width of the river cannot then take up the increasing width of its valley, the river is continually changing its location, departing from its bed in that place where it has scoured out most matter. This matter rolls over and lifts away the pebbly clay, until such time as all the previously deposited matter has been carried away, and the river regains its ancient bed, from which it does not depart until a similar occurrence removes it from the aforesaid location. And thus with successive rains the river successively scours out matter and material from every valley.[461]

Painting and the representation of the characteristics and components of mountainous landscapes

Plants and trees will be paler to the extent that the soil which nourishes them is more sterile and deficient in moisture. Soil is more deficient and sterile on top of the rocks of which mountains are composed. And the trees will be smaller and thinner to the extent that they are formed near the summits of mountains, and the soil is so much more sterile to the extent that it is closer to the aforesaid summits, and the soil will be so much more abundant and fertile to the extent that it is more adjacent to the hollows of the valleys.

Therefore, painter, at the summits of mountains show the rocks of which it is composed, in great part exposed of earth, and the plants that have arisen there should be small and scanty and largely pale and dry through lack of moisture. And the sandy and barren earth will be seen showing through between the pale plants. And small shrubs, stunted and aged and diminutive in size, with short and repeated branches and few leaves, largely reveal their blighted and dried up roots interwoven among the layers and fissures of the weathered crags... And in many places crags are seen to overhang the hills of high mountains, covered by thin and pale debris, and in certain places displaying their true colours which are revealed as a result of the percussion of bolts of lightning from the sky, the course of which the crags, not without reprisals, have often impeded.

And to the extent that the trees descend towards the bases of the mountains they will be more vigorous and thickly branched and leaved, and their greenery is of as much variety as there are species of trees of which such woods are composed. The branching of these will

be in diverse arrangements, with differing densities of branches and leaves, and they will have differing shapes and heights. And some will have straight branchings like the cypress and suchlike; others have infrequent and expansive branchings like the oak and the chestnut and suchlike; others have very small leaves; others have slender leaves like the juniper and the oriental plane and suchlike. Some numbers of trees planted together will be separated by spaces of various sizes, and others will be united without the interruption of meadows or other spaces.[462]

TREES

[On the diverse growth of trees]

Some branches, or rather some trees, proceed in a completely natural way, and some are hindered by natural deficiencies and these become dried up either wholly or in part. And some fall short of their natural size through being cut off by men and some through breakages caused by lightning or by winds or other storms.

Trees which begin to grow close to the sea coasts and are exposed to winds are all bent over from the wind, and accordingly they grow up bent and remain so.[463]

The tree that grows with the most consistent breadth and to the greatest length will be that which grows in the lowest and narrowest valley, and in the thickest wood, and most distant from the edges of it.[464]

That tree will be most misshapen in its dimensions that grows on the highest site and in the thinnest wood and furthest from the middle of the wood.[465]

On the branchings of trees

First every branch of any plant that is not pulled down by its own weight curves upwards, raising its tip towards the sky.

Second: the twigs on the branches of trees that grow from underneath are bigger than those which sprout above.

Third: all the twigs which grow in the centre of a tree wither in a short time, on account of the excessive shade.

Fourth: those branchings of trees will be more vigorous and favoured that are closer to the upper and outer regions of these trees. This is caused by the air and the sun.

Fifth: the angles at which the branchings of trees divide are equal to each other.

Sixth: But these angles become more obtuse to the extent that their side branches grow old.

Seventh: the side of the angle will become more oblique which is made by a thinner branch.

Eighth: every bifurcation of branches, when added together, recomposes the thickness of the branch to which it is joined. We may say that *a* and *b*, added together, make *e*; *c* and *d*, added together, make *f*; *e* and *f*, added together, make the thickness of the first branch *op*, the thickness of which is equal to all the thicknesses, *a*, *b*, *c*, *d*. And this arises so that the sap of the thickest branch is divided in accordance with its branching.*

118. Bifurcating branches, based on Urb 243v.

Ninth: there are as many diversions to the main branches as there are points of origin of their branchings which are not directly opposite each other.

Tenth: the diversion to a branch will be more pronounced to the extent that the branches are of a thickness more nearly equal to each other. Look at the branch *ac* and similarly at *bc*; since they are equal to each other, that branch *acd* is more bent than that which is above, *noa*, which has less developed branches.

119. Branches of varied thickness, based on Urb 243v.

Eleventh: the attachment of the leaf always leaves a trace of itself under its branch, increasing together with this branch until the bark cracks and bursts forth on account of the age of the tree.[466]

The proportion of the trunk to the branchings produced in the same year in each tree is the same as that between the first stem and the succeeding ones for all the other years, past and future. That is to say, if in every year the branches which each tree has acquired when they have finished growing are counted up and added together in thickness, these are equal to the branch created the previous year and which has given rise to them. Thus they continue in succession, and the same will be discerned at all future times. Let us say that the branches *ad* and *bd* are the last on the tree. If they are added

120. Final branchings of a tree, based on Urb 245r.

together, they will be equal to the branch *dc* which has produced them.[467]

That part of a tree will appear to be and will be of greater age which is closest to its point of origin, as is shown by the wrinkling of the bark. This is seen in walnut trees, which frequently have the greater part of their bark drawn tight and shiny over the old and cracked bark. And thus they are as varying in youth or age as their main branchings.

121. Successive branchings of a tree, based on Urb 246r.

The age of trees which have not been damaged by men can be counted in their main branchings. This is indicated by the circles *a*, *b*, *c*, *d*, *e*, *f*. Wherever a branching is made, the one closest to the centre of the tree is the principal one. The trees possess in themselves as varied ages as there are principal branchings...

Furthermore, the rings in the branches of trees that have been cut off show the number of its years, and which were damper or drier according to the greater or lesser thickness of these rings. The rings also reveal the side of the world to which they were turned, because they will be larger to the north than to the south, and thus the centre [of each branch] of the tree is for this reason closer to the bark on the south than on the north. And although these facts do not serve painting, I will none the less write them down to leave out as few of the things I have noticed about trees as possible...

That tree which is getting older puts out smaller branches. That branch extends with the most constant thickness and is most straight which generates the smaller twigs around it.[468]

The basal parts* of trees do not retain the roundness of the trunk where they approach the origins of the branches or of their roots, and this occurs because such upper and lower branchings are the members through which the trees are nourished. That is to say, in the summer they are nourished from above with dew and rain through their leaves, and in the winter from below through the contact which the earth has with its roots.[469]

The margin whence the leaf issues from the branch always increases in the same proportion as the branch increases, and this is always apparent until old age cracks and splits open the bark of this branch.

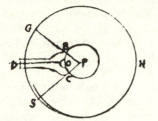

122. Diameters of branches in relation to the base of a leaf, based on Urb 244r.

Let *pbc* be the size of the said branch. *Bcd* will be the leaf which is attached to the branch across the whole of the space *boc*, which is a third of the breadth of the branch. O is the bud from which the tiny branch arises above the leaf. I say therefore that since a third part of the breadth of the branch surrounds the attachment of the leaf, when the branch *pbc* increases in the size to *hgs*, this attachment will still be a third part of a circle of such breadth, as is designated by *gs*.[470]

The thickness of any branch never diminishes along the interval between one leaf and another, except by the amount of the thickness of the bud which is above the leaf. This thickness is subtracted from the branch which proceeds as far as the next leaf.[471]

On the diversity which the branching of trees exhibit

There are three types of branching in trees. One of these is when the branches are placed on two opposite sides, one towards the east and the other towards the west and they are not directly opposite each other but are in the middle of the interval on the opposite side. Another places them two by two so that they are directly opposite each other, but if two of them are placed towards the east and west,

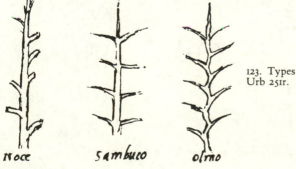

123. Types of branching, based on Urb 251r.

the other pair will be towards the south and north. The third type always has the sixth branch successively above the first.[472]

Nature has placed the leaves on the final branches of many trees so that the sixth leaf is always above the first, and thus it follows successively, unless the rule is impeded. This arrangement has two functions for these plants. The first is that, since the branch bears fruit in the following year from the twin vein of the bud which is above and in contact with the axil of the leaf, the water that bathes this branch is able to descend to nourish this twin vein by settling the drip in the hollow at the origin of this leaf. And the second benefit is that, since such branches arise in the following year, one does not cover the former, because the five [next] branches turn in five directions, and the sixth, which arises above the first, is far enough away.[473]

All those plants which put out branches in layers, one opposite the other and of equal thickness, will always be straight, like the fir *ab*. And this straightness arises because the opposite parts, being of equal

124. Branching system of a fir tree, based on Urb 251r.

thickness, draw in equal amounts of sap, or, rather, nourishment, and this makes branches of equal weight. From this it follows that, because from equal causes equal effects arise, the even straightness of this tree is maintained by this equality.[474]

When the trunk of a tree is divided into [three] or more principal

125. Division of a trunk into branches, based on Urb 245v.

branches at the same height, then the margins of the junctions bet-
ween such branches are higher to the extent that one is nearer the
centre of the tree than another. (At the meeting of these branches a
large hollow remains.) This happens when the angles that branches
make with each other are narrower than the angles between branches
that are further away from the centre of the tree trunk. Let us say
that the branches *a* and *b* are separated by a narrower angle, as are
b and *c*, than the branches *a* and *c*. Accordingly, since these branches
become thicker more quickly, they are more greatly amplified where
they join at *b* and *c*, and their junction is raised up higher than the
junction of *a* and *c*. And for this reason the junction towards the
middle of the tree remains lower.

This can be shown to occur by necessity. Let there be three circles,
n, *m*, *o*, which touch at points on the lines *nm* and *mo* and *on*, and
not in the middle. Since they cannot be attached together except
where they touch, they become attached therefore where they are in
contact and not in the middle, where they do not touch, and thus,
on becoming thickened, this point of attachment will be raised up as
is shown above by *yc*... The middle, which does not touch, remains
lower down and hollow.[475]

On the branchings of trees with their leaves

The branchings of some trees, like the elm, are wide and thin, in the
manner of an open hand seen in foreshortening. And these display
their disposition as follows: those below show their upper parts, and
those which are higher are displayed from below, and those in the
middle are displayed in part from below and in part from above, and
the upper part is shown towards the tip of the branch. And the sec-
tion of branches in the middle is more foreshortened than those of
any other sections which are turned with their points towards you.
And those sections in the middle of the height of the tree extend the
margins of these trees furthest outwards, and these branchings appear
similar to the leaves of the wild fern which grows in the clay of
rivers.

Other branchings make a round shape, like those of trees in which
the twigs and leaves are arranged so that the sixth is above the first,
and others are fine and transparent, such as the willow and other
similar trees.[476]

The cherry tree is of the nature of the fir in that its branchings are
made in layers around its trunk. And four or five or six branches
arise opposite each other, and the tips of the outer twigs compose a
pyramid from the middle upwards. And the walnut and the oak
compose a hemisphere from the middle upwards.[477]

126. Pyramidal branching of a cherry
tree, based on MS G 51r.

Hence, painter, you who do not know these laws, in order to escape
the censure of those who do understand them, may it please you to
portray all your subjects from nature, and do not despise study as do
those who aim [only] for monetary gain.[478]

[On colour and light in trees]

Trees in their rural settings are of various types of green, inasmuch as
some tend towards blackness, like firs, pines, cypresses, laurels, box
and other similar trees. Some tend towards yellow, like walnuts, pear,
vines and [those with] young greenery. Others tend towards darkish
yellow, like chestnuts and oaks. Others tend towards red with the ap-
proach of autumn, such as the sorbus [service tree], pomegranate, vine
and cherry. Others tend towards white, like willows, olives, reeds and
suchlike.[479]

In the composition of leafy trees care should be taken not to repeat
too many times the same colour in a tree which has as its background
another tree of the same colour, but vary it with greenery which is
brighter or darker or greener.[480]

On the effects [of light] on the branchings of trees

The four effects [of light] of the branchings of trees are these: namely
lustre, light, transparency and shadow. And if the eye is looking from
above at a branch, the illuminated portion is shown as of greater quan-
tity than the shaded part, and this occurs because the illuminated por-
tion is larger than the shaded portion inasmuch as it contains light, and
lustre and transparency. Transparency I shall leave aside at present,
and I will describe the appearance of the illuminated portion... It is
necessary to describe this second effect, which is of importance for the
representation of trees, even though it has not been employed by
anyone before me, as far as I am aware.[481]

On the universal light illuminating trees

That part of a tree will show itself as clothed in shadows of lesser darkness that is most distant from the ground. This is proved as follows: let *ab* be the tree; *nbc* will be the illuminated hemisphere [of the sky]. The lower part of the tree is exposed to the ground, *pc*. That is to say that the part *o* is exposed to a little of the hemisphere at *cd*,

127. Light on a tree, based on Urb 255v.

but the higher part in the hollow at *a* is exposed to the greater part of the hemisphere, namely *bc*. And inasmuch as it is not exposed to the darkness of the earth, it remains well illuminated. But if the tree is densely leafed, like the laurel, fir or box, then the rule varies, because, although *a* is not exposed to the earth, it is exposed to the darkness of the leaves, which are intersected by many shadows. This darkness rebounds upwards to the reverse sides of the superimposed leaves. And such trees have shadows of greater darkness to the extent that they are closer to the centre of the tree.[482]

On the variety of shadows in trees in the same light and in the same landscape under a specific light

When the sun is in the east, the trees to the east of you have large shadows, and those to the south medium shadows and those to the east will be wholly illuminated. But these three aspects are not enough, because it is better to say that the whole of the tree to the east will be in shadow, and that which is towards the south-east will be three-quarters in shadow, and the shadow of the southerly tree covers half of the tree, and a quarter of the tree to the south-west will be in shadow, and the easterly tree does not show any shadow.[483]

On the tips of branches of leafy trees

The first shadows which the first leaves make on the second leafy branches are less dark than those made by these second leaves on the third leaves, and accordingly these shadows cause the third leaves to overshadow the fourth, and from this it arises that the illuminated

128. The illumination of leaves
seen in a tree, based on Urb 253v.

leaves which have as their background the third and fourth leaves
show themselves as of greater relief than those that have as their
background the first shaded leaf. If the sun is *e* and the first leaf il-
luminated by this sun is *a*, which has as its background the second leaf,
b – taking the eye as *n* – I say that this leaf stands out less clearly, hav-
ing as its background the second leaf, than if it were to project further
and have as its background the leaf *c*, which is darker through having
more leaves interposed between it and the sun, and it would stand out
further if it had as its background the fourth leaf, namely *d*.[484]

On the lustre of the leaves of trees

The leaves of trees commonly have a shiny surface, on account of
which they partly reflect the colour of the air. This air takes on a white
colour, through being mixed with fine and transparent clouds. The
surfaces of the leaves, when they are of a dark nature, like those of the
elm, and when they are not dusty, give off lustres of a colour which
takes on a blue tinge. And this occurs... [according to the rule that]
brightness mixed with darkness composes blue. And these leaves will
have lustres that are so much bluer to the extent that the air which is
reflected in them is more purified and blue. But if such leaves are
young, as at the tips of branches in the month of May, then these will
be of a green colour which takes on a yellow hue, and if their lustres
are produced by the blue air which is reflected in them, their lustres
will be green... [according to the rule that] the colour yellow mixed
with blue always produces the colour green.

The lustres of all leaves with dense surfaces will take on the colour
of the air, and the darker the leaves the more they will act in the man-
ner of a mirror, and as a consequence these lustres take on more
blue.[485]

On the shadow of the leaf

A leaf with a concave surface seen in reverse from below sometimes
appears half shaded and half transparent. For example let *po* be the

the leaf and the light *m* and the eye *n*. The eye sees *o* as shaded, because the light does not strike the leaf at equal angles [i.e., perpendicularly] either on its upper or reverse surfaces. *P* is the light [portion] which shines through to the reverse.[486]

129. Shadow, lustre and transparency in a leaf, based on Urb 260v.

[On transparent leaves]

When trees are seen against the sun, on account of the transparency of the leaves, those towards the edges of the trees will show themselves as being of a more beautiful green than they originally were. Towards the centre, the tree will appear strongly darkened. Those leaves [towards the centre] will not be transparent and will be the ones to display their upper surfaces and will acquire very pronounced lustres.[487]

When leaves are interposed between the light and the eye, then the one closest to the eye will be darkest and the most distant will be brightest, providing they are not seen against the background of the air. This happens with leaves which are away from the centre of the tree; that is to say, facing the light.[488]

130. Transparency and shadow in leaves, based on Urb 260v.

TREES SEEN IN LANDSCAPES

[On trees in wind]

Trees and meadows appear much brighter when viewed along the path of the wind rather than towards its place of origin, and this comes about because each leaf is paler on its reverse side than on its upper, and someone who looks straight down the path of the wind sees each leaf reversed...

The whole of a tree will be most bent by the percussion of the wind

that has the thinnest and longest branches, such as willows and the like.

If the eye is between the point of origin of the wind and the point to which it goes, the trees will exhibit denser branching on the side facing the origin of the wind than on the side facing its destination, and this comes about because the wind strikes the tips of the branches facing it, pressing them against other stronger branches. Hence they will become compacted and of little transparency. But the branches opposite, which are struck by the wind which penetrates through the apertures within the tree, are thrust away from the centre of the tree and spread themselves out.

Amongst trees of equal thickness and height, that will be more bent over by the wind that has the tips of its lateral branches least distant from the centre of the tree, and this arises because the branches [at the lesser distance] cannot shield the centre of the tree from the advent or percussion of the wind.

Those trees are more bent by the course of the wind that are taller. Trees that are more densely leaved will be more bent by the percussion of the wind.

In great forests and in the cornfields and meadows, the waves may be seen that are made by the wind and they look just like those which are seen in the sea or oceans.[489]

Branching of trees at various distances

The trees at the first distance send their true shapes to the eye, and the lights, lustres, shadows and transparencies of each cluster of leaves arising from the terminal twigs of the trees are readily apparent. At the second distance... the cluster of leaves, placed like dots on the aforesaid twigs, is apparent. At the third distance the clusters of the aforesaid twigs appear like dots scattered amongst the larger branchings. At the fourth distance the aforesaid larger branchings are left so diminished that they only remain as dots of confused shape within the whole tree. Next follows the horizon, which is the fifth and last distance, at which the tree is wholly diminished in such a way that its shape remains as a dot.[490]

On the gaps within trees

The gaps made by air within the bodies of trees and the gaps made by trees within the air will not be shown to the eye over a long distance, because where the whole is perceived with effort, the parts are distinguished with difficulty. Rather, a confused mixture is made,

131. A coppice of trees, Windsor, RL 12431r.

132. Study of light on a tree (Robinia), Windsor, RL 12431v.
'the gaps made by air within the bodies of trees ... will not be shown to the eye over a long distance'

which mostly takes on [the appearance of] the part having the greater bulk. The gaps within trees are made by particles of illuminated air, which are considerably smaller [in volume] than the tree, and perception of the gaps is therefore lost before the perception of the tree itself. But this does not mean that the interstices cease to exist. Hence, of necessity, there is made a mixture of air and darkness within the shadowy tree, which run together into the eye which sees them.[491]

Why the same trees appear brighter close to than far away

Trees of the same species show themselves as being brighter nearby than far away, for three reasons: the first is that the shadows show themselves to be darker nearby, and on account of such darkness the illuminated branches which border on them look brighter than they are; the second is that on taking the eye further away, the air which is interposed between this shadow and the eye, having a greater thickness than it used to possess, brightens this shadiness and gives it a colour which takes on a blue hue, on which account the illuminated branches are not shown with as definite a contrast as previously, and they come to seem darker. The third reason is that the images of lightness and darkness which such branchings send to the eye have their boundaries mingled together and become confounded. Because the shadowy parts are always of greater quantity than the luminous parts, these shadows are more readily recognisable at a long distance than the lesser amounts of brightness. And for these three reasons trees show themselves as darker at a distance than nearby.[492]

On distances more remote than those described above

But when the trees are at a greater distance, then the whole of the shadowed and illuminated parts are muddled together by the interposed air and by their diminution in size, so that they appear to be completely of the same colour, that is to say blue.[493]

The blue which trees acquire in distant places is produced more in the shaded portions than in the illuminated ones, and this arises from the light of the air interposed between the eye and the shadow, which is tinted with the colour of the sky. And the illuminated parts of trees are the last to lose their greenness.[494]

On viewing trees

Between the trees which grow along the embankments of roads, make the shadows of the sun entirely discontinuous, resembling the clusters of boughs from which they derive.

Landscapes are bright at their beginning, because between the tips of the trees you see meadows and other spaces and intervals between other trees, but when you begin over a distance to lose these intervals, you see only the branchings of the trees, which, although they are of the same colour as the meadows, acquire more shade towards the centre of the tree through the compaction and diminution of the trees [by perspective], which does not happen with the meadow. For this reason there arises such darkness, which you can none the less over a distance brighten and transform into the colour of the horizon.[495]

On the sun which illuminates the forest

When the sun illuminates the forest, the trees in the wood will be displayed with defined shadows and lights, and for this reason appear to be closer to you, because they are rendered clearer in shape. And that part of them which is not exposed to the sun appears uniformly dark, except for the thin parts which are interposed between the sun and yourself. These thin parts will be rendered bright on account of their transparency. And it happens that that the light on trees which are illuminated by the sun is of lesser breadth than on those illuminated by the sky, because the sky is larger than the sun, and the larger cause makes a larger effect in this case.

By making the shadows of trees smaller, the trees will be taken to be thinner, and particularly when they are of the same colour. Trees which by nature have thin branches and sparse leaves, like the peach and plum and suchlike, appear to be diminished because [the mass of] their shadow is drawn back into the middle of the tree, and the branches which remain completely outside the shadow appear to form a single colour with the background.[496]

When clouds are interposed between the sun and the countryside, the greenery of woods is shown with shadows of little darkness and the difference between the shadows and the lights will show little variation in darkness and brightness. Because the trees are illuminated by the great quantity of light from the hemisphere of the sky, the shadows are chased away and take refuge towards the centre of the trees and towards that part of them which faces the earth.[497]

Part V:

THE PAINTER'S PRACTICE

The first picture was merely a line, drawn round the shadow of a man cast by the sun upon a wall.*[498]

Benign nature so provides that throughout the world you will find something to imitate.[499]

How painting falls into decline and deteriorates through the ages when painters have no other authority than existing works

The painter will produce pictures of little excellence if he takes other painters as his authority, but if he learns from natural things he will bear good fruit. We saw this in the painters who came after the Romans. They always imitated each other and their art went ever into decline from one age to the next. After these came Giotto the Florentine who was not content to copy the works of his master Cimabue. Born in the lonely mountains inhabited only by goats and other beasts, and being inclined by nature to such art he began to copy upon the stones the movements of the goats whose keeper he was. And thus he began to copy all the animals to be found in the countryside in such a way that after much study he surpassed not only the masters of his age but all those of many centuries before. After this, art fell back into decline, because everyone copied the pictures that had already been done, and thus from century to century the decline continued until Tomaso the Florentine, nicknamed Masaccio, showed to perfection in his work how those who take as their authority any other than nature, mistress of the masters, labour in vain.*

And likewise I would say in regard to those mathematical studies that those who only study the authorities and not the works of nature are grandchildren of art and not children of nature, mistress of the good authorities. O, the arch stupidity of those that reprove men who study from nature, leaving aside the authorities who were followers of nature.[500]

On imitating [other] painters

I say to painters that no one should ever imitate the style of another because he will be called a nephew and not a child of nature with regard to art. Because things in nature exist in such abundance, we

need and we ought rather to have recourse to nature than to those masters who have learned from her. And I say this not for those who wish to become wealthy through art but for those who by this art seek honour and renown.[501]

ETHICS FOR THE PAINTER

On the practitioner of painting and his precepts

I remind you, O painter, that whenever you, in your own judgement, or in the opinion of another, discover some error in your works, you should correct it so that when you do show the work you do not also display the error. And do not make excuses to yourself persuading yourself that you will be able to rebuild your reputation with your next work, because painting does not die in the act of its creation as does music, but will for a long time bear witness to your lack of knowledge. If you argue that in making corrections time is going to waste which, if directed towards another work, would greatly increase what you could earn, you should learn that money earned in excess of our daily requirements is not worth much, and if you desire an abundance of wealth you will end up not using it. It does not belong to you in just the same way that all treasure not put to use belongs to us all and whatever you earn that you do not need during your life is in the hands of others regardless of your intent.

But if you will study and perfect your works in line with the theory of the two kinds of perspective* you will leave behind works which will bestow upon you more honour than money would do, because money is celebrated only for its own sake and not for that of he who possesses it, who is like a magnet for envy. He is a target for thieves and he loses his reputation as a wealthy man along with his life, and the fame of the treasure and not the treasurer remains. The glory of the virtue of mortals is far greater than that of their treasures. How many emperors, how many princes have there been of whom no memory remains, yet they strove only after territory and wealth to secure their reputations? How many have there been who lived in material poverty in order to enrich their lives with virtue? The poor man has been as much more successful than the rich in this goal, as virtue surpasses wealth. Do you not see that treasure in itself does not heap praise on its accumulator after his life is spent, as does knowledge, which continues to provide testimony and a memorial to its creator because it is the daughter of whoever engendered it and not a stepdaughter like money. If you say that by means of such treasure

you could better satisfy your yearning for gluttony and excess, and that you could not do this through virtue, consider others who have satisfied only the filthy desires of the body like other base animals – where is their renown? If your excuse is that the struggle against poverty has left you no time to study and truly ennoble yourself, blame no one but yourself, because it is the study of virtue that is food for both body and soul. How many philosophers have there been who have been rich but who have given their fortune away so as not to be corrupted by it? If your excuse is that you have children to feed, a little will suffice for them: see to it that their sustenance be the virtues, which are the true riches, for they never leave us, departing only with life itself. If you say you wish first to accumulate some capital wealth as an endowment for your old age [I say] the pursuit of virtue will never let you down nor let you grow senile and the haven of the virtues will be filled with dreams and vain hopes.[502]

On those who censure whoever draws on feast-days and investigates the works of God

There is among the number of fools a certain sect, called hypocrites, who constantly strive to deceive themselves and others but more the others than themselves. In truth, they deceive themselves more than the others. These people reprove painters who on feast-days study things which relate to a true understanding of all the forms found in the works of nature and who solicitously contrive to acquire an understanding of these things to the best of their ability. But let such repressers be silent for this is the way to understand the maker* of so many wonderful things and the way to love so great an inventor, for in truth great love is born of thorough knowledge of the beloved and if you do not know it, you can love it little, if at all. If you love knowledge for the returns you expect of it, and not for its great virtue, you are like the dog who wags its tail and makes a fuss and jumps up on whoever might give it a bone. But if it could understand the man's goodness it would love him even more – if the concept of such goodness were within his understanding.[503]

Discourse* upon practice

Endeavour, painter, to make sure your works draw spectators to stop in admiration and delight, and do not attract them only to drive them away again, as the air does to someone who during the night leaps naked from bed to ascertain whether the nature of such air is either cloudy or clear. Immediately repelled by the chill, he returns to the bed

whence he rose. Rather make your work resemble the air which in hot weather draws men from their beds and detains them pleasurably as they partake of the coolness of a summer's night. Do not expect to be skilled before you are learned, lest avarice overcome the glory which is deservedly to be acquired from such art.

Do you not see that among the beauties of mankind it is a very beautiful face which arrests passers-by and not their rich adornments? And I say to you as you adorn your figures with costly gold and other expensive decorations, do you not see the resplendent beauty of youth lose its excellence through excessive devotion to ornament? Have you not seen the women who dwell among the mountains wrapped in their poor rude draperies acquiring greater beauty than women who are decked in ornament?[504]

On the miserable excuse made by those who falsely and undeservedly call themselves painters

There is a certain breed of painter who, having studied little, must spend their working lives in thrall to the beauty of gold and azure.* With consummate stupidity they argue against executing good work for meagre recompense, although they say they would be as able to produce it as another, were they to be well paid. But consider, foolish people, do such as these not realise that they should keep aside some good work saying, this is worth a good price, this is medium-priced and this is run-of-the-mill, thus showing they have works in all price ranges.[505]

JUDGING WORKS

There is nothing that deceives us more than our own judgement* when used to give an opinion on our own works. It is sound in judging the work of our enemies but not that of our friends, for hate and love are two of the most powerfully motivating factors found among living things. Thus, O painter, be eager to hear no less willingly what your enemies say about your work than what your friends say. Hate is more powerful than love for hate ruins and destroys love. If he is a true friend he is like another self to you and you find the opposite of this in an enemy. A friend could be deceived. There is a third kind of judgement, which is moved by jealousy and gives rise to flattery, praising the early stage of a good work so that the lie may blind the painter.[506]

On the painter's judgement of his own work and that of others

When the work stands equal to one's judgement of it, it is a bad sign for the judgement. When the work surpasses one's judgement that is worse, as happens to someone who is astonished at having produced such good work, and when the judgement disdains the work this is a perfect sign. If someone with such an attitude is young, without doubt he will become an excellent painter, but will produce few works, although these will be of such a quality that men will stop in admiration to contemplate their perfection.[507]

ADVICE FOR THE YOUNG PAINTER

He is a poor pupil who does not surpass his master.[508]

There are many men who have a yearning desire to be able to draw, but are temperamentally unsuited to it, as may be seen from those boys who, lacking diligence, never finish their copies* with shading.[509]

A youth should first learn perspective, then the proportions of all things. Next he should learn from the hand of a good master, to gain familiarity with fine limbs,*[510] ... then from work done in three dimensions* along with the drawing done from it, then from a good example from nature, and this you must put into practice.[511]

We plainly know that sight is one of the swiftest actions that there is, and that in one moment it takes in an infinite number of forms. Nevertheless it can only comprehend one thing at a time. Let us suppose that you, reader, were to glance over the whole of this written page: you would instantly judge it to be full of various letters but you would not in that time recognise what the letters were, nor what they might mean. And so you have to proceed word by word, and line by line if you wish to gather information from these letters. Again if you wish to climb to the top of a building you will have to go up step by step, otherwise it will be impossible to arrive at the top. So I say to you, whom nature inclines to this art, that if you wish to have a true knowledge of the forms of objects you should commence with their details, and not pass on to the second stage until you already have the first committed to memory and well practised. And if you do otherwise you will be throwing away your time, or, truly, prolonging your study considerably. Remember, learn diligence before speedy execution.[512]

... Once this knowledge is acquired you should move on to study the actions [of figures] in accordance with the events with which man is engaged and thirdly to compose figure compositions, for which the preparatory study should be based upon natural actions individually as and when they might occur. And one should be on the lookout for these in the streets and the city squares and in the country, and note them down, broadly indicating the outlines; that is, for a head one should make an 0, for an arm a straight or bent line, and the same would be done for the legs and the trunk and then on return home work up these notes into a complete form.

The adversary says that to gain practice and produce a quantity of work it is better to devote the initial study period to drawing various compositions that have been done either on paper or on walls by various masters, and that, in doing this, practice is speedily acquired together with good habits.

To this I reply that the habits would be good if based upon the well-composed works of studious masters. But since such masters as these are so rare as to be seldom found, it is safer to go to the objects in nature than to those imitated to much worse effect from nature and accordingly thus to acquire bad habits. He who can go to the fountain does not go to the vessel.[513]

How a young man should proceed in his study

The mind of the painter ought to be continuously tuned to as many analyses as there are shapes of noteworthy objects appearing in front of him. At these he should stop and make notes, and upon these found rules, taking into consideration the place, the surroundings and the lights and shadows.[514]

Draughtsman, if you wish to study well and profitably, accustom yourself in your drawing to work slowly and use your judgement as to which lights have the highest degree of brightness, and similarly, among the shadows, which are the ones that are darker than the others and in what way they merge, and compare the extent of one with the other. With regard to the outlines, consider which way they tend, and as for the lines, how great a part of each twists to one side or another and where they are more or less visible and thereby thick or fine, and finally, that your light and shade are blended in the manner of smoke without strokes or marks. And when you have exercised both your hand and your judgement with this degree of care, the skill will be yours so soon that you will be unaware of it.[515]

How to learn figure composition in narrative⋆ paintings

When you have been well-schooled in [linear] perspective and have committed to memory all the parts and forms of things, let it please you often when you are out walking to observe and contemplate the positions and actions of men in talking, quarrelling, laughing and fighting together – what actions there might be among them, among the bystanders, those who intervene or look on.

Record these with rapid notations† in this manner in a little notebook which you should always carry with you. It should be of tinted paper‡ so that you cannot make erasures, but you must renew it when it is used up. For these things should not be erased but rather kept with great care, because so great is the infinity of shapes and attitudes of things that the memory is incapable of retaining them all.

133. Method of sketching briefly in a little notebook, based on MS BN 2038 27v.

Therefore keep them as your points of reference and masters.[516]

The long winter evenings should be utilised by young students in studying the things prepared during the summer. For example, it would be useful to bring together all the drawings from the nude which you did in the summer, and select from among them the best limbs⋆ and bodies, and practise them and commit them to memory . . . Then the following summer select someone who is finely built from the waist up and who has not been brought up wearing doublets† and whose body consequently has not lost its natural bearing, and make him perform light and graceful movements. It does not matter at all if this does not show the muscles well within the contours of a limb, for it is enough for you only to exploit this figure for its fine poses, and you can correct the limbs using those you studied during the winter.[517]

Acquire in your youth that which will repair the damage of your old age. If you understand that old age feeds on wisdom, then take pains in your youth to ensure that it shall not lack nourishment.[518]

On variety in figures

The painter ought to strive to be universal because there is great lack of worthiness in doing one thing well and another badly, as do many who study from the nude of canonical proportions and do not seek after its variety, because a man can still be in proportion and be short and fat or tall and thin or medium, and whoever does not take account of such variety will cast his figures in one mould so that they will all appear to be brothers and this practice deserves great censure.[519]

How to study

First study science, then follow the practice born of that science.[520]

CRITERIA AND JUDGEMENTS

Discourse on the precepts of the painter

I have universally observed among all those who make a profession of portraying faces from life, that he who paints the best likeness is the worst of all composers of narrative painting. This arises because it is clear to a man who does one thing better than another that nature has more inclined him to that than to something else, and on this account he has more love for it and his greater love has made him more diligent. All the love which is concentrated on one part is missing from the rest. Having focused all his delight on that one thing, he has abandoned the universal for the particular. Since the talent's efficacy has been reduced in scope, it cannot be expansive. Such a talent is like a concave mirror which picks up a number of the sun's rays. When these are spread out on being reflected they have less heat, but when the mirror reflects them all into a smaller space then these rays are of immense heat but concentrated into a small space. Those painters are similar who do not love any part of the painting other than the human face. It is even worse that they do not recognise any other area of art which they can esteem, and on which they can exercise judgement. The things they paint are motionless for they themselves are lazy and given to little movement. They censure things that have greater and quicker movement than those done by themselves, saying that they look possessed, and are like the masters of a Moorish dance. It is true that decorum should be observed, that is, movements should announce the motion of the mind of the one who is moving. Accordingly, if the painter has to represent someone who must show fearful reverence, the figure should not be done with such audacity and presumption that the effect seems to be despair, or the uttering of a command. In this vein I saw one day recently an angel who looked, in his act of Annunciation, as if he would chase Our Lady from her room with movements which displayed as much offensiveness as you might show to your vilest enemy. Our Lady looked as if she would, in desperation, throw herself from a window. Therefore remember not to fall into such errors.

On this subject I will make apologies to no man, even if he does not accept what I am saying to him, because each one who has this

approach is doomed; but imagines he is doing well. This you will recognise in those who have adopted a way of working without ever looking to the works of nature for advice. They are only bent on a plentiful output and for one *soldo*★ more a day would sooner sew shoes than paint. But I will speak at no further length about these because I do not admit them to this art, daughter of nature. To speak of painters and their judgements, I say that to whoever gives too much movement to his figures it seems as if another who moves them just as much as is necessary makes figures who are asleep; to whoever moves them little, it seems as if one who moves them correctly, as required, has made them look as if they are possessed. Because of this the painter ought to consider the behaviour of men who are debating either coldly or in a heated manner, and should listen to the subject under discussion and see whether the actions are appropriate to the subjects.[521]

How a painter is not worthy of praise unless he is universal

Of some it may plainly be said that they deceive themselves when they call that painter a good master who can do only a head or a figure well. Certainly it is no great accomplishment if, having studied one sole thing for the whole of your life, you bring it to a degree of perfection. But since we know that painting embraces and contains within itself all things produced by nature or whatever results from man's passing actions – and ultimately everything that can be taken in by the eyes – he seems to me to be a pitiful master who can only do one thing well. For do you not see how many and various are the actions that belong just to men? Do you not see how many different animals and trees, too, and grasses and flowers there are, the diversity of mountainous regions and plains, fountains, rivers, cities, public and private buildings, machines designed to benefit mankind, various costumes, decorations and arts? All these things have a claim to be of equal use and value to him whom you would call a good painter.[522]

He is not universal who does not love equally all the elements in painting, as when one who does not like landscapes holds them to be a subject for cursory and straightforward investigation – just as our Botticelli said such study was of no use because by merely throwing a sponge soaked in a variety of colours at a wall there would be left on the wall a stain in which could be seen a beautiful landscape. He was indeed right that in such a stain various inventions are to be seen. I say that a man may seek out in such a stain heads of men, various animals, battles, rocks, seas, clouds, woods and other similar things. It is like the sound of bells which can mean whatever you want it to.

But although these stains may supply inventions they do not teach you how to finish any detail. And the painter in question makes very sorry landscapes.[523]

Therefore painter, you should know that you cannot be good if you are not a master universal enough to imitate with your art every kind of natural form, which you will not know how to do unless you observe them and retain them in your mind. Hence, as you go through the countryside see that you exercise your judgement upon various objects and in turn look now at this thing and now at that, making a compound of different kinds of things chosen and selected from among those of less value. Do not do as other painters who when tired of using their imagination,* leave off their works and take exercise by going for a walk, and yet retain such weariness of mind that, let alone seeing or taking in various objects, very often on meeting friends or relatives and being greeted by them, far from seeing and hearing them, these people are no more recognised than if the painter had met thin air.[524]

The painter ought to keep his own company and reflect upon that which he sees. He should debate with himself and choose the most excellent parts of the kinds of things he sees. He should be like a mirror which is transformed into as many colours as are placed before it, and, doing this, he will seem to be a second nature.[525]

How the mirror is the master of painters

When you wish to see whether your whole picture accords with what you have portrayed from nature take a mirror and reflect the actual object in it. Compare what is reflected with your painting and carefully consider whether both likenesses of the subject correspond, particularly in regard to the mirror. You should take the mirror as your master, that is a flat mirror, because on its surface things in many ways bear a resemblance to a painting. That is to say, you see a picture which is painted on a flat surface showing things as if in relief: the mirror on a flat surface does the same. The picture has but one surface and the mirror the same. The picture is intangible inasmuch as something which appears round and detached cannot be braced by the hands, and the mirror does the same. And if you recognise that the mirror by means of outlines and shades and lights makes things appear to stand out, you, who have among your colours stronger light and shade than those in the mirror, will certainly, if you know how to put them together well, make your picture, also, look like something from nature seen in a large mirror.[526]

On judging your painting

We clearly know that errors are recognisable more in the works of others than in our own, and often, while finding fault with the minor errors of others, you will ignore your own great ones. To avoid such ignorance first see to it that you are an accomplished perspectivist. Then acquire a thorough knowledge of the proportions of men and others animals and, additionally, become a good architect, that is, in so far as applies to the shape of buildings, and [acquire a thorough knowledge of] other things upon the face of the earth in all their infinity of forms. The more knowledge you have of these the more praiseworthy will your own efforts be. And when experience is lacking, do not hesitate to portray from nature. But to return to the advice I promised above to give, I say that when you are painting you ought to have by you a flat mirror in which you should often look at your work. The work will appear to you in reverse and will seem to be by the hand of another master and thereby you will better judge its faults. It is also good to get up and take a little recreation elsewhere, because when you return to your work your judgement will have improved. If you stay doggedly at work you will greatly deceive yourself. Again it is good to place yourself at a distance from it because the work will look smaller and more can be taken in at a glance: discordances, ill-proportioned limbs and the colours of things can be recognised more easily.[527]

How in the course of his work the painter should eagerly receive all men's opinions on it

Certainly while a man is painting he should not refuse anyone's judgement. For we know that one man, even though he may not be a painter, still knows what another man looks like and is well able to judge, whether he is hunchbacked or has one shoulder higher or lower than the other, or whether he has a large mouth, or nose or other deficiencies. And knowing as we do that men are able to judge with accuracy the works of nature, how much more does it behove us to admit that they are able to judge our errors, for you know how far a man may be deceived in his own work. And if you do not recognise error in yourself, think upon it in others, and learn by their mistakes. Therefore be eager to lend a patient ear to the opinions of others and think long and hard whether whoever finds fault has reason or not to censure you. And if the answer is yes, correct the fault. If no, give the impression that you have not heard him, or if he is a man whom you respect, explain to him why he is mistaken.[528]

On the greatest fault of painters

It is a fault in the extreme of painters to repeat the same movements, the same faces and the same style of drapery in one and the same narrative painting and to make most of the faces resemble their master, which is a thing I have often wondered at, for I have known some who, in all their figures seem to have portrayed themselves from the life, and in them one may recognise the attitudes and manners of their maker. If he is quick of speech and movement his figures are similar in their quickness, and if the master is devout his figures are the same with their necks bent, and if the master is a good-for-nothing his figures seem laziness itself portrayed from the life. If the master is badly proportioned, his figures are the same. And if he is mad, his narrative will show irrational figures, not attending to what they are doing, who rather look about themselves, some this way and some that, as if in a dream. And thus each peculiarity in a painting has its prototype in the painter's own peculiarity. I have often pondered the cause of this defect and it seems to me that we may conclude that the very soul which rules and governs each body directs our judgement before it is our own. Therefore it has completed the whole figure of a man in a way that it has judged looks good, be it long, short or snub-nosed. And in this way its height and shape are determined, and this judgement is powerful enough to move the arm of the painter and makes him repeat himself and it seems to this soul that this is the true way of representing a man and that those who do not do as it does commit an error. If it finds someone who resembles the body it has composed, it delights in it·and often falls in love with it. And for this reason many fall in love with and marry women who resemble them, and often the children that are born to such people look like their parents.[529]

On the selection of beautiful faces

It seems to me that a painter shows not inconsiderable grace* when he paints his figures well. If he does not possess this grace by nature he can acquire it by this incidental method of studying: make an effort to collect the good features from many beautiful faces,† but let their beauty be confirmed rather by public renown than by your own judgement. You might deceive yourself and choose faces which conform to your own, for often, it seems, such conformities please us. If you were ugly you would choose faces which were not beautiful and would paint ugly faces, as do many painters, with the result that often the figures resemble the masters. Therefore select your examples of beauty as I have said and commit them to memory.[530]

THE LIFE OF THE PAINTER

On the life of the painter in his studio

Lest bodily prosperity should stifle a flourishing talent the painter or draughtsman should be solitary, especially when intent on those speculations and reflections which continually appear before his eyes to provide subjects for safekeeping in the memory. If you are alone you belong entirely to yourself. If you are with just one companion you belong only half to yourself and less so in proportion to the intrusiveness of his behaviour. And the more of your companions there are, the more you will fall into the same trouble. If you should say 'I will go my own way, and draw apart – the better to be able to speculate upon the forms of natural objects', then I say this could be harmful to you because you will not be able to prevent yourself from often lending an ear to their idle chatter. And since you cannot serve two masters you will perform badly in the role of companion and there will be an even worse consequence for the speculative study of your art. And if you say I shall withdraw so far apart that their words will not reach me, and will cause me no disturbance, I for my part would say that you would be held to be mad. But consider: by doing it you would at least be alone. And if you must have company choose it from within your studio. This would enable you to reap the benefit of a variety of discussions. All other company could be extremely detrimental to you.[531]

The painter needs such mathematics as pertain to painting. He must forego companions who are disinclined to his studies, and have a brain capable of reacting to the different objects that present themselves before it, and removed from all other cares. And above all he must liken his mind to nature, giving it a surface like a mirror which is transformed into as many different colours as there are coloured objects placed before it. And the company he keeps should be like-minded towards those studies, and should such company not be found, he should keep his own during his contemplation, for in the end there will be no company more useful.[532]

... To draw in company is much better than to do so on one's own for many reasons.* The first is that you will be ashamed to be counted among draughtsmen if your work is inadequate, and this disgrace must motivate you to profitable study. Secondly a healthy envy will stimulate you to become one of those who are more praised than yourself, for the praises of others will spur you on. Another reason is that you will learn something from the drawings of those who do better than you, and if you become better than them you will have the advantage of showing your disgust at their shortcomings and the praises of others will enhance your virtue.†[533]

How to learn well by heart

When you wish to be able to make use of something committed to memory adopt this method, which is that when you have drawn the same thing so many times that it seems you have it by heart try to do it without the exemplar.* Have your exemplar traced on to a thin flat plane of glass. Place this on top of the drawing you have done without the exemplar, and note carefully where the tracing does not match up with your drawing, and in those places where you have made a mistake, resolve not to repeat the error. In fact, go back to the exemplar and draw over and over the erroneous part till you have it firmly in your memory. If you are unable to use flat glass for the tracing, take some very thin parchment, well-oiled and dried. When you have used it for one drawing, you can wipe it clean with a sponge and use it for a second one.[534]

How to make a portrait in profile after seeing the subject only once

In this event, you must commit to memory the variations of the four different features* in profile, which would be the nose, the mouth, the chin and the forehead. Let us speak first of noses, of which there are three kinds, that is, straight, concave and convex. Of the straight kind there are only four varieties, that is, long, short, high at the tip, and low at the tip. Concave noses are of three kinds, of which some have the concavity on the upper portion, some in the middle, and others on the lower part. Convex noses again vary in three ways, that is, some have the projection on the upper portion, some in the middle and others in the lower part. The contours on either side of the projecting part of the nose vary in three ways, that is, they are either straight, concave or really convex.[535]

134. Variations in types of nose in profile, based on Urb, 108v.

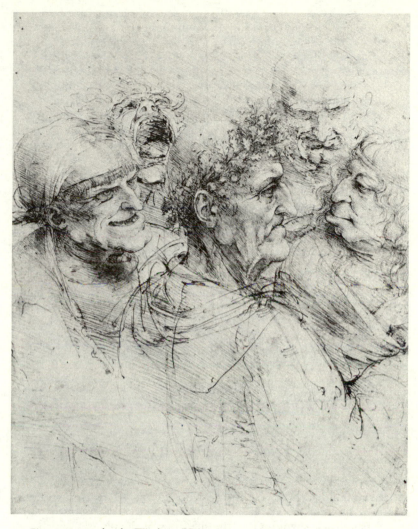

135. Five grotesque heads, Windsor, RL 12495r.
'I shall not speak of monstrous faces because they are easily kept in mind'

When you have to draw a face from memory, carry with you a little notebook in which you have jotted down these kinds of features. After glancing at the person you wish to portray, you can look from a little way off to see which nose or mouth resembles theirs and make a little mark against it to enable you to recognise it later at home. I shall not speak of monstrous faces because they are easily kept in mind.[536]

When, draughtsman, you are in the mood for games, a useful recreation is always to opt for something connected with your profession, for example, to develop a practised eye for being able to judge the true breadths and lengths of objects. To accustom the mind to such things let one of you make a straight line anywhere on a wall and each of you take in your hand a twig or a straw and cut it to the length that from a distance of ten *braccia*★ you think the first line [on the wall] is. Then let each go up to the model and measure his own estimate against it. And he who has come closest with his estimate to the length of the model will be the best and the winner, and may take from every one the prize which had been agreed upon beforehand. Again you ought to take foreshortened lengths; that is to say, take an arrow or some other measure of length,† and decide upon a certain distance in front of you. Then let each one use his judgement to estimate how many times this measure would go into that distance. Again see who can best draw a line one *braccio* long which can be tested with a tightly drawn thread. Games such as these give an opportunity to practice one's eye, which is the primogenitor of painting.[537]

HOW EFFECTS SHOULD BE ACHIEVED

How figures should be illuminated

Light should be employed in the same way as it would appear in the natural setting in which you portray your figure.★ That is, if you portray it in sunlight, make the shadows dark with large pools of light, and imprint their shadows and the shadows of the objects which surround them on the ground. If you represent your figure in dull weather, make little difference between the light and shade, and do not make any other shadow at its feet. If you paint them in an interior, make a great difference between the lights and the shadows and have shadow on the ground. But if you show the interior with a covered window and whitewashed walls, make little difference between the lights and shadows. If it is lit by a fire, give the lights a strong and ruddy glow and have darkened shadows. The point where the shadows strike the walls or floor will be clearly defined and the further away

the shadow moves from the body the greater and broader it will be. If it were to be partly lit by the fire and partly by the atmosphere the light from the atmosphere would be stronger and that from the fire almost red, in resemblance to the fire. Above all ensure that your painted figures are broadly lit from above, that is to say, whenever you are portraying any living thing. The reason is that the people you see in the street are all lit from above, and you must know that there is no acquaintance so well known to you that when lit from below you would not be hard put to recognise him.[538]

The error of painters who portray an object in relief indoors in one kind of light and then place it in a landscape or other place under different lighting conditions

A grave error is made by those who frequently portray an object in relief indoors under a specific light and then use the portrayal in a work featuring the universal light of the air in a landscape. And this air embraces and illuminates all the parts of the scene evenly, and thus the object painted indoors casts a dark shadow where none can be, or, if there were, it is so light as to be hardly discernible and similarly they make reflections where it is impossible for these to be seen.[539]

How to enhance the simulated relief of a painting with contrived light and shade

To add to the impression of relief in a painting you should place between the simulated figure and the visible [background] object on which its shadow falls a border of clear light which divides the figure from the darkened object. On the same object make two light parts which will surround the shadow made on the wall by the figure placed opposite it. And make frequent use of this in [painting] those limbs which you want to stand out somewhat from their body. In particular, when the arms are to be folded in front of the breast, make sure that – between the point where the shadow of the arm strikes the breast and the shadow of the arm itself – there remains enough light, to make it seem as if it falls through a space between the breast and the arm. The further you wish the arm to appear from the breast, correspondingly make the light larger. Always ensure that you are able to arrange the bodies against backgrounds where the dark part of the bodies is offset against a light background and the illuminated part against a dark background.[540]

136. The lighting of objects above and to the side of the eye, based on MS BN 2038 16v.

When you are painting objects above and to the side of the eye and you wish them to appear detached from the wall, you should place a light midway between the original shadow and the derived shadow, and the object will appear detached from the wall.[541]

A principal element of painting is the backgrounds of the things painted. In these backgrounds you can always distinguish the boundaries of natural bodies which are in themselves convex, and also the shapes of such bodies against these backgrounds, even though the colours [i.e., hues] of the bodies may be the same as the aforesaid background. This arises because the convex boundaries of the bodies are not lit in the same way by the same light that illuminates the background, for such a boundary will often be lighter or darker than the background. But if the boundary is of the same colour [i.e., tone] as the background then without doubt that part of the painting precludes recognition of the shape of the boundary.* Such an option as this in painting should be rejected by the discernment of good painters, since the intention of the painter is to make his bodies stand out from their background and in the above-mentioned case the opposite happens, not only in painting but also in works in three dimensions.[542]

How to make figures appear detached from their backgrounds

The shapes of all bodies will appear raised in relief and detached from their backgrounds when these backgrounds, be they of light or dark colours, contrast as much as possible with the borders of the said figures.[543]

Avoid profiles, that is, pronounced harsh outlines for objects

Do not make the boundaries around your figures of any colour other than its adjoining background. That is, do not make dark outlines between the background and your figure.[544]

On adding lights

First lay a universal shadow over the entire area containing whatever is not exposed to the light. Then put there the intermediate shadows* and the principal shadows and compare these with each other. In the same manner lay the light which contains the intermediate light, adding the intermediate and principal lights, likewise comparing them together.[545]

On the darkness of shadows, or rather brightness of lights

Although those who are skilled put into all shaded things such as trees, fields, hair, beards and furry skins four degrees of brightness in rendering one colour; that is to say, first a dark foundation, secondly a roughed-in area echoing the shape of the parts, thirdly a more finished and brighter portion, fourthly the lights which are more pronounced in shape than other areas [of light], it none the less seems to me that these variations are infinite [when light and shade is seen] across a continuous quantity, which is in itself infinitely divisible. And I prove it thus: let cg be a continuous quantity,* d be the light which

 137. The darkness of shadows or the brightness of lights, based on CA 199va/534v.

illuminates it ... That part of the illuminated body will be most luminous which is closest to the source which lights it. Therefore g is darker than c by as much as the line dg is longer than the line dc, and consequently these degrees of light, or rather shadow, are not only four but as infinite as one can imagine, because cg is a continuous quantity and every continuous quantity is infinitely divisible.[546]

On painting shadows

Do not give a finished or sharply bounded effect to those shadows which you make out with difficulty and those boundaries you cannot discern – or indeed which you are uncertain about selecting and transferring to your work – lest your work look wooden as a result.[547]

How to add to figures the shadow which accompanies the light and the body

When you make a figure and you wish to see whether the shadow corresponds to the light, and that it is neither more red nor more yellow than the essential nature of the colour you wish to portray, proceed as follows. Make a shadow with your finger over the lighted part, and if the accidental shadow depicted by you is similar to the real shadow made by your finger on your work, all will be well. You can, by moving your finger nearer or further away, make darker or lighter shadows. Always compare these with the one you have painted.[548]

How to surround bodies with shadow of varying outline

Ensure that the shadows cast on the surface of bodies by various objects always undulate and twist in accordance with the variety of parts which cause the shadows and [the shape of] the object on which the shadows fall.[549]

Figures that are separate should not appear joined together

The colours with which you clothe your figures should be such that they lend grace to one another and when one colour acts as background to another arrange it so that they do not appear joined and attached to one another, even though they may be of the same kind of hue, but let them vary in brightness as is required by the interposition of distance and the density of the air between them. Let the same rule hold for the visibility of their boundaries, that is, more or less finished or blurred as their proximity or distance requires.[550]

On the imitation of colours at any distance

When you wish to counterfeit a colour take care that if you are in a shady spot, you do not intend from there to imitate a bright place, because you would fall into error with such an imitation. What you must do in such a case in order to proceed with certainty, as befits mathematical proofs, is to compare all the colours you have to imitate – the copy with the original – in the same light, and check that your colour is conterminous with the visual axis of the colour in nature.

138. Drawing a mountain in the west at midday, based on Urb 240v.

Let us say that you wish to copy the side of a mountain which faces the sun. Bring your colours out into the sun, and there outside mix the colours for copying and compare them in the same sunlight holding your colours against the colours to be copied. Let us say it is midday and I am drawing the mountain to the west, which is half shaded and half lit, but here want to copy the illuminated part. I take a small piece of paper in the colour which seems to me to be similar to that to be imitated and I place it up against the original, so that there is no gap between the real and the copy, and thus I expose them to the sun's rays, and I add as many different colours as necessary and I proceed thus accordingly for every kind of shaded or illuminated colour.[551]

Whether the surface of every opaque body takes on the colour of the object opposite

You should understand that if a white object is placed between two walls, one of which is white and the other black, you will find the same proportion between the shadowed part and the illuminated part of the said object, as exists between the aforesaid walls. If the object were blue in colour it would be the same. Therefore, when you are about to paint, proceed as follows: take black to shade the blue object, this being similar to the black, or rather similar to the shadow of the wall you are depicting, and which is reflected on to your object. And if you do it this way you will execute it with sure and true science. Use the following when you execute your walls: with whatever colour you wish, take a little spoon, not much bigger than an ear spoon, but larger or smaller according to how large or small is the work on which the operation has to be carried out. The spoon should have an even rim and with it you will measure out the quantities of the colours you will use in making your mixtures, as would be the case when on the said walls you would have made the first shadow, with three degrees of darkness and one degree of lightness, that is to say, with three spoonfuls, levelled as in measuring grain, which would be three of simple black and one spoonful of white. And you would have made an accurate mixture, without any doubt. Now you have made one

wall white and one dark and must put a blue object between them, and you wish the object to have the shadows and lights which an object of such a blue ought to have. Therefore set aside the blue which you wish to remain free of shadow and place the black beside it. Then take three spoonfuls of black and mix them with a spoonful of clear blue,

139. The calculation of shadow on a spherical object between walls, based on Urb 138r.

and make from this the darkest shadow. When this is done, observe whether the object is spherical or cylindrical or square or whatever it may be. If it is spherical, draw lines from the edges of the dark wall to the centre of this spherical object and where the lines intersect on the surface of the object, here among many, the stronger shadows are [made by those lines which fall] at equal angles.* Next begin to lighten it as at *no* which renounces as much of the darkness as it takes on the colour of the upper wall *ad* and you should mix this colour with the first shadow of *ab* with the same gradations.[552]

THE STUDIO AND PAINTERS' AIDS

How the light for drawing from nature should be high up

The light for drawing from nature should come from the north, so that it is not subject to change, and if your light comes from the south keep the window screened,* so that when the sun shines throughout the course of a whole day, the light will not vary. The height of the light should be fixed so that every body casts a shadow on the ground which is as long as it is high.[553]

Concerning the windows in a place where figures are portrayed

Let the windows in the rooms of painters be screened without transoms and filled in gradually towards the edges of the windows with darkening shades of black in such a way that the boundary of the light will not coincide with the edge of the window.[554]

On choosing the atmosphere which will lend grace*
to faces

If you have a courtyard which you could for your purpose cover with a linen awning, the light there will be good. Otherwise, when you wish to portray someone, do it in dull weather or towards evening, and have the person to be portrayed keep his back to one of the walls of the courtyard. Pay attention in the street towards evening, when the weather is bad, to how much grace and sweetness can be seen in the faces of the men and women. Therefore, O painter, use a courtyard where the walls are coloured black, with some kind of overhanging roof above the wall. Let this wall be ten *braccia*† wide, twenty *braccia* long and ten *braccia* high, and when it is sunny it should be covered with an awning. Alternatively, work on a painting towards evening when it is cloudy or misty and this will be the perfect atmosphere.[555]

In what circumstances one should portray a face in
order to give it grace* through shadow and light

The utmost grace in the shadows and the lights is added to the faces of those who sit in the darkened doorways of their dwellings. Then the eye of the beholder observes the shaded part of the face thrown into deeper shade by the shadows from the aforesaid dwellings, and sees brightness added to the illuminated part of the face by the radiance of the atmosphere. Because of such increases in the shadows and lights the face acquires great relief, and in the illuminated part the shadows are almost indistinguishable, and in the shaded part the lights

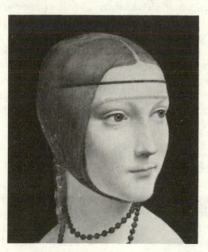

140. Detail of *Cecilia Gallerani*, Czartoryski Museum, Cracow. 'The utmost grace in the shadows and the lights is added to the faces of those who sit in the darkened doorways of their dwellings'

are almost indistinguishable. The face depicted in this way acquires much beauty with the increase in shadows and lights.[556]

On drawing the shadows of bodies by candle or lamplight

Place in front of this nocturnal light a frame on which has been stretched one whole sheet of chancery-size paper, either transparent or not. And you will see your shadows as smokey, that is, without [sharp] boundaries. The light where it is not cut off by the sheet of paper will serve to illuminate the sheet on which you are drawing.[557]

The painter's window and its usefulness

The painter who strives to imitate nature should have a source of light which he is able to raise and lower. The reason is that sometimes you will want to finish something you are portraying close up to the light.
 ... [Also make a] chest on which the work can be raised or lowered, so that it is the work which moves up and down and not the master. Each evening you can let down the work and fold it up on itself, so that in the evening it will look like a chest, which when closed may serve the purpose of a bench.[558]

How to portray a place accurately

Obtain a piece of glass as large as a half sheet of royal folio paper and fasten this securely in front of your eyes, that is, between your eye and the thing you want to portray. Next, position yourself with your eye at a distance of two-thirds of a *braccio** from the glass and fix your head with a device so that you cannot move it at all. Then close or cover one eye, and with the brush or a piece of finely ground red chalk† mark on the glass what you see beyond it. Then trace it on to paper from the glass, and pounce‡ it onto paper of good quality, and paint it if it pleases you, making good use of aerial perspective.

How to learn to pose figures well

If you wish to achieve good and correct postures for your figures, set up a square frame or stretcher, divided into squares within by thread, between your eye and the nude figure you are portraying. Mark the same squares lightly on to the paper where you wish to portray the

nude model. Then place a little blob of wax somewhere on the net to serve as a marker. Whenever you look at the figure you should line this marker up with the pit of the throat, or if it has its back turned to you, with one of the vertebrae of the model's neck. These threads will show you which of all the parts of the body, in each action, is seen below the pit of the throat, beneath the angles of the shoulders, under the nipples, hips or other parts of the body. The transverse lines of the net will show you how much further to place one leg above the other and similarly with the hips, the knees and the feet. But always secure the net on a perpendicular axis, and consequently the nude as viewed through the net will correspond to the nude seen within the drawn net on your paper. The drawn squares may be as much smaller than those of the net as you wish your figure to be smaller than the natural model. Afterwards, remember when drawing to apply the rule of the articulations of the limbs as shown to you by the net. The net should be three and a half *braccia* high and three *braccia* wide, seven *braccia* away from you and one *braccio* away from the nude model.[559]

WALL PAINTING AND ILLUSION

How to portray figures in narratives*

The painter must always take into consideration, in regard to the wall on which he is to paint his narratives, the height of the place where he wishes to put his figures, and of that which he is portraying from nature in connection with his project. He should make his viewpoint as far beneath the thing that he is portraying as it will itself be above the eye of the spectator when executed. Otherwise the work will be open to criticism.[560]

Why ranks of figures one above the other are to be avoided

This universal practice which is adopted by painters on the walls of chapels is very rightly to be censured, inasmuch as they execute a narrative on one level, complete with its landscape and buildings, then go up a tier and do another, varying the viewpoint from that of the first one. They then proceed to the third and the fourth tiers, so that on one wall there are four different viewpoints. This is the height of foolishness in such masters. We know that the viewpoint is located in the eye of the spectator of the narrative. If you were to say, 'how am

I to depict the life of a saint divided up into various episodes on one and the same wall?', for my part I answer you that you must position the foreground with the viewing point at the height of the eye of the spectator of this narrative. On this plane depict the main event on a large scale, and then, by diminishing step by step the figures and dwellings upon various hills and planes, you can include all the episodes of the narrative. In the remaining upper parts of the wall, put trees, scaled in proportion to the figures, or angels if appropriate to the narrative, or birds or clouds or similar. Do not trouble to proceed otherwise, as all your work will be incorrect.[561]

I remind you again ... that your narrative compositions should not be arranged one above the other on one and the same wall, with different horizons, so that the work resembles a haberdasher's shop with its little box-like drawers of merchandise.[562]

To draw a figure on wall 12 *braccia** high so that it looks 24 *braccia* high

If you wish to make a figure or anything else appear 24 *braccia* high do it in this way: draw first the wall *mr* with half of the man you wish to depict. Next, for the other half: put in the vault *mn* the figure you

141. Method of drawing a figure on a wall which will appear to be twice the height of that wall, based on Urb 139v.

wish to depict as mentioned above. On the floor of a room first set down an intersecting plane† in the shape of the wall with the vault where you are to depict your figure. Then behind it make the figure, drawn in profile, of whatever size you like, and continue all the lines to the point f, and just as they cut the intersection mn so the figure is made on the wall, which resembles the intersecting plane, and it will have all the heights and actions of the figure. The breadths or thicknesses which are on the straight wall mr should be drawn as they are since the natural foreshortening of the wall will cause the figure to diminish by itself. You will require to foreshorten the figure which goes in the vault as if it were straight and you should carry out this foreshortening on a completely flat floor, and there will appear the figure which is detached from the wall rn with its true dimensions.[563] Always ensure that the intersecting plane on which you foreshorten the seen objects is of the same shape as the wall where the work is to be executed.[564]

That which has been rendered in perspective will be more clearly seen when viewed from the place from which it was constructed

If you wish to draw something close up so as to achieve the same effect as in nature, it is impossible that your perspective will not appear incorrect, with all the false proofs and discordant proportions that can be imagined in a pitiful work, if the person looking at the perspective does not view it from the exact distance and height and direction of your eye, or rather from the viewpoint at which you placed yourself when you constructed the perspective. Hence it would be necessary to construct a window of the size of your face or rather, a hole, from where you could look at the work. If you do this, no work of yours, when properly accompanied with shadow and lights, can but have the effect of the real object, and you will not be able to convince yourself that these things are painted.[565]

If you wish to represent a figure on a wall and this wall is seen as foreshortened and the figure you are to draw is to appear in its proper shape and detached from this wall, do as follows: obtain a thin plate of iron and make in the centre a small aperture which should be round. Bring a light up to the plate so that the mid-point touches the plate. Then place whatsoever body or figure you like against the said wall so that it touches it. Mark in its shadow on the wall, and then add the shadows and the lights. Arrange it so that the person who wishes to see the said figure looks through the same hole where formerly the light was. And you will never be able to persuade yourself that the said figure is not detached from the wall.*[566]

THE INVENTION AND COMPOSITION OF NARRATIVES

On the elements of narrative painting

That which is included in narrative paintings ought to move those who behold and admire them in the same way as the protagonist of the narrative is moved. So if the narrative shows terror, fear or flight or, indeed, grief, weeping and lamentation, or pleasure, joy and laughter and similar states, the minds of the beholders should move their limbs in such a way as to make it seem that they are united in the same fate as those represented in the narrative painting. And if they do not do this, the painter's ability★ is useless.[567]

On varying the health, age and constitution of bodies in narrative paintings

I say that in narrative paintings you should closely intermingle direct opposites, because they offer a great contrast to each other, and the more so the more they are adjacent. Thus, have the ugly next to the beautiful, the large next to the small, the old next to the young, the strong next to the weak. In this way there is as much variety, as closely juxtaposed as possible.[568]

... It is an extreme defect in the painter to make the faces so that they resemble each other and similarly the repetition of gestures is a great fault.[569]

On the posture and the movements of limbs

Do not repeat the same movements in a single figure, be it in its limbs, hands or fingers. Nor should the same pose be repeated in one narrative. If the narrative is a very large-scale painting, for instance depicting a skirmish★ or the killing of soldiers where there are no more than three poses, namely the thrust, the backhand and the slash, you must in this case contrive it so that the swordsmen are shown from various viewpoints; that is to say, some will have their backs turned, others will be seen side on and others from the front, and all other views of the same three movements will be taken from these three simple movements. By this token we will require all the others to be based on one of them. But compound motions in battles require great ingenuity, and call for great vivacity and movement. Compound motions are those where [for example] one simple figure shows you his legs from the front and a part of his shoulder in profile.[570]

142. An old man and a youth facing one another, Florence, Uffizi.
'You should closely intermingle direct opposites because they offer a great contrast with each other . . . Thus have the ugly next to the beautiful . . . the old next to the young . . .'

Rules for composing narrative paintings

O painter, when you compose a narrative painting, do not draw the limbs on your figures with hard contours or it will happen to you as to many different painters who wish every little stroke of charcoal to be definitive. These kinds of painters well suppose that they will accumulate riches, but they will not acquire praise for their art for on many occasions the creature represented does not move his limbs in a manner that reflects the motions of his mind. When the painter has achieved a beautiful and graceful and well-defined rendering of these limbs, it seems to him an outrage to raise or lower the position of the limbs, or move them further back or forward, and these painters do not deserve any praise for their science. Have you never reflected on the poets who in composing their verses are unrelenting in their pursuit of fine literature and think nothing of erasing some of these verses in order to improve upon them? Therefore, painter, decide broadly upon the position of the limbs of your figures and attend first to the movements appropriate to the mental attitudes of the creatures in the narrative rather than to the beauty and quality of their limbs. You should understand that if such a rough composition turns out to be right for your intention, it will all the more satisfy in subsequently being adorned with the perfection suitable to all its parts. I have in the past seen in clouds and walls stains which have inspired me to beautiful inventions of many things. These stains, while wholly in themselves deprived of perfection in any part, did not lack perfection in regard to their movements or other actions.[571]

A way of enhancing and arousing the mind to various inventions

I shall not refrain from including among these precepts a new aid to contemplation, which, although seemingly trivial and almost ridiculous, is none the less of great utility in arousing the mind* to various inventions. And this is, if you look at any walls soiled with a variety of stains, or stones with variegated patterns,† when you have to invent some location, you will therein be able to see a resemblance to various landscapes graced with mountains, rivers, rocks, trees, plains, great valleys and hills in many combinations. Or again you will be able to see various battles and figures darting about, strange-looking faces and costumes, and an endless number of things which you can distill into finely-rendered forms. And what happens with regard to such walls and variegated stones is just as with the sound of bells, in whose peal you will find any name or word you care to imagine.[572]

143. *Virgin and Child with a Cat*, London, British Museum 1861–6–21–iv.
'...decide broadly upon the position of the limbs of your figures and attend
first to the movements appropriate to the mental attitudes of the creatures in
the narrative rather than to the beauty and quality of their limbs'

How to make a fictional animal look natural

You know that it is impossible to fashion any animal without its in-
dividual parts, and that each of these in itself will bear a resemblance
to those of other animals. Therefore if you wish to make your imagin-
ary animal seem natural, let us say it was a serpent,* take for the head

144. A dragon, Windsor, RL 12360.
'...If you wish to make your imaginary animal seem natural ... take for the head that
of a mastiff ...'

that of a mastiff or a hound, the eyes of a cat, the ears of a porcupine,
the nose of a greyhound, the brow of a lion, the temples of an old cock
and the neck of a turtle.[573]

On studying even as you awaken or in bed in the dark before you go to sleep

I myself have proved it to be of no little use when in bed in the dark
to run the imagination over the surface delineations of forms pre-
viously studied, or other remarkable things encompassed within

subtle speculation. This is really a most praiseworthy activity and one that is useful for fixing things in the memory.[574]

The master who gives it to be understood that he can retain in his own mind all the forms and effects of nature would certainly appear to me to be graced with a great ignorance, for these effects are infinite and our memory is not of a capacity great enough to suffice. Therefore, O painter, take care that lust for gain does not override in your mind the glory of art. For the gaining of glory is a much greater thing than the glory of riches. For these, then, and other reasons which might be given, apply yourself first through draughtsmanship to giving a visual embodiment to your intention and the invention which took form first in your imagination.* Next set about adding and subtracting until you are satisfied, and then pose models, draped or nude as your work requires them. And see that in regard to proportion and dimensions, which are subject to perspective, nothing is allowed to remain in the work which is not dictated by reason and the effects of nature. This will be the way to bring honour upon yourself through your art.[575]

On composing narratives in the first sketch

The sketching out of the narratives should be rapid, and the arrangement of the limbs not too defined but merely confined to suggesting their disposition. Later, at your leisure, you can finish them to your liking.[576]

Those who would compose narrative paintings should study how to set down figures broadly – that is to say, sketchily – first learning how to depict them well throughout all the turning, bending and stretching of their limbs. Next should be undertaken the description of two men locked in ardent combat. This invention should be considered with various actions and from a variety of viewpoints. Next let this be followed by the fight between a daring man and a cowardly and frightened one, and these actions and many other states of mind should be pondered and studied with great scrutiny.[577]

Discourse on practice

... Do not depict elaborate hairstyles* or headgear where among the simple-minded one single hair out of place presages to the wearer high disgrace, in the belief that those around would abandon their initial trains of thought and talk only of that and find fault only therein. And such as these keep only a mirror and comb for their counsel and the

145. Study for the head of St Philip in *The Last Supper*, Windsor, RL 12551.
'Therefore make the hair on the head play in the wind around youthful faces and gracefully adorn them with many cascades of curls'

wind is their principal enemy that dishevels their carefully arranged hair. Therefore make the hair on the heads [that you paint] play in the wind around youthful faces and gracefully adorn them with many cascades of curls. Do not do as those who plaster it with glue, for this gives a glazed look to the faces. Human folly ever increases. It is not enough that mariners bring gum arabic from the east to use as protection lest the wind disturb the arrangement of their tresses. They continue to search for more.[578]

EXAMPLES OF COMPOSITIONS

The Last Supper

One who was drinking has left his glass in its place and turned his head towards the speaker.

146. *The Last Supper*, Milan, S. Maria delle Grazie.
'... with hands spread open to show the palms shrugs his shoulders up to his ears and mouths astonishment'
'Another places his hand upon the table and stares'

Another wrings the fingers of his hands and turns with a frown to his companion. Another with hands spread open to show the palms shrugs his shoulders up to his ears and mouths astonishment.

Another speaks into his neighbour's ear, and the listener twists his body round to him and lends his ear while holding a knife in one hand

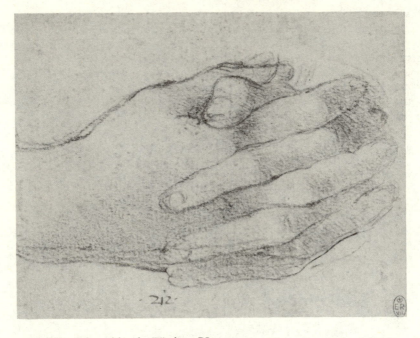

147. Study of clasped hands, Windsor, RL 12543.
'Another wrings the fingers of his hands'

and in the other some bread half cut through by a knife. Another while
turning round with a knife in his hand upsets a glass* over the table
with that hand.[579]

 Another places his hands upon the table and stares. Another splut-
ters over his food. Another leans forward to see the speaker and shades
his eyes with his hand. Another draws back behind the one who in-
clines forward and has sight of the speaker between the wall and the
leaning man.[580]

How to represent a battle

You must first represent the smoke from the artillery, mingled in the
air with the dust stirred up by the movement of the horses and the
combatants. Realise the mingling effect as follows: dust, being com-
posed of earth, has weight, and although on account of its fineness it
will rise easily to mingle with the air it none the less is eager to resettle.
The finest particles attain the highest reaches and consequently there

it will be least visible and will seem almost to have the colour of the air. The more the smoke mingling with the dust-impregnated air rises to a certain height, the more it will have the appearance of a dark cloud, and at the summit the smoke will be more distinctly visible than the dust. The smoke will incline to a somewhat bluish colour, and the dust will tend to its own colour. From the side from which the light comes this mixture of smoke and dust will seem much more luminous than from the opposite side. The further amidst the swirling mass just described that the combatants are, the less will they be visible and the less difference will there be in their lights and shadows. You must give a reddishness to the faces and figures and the air surrounding them and to the musketeers and those near them. And the further it is away from its cause the more this reddishness will fade. The figures that are between you and the light, if some distance away, will appear dark against a light background, and the parts of their legs nearest to the ground will be the least visible because the dust there is denser and murkier. And if you depict horses galloping out of the throng make little clouds of dust set as far apart from each other as the gap between the horses' strides, and that cloud which is furthest away from the horse should be the least visible, being, indeed, high and thinly spread out; and a nearer one should be made more noticeable, smaller and more tightly packed. Let the air be full of arrows of every kind, some shooting upwards, others falling, others flying straight. And let the shot from the muskets trail some smoke in its wake. You must make the foreground figures covered in dust – in their hair, on their brows and other level surfaces suitable for dust to settle. Show the victors running, with their hair and other lightweight things strewn to the wind, and their brows lowered. Have them thrusting their opposite limbs forward, that is, if a man puts forward his right foot, his left arm should also come forward. And if you show one who has fallen, indicate the spot where he has slithered in the dust turned into blood-stained mire. And all around in the semi-liquid earth show the imprints of the men and horses who have trampled over it. Show a horse dragging along its dead master, leaving behind it the tracks where the corpse has been hauled through the dust and mud. Make the conquered and beaten pale, with their brows knit high and let the skin above be heavily furrowed with pain. Let the sides of the nose be wrinkled in an arch starting at the nostrils and finishing where the eyes begin. [Show] the flared nostrils which cause these crease lines, and the lips arched to reveal the upper teeth and the teeth parted, as if to wail in lamentation. [Show one who] shields his terrified eyes with one hand, the palm turned outwards toward the enemy, and the other hand resting on the ground to support his half raised body. Show others shrieking, open-mouthed and in flight. Show various kinds of weapons between the feet of the combatants such as broken shields

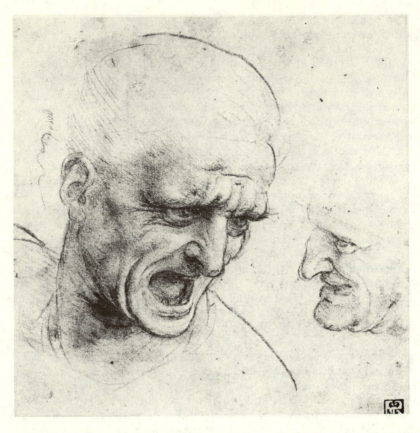

148. Study of the head of a man shouting and of a profile for *The Battle of Anghiari*, Budapest, Museum of Fine Arts.
'Let the sides of the nose be wrinkled in an arch starting at the nostrils and finishing where the eyes begin. Show the flared nostrils which cause these crease lines and the lips arched to reveal the upper teeth and the teeth parted, as if to wail in lamentation'

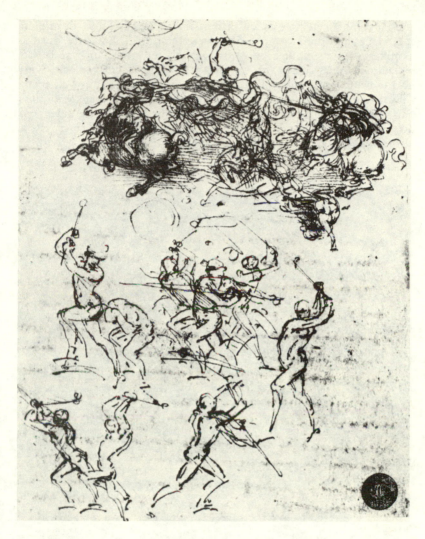

149. Battle of horsemen and footsoldiers for *The Battle of Anghiari*, Venice, Accademia. 'You might see someone disarmed and struck down by the enemy.'

and lances, broken swords and other similar things. Show dead men,
some half and others completely covered in dust. [Show] the dust, as
it mixes with the spilt blood turning into red mud, and the blood,
picked out by its colour, running its perverted course from the body
into the dust; and others in their death throes, grinding their teeth,
rolling their eyes or clutching their crippled legs and bodies with their
fists. Someone might be seen who, having been disarmed and struck
down by the enemy, turns on him to fight tooth and nail in cruel and
bitter vengeance. You might see a riderless horse galloping with its

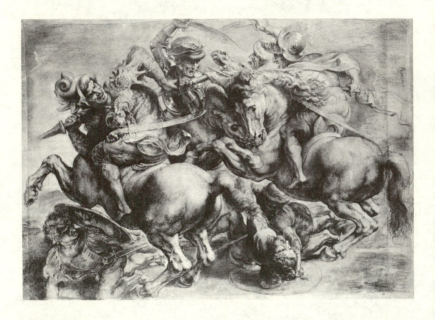

150. Peter Paul Rubens, *The Fight for the Standard* (after Leonardo's *Battle of Anghiari*),
Paris, Louvre.
'Your might see one who has been maimed fall to the ground and cover himself with
his shield...'

mane spread to the wind, doing much damage among the enemy with
its hooves. You might see one who has been maimed fall to the ground
and cover himself with his shield, and the enemy bending low in an
endeavour to deal him his death-blow. Many men might be seen fallen
in a heap on top of a dead horse. You will see some of the victors leave
off fighting and emerge from the crowd using both hands to wipe eyes
and cheeks that are caked in mud made from the tears caused by the
dust. You would see the reserves poised full of hope and fear, their
eyes sharpened and shaded with their hands as they survey the dense

and murkey chaos and wait upon their Captain's orders; likewise the Captain with his baton of command raised, as he hastens towards the reinforcements and points out to them the place where they are needed. And [show] a river within which horses are galloping, engulfing the water all around in great swirling waves of foam, and water exploding into the air and among the legs and bodies of the horses. And do not depict a single level place that lacks a bloodied imprint.[581]

[The Deluge – topics]

Darkness, wind, tempest at sea, deluge of water, forests on fire, rain, bolts from heaven, earthquakes and the collapse of mountains, razing of cities.

Whirlwinds which sweep water, boughs of trees and men through the air.

Windtorn branches with people on top of them, caught up in the path of the winds.

Broken trees weighed down with people.

Ships smashed to pieces and dashed upon the rocks.

Herds of beasts, hailstones, thunder and lightning, whirlwinds.

People on top of trees which cannot bear their weight, trees and rocks, towers, hills crowded with people, boats, tables, troughs and other contrivances for swimming, hills covered with men and women and animals, and flashes from the clouds which light everything up.[582]

Water that leaps up . . . Vortices of winds and rain with branches and trees caught up in the air. Emptying the boats of rainwater.

The Deluge and its display in painting

Let there first be represented the summit of a rugged mountain with a number of valleys surrounding the base, and on its sides let the surface of the soil be seen heaving up and dislodging the fine roots of low shrubs and freeing itself of a great many of the surrounding rocks. Wreaking havoc in its downward course let such a landslide go turbulently on striking and laying bare the twisted and gnarled roots of great trees as it overturns and destroys them. And let the mountains as they lay themselves bare reveal the deep fissures made in them by ancient earthquakes. And let the foot of the mountains for the most part be earthed up and clad in the debris of the shrubs hurled from the sides of the high peaks of the aforesaid mountains, and let these be mixed through with mud, roots and boughs of trees whose many leaves will be fused together with mud and earth and stones.

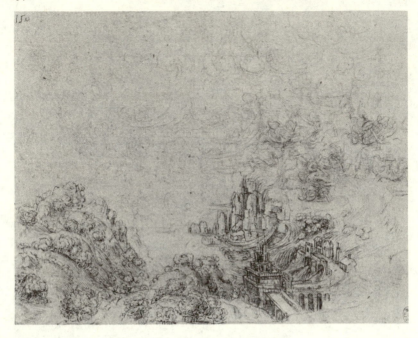

151. A flood breaking into a valley, and wind blowing away battle tents, Windsor, RL
12401.
'... the river bursts the dam and gushes out in high waves ... the biggest of these strike
and demolish the cities and country residences of that valley'

And let some mountains collapse headlong into the depths of a
valley and dam up the swollen waters of its river. But soon breached,
the river bursts the dam and gushes out in high waves. Let the biggest
of these strike and demolish the cities and country residences of that
valley. And let the disintegration of the high buildings of the said cities
raise much dust which will rise up like smoke or wreathed clouds
through the descending rain.

Let the pent up water go coursing round the vast lake that encloses
it with eddying whirlpools that strike against various objects and re-
bound into the air as muddied foam, which, as it falls, splashes the
water that it strikes back up into the air. The waves that in concentric
circles flee the point of impact are carried by their impetus across the
path of other circular waves moving out of step with them, and after
the moment of percussion* leap up into the the air without breaking
formation. And at the point where the water issues from this lake the
spent waves can be seen spreading out towards their own means of
escape, beyond which point as they fall or rather descend through the

air they acquire weight and impetus, and then, assaulting the water [in the lake below], split it open and furiously strike home to its depths; whence reflected, the water rebounds to the surface of the lake accompanied by the air which was submerged with it. And this remains as bubbling foam, and is intermingled with timber and other items lighter than water. Around these begin the waves that ripple out in ever increasing circles in proportion to the motion they have acquired, and this motion causes them to become so much shallower to the extent that they acquire a greater amplitude, and for this reason they become almost imperceptible as they die away. But if the waves strike against any object, they then rebound on top of the advent of the other waves, following the same increase in curvature which they would have possessed in performing their former primary motion.[583]

People were to be seen eagerly laying in provisions on board various kinds of craft that had, of necessity, been hastily constructed.

The highlights on the waves were not visible in those places where the murky rainclouds were reflected.

But where the flashes generated by the heavenly bolts were reflected, there were seen as many brilliant lights caused by the images* of the flashes as there were waves that could reflect them into the eyes of those around.

The number of images produced by the flashes of lightning upon the waves of the water increased the more their distance from the eyes of the spectator increased.

And after the same manner, the number of these images decreased the closer they came to the eyes of the beholder. This is proved by the [degree of] definition of the brightness of the moon, and in our marine horizon, when the sun's rays are reflected there, where the eye that picks up the reflection is a long way off from the sea.[584]

You would see the dark and overcast air buffeted by the path of the various winds that are both shot through with continuous rain and studded with hail, as they carry hither and thither an infinite number of branches rent from uprooted trees and mixed with countless autumn leaves. You would see ancient trees uprooted and torn apart by the fury of the winds; and the collapse of mountains, already undermined by the coursing of their rivers, crashing down on to these same rivers and sealing off their valleys. And the rivers thus pent up were flooding out and submerging a great many lands and their inhabitants. Again, you might have seen many diverse kinds of animals huddled together on the summits of many mountains, terrified and broken, at last, like domestic beasts, in company with the men and women who had fled there with their children. And the waves atop the submerged fields were for the most part to be seen covered with tables, bedsteads, boats and various other contraptions fashioned out of necessity and fear of death. Scattered on top of these amid much

weeping and wailing were men and women and children, all terror-
striken by the fury of the winds which with tempestuous gusts were
churning the waters under and over and all around the corpses which
had met their death by drowning. And there was no thing lighter than
the water that was not covered with various animals, who having
made a truce, now huddled together in fearful union. Among these
were wolves, foxes, serpents and all manner of fugitives from death.
And all the waves that dashed against their shores were beating with
blows of varying intensity from all the different drowned bodies, and
these blows killed those in whom any life remained. You might have
seen some group of men who, weapons in hand, were defending the
tiny spots (that remained to them) against the lions, wolves and savage
beasts that sought safety there. Oh what fearful noises were heard
throughout the dark air as it was pounded by the fury of the discharg-
ed bolts of thunder and lightning that violently shot through it to
strike whatever opposed their course. Oh, how many might you have
seen covering their ears with their hands in abhorrence of the uproar
caused throughout the gloomy air by the raging, rain-soaked winds,
the thunder of the heavens and the fury of the fiery bolts. For others,
the mere closing of their eyes was not enough. By placing their hands
one over the other they more effectively covered them in order not to
see the pitiless slaughter of the human race by the wrath of God. Oh,
how much weeping and wailing! Oh, how many terrified beings
hurled themselves from the rocks!

Huge branches of great oaks could be seen weighed down with men
and borne through the air by the fury of the impetuous winds. How
many capsized boats there were with people atop both those still
sound and those in pieces, toiling for means of escape with painful
actions and sad gestures that presaged awful death! Others, with
gestures of hopelessness were taking their own lives in despair of
being able to bear such grief, and of these, some were flinging
themselves from high rocks. Others were strangling themselves with
their own hands, while yet others seized their own children and in an
instant dashed them to their death. Some wounded themselves with
their own weapons and took their own lives. Others were falling upon
their knees and commending themselves to God. Oh how many
mothers wept for the drowned children they held upon their knees,
their arms raised towards heaven as they voiced their shrieking curses
and remonstrated against the wrath of the gods. Others, crouched for-
ward with their breast touching their knees in their hugely unbearable
grief gnawed bloodily at their clasped hands and devoured the fingers
they had locked together. Herds of animals such as horses, oxen, goats
and sheep, could be seen already encircled by the waters and left
marooned on the high peaks of the mountains. Now they would be
huddled together, with those in the middle clambering up on top of

the others, and all scuffling fiercely amongst themselves. A good many
of them were dying from lack of food. And the birds had already
settled upon men and other animals, finding no uncovered land that
was not occupied by living creatures. Already hunger, the minister of
death, had taken the lives of a great many of the animals by the time
corpses, now fermented, were rising from the bottom of the deep and
breaking the surface of the water. Beating one against the other among
the contending waves like inflated balls bouncing back from the spot
where they have struck, they came to rest on the aforementioned
bodies of the dead animals. And above these accursed horrors the air
was seen covered with dark clouds ripped apart by the jagged course
of the raging bolts from heaven that flashed their light now here now
there amid the obscurity of the darkness.[585] The air was darkened by
the heavy rain that, driven aslant by the crosswinds and wafted up and
down through the air, resembled nothing other than dust, differing
only in that this inundation was streaked through by the lines that
drops of water make as they fall. But its colour was tinged with the
fire engendered by the thunderbolts that rent and tore the clouds

152. Neptune with four sea-horses, Windsor, RL 12570.
'Neptune might be seen amidst the waters with his trident...'

asunder and whose flashes struck and split open the vast seas of the
flooded valleys, where the bowed tops of trees could be seen in the
bowels of their fissures. Neptune could be seen amidst the waters with
his trident, and Aeolus, enveloping in his winds the uprooted vegeta-
tion that bobbed up and down on the immense waves.[586]

How to represent a night scene

That which is wholly deprived of light is all in darkness. Such being the condition of night, if you wish to represent a night scene, have a great fire in it, for then the object which is closest to this fire will be most tinged with its colours, because that which is nearest to an object most shares in its nature. And in making the fire tend towards a red colour, make everything illuminated by it reddish in colour too. Those things which are furthest from this fire are more tinted by the black colour of the night. The figures which are drawn towards the fire appear dark against the brightness of the fire because the part of the object which you see is coloured with the darkness of the night and not by the brightness of the fire. Those who stand at the sides will be half dark and half reddish, while those who can be seen beyond the edges of the flames will all be lit by the reddish light against a black background. As for their gestures, show those which are near the fire shielding themselves with their hands and cloaks as protection against the intense heat, with their faces turned in the opposite direction as if to flee. Show many of those further away with their hands raised to their eyes which are smarting from the intolerable glare.[587]

EXAMPLES OF ALLEGORIES AND EMBLEMS:*
'FICTIONS THAT SIGNIFY GREAT THINGS'

[Pleasure and Pain]†

Pleasure and Pain are represented as twins because there is never one without the other just as if they were conjoined, and they are back to back because they are opposites.

Mud, gold.

If you choose Pleasure take heed that he has at his back one who will bring you Tribulation and Repentance.

This is Pleasure together with Pain, shown as twins, because the one is never separated from the other. They have their backs to each other because they are opposites. They share the same trunk because they have the same basis, inasmuch as the foundation of pleasure is labour and pain and the basis of pain lies in vain and wanton pleasures. Therefore here he is shown with a reed in his right hand which is useless and impotent and the wounds inflicted by it are poisonous. In

153. Allegories of Pleasure and Pain and of Envy, Oxford, Christ Church.
'Pleasure and Pain are represented as twins because there is never one without the other just as if they were conjoined; and they are back to back because they are opposites'

Tuscany they are used to support beds, signifying that there vain dreams are made and a great part of one's life consumed. There much useful time is wasted such as in the morning, when the mind is calm and relaxed and the body is ready to renew its labours. There also many vain pleasures are indulged, either by the mind imagining the impossible or by the body taking those pleasures which often result in a lack of vitality, and thus it is that the reed is used as support.[588]

[Envy]

This Envy is represented making an obscene gesture towards heaven for, if she could, she would use her powers against God. Show her with her face covered by a mask of fair appearance.

Show her as wounded in the eye by a palm and an olive branch, and wounded in the ear by laurel and myrtle, to signify that victory and virtue are injurious to her. Make many thunder bolts emanate from her to signify her evil speaking. Make her lean and wizened because she is fixed in perpetual torment. Show her heart as gnawed by a

154. Two allegories of Envy, Oxford, Christ Church.
'This Envy is represented making an obscene gesture towards heaven ... Make her ride
upon Death because Envy, never dying, never tires of holding sway. As soon as Virtue
is born it gives rise to Envy in opposition to it and sooner will there be a body without
a shadow than Virtue without Envy'

bloated serpent. Give her a quiver with tongues for arrows, for with
these she frequently wounds. Give her a leopard skin because the
leopard treacherously kills the lion out of envy. Let her have in her
hand a vase full of flowers, that is also full of scorpions and other
venomous creatures. Make her ride upon Death because Envy, never
dying, never tires of holding sway. Show her bridled and loaded down
with many weapons, all of them instruments of death ...

As soon as virtue is born it gives rise to Envy in opposition to it and
sooner will there be a body without a shadow than Virtue without
Envy.[589]

[Fame and Infamy]

With regard to Fame the entire figure should be shown covered in
tongues as opposed to feathers and in the shape of a bird.[590]

Fame flies and rises heavenwards because virtuous things find
favour with God. Infamy should be represented upside-down,

because all her works are contrary to God and are directed towards hell.[591]

155. Ill Repute, based on MS H1 50r.

Nothing is to be feared more than Ill Repute. This Ill Repute is born of vices.[592]

[Il Moro]

Il Moro⋆ in the guise of Good Fortune with his hair and robes and hands in front and Messer Gualtieri† coming towards him with a respectful gesture and taking him by the hem of his robes.

Again, Poverty, as a fearsome figure, running behind a young man and Il Moro covering him with the hem of his garment and with a gilded sceptre threatening the monster.

Grass with its roots uppermost to represent one who was at the end of his grace and favour.[593]

156. *The Unmasking of Envy*, Bayonne, Musée Bonnat.

Il Moro with spectacles and Envy depicted with False Report, and Justice black for Il Moro.

Labour with a screw in her hand.[594]

[Galeazzo]

The ermine with mud. Galeazzo★ between calm weather and the flight of fortune.† The ostrich which, with patience, gives birth to its young. Gold in bars is refined in fire.[595]

[Inventions for a pageant]

On the left side there will be a wheel whose centre should be placed in the centre of the hind quarter of the horse.★ And in the centre Prudence will appear dressed in red.

157. Sketches for an allegorical decoration to include a horse and rider ornamented with peacock feathers, based on MS BL 2500.

Charity is sitting on a bright throne† with a laurel branch in her hand to signify Hope which is born of serving well.

On the opposite side Fortitude will be similarly placed with her pillar in her hand and dressed in white to signify ...

And all crowned; and Prudence with three eyes.

The outer garment of the horse is to be plain gold cloth densely studded with peacocks' eyes. The whole of the horse's garment and that of the man should be like this. The man's crest and his chain should be of peacocks' feathers on a gold ground.

Above the helmet there will be a half globe, which represents our hemisphere, in the shape of the world. On top of this let there be a peacock with its tail fanned out over its rear, richly decorated. And every ornament belonging to the horse, will be made of peacock

feathers, on a gold ground, to signify the beauty that ensues from grace in him who serves well.

On the shield a large mirror to signify that he who truly desires favour should see himself reflected in his own virtues.[596]

'I never tire of being useful' is a motto for carnival.[597]

[Prudence and Strength]

Victory
Prudence Strength[598]

prudence strength

158. Design for a shield, based on MS H² 49v.

[An allegory of human misery]

On this side Adam, Eve on the other. O human misery, of how many things do you make yourself the slave for money!★[599]

[Ingratitude]

sun

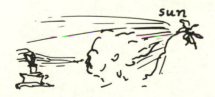

159. Ingratitude, based on MS BL 17300.

When the sun appears which dispels the general darkness, you extinguish the light which dispelled it locally for you, and conveniently for your need.[600]

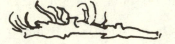

160. An attribute of Ingratitude, based
on MS BN 2038 34v.

Let this be placed in the hand of ingratitude.
Wood nourishes the fire that consumes it.[601]

[Truth and falsehood]

Truth　　　the sun
falsehood　　　a mask
innocence
malice
Fire destroys falsehood, that is, sophistry, and restores truth,
driving out darkness

　　　　　　　　　　　Truth

Fire destroys all sophistry, that is, deceit, and preserves truth alone,
that is, gold.
Truth, ultimately, cannot be hidden.
Dissimulation is of no avail. Dissimulation is thwarted before so
great a judge.
Falsehood puts on a mask.
Nothing [is] hidden under the sun.
Fire stands for truth because it destroys all sophistry and falsehood
and the mask is for deceitfulness and falsehood – concealer of
Truth.[602]
Here Truth makes Falsehood trouble lying tongues.[603]

[Liberty]

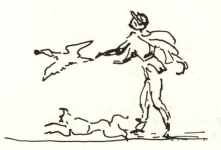

161. The falconer as an allegory of
Short Liberty, based on MS H^2
63v.

Short liberty.[604]

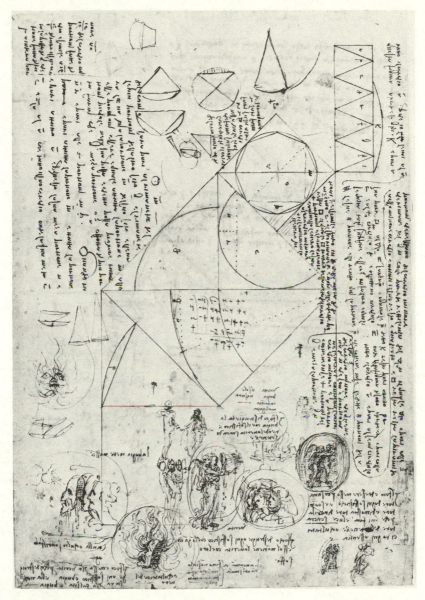

162. Geometrical figures and designs for allegorical representations of Truth and Falsehood, Windsor, RL 12700v.
'Fine stands for truth because it destroys all sophistry and falsehood and the mask is for deceitfulness and falsehood – concealer of Truth

[Hope]

I am still hopeful.

163. *Falcon tempo*, based on MS Forster II 63r.

A falcon.
Time.★605

164. Emblems of a caged bird (the *Calandrino*?), based on CA 68vb/190v.

One's thoughts turn to Hope.★606

[Fidelity]

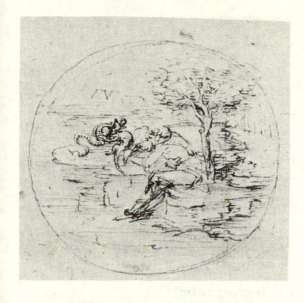

165. *Allegory of the Lizard Symbolizing Truth*, New York, Metropolitan Museum.

The lizard is faithful to man and when he sees him asleep fights with the snake and if it sees that it cannot conquer, it runs across the face of the man and wakens him so that the snake will not harm him as he sleeps.[607]

166. The faithful dog, based on MS H¹ 40v.

Not to disobey.[608]

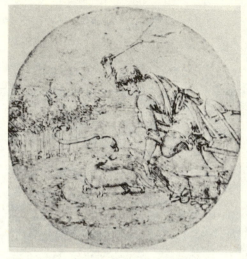

167. *The Ermine as a Symbol of Purity*, London, Private Collection.

The ermine would rather die than soil itself.*[609]

[Regeneration]

168. The sprouting trunk, based on MS Forster II 63r.

A severed tree which shoots forth again.[610]

[Unity]

169. The sieve as an allegory of unity, based on MS H³ 150v.

'I do not fall, through being united'[611]

Part VI:

LEONARDO'S ARTISTIC CAREER

LETTERS FROM LEONARDO

To Ludovico Sforza, *c.* 1481–2*

My Most Illustrious Lord, having now sufficiently seen and con-
sidered the achievements of all those who count themselves masters
and artificers of instruments of war, and having noted that the inven-
tion and performance of the said instruments is in no way different
from that in common usage, I shall endeavour, while intending no
discredit to anyone else, to bring myself to the attention of Your Ex-
cellency for the purpose of unfolding to you my secrets, and thereafter
offering them at your complete disposal, and when the time is right
bringing into effective operation all those things which are in part
briefly listed below:

1. I have plans for very light, strong and easily portable bridges
with which to pursue and, on some occasions, flee the enemy, and
others, sturdy and indestructible either by fire or in battle, easy and
convenient to lift and place in position. Also means of burning and
destroying those of the enemy.

2. I know how, in the course of the siege of a terrain, to remove
water from the moats and how to make an infinite number of bridges,
mantlets and scaling ladders and other instruments necessary to such
an enterprise.

3. Also, if one cannot, when besieging a terrain, proceed by bom-
bardment either because of the height of the glacis or the strength of
its situation and location, I have methods for destroying every fortress
or other stronghold unless it has been founded upon a rock or so forth.

4. I have also types of cannon, most convenient and easily portable,
with which to hurl small stones almost like a hail-storm; and the
smoke from the cannon will instil a great fear in the enemy on account
of the grave damage and confusion.

5. Also, I have means of arriving at a designated spot through mines
and secret winding passages constructed completely without noise,
even if it should be necessary to pass underneath moats or any river.

6. Also, I will make covered vehicles, safe and unassailable, which
will penetrate the enemy and their artillery, and there is no host of arm-
ed men so great that they would not break through it. And behind these
the infantry will be able to follow, quite uninjured and unimpeded.

170. Scythed chariot and armoured cars, London, British Museum 1860–6–16–99.
'...I will make covered vehicles, safe and unassailable, which will penetrate the enemy
and their artillery ... In short, as the variety of circumstances dictate, I will make an in-
finite number of items for attack and defence...'

7. Also, should the need arise, I will make cannon, mortar and light
ordnance of very beautiful and functional design that are quite out of
the ordinary.

8. Where the use of cannon is impracticable, I will assemble
catapults, mangonels, trebuckets† and other instruments of wonderful
efficiency not in general use. In short, as the variety of circumstances
dictate, I will make an infinite number of items for attack and defence.

9. And should a sea battle be occasioned, I have examples of many
instruments which are highly suitable either in attack or defence, and
craft which will resist the fire of all the heaviest cannon and powder
and smoke.

10. In time of peace I believe I can give as complete satisfaction as
any other in the field of architecture, and the construction of both
public and private buildings, and in conducting water from one place
to another.

Also I can execute sculpture in marble, bronze and clay. Likewise
in painting, I can do everything possible as well as any other,
whosoever he may be.

Moreover, work could be undertaken on the bronze horse‡ which

will be to the immortal glory and eternal honour of the auspicious
memory of His Lordship your father, and of the illustrious house of
Sforza.

And if any of the above-mentioned things seem impossible or im-
practicable to anyone, I am most readily disposed to demonstrate them
in your park or in whatsoever place shall please Your Excellency, to
whom I commend myself with all possible humility.[612]

To Ludovico Sforza [?], c. 1494

Most Illustrious and Excellent Lord,

Your most faithful servants Giovanni Ambrogio de Predis and
Leonardo da Vinci the Florentine have covenanted with the members
of the Confraternity of the Immaculate Conception of S. Francesco in
Milan to undertake for them the complete gilding of the figures in
relief of an altarpiece, and to make a picture of Our Lady painted in
oil* and two pictures with two large angels, similarly painted in oil
with the provision that two of the said members of the confraternity
and the priest Brother Agostino as third [party] should be appointed
to give a valuation of the said works.

The valuation was done, and, as the expenses in producing the
works amounted to more than 800 *libre de imperiali*, the members of the
confraternity should have been obliged to reimburse the said peti-
tioners to an amount in excess of the said 800 *libre* as would be agreed
upon by the three.

And notwithstanding that the said two works [i.e., the panel paint-
ings and the decoration of the carved sections] have a value of 300
ducats, as is apparent from a list furnished by the petitioners for the
said members, and which the said petitioners had lodged with the said
commissioners, they [the members] swear by their valuation and do
not want to do anything with fairness, wishing as they do to value the
said Our Lady done in oils by the said Florentine at only 25 ducats,
albeit that it may be valued at 100 ducats as is seen by the petitioners'
list, and this price of 100 ducats has been offered by persons who wish-
ed to buy the said Our Lady: wherefore, the petitioners are constrain-
ed to have recourse to Your Lordship.

They [the petitioners] humbly beseech Your Excellent Lordship
that – taking note of the foregoing and seeing that the said members
[of the confraternity] are not expert in such matters and that the blind
cannot judge colours – it should be granted without further lapse of
time either that the three commissioners should provide the [true]
valuation of the two said works in accordance with their oath; or that
there should be appointed two valuers expert in such matters, namely
one for each party, who are required to value the said two works, and

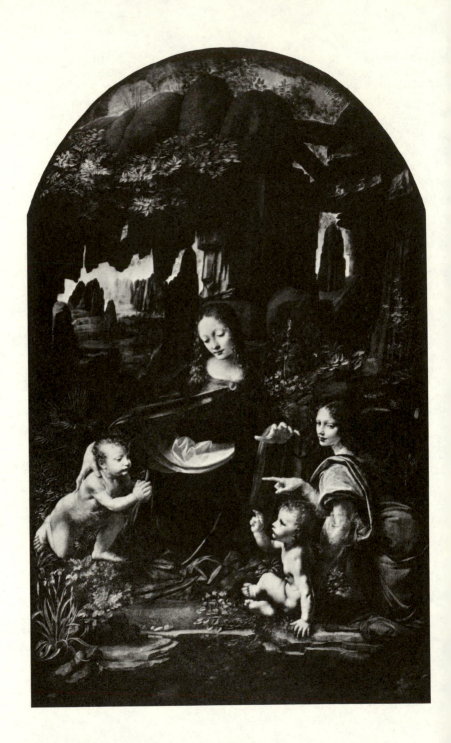

according to this same valuation the said members should satisfy the said petitioners; or that these members leave to the executants the said Our Lady done in oils (considering that the [work on the] sculpted parts of the altarpiece alone amounts to 800 *libre de imperiali* which the said petitioners have received and which have gone on expenses as above) as is just and fitting. And they believe that Your Lordship will be so minded and they commend themselves to You.

Petition of Giovanni Ambrogio de Predis and
Leonardo da Vinci the Florentine[613]

To Ludovico Sforza, *c.* 1495-7*

And if you give me any further commission of any...
of the reward of my service, because I am not to be of...
assignments, because they have receipts [?] for...
which they can better arrange than I...
not my art which I want to change and...
given some clothing if I name a sum...
My Lord, knowing Your Excellency's mind to be occupied...
to remind Your Lordship of my small matters and I should have maintained silence...
that my silence should have been the cause of making Your Lordship angry...
my life in your service. I hold myself ever in readiness to obey...
of the horse I shall say nothing because I know the times...†
to your Lordship how I was still 2 years salary in arrears from...
with 2 masters who were continuously maintained at my expense...
that in the end I found myself 15 lire out of pocket over the said work...
works of renown by which I could show to those to come that I have been...
does for everything. But I do not know where I could expend my labours...
my having expected to earn my living...
through not being informed as to what condition I find myself in...
remember the commission to paint the small rooms...‡
I brought to your lordship, only requesting from you...[614]

171. Facing: *Virgin of the Rocks*, Paris, Louvre.
'Giovanni Ambrogio de Predis and Leonardo da Vinci the Florentine have covenanted with the Confraternity of the Immaculate Conception of S. Francesco in Milan to make for them an altarpiece, with figures in relief and completely gilded, and a picture of Our Lady painted in oil...'

I very much regret that the need to earn my living has forced me to break off from pursuing the work which Your Lordship had entrusted to me. But I hope in a short time to have earned enough as to be able with renewed heart to satisfy Your Excellency, to whom I commend myself. If Your Lordship believed that I had money, then Your Lordship was deceived, because I have had six mouths to feed for 36 months, and have had 50 ducats...
Perhaps Your Excellency did not entrust anything further to Messer Gualtieri,* thinking that I had money...[615]

To the Signori padri diputati of Milan Cathedral, c. 1487–8*

Signori padri diputati, just as it is necessary for doctors who are the guardians of the sick, to understand what man is, what life is and what health is and in what way a balance and harmony of these elements maintains it, and how similarly when these are out of harmony it is ruined and destroyed, and whoever has a good knowledge of the aforesaid characteristics will be better able to heal than he who is lacking in it.

You know that medicines when well used restore health to the sick. Good practice is when the doctor, together with an understanding of their nature, also understands what man is, what life is, what constitutes the temperament and thus, health. When these have been well understood, he will also understand their opposite, and when this is the case he will well know how to heal ...

The very same is required by an ailing cathedral, that is, a doctor-architect who well understands what a building is, and from what rules correct building derives, and from where such rules are drawn and into what number of parts they be divided, and what are the causes whereby the building is held together, and is made to endure, and what is the nature of weight and the propensities of force, and how these are apportioned and related to each other, and when joined, to what effect do they give rise. Whoever shall have understanding of the above mentioned things will leave you satisfied both to his theory and his practice.

Therefore in view of this I shall endeavour, without disparaging or ... defaming anyone ... to satisfy you, partly with theory and partly with practice, sometimes showing effects from causes, sometimes affirming principles with experiments, making use, as is convenient, of the authority of the ancient architects, the evidence of the buildings constructed, and what were the reasons for their destruction or their endurance.

And by these means will be shown the first rule of load-bearing, and

which and how many are the reasons that spell ruin for buildings, and by what means do they achieve their stability and permanence.

But to avoid prolixity to your Excellencies I shall first of all describe the invention of the first architect of the cathedral, and shall clearly show you what he had in mind, confirming what I say with the building as already constructed, and by making you understand this you will be able to recognise clearly that the model I have made in itself possesses that symmetry, that correspondence and that conformity which belong to the building already begun.

Either I or another who may expound it better than I – choose whichever – set aside all partiality.[616]

To the Magnifici fabbricieri of Piacenza Cathedral, c. 1493*

Magnifici fabbricieri, understanding that your Magnificencies have taken the decision to commission certain great works in bronze, may I remind you of the following: firstly, that you should not be so quick or so hasty in giving the commission that the very speed itself removes the means of arriving at a good choice of subject and of master. Some man may be chosen who by reason of his inadequacy may cause your descendants to revile you and your age,† judging that this epoch was badly provided with men of good judgement or good masters. We see that other cities and especially the city of the Florentines have, more or less in modern times, been endowed with such beautiful and great works in bronze amongst which are the doors of their baptistery. And Florence, like Piacenza, is a point of interchange where many foreigners converge. When they see her beautiful works of fine quality, they all acquire the one impression: that they see the city is endowed with worthy inhabitants, the works they see testifying to that opinion. On the contrary, I say that to see so much expenditure of metal so piteously wrought that it would be of less shame to the city if those doors were of plain wood, since the modest outlay on the material would not appear deserving of great expenditure of skill…

The main parts of cities that one seeks out are the cathedrals, of which the first features that appear to the eye as one approaches them are the doors whereby entrance is gained.

Have a care, Signori fabbricieri, lest the excessive haste of your desire to dispatch promptly the commission of such a great work as I hear that you have ordered be the cause of turning that which is done to the honour of God and of men into the great dishonour of your own judgements, and of your own city, which being a place of note and interchange is the gathering place of a number of foreigners. And this dishonour would be occasioned if, by your negligence, you were

to put your faith in some braggart who by his wiles or by the favour
shown to him here should impetrate from you such work as would
beget very great and lasting shame to himself and to you. Thus I cannot
but be troubled when I recall what manner of men have spoken with
me about their intention to enter into such an undertaking without heed
to their capability, to say the least. One is a potter, another an armourer,
another a bell-ringer, one is a maker of bells for harnesses, and there is
even a bombardier. Also among them is one of the Duke's household
who boasts among other things that he is a familiar of Messer Am-
brogio Ferere who is a man of some influence and from whom he has
fair expectations. And if this would not carry it, he would go on
horseback to the Duke and entreat from him such letters [of recommen-
dation] that you would never be able to refuse him work of this calibre.
Oh, consider to what point are the impoverished and conscientious
who are qualified to do such work reduced when they are to compete
with such men. With what hope can they look for a reward for their
merit? Open your eyes and look well to it that your money is not spent
in purchasing your own shame. I can assure you that from this region
you will only procure indifferent works by cheap and coarse masters.
Here there is no man of merit, believe me, except Leonardo the Floren-
tine who is making the Equestrian statue of the Duke Francesco in
bronze but there is no need to consider him, for he has enough to do
to last him the rest of his life. And I doubt, since it is so great a work
whether he will ever finish it.[617]

To Ippolito d'Este, 1507

My Most Illustrious and Most Reverend Lord, Don Ippolito, Cardinal
of Este and Most Respected Highness in Ferrara.
 My Most Illustrious and Most Reverend Lord,
 Being but a few days since arrived from Milan and finding that my
elder brother will not comply with the terms of a will made three years
ago when our father died, and although my motive is no less than to
do myself justice in a matter I consider important to me, I cannot
forbear to request of Your Most Reverend Highness a letter of recom-
mendation and favour to Ser Raffaello Hieronymo, who is at present
one of our exalted members of the Signoria among whom my case is
being argued, and has more particularly been referred by His Ex-
cellency the Gonfaloniere* into the hands of the aforesaid Ser
Raffaello. His Worship must come to a decision and close the case
before the Feast of All Saints. And therefore, My Lord, I beseech you
as earnestly as I know how and am able that Your Highness will write
a letter to the said Ser Raffaello in the adoit and effective manner that
is Your own, recommending Leonardo Vincio your most devoted

servant, as I consider myself and always wish to remain, urging and pressing that he may do me justice and with fair haste. And I have no doubt at all, from the many reports I have had that, Ser Raffaello being held in great affection by Your Highness, the matter will proceed *ad votum*. And this I shall attribute to the letter of Your Most Reverend Highness, to whom, once more, I commend myself. *Et bene valeat*.

Florence 18th September 1507
Of Your Most Excellent and Most Reverend Lordship
Your humble servant and painter,
Leonardo da Vinci[618]

To Charles d'Amboise,★ *c.* 1508

I am wondering whether the slight return I have made for the great benefits received from Your Excellency may not have made you somewhat angry with me, and that this is the reason why I have never had a reply to the many letters I have written to Your Lordship. I am now sending Salai† to you to explain to Your Lordship that I am almost at the end of my litigation with my brothers, and that I expect to find myself with you this Easter, and to bring with me two pictures of ... Our Lady, of different sizes, which have in my own time been brought almost to completion for our own most Christian King, or for whomsoever Your Lordship pleases. I should dearly like to know where upon my return to you I might have lodgings, for I should not like to trouble Your Lordship further. And also whether having worked for the most Christian King, my salary is to continue or not. I am writing to the President, concerning that stretch of water which was granted to me by the King and which I was not put in possession of because at the time the level was low in the canal by reason of the great droughts and because its sluice gates were not regulated. But he certainly promised me that once they had been regulated I should be put in possession of them. I therefore beseech Your Lordship, if it shall not inconvenience you, now that the gates are regulated, to remind the President of my suit, that is, to give me possession of this water for on my arrival I hope to set up my mechanical devices and things which will greatly please Our Most Christian King. I have nothing further to add. I am always at your command.[619]

To Francesco Melzi,★ *c.* 1508

Good day Messer Francesco, God knows why of all the letters that I have written to you, you have never replied. Just wait till I am with

you, by God, and I shall make you write so much that perhaps then you will be sorry.

My Dear Messer Francesco, I am sending thither Salaì† to find out from His Magnificence the President what the outcome is in regard to the regulation of the water which on my departure was ordered for the sluice gates of the canal, because the Magnificent President promised me that as soon as the regulation was carried out my business should be expedited. Now it is some time since I have heard that the canal has been adjusted and likewise its sluice gates, and I immediately wrote to the President and to you, and I wrote again, but never had a reply. Therefore be so good as to let me know what has happened and unless it is on the point of being resolved, do not forbear, for my sake, to press the President a little, and similarly Messer Girolamo Cusano to whom please commend me and offer my respects to His Magnificence.[620]

To Guiliano de' Medici,★ c. 1515

I am so much rejoiced Most Illustrious lord at the desired restoration of your health that my own illness has almost left me. But I very much regret not having been able wholly to satisfy the wishes of Your Excellency, through the malice of that German deceiver, for whom there is nothing I have failed to do in an attempt to please him.

First of all his salary was paid to him immediately in advance, which I believe he would willingly deny if I did not have the written testimony of the interpreter.[621]

He said he had been promised eight ducats per month from the first day that he set out, or at the latest when he spoke with you and you accepted him.[622] I have ascertained that he works for everybody, and that his workshop is open to the general public. For this reason I do not want him to work for me on a salaried basis, but for him to be paid for the pieces of work he does produce for me, and since his workshop and lodgings are provided by Il Magnifico† he should be obliged to put the works of Il Magnifico before everything.[623]

Seeing that he did not work for me unless he lacked work from others, something he was eager to seek out,[624] I invited him to lodge and board with me for which purpose I had a bench placed at the foot of one of these windows where he could file and finish off the things made below, and thus I would see constantly the work he was doing and it could easily be corrected. And besides this he would learn the Italian language which would allow him to speak fluently without an interpreter.[625] He always promised but would never do it.[626]

...I arranged for him to be told that if it pleased him I would

negotiate with him for each thing that he made and I would give him what we agreed was its value.[627]

I did this also because that young German the mirror-maker was there every day in the workshop wanting to see and to know all that was going on, and would broadcast it about, censuring what he did not understand.[628] I cannot make anything in secret because of him as the other is always at his elbow, since the one room leads into the other.[629]

And I did it because he used to eat with the Swiss Guard and would afterwards go out with them in a gang, with muskets killing birds among the ruins, and it would go on like this from early afternoon until evening. And if I sent Lorenzo to press him for work, he would become irritated and say that he would not have so many masters over him and that his work was for Your Excellency's Household. It went on like this for two months, and then one day, coming upon the Superintendent of the Household I asked him whether the German had finished the work for Il Magnifico and he told me that this had not been the case, but that he had only been given two muskets to clean. Later, because I was pressing him, he left the workshop and began to work in his room, and he wasted a lot of time in making another vice and files and other tools with screws. And there he made spindles for twisting silk which, whenever any of my people entered, he would hide, with a thousand oaths and rebukes so that none of them wanted to go in any more.

Then he asked to have the models finished in wood just as they were to be in iron, and he wanted to take those back to his own country. But this I refused him, saying that I would give him a drawing with the breadth, length, height and shape of what he had to do. And so we remained at variance.

In the end I found out that this Master Giovanni the mirror-maker was the one who had done it all, for two reasons. The first was because he had been saying that my arrival deprived him of the countenance and favour of Your Lordship ... The other is that the room of this ironworker, he said, suited him for mirror-making and of this he gave me proof. Over and above making me the enemy of that fellow, he made him sell up and leave his workshop to him, where he produces, along with many workmen, a good many mirrors to send to the fairs.[630]

This other has hindered me in anatomy, censuring it before the Pope and likewise at the hospital, and he is filling this whole Belvedere with workshops for mirrors, and workmen, and he has done just that in Master Giorgio's room...[631]

His whole intention was to get possession of those two rooms for his mirror-making.[632]

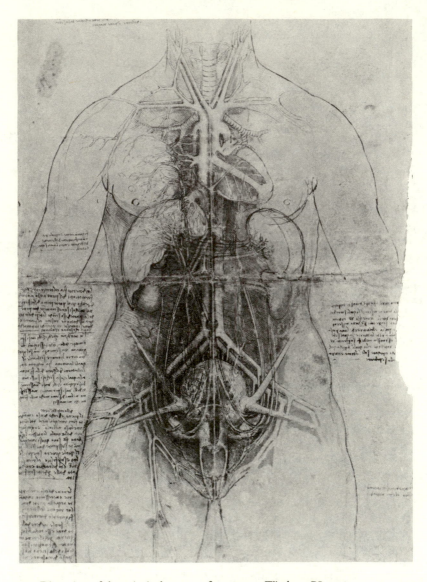

172. Dissection of the principal organs of a woman, Windsor, RL 12281r.
'This other has hindered me in anatomy censuring it before the Pope and likewise at the hospital'

MEMORANDA

tell me...[633]
tell me how...[634]
tell me if ever...*[635]
tell me how things are done...[636]
tell me how things went...[637]
tell me if anything was ever done...[638]
tell me if ever, tell me if ever anything was built in Rome[639]

Professional (in chronological order)

A head, full face, of a youth with beautiful hair
Many flowers portrayed from nature
a head, full face, with curly hair
certain [figures of] St Jerome
the proportions of a figure
drawings of furnaces
a head of the Duke
Many drawings of knots
4 drawings for the panel of the Holy Angel
a small narrative painting of Girolamo da Fegline
a head of Christ done in pen
8 Saint Sebastians
Many compositions of angels
a chalcedony
a head in profile with beautiful hair
certain bodies [drawn] in perspective
certain devices for ships
certain devices for water
a head portraying Atalante* who raises his face
the head of Geronimo de Fegline
the head of Gian Francesco Boso
many throats of old women
many heads of old men
many complete nude figures
many arms, legs, feet and poses
an Our Lady, finished
another which is almost in profile†
the head of Our Lady ascending into heaven
a head of an old man with a long chin
a head of a gypsy
a head wearing a hat

a cast of a narrative depicting the Passion
a head of a girl with knotted braids
a head with an [elaborate] hairstyle[640]

In the one at Pavia [i.e., the Roman equestrian monument, *Il Regisole*]★ the movement is to be praised more than anything else.

The imitation of the antique is more praiseworthy than that of the modern.

Beauty and utility together cannot be as is evident in fortresses and in men.

The trot has almost the quality of that of a free horse.

Where natural vivacity is lacking it is necessary to supply it.[641]

On the 2nd April 1489 a book entitled 'On the Human Figure'.[642]

Caterina came on the 16th July 1493.
Messer Mariolo's Florentine morel is a big horse★ with a beautiful neck and a very fine head.
The falconer's white stallion has fine hind quarters: it is kept behind the Comasina Gate.[643]

Cristofano da Castiglione★ lives at the Pietà and has a fine head.[644]

Guiliano da Marian, the physician, has a steward without a hand.[645]

Alessandro Carissimo of Parma★ for the hand of Christ.[646]

Giovannina with the fantastic face lives at Santa Caterina at the hospital.[647]

The young Count.★ The one with the Cardinal of Mortaro.[648]

When I made a Christ Child you put me in gaol. Now, if I depict him as an adult you will do worse to me.★[649]

On Friday, in June, at the 13th hour.
On the 6th June 1505, a Friday, on the stroke of the thirteenth hour,★ I began to paint in the palace.† At the very moment of laying down the brush, the weather broke and the bell started to toll, calling the men to the court, and the cartoon came loose, the water spilled, and the vessel which had been used for carrying it broke. And suddenly the weather broke and the rain poured until evening and it was as dark as night.[650]

Begun in Florence in the house of Piero di Braccio Martelli, on the 22nd of March 1508: and this will be a collection without order, drawn from many pages which I have copied here, hoping to put them in order in their places, according to the subjects with which they will

deal, and I believe that before I am at the end of this, I will have to repeat the same thing many times – for which do not blame me, reader, because the topics are many and memory cannot retain them all and say 'I will not write this because it is written before'. And if I wished not to fall into this error, it would be necessary that in every case which I wished to copy, in order not to duplicate it, I would always have to reread all the preceding material, and all the more so because of the long intervals of time between the writing of one thing and the next.[651]

In the winter of this year, 1510, I hope to complete all this anatomy.[652]

Finished on the 7th of July (1514) at the 23rd hour★ in the Belvedere in the studio provided for me by the Magnifico.[653]

The medici★ made me and destroyed me.[654]

Reserve until the end of my book on shadows the figures which could be seen in the writing room of Gherardo the illuminator★ at San Marco in Florence.[655]

The Ligny memorandum, *c.* 1499

Find Ligny★ and tell him that you will wait for him in Rome and that you will go with him to Naples; see that the donation is made to your name; take the book by Witelo,† and the measurements of the public buildings; have two boxes made; muleteers' blankets, though the bedcovers would be better, of which there are three, and one of which I shall leave at Vinci; take the braziers from the *Grazie*; get from Giovanni Lombardo the [plan of?] the theatre of Verona; buy some tablecloths, and napkins, cloaks, caps and shoes, four pairs of hose, a doublet of chamois and skins to make new ones; the lathe of Alessando; sell whatever cannot be carried; get from Jean de Paris the method of colouring *a secco* and the white salt method, and how to make coated paper; single sheets and many doubles; and his box of colours; learn how to make *cornage tempera*, learn how to dissolve gum lac, take the seed of *fotteragi*, and parsnips, garlic from Piacenza, take *De Ponderibus*; take the works of Leonardo of Cremona; remove Giannino's little furnace. Take the seed of lillies and common lady's mantle, and red bryony, sell the scaffolding, make the one who stole it give you the brazier, and take the tools for surveying, how much ground can one man dig in a day?[656]

Workshop and household

Giacomo* came to live with me on St Mary Magdalen's day, 1490, aged 10 years. On the second day I had two chemises cut out for him, a pair of hose, and a doublet, and when I put to one side the money to pay for these things, he stole it out of my purse *4 lire*†
and it was never possible to make him confess to it, although I was quite certain of the fact – thief, liar, obstinate, glutton.

The following day I went to dinner with Giacomo Andrea‡ and the aforementioned Giacomo ate enough for two and misbehaved for four, for he broke three cruets, spilled the wine and after this came over to eat where I...

Also on the 7th of September he stole from Marco who was living with me a silver point worth 22 soldi. He took it from his workshop and then when the said Marco had searched high and low for it he found it hidden in the aforesaid Giacomo's box. *1 lire [2] s[oldi]*

Also on the 26th of January following I was in the house of Messer Galeazzo di San Severino to organise the festivities for his tournament and while some footmen were undressing in order to try on some costumes of savages, that were called for in the performance, Giacomo went up to the purse of one of them which was on the bed along with other clothes and removed such money as he found inside it.
 2 lire 4 s[oldi]

Also when I was presented by Maestro Agostino da Pavia in this same house with a Turkish hide with which to make a pair of ankle boots, this Giacomo stole it from me within a month and sold it to a cobbler for 20 soldi with which money, according to his own confession, he bought aniseed comfits. *2 lire*

Yet again, on the 2nd of April Gian Antonio left a silver point on top of one of his drawings and this Giacomo stole it and it was valued at 24 soldi. *1 lire 4 soldi*

The first year	
a cloak	*2 lire*
6 chemises	*4 lire*
3 doublets	*6 lire*
4 pairs of hose	*7 lire 8 s[oldi]*
1 lined garment	*5 lire*
4 pairs of shoes	*6 lire 5 s[oldi]*
a cap	*1 lire*
laces for belts	*1 lire*[657]

On Thursday the 27th of September, Maestro Tommaso came back, and worked on his own account until the penultimate day of February. On the 18th of March, 1493 Giulio Tedesco came to live with me. Antonio, Bartolomeo, Lucia, Piero, Leonardo.[658]

1493

On the first day of November we settled accounts. Giulio had four months to pay and Maestro Tommaso nine. Maestro Tommaso later made six candlesticks, 10 days; Giulio some tongs, 15 days; Giulio worked on his own account until the 27th of May and worked at making a [wooden] jack for me until the 18th of July, then for himself till the 7th of August. This was a half day for a lady, then he worked for me on two locks until the 20th of August.[659]

On the 23rd of August 12 lire from Pulisena; on 14th March 1494 Galeazzo came to live with me, agreeing to pay five lire a month for his keep, on the 14th day of each month.

His father gave me two Rhenish florins.

On the 14th of July I received two Rhenish florins from Galeazzo.[660]

Saturday morning, the 3rd of August 1504 Jacopo Tedesco came to live at my house. He agreed that I would charge him one *carlino*★ a day.[661]

1510

On the 26th of September Antonio broke his leg; he must rest it for 40 days.[662]

I left Milan for Rome on the 24th of September 1513 with Giovan Francesco Melzi, Salai, Lorenzo and Il Fanfoia.[663]

On the 3rd day of January

Benedetto came on the 17th October at four ducats a month; he was with me for two months and 13 days last year, during which time he earned 38 li[re] 18 s[oldi] 8 di[nari]. He has had 26 lire 8 s[oldi] and has still to receive for the last year 12 lire 10 s[oldi].

Joditti came on the 8th of September at four ducats a month. He was with me 3 months and 24 days; he earned 59 li[re] 14 s[oldi] 8 di[nari] and has had 43 lire 4 s[oldi]. He has still to receive 16 lire 10 [soldi] 8 di[nari].

Benedetto 24 *grosoni*★[664]

Record of the money I have had from the King as my salary from July 1508 till April next, 1509; first of all, 100 scudi, followed by another 100, then 70, then 50, and then 20; then 200 francs at 48 s[oldi] to the franc.[665]

CONTRACTS AND DOCUMENTS REGARDING COMMISSIONS

Contract for the Adoration of the Magi, July 1481

Leonardo di Ser Piero da Vinci has undertaken as of March 1480 [i.e., 1481] to paint a panel for our main altarpiece which he is obliged to have completed in 24 or at the most 30 months. And in the event of his not bringing it to completion he will forfeit that part of it which he has done, and we shall be at liberty to do as we please with it. For painting this altarpiece he is to have one third of a holding in Valdelsa which was formerly the property of Simone, father of Brother Francesco, who bequeathed it with the following injunction, that when three years have elapsed from the time of its completion we may buy it back for 300 *fiorini di sugello*,* and within this stipulated time he may not enter into any other undertaking about it. And he must supply his own colours, [and] gold, and meet any other expenses he might incur. And moreover he must pay from his own pocket the appropriate deposit into the Monte† to provide a dowry to the value of 150 *fiorini di sugello*, for the daughter of Salvestro di Giovanni.

– Fior[ini] 300

He has had 28 *fiorini larghi* in order to arrange the above-mentioned dowry on our behalf, because he says he does not have the means to pay, and time was elapsing and it was prejudicial to us.

– Fior[ini] 28 larghi

In addition he must pay for the colours obtained for him from the Ingesuati‡ which amounts to one and a half *fior[ini] larghi:* four L[ire] 2 sol[di] 4 din[ari].[666]

List of work to be undertaken on the Altarpiece of the Confraternity of the Immaculate Conception, 1483

Jesus*

List of the decorations to be applied to the altarpiece of the Conception of the Glorious Virgin Mary placed in the Church of S. Francesco in Milan.

First, we desire that [on] the whole altarpiece, namely the carved compartments together with the figures, but excepting their faces, everything is to be done in fine gold to the value of 3 libre 10 s[oldi] per leaf.

Also, that the cloak of Our Lady in the middle be of gold brocade and ultramarine blue.

Also, that the gown be of gold brocade and crimson lake, in oil

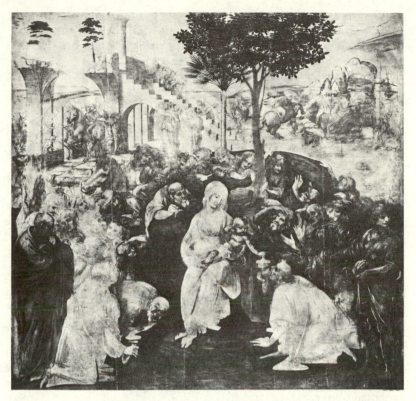

173. *Adoration of the Magi*, Florence, Uffizi.
'Leonardo di Ser Piero da Vinci has undertaken as of March 1481 to paint a panel for
our main altarpiece which he is obliged to have completed in 24 or at the most 30
months'

Also, the lining of the cloak to be gold brocade and green, in oil. Also, the seraphim done in sgraffito work.

Also, God the Father, to have a cloak of gold brocade and ultramarine blue.

Also, the angels above them to be decorated and their garments fashioned after the Greek style, in oil.

Also, the mountains and rocks to be worked in oil and differentiated with several colours.

Also, in the empty panels there are to be four angels, each differing from one picture to the other, namely one picture where they sing, another where they play an instrument.

Also, in all the other compartments where Our Lady may be, she shall be decorated like the one in the middle and the other figures are to be in the Greek style, decorated with various colours, in the Greek or the modern style, all of which shall be done to perfection; similarly the buildings, mountains, soffits, flat surfaces of the said compartments – and everything done in oil. And any defective carving to be rectified.

Also, the sybils to be decorated. The background to be made into a vault in the form of a housing [for the sybils] and the figures in garments differentiated from each other, all done in oil.

Also, the cornices, pilasters, capitals and all their carving done in gold, as specified above, with no colour thereon.

Also, on the middle panel is to be painted on the flat surface Our Lady with her son and the angels all done in oil to perfection with the two prophets painted on the flat surfaces in colours of fine quality as specified above.

Also, the plinth, decorated like the other internal compartments.

Also, all the faces, hands, legs, which are uncovered shall be painted in oil to perfection.

Also, in the place where the infant is, let there be put gold worked to look like *spinnchristi*.†[667]

Contract for the Battle of Anghiari, 1504

4th May 1504
... The Magnificent and Sublime Signori, the priors of Liberty and the Standardbearer of Justice of the Florentine people, considering that several months ago Leonardo, son of Ser Piero da Vinci, and a Florentine citizen, undertook to do a painting for the Sala del Consiglio Grande,★ and seeing that this painting has already been begun as a cartoon by the said Leonardo, he moreover having received on such account 35 *fior[ini] lar[ghi] d'oro* in gold, and desiring that the work be brought as soon as possible to a satisfactory conclusion and that the

said Leonardo should be paid a certain sum of money in instalments for that purpose they, the aforesaid Signori have resolved, etc., that the said Leonardo da Vinci is to have completely finished painting the said cartoon and brought it wholly to perfection by the end of February next (1504) [i.e., 1505] without quibble or objection and that the said Leonardo be given in the meanwhile in payment each month 15 *fior[ini] lar[ghi] d'oro* in gold, the first month understood as commencing on 20th April last. And in the event that the said Leonardo shall not, in the stipulated time, have finished the said cartoon, then the aforesaid Magnifici Signori can compel him by whatever means appropriate to repay all the money received in connection with this work up to the said date and the said Leonardo would be obliged to make over to the said Magnifici Signori as much as had been done of the cartoon, and that within the said time the said Leonardo be obliged to have provided the drawing for the said cartoon.

And since it might occur that the said Leonardo will have been able to begin painting on to the wall of the said Sala that part which he had drawn and submitted on the said cartoon, the Magnifici Signori, in that event, would be content to pay him a monthly salary befitting such a painting and as agreed upon with the said Leonardo. And if the said Leonardo thus spends his time painting on the said wall the aforesaid Magnific Signori will be content to prolong and extend the above-mentioned period during which the said Leonardo is obliged to produce the cartoon in that manner and to whatever length of time as will be agreed by the said Magnifici Signori and the said Leonardo. And since it might also occur that Leonardo within the time in which he has undertaken to produce the cartoon may have no opportunity to paint on the wall but seeks to finish the cartoon, according to his obligation as stated above, then the aforesaid Magnifici Signori agree that the painting of that particular cartoon shall not be commissioned from anyone else, nor removed from the said Leonardo without his express consent but that the said Leonardo shall be allowed to provide the painting when he is in a position to do so, and transfer it to paint on the wall for such recompense each month as they will then agree and as will be appropriate . . .

Drawn up in the palace of the said Magnifici Signori in the presence of Niccolò, son of Bernardo Machiavelli, Chancellor of the said Signori, Marco Zati and Ser Giovanni di Romena, Florentine citizen, witnesses etc.[668]

Letters from Fra Pietro da Novellara to Isabella d'Este, 1501

Your Most Illustrious, Excellent and Singular Lady;*
I have just received Your Excellency's letter and will carry out with

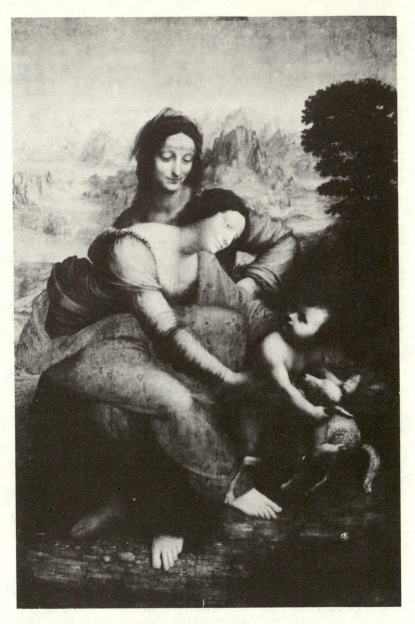

174. *Virgin, Child and St Anne*, Paris, Louvre.
'His mother, half rising from the lap of St Anne takes hold of the Child to separate him
from the lamb (a sacrificial animal) signifying the Passion'

all speed and diligence that which you instruct me to do. From what I gather, the life that Leonardo leads is haphazard and extremely unpredictable, so that he seems to live only from day to day. Since he came to Florence he has done the drawing of a cartoon.† He is portraying a Christ Child of about a year old who is almost slipping out of his Mother's arms to take hold of a lamb which he then appears to embrace. His Mother, half rising from the lap of St Anne takes hold of the Child to separate him from the lamb (a sacrificial animal) signifying the Passion. St Anne, rising slightly from her sitting position, appears to want to restrain her daughter from separating the Child from the lamb. She is perhaps intended to represent the Church which would not have the Passion of Christ impeded. These figures are life-sized but can fit into a small cartoon because all are either seated or bending over and each one is positioned a little in front of each other and to the left-hand side. This drawing is as yet unfinished. He has done nothing else save for the fact that two of his apprentices are making copies and he puts his hand to one of them from time to time. He is hard at work on geometry and has no time for the brush. I write this only to let Your Excellency know that I have received your letters. I shall carry out Your Excellency's commission and keep Your Excellency informed. I commend myself to Your Excellency and may God keep Her in his grace...

Florence, the 3rd of April 1501[669]

Your Most Illustrious, Excellent and Singular Lady,

During this Holy Week I have learned the intention of Leonardo the painter through Salai* his pupil and from some other friends of his who, in order that I might obtain more information, brought him to me on Holy Wednesday. In short, his mathematical experiments have so greatly distracted him from painting that he cannot bear the brush. However, I tactfully made sure he understood Your Excellency's wishes ... seeing that he was most eagerly inclined to please Your Excellency by reason of the kindness you showed to him at Mantua, I spoke to him freely about everything. The upshot was that if he could discharge himself without dishonour from his obligations to His Majesty the King of France as he hoped to do within a month at the most, then he would rather serve Your Excellency than anyone else in the world. But that in any event, once he has finished a little picture that he is doing for one Robertet,† a favourite of the King of France, he will immediately do the portrait and send it to Your Excellency. I leave him well entreated. The little picture which he is doing is of a Madonna seated as if she were about to spin yarn. The Child has placed his foot on the basket of yarns and has grasped the yarn-winder and gazes attentively at the four spokes that are in the form of a cross. As if desirous of the cross he smiles and holds it firm, and is unwilling

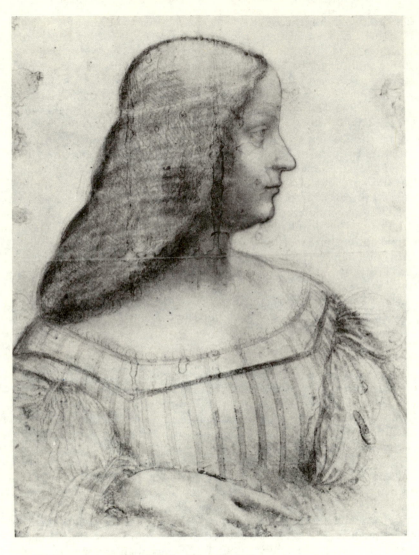

175. Half-Length portrait of Isabella d'Este, Paris, Louvre.
'...once he has finished a little picture ... he will immediately do the portrait and send it to your Excellency'

to yield it to his Mother who seems to want to take it away from him. This is as far as I could get with him. Yesterday I delivered my sermon.‡ May God be willing that it bears as much fruit as it was plentifully listened to...

Florence, the 14th day of April 1501[670]

THE END OF LEONARDO'S LIFE

The will

Let it be known to all persons present and to come that at the Court of Our Lord the King, at Amboise, and before ourselves in person, Messer Leonardo da Vinci, painter to the King, presently residing in the place known as Cloux, near Amboise, considering the certainty of death and the uncertainty of its hour, has acknowledged and avowed before us in the said Court that he has made and ordained accordingly as herein his last will and testament, as follows.

First, he commends his soul to Our Lord Almighty God, to the Glorious Virgin Mary, to Our Lord St Michael and to all the blessed Angels and Saints in Paradise.

Also, the said Testator wishes to be buried within the church of St Florentin at Amboise and that his body be borne there by its Chaplains.

Also, that his body shall be accompanied from the said place to the said church of St Florentin by the members of the college of the said church, that is, by the Rector and the Prior, or alternatively, by their Vicars and the Chaplains of the church of St Denis at Amboise, and also the Minorite brothers of the said place and before his body shall be carried to the said church, the Testator wishes that in the said church of St Florentin three high masses shall be celebrated with the participation of the deacon and sub-deacon, and on the day that the three high masses are celebrated, 30 low Gregorian masses are to be said.

Also, in the said church of St Denis a similar service to the above shall be performed.

Also, in the church of the said brothers and minor brethren, a similar service.

Also, the aforesaid Testator gives and bequeaths to Messer Francesco Melzi,* nobleman of Milan, in remuneration for services and kindnesses done to him in the past, each and all of the books of which the Testator is currently in possession, and other tools and depictions† connected with his art and the profession of painters.

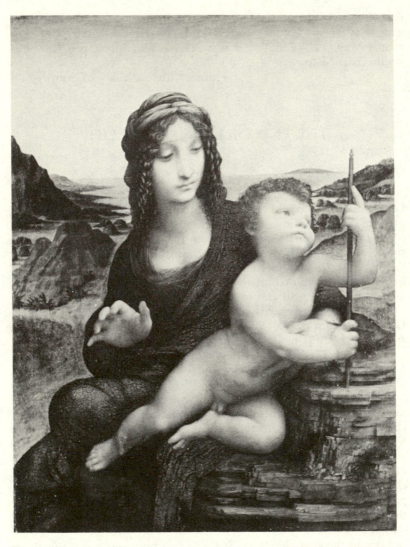

176. Leonardo and Studio, *Virgin and Child with a Yarn-winder*, Collection of Duke of Buccleuch and Queensberry.
'As if desirous of the cross he smiles and holds it firm, and is unwilling to yield it to his Mother who seems to want to take it away from him'

Also, the same Testator gives and bequeaths in perpetuity to Battista de Vilanis his servant, the half, that is, the moiety of the garden which he has outside the city of Milan, and the other half of his garden he gives to Salai, his servant, in which garden, the aforesaid Salai has built and constructed a house, which shall be and shall remain similarly in perpetuity the property of the said Salai, and of his heirs and successors, and this is in remuneration of the good and kind services which the said de Vilanis and Salai, his servants, have done him to this time.

Also the said Testator gives to Maturina, his maidservant, a garment of good black cloth, lined in skin, a woollen gown and two ducats paid once only, and this likewise is in remuneration for good service rendered to him by the said Maturina until now.

Also, he desires that at his funeral there be 60 tapers, to be carried by 60 poor men, to whom shall be given money for carrying them at the discretion of the said Melzi and these tapers are to be divided among the above-mentioned four churches.

Also, the said Testator gives to each of the aforesaid churches 10 pounds of wax in thick candles, to be placed in the said churches on the day on which the said offices are celebrated.

Also, that alms shall be given to the poor at the hospital, to the poor of Saint Lazare and Amboise and for this purpose the sum and amount of 70 *soldi tornesi*‡ shall be given and paid to the treasurers of that Confraternity.

Also, the said Testator gives and bequeaths to the said Messers Francesco Melzi, he being present and agreeing the remainder of his salary and the total sum of money which is owing to him from the past time till the day of his death by the Cashier, or Treasurer-General M. Johan Sapin, and each and every sum of money which he has received from the aforementioned Sapin of his said salary in the event that he shall be deceased before the said Melzi and not otherwise.

This money is at present in the possession of the said Testator in the said place called Cloux, as he says. And likewise he gives and bequeaths to the said Melzi each and all of the clothes which he presently possesses in the said place of Cloux, more in remuneration of the good and kind services done to him until now, than for the costs, time and trouble he may incur with regard to the execution of the present Testament, all of which however shall be at the expense of the said Testator.

He orders and desires that the sum of 400 *scudi del Sole* of his, which he has on deposit with the Bursar at Santa Maria Nuova in the city of Florence, may be given to his natural brothers resident in Florence with the profit and emoluments which has accured to the present time from the aforesaid Bursars to the aforesaid Testator, on account of

the said 400 scudi from the day they were given and consigned by the aforesaid Testator to the said Bursars.

Also, the said Testator desires and orders that the said Messer Francesco Melzi shall be and shall remain the sole executor of the Testament of the aforesaid Testator and that this said Testament shall be executed to its full and complete effect and in regard to what is here stated and related, to have, to hold, to keep and to observe the said Messer Leonardo da Vinci, constituted Testator, has obliged and obliges herein, his own heirs and successors with all his movable and immovable possessions, present and future, and has renounced and renounces herein each and every thing which is contrary to it.

Given in the said place of Cloux in the presence of Magister Spirito Fleri, vicar of the church of Saint Denis of Amboise, M. Gulielmo Croysant, priest and chaplain, Magister Cipriane Fulchin, Brother Francesco de Corton and Francesco da Milano, a brother of the convent of the Minorities at Amboise, witnesses called and summoned by the power of the said Court in the presence of the aforesaid Francesco Melzi, who, accepting and consenting to the same, has sworn to us personally by his faith and on his life never to cause, say or act to the contrary. And it is sealed at his request with the Royal seal affixed to legal contracts at Amboise as a proof of its authenticity. Given on the 23rd of April 1518 [1519] before Easter.

And on the 23rd of this month of April 1518 [1519] in the presence of M. Gulielmo Borian, royal notary at the court of the bailiwick of Amboise the aforesaid M. Leonardo da Vinci has given and bequeathed by his aforesaid last will and testament to the said M. Baptista de Vilanis, being present and agreeing the rights which King Louis XII of pious memory lately deceased has elsewhere given to the same da Vinci of the water in the canal of S. Cristoforo in the Duchy of Milan for his enjoyment, to be given to the said De Vilanis, in perpetuity and with the same terms and conditions of the said Lordship's gifting of it in the presence of M. Francesco Melzi, Nobleman of Milan, and in mine.

And on the aforesaid day of the said month of April in the said year of 1518 [1519] the same M. Leonardo da Vinci by his last will and testament has given to the aforesaid M. Baptista de Vilanis, here present and agreeing, each and all of his furnishings and household effects in the said place of Cloux, always in the event of the said de Vilanis surviving the aforesaid M. Leonardo da Vinci. In the presence of the aforesaid M. Francesco Melzi and of myself, Notary etc., Borian.[671]

From Francesco Melzi* to Leonardo's brothers, on the painter's death, 1519

To the honourable Ser Giuliano and his brothers.

I understand that you have been informed of the death of Master Leonardo, your brother, who was like an excellent father to me. It is impossible to express the grief that I feel at his death, and as long as my bodily parts sustain me I will feel perpetual unhappiness, which is justified by the consuming and passionate love he bore daily towards me. Everyone is grieved by the loss of such a man whose like nature no longer has it in her power to produce. And now Almighty God grants him eternal rest. He passed on from this life on 2nd May with all the rites of the Holy Mother Church, fully prepared. Having the permission of the most Christian King,† he was able to make a will and leave his possessions to whomsoever he wished: and I understand *quod Eredes supplicantis sint regnicolae*:‡ without this permission he would not have been able to make a valid will, for everything would have been forfeited, as is the custom here; that is to say that the said Master Leonardo, therefore, made a will concerning all in his possession here, which I would have forwarded to you had I found someone I could trust. I am waiting for an uncle of mine to come to see me, and he will be returning thereafter to Milan. I shall give the will to him and he will ensure a safe delivery, there being no one else available. With regard to the parts of the will which concern you, there is nothing except that Master Leonardo has on deposit with the Bursar at Santa Maria Nuova [in Florence] none other than 400 *scudi di Sole*, in certificated bonds, accruing interest at five per cent and on 16th October they will have been there for six years. Similarly with a smallholding at Fiesole, he wishes to be distributed among you. The will contains nothing else concerning you. This is all except to offer you my services as far as I am able. I am most willingly disposed to do your wishes and commend myself to you continually.

Given in Amboise, 1st June 1519.

Send your reply to me via the Gondi.

As if in brotherhood with you,
Francesco Melzi[672]

MANUSCRIPT SOURCES AND NOTES

1 CA 119va/327v (R10
 ⋆ A paraphrase of the opening of
 Aristotle's *Metaphysics*: 'All men by
 nature desire to have knowledge.
 Compare also Dante, *Convivio*, I, 1.
 † The previously unrecognised
 source for the scathing remark by
 Demetrius the Cynic (1st C. A.D.)
 is Seneca's *Epistulae Morales*, 91, 19
 (ref. provided by Professor Harry
 Hine).
 ‡ A reference to the speech by the
 Roman general Marius, a 'new
 man', as recorded in Sallust's *Bellum
 Iugurthinum*, LXXXV, 25.
2 CA 117rb/323r (R11)
3 CA 76ra/207r (R1159)
4 CA 119va/327v (R12)
5 CA 221vd/597iiv (R18)
6 CA 154rb/417r (R1153)
7 Urb 19r (McM 19)
8 Urb 19r-v (McM 19)
9 BN 2038 20v, Urb 4v-5r (McM 6)
10 Urb 19v-20r (McM 25)
11 Urb 1r-v (McM 1)
 ⋆ In Leonardo's strictly geometrical
 definition of terms, the point has
 no physical existence because it has
 no dimensions; the line has no
 physical existence because it has no
 breadth and depth; and surface has
 no physical existence because it has
 no depth.
12 Madrid II 67r
 ⋆ For *sensus communis* see the
 glossary.
13 Urb 1v-2r (McM 3)
 ⋆ Leonardo's title, 'On the first
 principle...', has been modified
 in the light of his varied
 numbering and ordering of the
 'principles'.
14 CA 253vd/683v
 ⋆ The term for 'boundary' or edge
 used here is *lembo* rather than his

more normal *termine* or *stremo* (see
the glossary)
15 Urb 2r (McM 4)
16 Urb 133r-v (McM 434)
 ⋆ For *chiaroscuro* see the glossary.
17 Urb 50r (McM 102)
18 BN 2038 22v (R23), Urb 160v
 (McM 427)
 ⋆ The definition of the visual
 properties is based in general terms
 on Aristotle as interpreted in the
 Middle Ages.
19 Urb 3v (McM 14)
20 Urb 2r-v (McM 5)
21 Urb 7v (McM 15)
22 Urb 3v-4r (McM 14)
23 Urb 4r (McM 10)
24 Urb 4v (McM 11)
25 Urb 2v-3v (McM 17-18)
 ⋆ For *sensus communis* see the
 glossary.
26 BN 2038 19r (R653), Urb 8r (McM 30)
 ⋆ For *sensus communis* see the
 glossary.
 † A reference to the statement by
 Simonides of Keos as recorded in
 Plutarch's *De gloria Atheniensium*,
 III, 346f-347c, that painting is mute
 poetry and poetry speaking
 painting.
27 Urb 6v (McM 36)
28 Urb 5r (McM 31)
29 Urb 15v-6r (McM 34)
30 Urb 7r (McM 13)
31 Urb 13r (McM 12)
32 Urb 15r (McM 28)
33 Urb 15v (McM 34)
34 Urb 7r-v (McM 13)
 ⋆ A probable reference to the
 legend of the blindness of
 Democritus.
35 Urb 10v (McM 37)
36 Urb 5v-6r (McM 23)
 ⋆ For *imprensiva* and *sensus communis*
 see the glossary.

37 Urb 10v-11r (McM 37)
38 BN 2038 19v, Urb 11r-v (McM 42)
39 BN 2038 19v (R654), Urb 9r (McM 30)
40 Urb 11v-12r (McM 42)
41 Urb 10r-v (McM 40)
42 Urb 14v-15r (McM 28)
 * Mathias Corvinus, King of
 Hungary, a notable patron of the
 arts, one-time ally of Ludovico
 Sforza (Leonardo's patron), and the
 intended recipient of a painting by
 Leonardo.
43 Urb 13r (McM 33)
44 Urb 13v-r (McM 33)
45 Urb 6r-v (McM 36)
46 Urb 7v (McM 22)
47 Urb 14r (McM 33)
48 Urb 12r-v (McM 42)
49 Urb 5r (McM 35)
50 Urb 14r (McM 32)
51 Urb 15r (McM 28)
52 BN 2038 19v, Urb 9r (McM 30)
 * The lost painting by the revered
 Greek artist, Apelles, was known
 through the literary description by
 Lucian (De calumnia), and became a
 touchstone of excellence for
 Renaissance theorists of narrative
 painting.
53 Urb 13r (McM 33)
54 Urb 13v (McM 33)
55 BN 2038 19v (R654), Urb 9r (McM
 30)
56 Urb 5v (McM 31)
 * The stories of animals and birds
 fooled by paintings were favoured
 by Pliny (Historia naturalis) as
 indications of the Greek painters'
 success in imitating nature.
57 Urb 12v (McM 42)
58 Urb 6v (McM 38)
59 Urb 16r-v (McM 39)
60 BN 2038 23r (R102), Urb 17r (McM
 44)
 * See voce in the glossary for voce as
 'note' in music.
61 Urb 16v (McM 39)
62 Urb 16v-17r (McM 43)
63 Urb 16v (McM 39)
64 Urb 17v (McM 26)
65 BN 2038 23r, Urb 17r-18r (McM 44)
66 Urb 18r (McM 16)
67 Urb 17v (McM 26)
 * For arti liberali see the glossary.

68 Urb 18r-19r (McM 41)
 * The comparison between the
 licence of the poet and painter in
 composing fictions recalls the
 opening sections of Horace's Ars
 poetica in which the principle ut
 pictura poesis is enunciated.
69 Urb 20r (McM 49)
70 BN 2038 25r (R655), Urb 23r (McM
 47)
71 Urb 20r (McM 49)
72 BN 2038 25r, Urb 23v (McM 47)
73 Urb 20r-21r (McM 51)
74 Urb 26v (McM 52)
75 Urb 21r (McM 51)
76 Urb 22r-v (McM 56)
77 BN 2038 25r, Urb 32r (McM 47)
78 Urb 24v-25r (McM 55)
79 BN 2038 25r (R655), Urb 23r (McM
 47)
80 Urb 25r (McM 55)
81 Urb 22v (McM 56)
82 Urb 25v-26r (McM 50)
83 Urb 27r-v (McM 54)
84 Urb 26v (McM 52)
85 BN 2038 25r, Urb 23v (McM 47)
86 BN 2038 25r (R655), Urb 23r-v
 (McM 47)
87 Urb 28r (McM 53)
88 Lomazzo p. 159
 * Lomazzo claims to be quoting
 directly from a Leonardo
 manuscript in this passage.
 Although its authenticity cannot be
 established beyond doubt, it is
 consistent with Leonardo's views
 and is of sufficient interest to
 justify its inclusion here.
89 Urb 12v (McM 42)
90 BN 2038 19v (R654), Urb 8v (McM
 30)
91 Urb 28v (McM 20)
92 Urb 8v-9r (McM 30)
93 Urb 15v (McM 28)
94 Urb 140r (McM 426)
95 CA 203ra/543r (R13)
 * This is a translation on the
 opening of John Pecham's
 Perspectiva Communis, the standard
 medieval textbook on optical
 science.
96 CA 119va/327v (R21)
97 CA 345vb/949v (R22)
 * A reference to the refractory

spheres of the eye as characterised in medieval optics.

98 CA 85va/232r (R51)
99 BL 232v
100 CA 101vb/278r (R64)
 ★Closely related to the optics of Pecham (see note 95)
101 A 27r (R58)
102 BN 2038 1r (R68)
 ★ An argument for the intramission theory of vision (as opposed to the idea that the eye sends out 'seeing rays') derived from medieval optical science in the tradition of the Islamic philosopher, Alhazen.
103 CA 85va/232r (R51)
 ★ For *luce*, see the glossary.
 † For *sensus communis*, see the glossary.
 ‡ Closely related to the optics of Pecham (see note 95)
104 G 8r (R19), Urb 39v (McM 70)
105 Urb 136r-v (McM 499)
106 G 8r (R19), Urb 39v (McM 70)
107 CA 76ra/207r (R20)
 ★ *ritrae* is here translated in the specific sense of 'copies' rather than 'portrays' (see the glossary).
108 G 53v (R16), Urb 154v (McM 484)
109 E 79v (R17), Urb 50v (McM 103)
 ★ The three kinds of perspective are used as the basis for the sections that follow, although the perspective of colour is preceded by general statements about colour.
110 CA 221vd/597iir (R18)
111 A 3r (R50)
112 CA 132rb/365r (R42)
113 BL 27v (R45)
114 G 37r (R49)
115 A 36r (R55)
116 K³ 120v
117 A 37v (R57)
118 A 10v (R85)
119 BN 2038 23r (R99), Urb 146v-147r (McM 44)
120 A 8v (R100)
121 G 29v (R106)
122 Urb 283v (McM 998)
123 C 27v (R53)
 ★ Heading supplied by the editor. Under this and the following headings, dealing with the 'problems' associated with the

conventional perspective construction, are grouped a series of notes which demonstrate Leonardo's growing awareness of inconsistencies within the system itself and the extent to which it did not correspond to the vagaries of the visual process. He showed an awareness of these problems in his early writings on perspective, but they come strongly to the fore in his later writings (after *c*. 1508).

124 A 38r (R86)
125 E 16r-v (R107-8)
 ★ Leonardo is here describing the principle of anamorphosis; that is to say, the portrayal of something in perspective on a plane to be viewed obliquely from a specific position in such a way that it looks wildly distorted from other positions. He may have been the inventor of this kind of trick painting, which subsequently became popular in northern and southern Europe.
126 BL 62r (R109)
127 BN 2038 17v (R19), Urb 49v-50r (McM 216)
128 A 41r-v (R544-5)
129 E 4r
 ★ This and the following text are considerably later than the two preceding passages, and suggest that he was more prepared to depart from orthodoxy in his later practice, whereas in his earlier work the problems of perspective appear to have been more a matter for theoretical debate.
130 G 32r
131 Urb 155v-156r (McM 487)
132 BN 2038 19r, Urb 155r-v (McM 489)
133 Urb 152v-153r (McM 464)
134 F 34r (R81A)
135 D 4v (R81C)
136 D 10v
 ★ This and related passages from Ms D (composed *c*. 1508-8), in which he argues that the power of vision resides in a surface rather than in a point (as earlier), reflect his greater understanding of

medieval optics, and show how he
moved away from a theory of the
visual process based upon painter's
perspective.

137 K 125r

138 D 6v

139 BN 2038 23v (R92)

140 A 10v (R85)
*That is to say, a greater amount of
its circumference will be visible as
the spectator moves further away.

141 Turin 38v (R28)

142 BL 220r (R75)

143 C 15r

144 Forster II² 101r

145 A 26v
*For *imprensiva* see the glossary

146 CA 221vc/597ir

147 C 7v

148 F 37r

149 Urb 142v-143r (McM 457)

150 CA 126rb/348r (R246)

151 E 17v (R24)

152 Madrid II 70v

153 CA 203ra/543r (R39)

154 H² 88r (R32)

155 H² 86r (R31)

156 Windsor 19152r (R274)

157 Urb 75v-76v (McM 176-7)

158 Urb 67r (McM 179)

159 Urb 62v (McM 191)

160 Windsor 19150r (R288)

161 Urb 68r-v (McM 178)

162 BN 2038 33r (R284), Urb 67v (McM
 188)

163 Urb 67r (McM 190)

164 Urb 70r (McM 210)

165 Urb 62r (McM 185)

166 CA 184vc/505v (R280)

167 Urb 77r (McM 180)

168 Urb 75v (McM 182)
*This account of colours which 'go
well together' comes close to the
doctrine of 'complementary
colours' as defined in the 18th and
19th centuries, but lacks the
systematic base provided by the
later colour wheels etc.

169 Urb 77v (McM 246)

170 Urb 72v (McM 184)

171 BN 2038 26r (R285), Urb 154v
 (McM 466)

172 Urb 206v (McM 765)

173 E 18r (R286), Urb 74r (McM 193)

174 BN 2038 10r (R293), Urb 205r-v
 (McM 815)

175 Windsor 19151v

176 CA 45va/124v (R272)

177 BN 2038 13v (R275), Urb 212v
 (McM 756, incomplete)

178 Urb 193r-v (McM 793-4)
*Reminiscent of the statement in
De coloribus (then thought to be by
Aristotle) that 'we do not see any
of the colours pure, as they really
are'.

179 BN 2038 33v (R267), Urb 195v-196r
 (McM 791)

180 CA 181ra/495r (R271)

181 Urb 204r (McM 724)

182 Urb 206v (McM 792)

183 Urb 206r-v (McM 785)

184 BN 2038 20r (R566), Urb 229v-230r
 (McM 786)

185 Urb 191v (McM 798)

186 Urb 207v (McM 802)

187 Urb 148v-149r (McM 478)

188 Madrid II 125r

189 Madrid II 127v, Urb 225v-226r
 (McM 795)

190 Windsor 12629r (R297)

191 Urb 238v (McM 822)

192 Urb 69v (McM 228)

193 Madrid II 73v, Urb 73r (McM 234)

194 Urb 63v (McM 224)

195 BN 2038 16r, Urb 67v (McM 239)

196 Urb 205r (McM 182)

197 Urb 76v (McM 234)

198 Urb 63r (McM 235)

199 Urb 72r (McM 237)

200 Urb 230r (McM 818)

201 Urb 205r (McM 201)

202 BN 2038 22v (R94), Urb 77v-78r
 (McM 236)

203 Urb 65r-v (McM 231)

204 Urb 64r-65r (McM 232)

205 BN 2038 25v (R295), Urb 78r-v
 (McM 238)

206 Urb 73r-v (McM 225)

207 Urb 70v (McM 226)

208 Urb 189r (McM 814)

209 Urb 73v (McM 242)

210 BN 2038 18v (R298), Urb 54r (McM
 227)

211 Urb 194r-v (McM 836)

212 Urb 77r-v (McM 244)

213 E 19r (R461), URB 235r (McM
 843)

214 BN 2038 18r, Urb 53v-54r (McM 230)
215 Urb 232v (McM 826)
216 Urb 233v (McM 833)
217 Urb 233r-v (McM 823)
218 Urb 145v (McM 504)
219 Urb 145r (McM 502)
220 E 80v (R223)
221 BN 2038 12v (R224)
 * For *imprensiva* see the glossary
222 BN 2038 20v (R567), Urb 146r-v (McM 503)
223 Urb 148r-v (McM 523)
224 E 80r (R222)
225 Urb 153v-154r (McM 506)
226 Urb 150v-151r (McM 520)
227 Urb 136v-137r (McM 522)
228 Urb 49r-v (McM 218)
229 Urb 141v-142r (McM 501)
230 Urb 196r-v (McM 840, 842)
231 Urb 208v (McM 844)
232 E 17r (R153), Urb 149r (McM 448)
233 Urb 196v (McM 841)
234 M 80r (R115)
235 G 3v (R118), Urb 195r (McM 598)
236 E 32v (R157), Urb 321r (McM 855)
237 BN 2038 22r (R119), Urb 175v (McM 577)
238 Urb 175r (McM 579)
239 Urb 195r (McM 578)
240 Urb 208v (McM 668)
241 CA 132vb/365v (R151)
242 Urb 209r (McM 668)
243 Urb 223r (McM 667)
244 BN 2038 32r (R574) and Windsor 12604r (R575), conflated into a single text as Urb 218v-219v (McM 672-3)
245 Urb 223r-v (McM 677)
246 Urb 201r-v (McM 675)
247 Urb 201v (McM 676)
248 Urb 220v-221r (McM 679)
249 Urb 222r (McM 686)
250 Urb 195r (McM 769)
251 Urb 227r (McM 774)
252 E 31v (R135), Urb 227r-v (McM 780-1)
253 Madrid II 26r, Urb 228r (McM 782)
254 Urb 227r (McM 776)
255 Urb 197r (McM 770)
256 Urb 227r (McM 775)
257 Urb 226v (McM 777)
258 Madrid II 26r, Urb 228r (McM 782)
259 CA 250ra/676r (R111)
 * Although it is not possible to

classify the surviving notes according to this scheme, the general sense of Leonardo's arrangement has been followed.
260 BN 2038 21v (R122), Urb 175r-v (McM 576)
261 Urb 175v (McM 584)
262 C 14v (R123)
263 Urb 179r (McM 587)
264 BN 2038 22r (R125), Urb 187r (McM 595)
265 Urb 210v (McM 602)
266 Urb 211r (McM 610)
267 Urb 199r-200r (McM 646-7)
268 Urb 238r-v (McM 665)
 * For *quantità continua* see the glossary.
269 BN 2038 32r (R245), Urb 219v-220r (McM 750)
270 Urb 176r (McM 711)
271 Urb 184v (McM 712)
272 C 21r (R174)
273 Urb 191r (McM 689)
274 CA 126rb/348r (R192)
275 CA 371rb/1036iir (R193)
276 E 32r (R162), Urb 182r-v (McM 617)
277 C 8v (R180)
278 Urb 187v (McM 706)
279 Urb 180v (McM 715)
280 Urb 185r (McM 716)
281 E 32r (R198)
282 Urb 179v (McM 615)
283 C 7v (R160)
284 E 32r (R162), Urb 182r-v (McM 617)
285 Urb 179v (McM 615)
286 Urb 185v-186r (McM 632)
287 Urb 184r (McM 623)
288 C 18r
289 Urb 211v-212r (McM 639-40)
290 BN 2038 11r (R173), Urb 212r-v (McM 643-4)
291 BN 2038 15v (R140), Urb 215v-216r (McM 622)
292 Urb 177r (McM 594)
293 E 32v (R159), Urb 175v (McM 590)
294 Urb 176v-177r (McM 594)
295 Urb 177r-v (McM 707)
296 BN 2038 13v (R148), Urb 212v-213v (McM 756)
297 BN 2038 14r (R149), Urb 213v-214v (McM 674)
298 CA 241rc/658r
299 Urb 181r (McM 658)
300 E 30v (R212), Urb 183r (McM 662)

301 Urb 45v (McM 104–5)
302 E 36v (R366), Urb 125r (McM 287)
303 Urb 105r (McM 286)
304 Urb 104r-v (McM 291)
305 CA 119va/327v
306 Urb 107r (McM 438)
 ⋆ See p. 204.
307 Urb 157r (McM 437)
308 Urb 104v (McM 296)
309 Venice, Accademia, 228, 29 (R343)
 ⋆ Vitruvius, the Roman architect,
 was the author of the *Ten Books on
 Architecture*, the only surviving
 treatise on the visual arts from
 classical antiquity. The systems of
 proportion in this and the
 following passages indicate that
 Leonardo did not settle upon a
 fixed set of ratios.
310 Windsor 12304r (R310)
 ⋆ For *braccio* see the glossary.
311 Urb 103r (McM 285)
312 BN 2038 28v (R364), Urb 103v
 (McM 289)
313 BN 2038 28v (R367), Urb 103v
 (McM 290)
314 Urb 105r (McM 286)
315 Windsor 12304r (R310)
316 Turin 15576 (R320)
317 Windsor 19129r (R321)
318 Windsor 19130v (R335)
319 B 2v (R346)
320 Windsor 19134r-19135r (R348)
321 Windsor 19136r-19139v (R328)
322 Windsor 19133v (R322)
323 Windsor 19133r (R324)
324 Windsor 19129r (R327)
325 Urb 104v (McM 296)
326 Windsor 19134r-19135r (R348)
327 Windsor 12624v
328 Windsor 19132r (R332)
329 Windsor 19136r-19139r (R338)
330 E 3r (R360)
331 BN 2038 27r (R489), Urb 43v-44r
 (McM 124)
 ⋆ For *corda* see the glossary.
332 Urb 110v-111r (McM 313)
333 L 79r (R488), Urb 118v (McM 329)
334 Urb 110v-111r (McM 313)
335 E19v (R363), Urb 48v (McM 126)
336 G 26r, Urb 117r (McM 327)
337 Windsor 19141r (R365)
338 Urb 116r-v (McM 325–6)
339 Urb 123v (McM 322)

340 BN 2038 28v (R367), Urb 126v-127r
 (McM 323)
341 Urb 111r-v (McM 355)
 ⋆ For *moto locale* and *moto actionale*
 see the glossary.
342 Urb 110v (McM 361)
 ⋆ For *quantità continua* see the
 glossary.
343 BN 2038 29r (R368), Urb 123r
 (McM 374)
344 Urb 113v (McM 336)
345 Urb 115r (McM 330)
346 BN 2038 29v (R592), Urb 114r
 (McM 382)
347 Urb 160v (McM 333)
348 Urb 113v-114r (McM 336)
349 BN 2038 20v (R361), Urb 109v
 (McM 335)
350 Urb 113r-v (McM 340)
351 Urb 128v (McM 332)
 ⋆ A famous classical subject, known
 in antique versions and portrayed
 in the Renaissance by Antonio
 Pollaiuolo.
352 Urb 112v (McM 342)
353 Urb 113r (McM 293)
354 Windsor 19038r (R357)
355 Urb 119v (McM 379)
356 Urb 107r (McM 358)
357 Urb 121r (McM 297)
358 Urb 107r (McM 356)
359 Urb 103v-4r (McM 299)
360 Urb 104r (McM 359)
 ⋆ For *quantità continua* see the
 glossary
361 CA 45va/124v (R353)
362 Urb 130v (McM 363)
363 CA 99va/273ir (R354)
364 BN 2038 29v, Urb 114r (McM 382)
365 Urb 113v (McM 346)
366 Urb 129v (McM 350)
367 Urb 138v (McM 352)
368 Forster II[1] 50v (R372)
369 Urb 137r (McM 354)
370 Windsor 19038v (R375)
371 A 28v (R369)
372 Windsor 12639r (R379)
373 Windsor 19038r (R375)
374 Urb 127v (McM 378)
375 Urb 130r (McM 376)
376 I 104v
377 Urb 122r (McM 367)
378 Madrid II 78v, Urb 128r (McM 364)
379 Urb 120v-121r (McM 366)

380 Urb 120r (McM 368)
381 CA 352va/975v (R388)
382 Urb 128r (McM 371)
383 Urb 128v (McM 370)
384 Forster I² 44r (R385)
385 Forster I² 44r (not in R)
386 Urb 105v-106v (McM 373)
387 Urb 130v (McM 430)
388 Urb 60v (McM 248)
389 Urb 46r (McM 250)
390 BN 2038 29v (R584), Urb 123v (McM 400)
391 Urb 110r (McM 395)
392 Urb 110r (McM 401)
393 CA 345vb/949v (R598)
394 Urb 123r (McM 397)
395 BN 2038 27r, Urb 124r-v (McM 124)
396 BN 2038 29v, Urb 126v (McM 422-3)
397 BN 2038 17v (R583), Urb 51v-52r (McM 252-5)
398 Urb 109r-v (McM 425)
 *Leonardo is here referring to claims that character can be read precisely from a face according to a fixed formula of features or 'signs' (see the glossary), and that fortune can be told from the reading of lines on the palm of the hand. He was, however, sympathetic to some aspects of the science of physiognomy as developed in the Middle Ages within the Aristotelian tradition (e.g., by Michael Scot).
399 Urb 127r (McM 420-1)
400 BN 2038 21r (R594), Urb 126r-v (McM 424)
401 Urb 123v (McM 396)
402 Urb 123r (McM 412)
403 Urb 115v-116r (McM 394)
404 Urb 125r-v (McM 403)
405 Urb 115v (McM 389)
406 Urb 125v (McM 387)
407 Urb 127v (McM 392)
408 Urb 170r-v (McM 574)
409 Urb 167r (McM 559)
410 BN 2038 17v (R392), Urb 169r (McM 572)
411 Urb 167r-v (McM 564)
412 Urb 168r-v (McM 567)
413 Urb 171r (McM 571)
414 BN 2038 18r (R391), Urb 169v (McM 569)

415 Urb 167r (McM 568)
416 Urb 169r (McM 573)
417 Urb 168v (McM 566)
418 BN 2038 4r (R390), Urb 168v-169r (McM 563)
419 Urb 170v (McM 565)
420 Urb 169v-170r (McM 560)
421 Urb 222v-223r (McM 866)
422 Urb 202v-203r (McM 860)
423 BL 113v (R458)
424 Urb 276v (McM 995)
425 G 18v, Urb 41v (McM 139)
426 BN 2038 33v (R516), Urb 207v (McM 764)
427 Urb 152r (McM 482)
428 CA 176ra/480ir
429 Urb 150r-v (McM 480)
430 Urb 275r-v (McM 991)
431 Urb 143v-144r (McM 476)
432 Urb 275r (McM 989)
433 Urb 142r-v (McM 529)
434 Urb 144v-145r (McM 537)
435 Urb 149r (McM 472)
436 Urb 149r-v (McM 471)
437 F 18r (R302)
438 G 22v (R468), Urb 161v-162r (McM 473)
439 G 23r (R469), Urb 162r (McM 474)
440 Hammer (Leic) 4r (R300)
441 Urb 149r (McM 479)
442 Urb 157v-158r (McM 552)
443 E cover (R479)
444 CA 97va/266v
445 E 6v (470), Urb 157v (McM 551)
446 BL 113v
447 Windsor 12412r
448 Urb 159v-160r (McM 524)
449 CA 354rd/980iir (R478)
450 Urb 163r-v (McM 542-3)
451 Urb 71r (McM 212)
452 Urb 158v (McM 545)
453 Urb 163r-v (McM 544)
454 Urb 72v (McM 213)
455 Urb 160r (McM 525)
456 Urb 158v-159v (McM 546)
 *This difficult account, which opens with an optical analysis, thus concludes with a perceptual or 'subjective' explanation.
457 Urb 283r (McM 998)
458 Urb 285r (McM 1001)
459 Urb 284v-285r (McM 1004)
460 Urb 235v-236v (McM 837)
461 Urb 236v (McM 838)

462 Urb 236v-237v (McM 839)
463 Urb 267v (McM 905)
464 Urb 252v (McM 907)
465 Urb 252v (McM 906)
466 Urb 243r-v (McM 874)
 *'Thickness' here means cross-
 sectional area, and relates to
 Leonardo's hydrodynamic law that
 the total volume of liquid passing
 through a tube at a constant
 velocity is proportional to the
 cross-sectional area of that tube.
467 Urb 244v-5r (McM 899)
468 Urb 246r-v (McM 900)
469 Urb 255r (McM 884)
 *Leonardo here uses a technical
 term, *pedali*, to denote the basal
 areas of trees, that is to say, the
 bases where one branch is inserted
 into another or into the trunk.
470 Urb 243v-244r (McM 896))
471 G 16v (R415), Urb 247r (McM 887)
472 Urb 251r (McM 890)
473 G 16v (R415), Urb 247r (McM 887)
474 Urb 251r-v (McM 891)
475 Urb 245v-246r (McM 894)
476 G 30v (R416), Urb 247r-v (McM
 875)
477 G 51r (R410)
478 G33r (R402), Urb 248v (McM 982)
479 BL 114v (R435)
480 G 27v (R457), Urb 264v (McM 901)
481 Urb 251v-252r (McM 910)
482 G 12r (R436), Urb 255v-256r (McM
 914)
483 Urb 254v (McM 919)
484 Urb 253v-254r (McM 952)
485 Urb 256v-257r (McM 936)
486 G 10r-v (R423-4), Urb 260r-v
 (McM 939)
487 Urb 257r (McM 929)
488 G 10v (R433), Urb 260v (McM 927)
489 Urb 266r-v (McM 946)
490 Urb 253r (McM 950)
491 G 25v (R450), Urb 265v (McM 963)
492 Urb 254r (McM 952)
493 Urb 253v (McM 959)
494 Urb 258v (McM 960)
495 Urb 262v-3r (McM 971)
496 Urb 258r (McM 975)
497 Urb 276v (McM 996)
498 BN 2038 17v (R661), Urb 49v
 (McM 98)
 *This legend was widely recorded.

Leonardo's source may have been
Pliny's *Natural history* XXXVI.
499 BN 2038 31v (R504)
500 CA 141rb/387r (R660)
 *Leonardo is here outlining what
 became the standard account of the
 revival of painting. A similar
 account had previously been given
 by Lorenzo Ghiberti in his second
 Commentary and would later
 reappear in Vasari's *Lives of the
 Painters*.
501 Urb 39v (McM 77)
502 Urb 34r-5r (McM 78)
 *i.e., linear and aerial.
503 Urb 38v-9r (McM 80)
 *For *operatore* see the glossary.
504 Urb 130v-1r (McM 442)
 *For *discorso* see the glossary.
505 BN 2038 25r (R501), Urb 38v (McM
 79)
 *Gold and blue (lapis lazuli) were
 the costliest materials available to
 painters, and contracts frequently
 stipulated their use, to ensure the
 material richness of the work.
506 Urb 35r (McM 84)
 *For *giudizio* see the glossary.
507 Urb 131v (McM 439)
508 Forster III 66v (R498)
509 G25r (R482), Urb 31v, (McM 64)
 *It was common studio practice
 for pupils to copy their masters'
 drawings.
510 BN 2038 17v (R483), Urb 31r (McM
 59)
 *For *membra* see the glossary.
511 BN 2038 33r (R484), Urb 39v (McM
 112)
 *i.e., from work done from
 sculpture in the round as well as in
 relief.
512 BN 2038 28r (R491), Urb 31r-v
 (McM 60)
513 CA 199va/534v (R490)
514 Urb 32r (McM 69)
515 BN 2038 27v (R492), Urb 37r
 (McM 63)
516 BN 2038 27v (R571), Urb 58v-9r
 (McM 258)
 *For *storie* see the glossary.
 †'*brevi segni*'.
 ‡Paper prepared with an abrasive
 coating for drawing in metalpoint.

The resulting line cannot be readily erased.

517 BN 2038 27r (R497), Urb 42v–3r (McM 112 and 123)
★ For *membra* see the glossary.
† 'che non sia allevato in giubbone' – i.e., in tight-fitting garments.

518 CA 112ra/310r (R1171)

519 G5v (R503), Urb 39r (McM 97)

520 Urb 32r (McM 67)

521 Urb 32v–33v (McM 92)
★ *soldo* = solidus. Like a shilling it was equal to 1/20 of a *lira* (= pound = libra). See also note to 657.

522 BN 2038 25r (R500), Urb 37v–38r (McM 95)

523 Urb 33v–34r (McM 93)
★ Sandro Botticelli (1445–1510) may for a short time have worked in the studio of Andrea del Verrocchio, to whom Leonardo was apprenticed.

524 BN 2038 2r (R506), Urb 32r–v (McM 71)
★ For *fantasia* see the glossary.

525 Urb 33v (McM 72)

526 BN 2038 24v (R529), Urb 132r–v (McM 432)

527 BN 2038 28r (R530), Urb 131v–132r (McM 440)

528 BN 2038 26r (R532), Urb 38r–v (McM 83)

529 Urb 44r–v (McM 86)

530 BN 2038 27r (R587), Urb 50v–51r (McM 276)
★ For *grazia* see the glossary.
† As the ancient Greek painter Zeuxis had done. When painting a picture of Venus he chose the most beautiful features from each of five Crotonian girls to achieve a composite ideal.

531 BN 2038 27v-a (R494), Urb 31v (McM 74)

532 CA 184vc/505v (R493)

533 BN 2038 26v (R495), Urb 37r–v (McM 73)
★ There would seem here to be a possible contradiction with what Leonardo says about the need to avoid company, but he is probably referring here to the collective training of young artists within the studio.
† For *virtù* see the glossary.

534 BN 2038 24r (R531), Urb 37v (McM 66)
★ In the sense of an exemplary drawing, to be copied in the workshop, rather than a human model.

535 Urb 108v (McM 416)
★ For *membri* see the glossary.

536 BN 2038 26v (R572), Urb 109r (McM 415)

537 BN 2038 26v (R507), Urb 36v–37r (McM 75)
★ For *braccia* see the glossary.
† *canna*.

538 BN 2038 33r (R551), Urb 133v–134r (McM 443)
★ There is not a rigid separation between the passages in this section and those on light and shade previously included in Part II, but those given here are more in the nature of practical instructions than theoretical formulations.
† *finestra impanata*, i.e., windows which have a waxed skin or paper covering as 'panes'. See p. 244 for a description of such a covered window.

539 Urb 45r–v (McM 142)

540 BN 2038 21v (R552), Urb 224v (McM 845)

541 BN 2038 16v (R565)

542 G23v (R564), Urb 153r (McM 464)
★ The difficulty of this passage arises because *colore* (see the glossary) is used by Leonardo for 'tone' as well as for 'hue'.

543 Urb 54r (McM 152)

544 Urb 46r–v (McM 156)

545 BN 2038 28v (R555), Urb 224r–v (McM 868)
★ For *ombre mezzane* see the glossary.

546 CA 199va/534v (R548)
★ For *quantita continua* see the glossary.

547 BN 2038 14v, Urb 50v (McM 130)

548 BN 2038 23r (R558), Urb 225r (McM 870)

549 BN 2038 21v (R559), Urb 224v–225r (McM 846)

550 Urb 55r (McM 260)

551 Urb 240v-241r (McM 872)

552 Urb 137v-138v (McM 469)
* i.e., where the darkness of the wall falls perpendicularly on the surface.

553 BN 2038 33r (R515), Urb 40r (McM 129)
* See the following section and note 538†.

554 Urb 137r-v (McM 451)

555 BN 2038 20v (R520), Urb 51r (McM 134)
* For *grazia* see the glossary.
† For *braccia* see the glossary.

556 Urb 41v (McM 137)
* For *grazia* see the glossary.

557 Urb 41v (McM 142)

558 BN 2038 4v (R512)

559 BN 2038 24r (R523), Urb 41r-42v (McM 118-9)
* For *braccio* see the glossary.
† *Lapis a matita macinata.* Pedretti vol 1 p. 33 notes that Cennino Cennini in the *Libro dell' Arte* cxxvi writes *abbi un pezzo di lapis amatita*.
‡ Pounce (*spolverizzare*) refers to the process of pricking the drawing around the principal lines and dabbing a bag filled with charcoal dust over the holes so that the outline is transferred.

560 BN 2038 10r (R537), Urb 42r-v (McM 264)
* For *istorie* see the glossary.

561 BN 2038 16r (R542), Urb 47r-v (McM 265)

562 Urb 107v-108r (McM 418)

563 A 38v (R526), Urb 139v-140r (McM 497)
* For *braccia* see the glossary.
† For *pariete* see the glossary.

564 A 41v (R545)

565 A 40v (R543)

566 A 42v (R525)
* The phenomenon described here is anamorphosis. See note to 125.

567 Urb 61v (McM 267)
* For *ingegnio* see the glossary.

568 Urb 61r-v (McM 271)

569 Urb 60r (McM 270)

570 Urb 106v-7r (McM 384)
* i.e., a military subject.

571 Urb 61v-2r (McM 261)

572 BN 2038 22v (R508), Urb 35v (McM 76)
* For *ingegnio* see the glossary.
† *pietre di vari misti.* Leonardo is referring to a particular kind of stone or pebble, the *mischio*, which was characterised by twisted veins of coloured minerals running through it. Leonardo strove to reproduce the effect in artificial preparations which he called *mistioni*.

573 BN 2038 29r (R585), Urb 135r (McM 554)
* The *serpente* was one of the fantastic animals in his bestiary (CH21r, R1249).

574 BN 2038 26r (R496), Urb 36r (McM 65)

575 BN 2038 26r (R502), Urb 38v (McM 256)
* For *imaginativa* see the glossary.

576 BN 2038 8v (R579), Urb 34r (McM 257)

577 Urb 60v (McM 259)

578 Urb 131r (McM 442)
* However, Leonardo did depict female heads with elaborately braided and knotted hair – a fashion and practice dating from his time in Verrocchio's studio and carried through to his later projects for *Leda and the Swan*. Compare the memorandum of works completed (pp. 263-4), where he lists 'a head of a girl with knotted braids' and 'a head with an [elaborate] hairstyle'.

579 Forster II[1] 62v (R665)
* Early copies of the painting show Judas upsetting a salt cellar.

580 Forster II[1] 63r (R666)

581 BN 2038 31r-30v (R601-2), Urb 53r-v; 85r (McM 282-3)

582 W 12665v (R608)

583 W 12665r (R609)
* For *percussione* see the glossary.

584 CA 155rc/418ir (R611)
* For *simulacri* see the glossary.

585 W 12665v (R608)

586 G6v (R607)

587 BN 2038 18v (R604), Urb 52r (McM 284)

588 Oxford A 29r (R676)
* As a *stipendiato* (court artist) at the

Sforza Court in Milan, an important part of Leonardo's function was to provide propaganda which would glorify the dynasty in the form of allegories and emblems. For these latter, and also for his bestiary, Leonardo frequently drew upon the medieval corpus known as the *Fior di Virtù*, (a copy of which we know he owned), where various shades of moral behaviour were attributed to familiar and fabulous creatures.

† On this subject, and on Envy (q.v.), Leonardo appears to have written more, which is now lost, but which apparently was known to Lomazzo who paraphrases it in his *Trattato*, pp. 449–51.

589 Oxford A 29v (R677)
590 B 3v (R675)
591 H² 61r (R693)
592 H¹ 40r (R695)
593 I² 138v (R672)
★ Ludovico Sforza, Duke of Bari, fourth son of Duke Francesco Sforza, usurped power from the infant son of his young nephew Gian Galeazzo (who had died in dubious circumstances), and was created Duke of Milan in 1495, ruling till 1499 when he was driven out by Louis XII of France. His nickname of Il Moro gave scope for the representation of him in allegories and emblems as a black man or by a blackberry (*mora*) or mulberry (*morus*).

†Gualtieri Bascapè, an influential member of the Sforza government. See also p. 256 for another reference to him.

594 H² 88v (R671)
595 H³ 98r (R670)
★ Probably a reference to the ill-fated Gian Galeazzo Maria Sforza whose death in 1494 prompted rumours of Ludovico's involvement.

† For *fortuna* see the glossary.

596 BL 250r (R674)
★ This pageant was probably devised for the celebrations of the Sforza–d'Este weddings of 1491.

† *focosa quadriga* – an alternative translation is 'fiery chariot'.

597 W 12700r (R685)
598 H² 49v (R692)
599 W 12698v (R688)
★ Windsor 12698r. Adam and Eve are written above the clouds in the drawing accompanying this note, which may signify the labours to which man was condemned by his Fall in the Garden of Eden.

600 BL 173r (R687)
601 BN 2038 34v (R686)
602 W 12700v (R684)
603 F Cover (R698)
604 H² 63v (R694)
605 Forster II¹ 63r (R697)
★ This is in the form of a rebus: *falcon tempo* = *fa l[o] con tempo:* The bird carries the '*tempo*' of a clock in its beak.

606 CA 68vb/190v (R702)
★ The bird is probably a *calandrino* which, when brought to a sick person, would refuse to look at him if he was going to die.

607 New York: Metropolitan Museum of Art (R1264A).
608 H¹ 40v (R696)
609 H¹ 48v (R1263)
★ In Leonardo's portrait of *Cecilia Gallerani*, mistress of Ludovico, (Fig. 4) the sitter holds an ermine which symbolises her purity, and works a pun on her name; *galee* is Greek for ermine.

610 Forster II¹ 63r (R697)
611 H³ 150v
612 CA 391ra/1082r (R1340)
★ This famous draft of a letter recommending his services to Ludovico Sforza (*de facto* ruler but not yet Duke of Milan) is not in Leonardo's own hand.

†*trabocchi* – trébuchets, old war engines. One is illustrated in the background of the painting of Guidoriccio da Foglino in the Palazzo Pubblico, Siena.

‡ This refers to the long-standing project for a bronze equestrian monument to the memory of Francesco, the first Sforza Duke. Leonardo assumed responsibility

for the project which was
eventually terminated when the
bronze set aside for it had to be
used to make cannons to defend
Lombardy from the French.

613 Milan, Archivio di Stato.
Autografi... Pittori, Leonardo da
Vinci, cartella n. 102, fasc. 34, doc
10. A transcription of this
document is published in Glasser,
pp. 345–6.
* The Virgin of the Rocks. The
tangled and incomplete
documentation, relating to the
creation of two variants of this
composition, the earlier in the
Louvre (Fig. 171), the later in the
National Gallery, is much debated.
See, inter alia, Kemp pp. 93–99. This
document is not precisely dated but
is reasonably assigned to 1494. It is
the first surviving indication of the
protracted dispute which developed
between the Confraternity and the
artists. See also the list of
decorations to be applied to the
altarpiece of the Confraternity of
the Immaculate Conception.
(pp. 268–70).

614 CA 335va/914ir (R1345). Also
transcribed in Calvi, pp. 167–8.
* The sheet from which this
fragment comes has been vertically
torn in half but it is still possible to
catch the tone of Leonardo's
relationship with his patron.
† see note to 612‡.
‡ The decoration of the small
rooms (camerini) in the Castello
Sforzesco was begun in 1495.

615 CA 315va/867r (R1344)
* see note to 593†.

616 CA 270rc/730r (R1347A)
* Edited from drafts, possibly
incomplete, of a letter which may
have been intended to accompany
the model Leonardo submitted in
the competition to design the tiburio
for Milan Cathedral. For the
comparison between a sick body
and the building in need of repair,
see Francesco di Giorgio, Trattato di
Architettura Civile e Militare, book IV,
ch. 4; and Filarete, Trattato

d'Architettura, book I. Alberti draws
a comparison between doctor and
architect in De Re Aedificatoria,
book x, ch. 1.

617 CA 323rb/887r (R1346)
* Draft of a letter to the authorities
of Piacenza Cathedral who sought
to commission bronze doors for
their building. From the last
section, it might appear that
Leonardo intended the letter to be
sent under someone else's name (to
give the impression that he was not
actively seeking the work), but this
cannot necessarily be assumed.
† Inserted over the line is the
phrase 'because Italy is running out
of men of talent'.

618 Modena, Archivio di Stato (ASE
Pittori, Busta 4) R1348
* The Standard-bearer of Justice of
the Florentine Republic: the highest
office in government.

619 CA 317rb/872r (R1349)
* Governor of Milan under the
French King Louis XII.
† Giacomo Salai, a member of
Leonardo's household from the age
of 10.

620 CA 372va/1037v (R1350)
* Giovanni Francesco Melzi was a
cultured young Milanese nobleman
and pupil and friend of Leonardo.
He became the executor of
Leonardo's will (qv) and was
almost certainly responsible for the
compilation of the Codex Urbinas,
the Treatise on Painting.
† see note to 619†.

621 CA 247vb/671r (R1351)
* Brother of Pope Leo X. Leonardo
was in Rome 1513–16 under the
patronage of Guiliano, who died in
1515. Leonardo's relationship with
the two German assistants assigned
to him, Giorgio the ironworker
and Giovanni the mirrormaker, is
reconstructed here from the
incomplete and confusing drafts of
his letter to Guiliano.

622 CA 182vc/500r (R1353)

623 CA 92rb/252r (R1353A)
* i.e. Giuliano de' Medici

624 CA 247vb/671r (R1351)

625 CA 283r-a/768r (R1352)
626 CA 247vb/671r (R1351)
627 CA 182vc/500r (R1353)
628 CA 247vb/671r (R1351)
629 CA 182vc/500r
630 CA 247vb/671r (R1351)
631 CA 182vc/500r (R1353)
632 CA 182vc/500r
633 CA 10va/37r
634 CA 309rb/847r
635 CA 361rb/1007r
 * This, *dimmi semmai*, and variants, is the verbal doodle which came most readily to Leonardo's hand, throughout his notebooks.
636 CA 28rb/80r
637 CA 39ve/110v (R1360)
638 BL 251v (R1365)
639 CA 216vb/579r [161]
640 CA 324r/888r (R680)
 * Atalante Migliorotti, who may have accompanied Leonardo to Milan.
 † *'una nostra donna finita, un altra quasi ch' è in profilo'*. There is a crucial ambiguity in Leonardo's words. The second Our Lady could be either *almost finished* or *almost in profile*.
641 CA 147rb/399r (R1445) and (R487)
 * Leonardo's interest in the *Regisole* is natural in view of his work on the Sforza equestrian monument.
642 W 19059r (R1370)
643 Forster III 88r (R1384)
 * Horses selected for study in connection with the Sforza monument.
644 Forster III 1v (R1387)
 * A Cristofano de Castiglione is mentioned in a document of 1486.
645 Forster II 1.43v (R1396)
 * Guiliano da Marliano, learned member of a family of physicians, known to Leonardo in Milan.
646 Forster II 1.6r (R1403)
 * The context of this note suggests that Leonardo had him in mind as a model for the *Last Supper*.
647 Forster I 3r (R1404)
648 Forster II¹ 3r (R667)
 * Possibly another potential model for the *Last Supper*.
649 CA 252ra/680r [2] (R1364)

 * This enigmatic note has been interpreted as a reference to a work for which Leonardo had used a well-known homosexual model (taking 'child' in the sense of adolescent), but it might refer to the troubled history of the *Virgin of the Rocks* (see pp. 253–5).
650 Madrid I 1r
 * i.e., early morning.
 † Leonardo is describing work on the ill-fated wall painting of the *Battle of Anghiari* for the Hall of the Great Council in the Palazzo della Signoria, Florence. See pp. 270–71 for the contract which was drawn up for this work.
651 BL 1r (R4)
652 W 19016 (R1376)
653 CA 90va/244v (R1376B)
 * i.e., just before sunset.
654 CA 159rc/429r (R1368A)
 * Leonardo writes 'medici' not 'Medici'; it is unclear whether he refers to doctors or indeed the Medici family.
655 W 19076r (R1424)
 * Gherardo di Giovanni di Miniato, 1446–97
656 CA 247ra/669r (R1379)
 * Count Louis de Ligny, who accompanied Charles VIII and Louis XII to Italy. Leonardo clearly intended to make a secret expedition with Ligny. The words *Ligny, a Roma, Napoli* and *donagione* appear backwards, i.e., in code.
 † Witelo (Vitolone), medieval optical theorist. Leonardo on another occasion reminded himself to look at a manuscript of Witelo in Pavia; '*Grazie*' refers to the Church of Santa Maria delle Grazie in Milan, where Leonardo painted the *Last Supper*; Jean de Paris = Jean Perréal, the French painter who had accompanied Charles VII and Louis XII to Italy; *a secco* – a method of wall painting where, unlike a true fresco painting, speed of execution is not crucial. It is less permanent than fresco; 'cornage tempera' (*tempera della cornage*) – Richter read this as 'carnage' and

translated as 'learn to work flesh colours in tempera' which makes more immediate sense than 'cornage' which, it has been suggested, might be some kind of bone-meal; '*fotteragi*' has no equivalent in modern Italian. *De Ponderibus* – a fifteenth century treatise on weights (statics) by Biagio Pelacani.

657 C 15v(1) (R1458)
　★ Giacomo Salai, see note 619†.
　† Where *lire*, *soldi* and *denari* are mentioned in transactions, as in Leonardo's household and workshop accounts, it is important to realise that these names represent the so-called money of account commonly used to evaluate everyday costs. Sometimes referred to as 'ghost money', they are expressions of value and *not* coinage for making payments.
　‡ Giacomo Andrea da Ferrara, architect and an expert on Vitruvius; Marco d'Oggiono, a pupil of Leonardo; Galeazzo di San Severino, Ludovico Sforza's son-in-law; Gian Antonio Boltraffio 1467-1516, a pupil of Leonardo.

658 Forster III 88v (R1459)
659 H¹ 106v (R1460)
660 H¹ 41r (R1461)
661 BL 271v (R1463)
　★ *carlino* – a silver coin, later known as a *barile*, struck for the first time in Florence in August 1504.
662 G rear cover (R1464)
663 E 1r (R1465)
664 CA 68ra/189r (R1466)
　★ *gros(s)one* (*grosso*) – a silver coin with a value in Florence of around 7 *soldi*.
665 CA 192ra/522r (R1529)
666 Florence, Archivio Centrale di Stato, Conventi Soppressi. Convento di S. Donato a Scopeto. Carte di S. Jacopo Sopr' Arno. Giornale e ricordi 1479-1482 cart. 74. For a transcription of this document see Beltrami, pp. 7-8. doc. no. 16.
　★ From *sigillo* = seal. One of

several variants of the gold florin. The florin was often qualified by a description of its characteristics i.e., *largo, stretto, vecchio, nuovo, di sugello*, and others less self-explanatory. Savonarola complained of the confusion this caused.
　† The *Monte delle Doti*, a government-sponsored fund set up in 1425 to enable Florentine citizens to provide their daughters with dowries by depositing a sum and allowing interest to accumulate for a fixed term, often 15 years. One of the central institutions of Florentine life in the fifteenth century. Leonardo was lent the money to make the initial investment of 28 *fiorini larghi* for Lisabetta who was the grandaughter of Simone.
　‡ The Compagnia degli Ingesuati, a lay religious company, whose members assisted the sick poor and distributed free remedies to them. It is not surprising therefore to find Leonardo obtaining his colours from them, since painters and apothecaries were already linked through their membership of the same guild.

667 1483, 25 aprile. ASM Notarile, rog. Antonio de Capitani, Raccolta Cimieli, busta 1. For a transcription of this document by Janice Shell and Grazioso Sironi see the catalogue to the exhibition *Zenale e Leonardo*, p. 67.
　★ This specification for work on the altarpiece for the Confraternity of the Immaculate Conception was written in Italian and added to the Latin contract. For the subsequent appeal, made with Ambrogio de Predis, see pp. 253-5 and note to 613.
　† *gradiza* = *spinnchristi* (?) = a flower symbolic of Christ's passion.
668 Florence, Archivio di Stato. Déliberazioni della Signoria, vol. 168, fol. 44v. For a transcription of this document see Beltrami pp. 87-89. doc. no. 140.

*Leonardo's painting was to take its place there with the *Battle of Cascina* by Michelangelo, a statue of Christ 'as King of Florence' by Andrea Sansovino and an altarpiece by Filippino Lippi, in a grand decorative scheme intended to reaffirm Florence's commitment to Republicanism. The project was never completed. In May 1506 Leonardo was summoned to Milan and from that point appears to have ceased work for the Council Hall. See also note to 649†.

669 Mantua, Archivio di Stato, Archivio Gonzaga, serie E, xxviii, 3, busta 1103. For a transcription and facsimile reproduction of this document see the catalogue to the exhibition *Leonardo dopo Milano*, nos. 27 and 28, pp. 54–5.
 *Isabella d'Este, sister of Ludovico Sforza's wife Beatrice, was a keen admirer of Leonardo's works. Fra Pietro da Novellara, head of the Carmelites in Florence, was acting as her emissary there.
 † This cartoon has disappeared, but the description calls to mind the painting in the Louvre (Fig. 175), although there are significant differences between the two. A record of the lost cartoon may be provided by a drawing in a private collection (see Kemp, introduction to K. Clark, *Leonardo da Vinci*).

670 Geneva, private collection. For a transcription and facsimile reproduction of this document see

Leonardo dopo Milano (op. cit.) no. 44, pp. 60–61.
 * See note to 619†.
 † Florimond de Robertet, Secretary of State to Louis XII and a notable patron in his own right. The paintings in the collection of the Duke of Buccleuch (Fig. 176), and in a New York private collection are the best of the surviving versions of this composition, and the Buccleuch painting may be partly by Leonardo himself. They differ from Fra Pietro's account only in that Christ's foot does not rest in the flax basket.
 ‡ This probably refers to a sermon preached at Easter rather than his pleas to Leonardo.

671 R1566 See Beltrami pp. 152–4, doc. no. 244.
 * See note to 620*.
 † *portracti* which might suggest 'portraits', but the sense seems to require a broader meaning.
 ‡ *soldi tornesi* – Tornesi, in Italy, were base silver and copper coins.
 § *Scudi del Sole* – gold coins issued by Charles VIII of France as King of Naples and Sicily in 1495, showing a sun over the armorial shield.

672 Beltrami p. 155, doc. no. 245.
 * See note to 620*.
 † Francis I.
 ‡ 'the possessions of a subject must be petitioned for'.
 § See note to 671§.

CONCORDANCE OF MANUSCRIPT SOURCES

1. CODEX URBINAS
2. ORIGINAL LEONARDO MANUSCRIPTS IN ALPHABETICAL ORDER BY ABBREVIATION

CODEX URBINAS FOLIO No	CORRESPONDING MSS SOURCE	McMAHON PARA No. (URB)	MK/MW No
1r–v		1	11
1v–2r		3	13
2r		4	15
2r–2v		5	20
2v–3v		17, 18	25
3v		14	19
3v–4r		14, 78, 87	22
4r		10	23
4v		11	24
4v–5r	BN 2038, 20v	6	9
5r		31, 35	28, 49
5v		31	56
5v–6r		23	36
6r–6v		36	45
6v		36, 38	27, 58
7r		13	30
7v		15, 22	21, 46
7r–7v		13	34
8r	BN 2038, 19r	30	26
8v	BN 2038, 19v	30	90
8v–9r		30	92
9r	BN 2038, 19v	30	39, 52, 55
10r–v		40	41
10v		37	35
10v–11r		37	37
11r–v	BN 2038, 19v	42	38
11v–12r		42	40
12r–v		42	48
12v		42	57, 89
13r		12, 33	31, 53
13v		33	43, 54
13r–v		33	44
14r		33, 32	47, 50
14v–15r		28	42
15r		28	32, 51
15v		34, 28	33, 93

CODEX URBINAS FOLIO No	CORRESPONDING MSS SOURCE	McMAHON PARA No. (URB)	MK/MW No
15v–16r		34	29
16r–v		39	59
16v		39	63, 61
16v–17r		43	62
17r	BN 2038, 23r, (44)	39, 44	64, 60, 65
17v		26	67, 64
17r–18r	BN 2038, 23r	44	65
18r		16	66
18r–19r		41	68
19r		19	7
19v		19	8
19v–20r		25	10
20r		49	69, 71
20r–21r		51	73
21r		51	75
22r–v		56	76
22v		56	81
23r	BN 2038, 25r	47	70, 79
23v	BN 2038, 25r	47	72, 85, 86
24v–25r		55	78
25r		55	80
25v–26r		50	82
26v		52	74, 84, 85
27r–v		54	83
28r		53	87
28v		20	91
31r	BN 2038, 17v	59	510
31v	G 25a	64	509
31r–v	BN 2038, 28r	60	512
31v	BN 2038, 27v	74	531
32r	BN 2038, 25r	47	77
32r		69, 67	514, 520
32r–v	BN 2038, 2r	71	524
32v–33v		92	521
33v		72	525
33v–34r		93	523
34r	BN 2038, 8v	257	576
34r–35r		78	502
35r		84	506
35v	BN 2038, 22v	76	572
36r	BN 2038, 26r	65	574
36v–37r	BN 2038, 26v	75	537
37r–v	BN 2038, 26v	73	533
37r	BN 2038, 27v	63	515
37v	BN 2038, 24r	66	534
37v–38r	BN 2038, 25v	95	522
38r–v	BN 2038, 26r	83	528
38v	BN 2038, 26r	256	575
38v	BN 2038, 25r	79	505
38v–39r		80	503
39r	G 5v	97	519
39v		77	501

CODEX URBINAS FOLIO No	CORRESPONDING MSS SOURCE	McMAHON PARA No. (URB)	MK/MW No
39v	BN 2038, 33r	112	511
39v		70	104, 106
40r	BN 2038, 33r	129	553
41v	G 18v	139, 137, 132	425, 556, 557
41r–42v	BN 2038, 24r	118–119	559
42r–v	BN 2038, 10r	264	560
43r	BN 2038, 27r	122	517
43v–44r	BN 2038, 27r	124	331
44r–v		86	529
45r–v		142	539
45v		105, 104	301
46r		250	389
46r–v		156	544
47r–v	BN 2038, 16r	265	561
48v	BN 2038, 22v/E 19v	126	335
49r–v		218	228
49v	BN 2038, 17v	98	498
49v–50r	BN 2038, 17v	216	127
50r		102	17
50v	E 79v	103	109
50v	BN 2038, 14v	130	547
50v–51r	BN 2038, 27r	276	530
51r	BN 2038, 20v	134	555
51v–52r	BN 2038, 17v	252–5	397
52r	BN 2038, 18v	284	587
53r–v	BN 2038, 31r–30b	282	581
53v–54r	BN 2038, 18r	230	214
54r	BN 2038, 18v	227	210
54r		152	543
55v		260	550
58v–59r	BN 2038, 27v	258	516
60r		270	569
60v		259, 248	577, 388
61r–v		271	568
61v		267	567
61v–62r		261	571
62r		185	165
62v		191	159
63r		235	198
63v		224	194
64r–65r		232	204
65r–v		231	203
67r		179, 190	158, 163
67v	BN 2038, 16r	239	195
67v	BN 2038, 33r	188	162
68r		178	161
69v		228	192
70r		210	164
70v		226	207
71r		212	451
72r		237	199
72v		184, 213	170, 454

CODEX URBINAS FOLIO No	CORRESPONDING MSS SOURCE	McMAHON PARA No. (URB)	MK/MW No
73r	MADRID II, 78v	234	193
73r–v		225	206
73v		242	209
74r	E 18r	193	173
75v		182	168
75v–76v		176, 177	157
76v		243	197
77r		180	167
77r–v		244	212
77v		246	169
78r–v	BN 2038, 25v	238	205
103r		285	311
103v	BN 2038, 28v	289	312
103v	BN 2038, 28v	290	313
103v–104r		299	359
104r		359	360
104r–v		291	304
104v		296	308, 325
105r		286	303, 314
105v–106v		373	386
106v–107r		384	570
107r		438, 358	306, 356
107v–108r		418	562
108v		416	535
109r	BN 2038, 26v	415	536
109r–v		425	398
109v		335	349
110r		395, 401	391, 392
110v		361	342
110–111r		313	332, 334
111r–v		355	341
112v		342	352
113r		293	353
113r–v		340	350
113v		336, 346	344, 365
113v–114r		336	348
114r	BN 2038, 29v	382	346, 364
115r		330	345
115v		389	405
115v–116r		394	403
116r–v		325, 326	338
117r	G 26r	327	336
118v	L 79r	329	333
119v		379	355
120r		368	380
120v–121r		365, 366	379
121r		297	357
122r		367	377
123r		412	402
123r	BN 2038, 29r	374	343
123r		397	394
123v		322, 396	339, 401

CODEX URBINAS FOLIO No	CORRESPONDING MSS SOURCE	McMAHON PARA No. (URB)	MK/MW No
123v	BN 2038, 29v	400	390
124r–v	BN 2038, 27r	124	395
125r	E 36v	287	302
125r–v		403	404
125v		387	406
126r–v	BN 2038, 21r	424	400
126v	BN 2038, 29v	422–3	396
126v–127r	BN 2038, 28v	323	340
127r		420–1	399
127v	W 19070	378, 392	374, 189, 407
127v	MADRID II, 127v	795	189
128r	MADRID II, 78v	364, 371	378, 382
128v		332, 370	351, 383
129v		350	366
130r		376	375
130v–1r		442	504
130v		363, 430	362, 387
131r		442	578
131v		439	507
131v–32r	BN 2038, 28r	440	527
132r–v	BN 2038, 24v	432	526
133r–v		434	16
133v–134r	BN 2038, 33r	443	538
135r	BN 2038, 29r	554	573
136r–v		499	105
136v–37r		522	227
137r		354	369
137r–v		451	554
137v–38v		469	552
138v		352	367
139v–40r	A 38v	497	563
140r		426	94
141v–42r		501	229
142r–v		529	433
142v–43r		457	149
143v–44r		476	431
144v–45r		537	434
145r		502	219
145v		504	218
146r–v	BN 2038, 20v	503	222
146v–47r	BN 2038, 23r	491	119
148r–v	MADRID II, 71r	523	223
148v–49r		478	187
149r		472, 479	435, 441
149r	E 17r	448	232
149r–v		471	436
150r–v		480	429
150v–51r		520	226
152r		482	427
152v–53r		488, 464	133
153r	G 23v	464	542
153v–54r		506	225

CODEX URBINAS FOLIO No	CORRESPONDING MSS SOURCE	McMAHON PARA No. (URB)	MK/MW No
154v	G 53v	484	108
154v	BN 2038, 26r	466	171
155r–v	BN 2038, 19r	489	132
155v–56r		487	131
157r		437	307
157v	E 6v	551	445
157v–58r		552	442
158v		545	452
158v–59v		546	456
159v–60r		524	448
160r		525	455
160v		333, 427	347, 18
161v–62r	G 22v	473	438
162r	G 23r	474	439
163r–v		542–3, 544	450, 453
167r		568, 559	415, 409
167r–v		564	411
167v–68r	BN 2038, 17v	572	410
168r–v		567	412
168v		566	417
168v–69r	BN 2038, 4r	563	418
169r		573	416
169r–v	BN 2038, 17v	572	410
169v	BN 2038, 18r	569	414
169v–70r		560	420
170r–v		574	408
170v		565	419
171r		571	413
175r		579	238
175v	BN 2038, 22r	577	237
175v		584	261
175v	E 32v	590	293
176r		711	270
176v–77r		594	294
177r		594	292
177r–v		707	295
179r		587	263
179v		615	282, 285
180v		715	279
181r		658	299
182r–v	E 32r	617	284
183r	E 30v	662	300
184r		623	287
184v		712	271
185r		716	280
185v–86r		632	286
187r	BN 2038, 22r	595	264
187v		706	278
189r		814	208
191r		689	273
191v		798	185
193r–v		793, 794	178

CODEX URBINAS FOLIO No	CORRESPONDING MSS SOURCE	McMAHON PARA No. (URB)	MK/MW No
194r–v		836	211
195r	G 3v	598	235
195r		578	239
195r		769	250
195v–96r	BN 2038, 33v	791	179
196r–v		840, 842	230
196v		841	233
197r		770	255
199r–200r		646, 647	267
201r–v		675	246
201v		676	247
202v–03r		860	422
204r		724	181
205r		812	196
205r	BN 2038, 10v	815	201
205r–v	BN 2038, 10r	815	174
206r–v		785	183
206v		765, 792	172, 182
207v		802	186
207v	BN 2038, 33v	764	426
208v		844, 668	231, 240
209r		668	242
210v		602	265
211r		610	266
211v–12r		639, 640	289
212r–v	BN 2038, 11r	643–44	290
212v	BN 2038, 13v	756	177
212v–13v	BN 2038, 13v	756	296
213v–14v	BN 2038, 14r	674	297
215v–16r	BN 2038, 15v	622	291
218v–19v	BN 2038, 32r	672	244
	W 12604	673	244
219v–220r	BN 2038, 32r	750	269
220v–21r		679	248
222r		686	249
222v–23r		866	421
223r		667	243
223r–v		667	245
224r–v	BN 2038, 28v	868	545
224v	BN 2038, 21v	845	540
224v–25r	BN 2038, 21v	846	549
225r	BN 2038, 23r	870	548
225v–26r	MADRID II, 127v	795	189
226v		777	257
227r		774, 776, 775	251, 254, 256
228r	MADRID II, 26r	782	253, 258
229v–30r	BN 2038, 20r	786	184
230r		818	200
231r	E 32v	855	236
232v		826	218
233r–v		823	217
233v		833	216

CODEX URBINAS FOLIO No	CORRESPONDING MSS SOURCE	McMAHON PARA No. (URB)	MK/MW No
235r	E 19r	843	213
235v–36v		837	460
236v		838	461
236v–37v		839	462
238r–v		665	268
238v		822	191
240v–41r		872	551
243r–v		874	466
243v–44r		896	470
244r–45r		899	467
245v–46r		894	475
246r–v		900	468
247r–v	G 30v	875	476
247r	G 16v	887	471, 473
248v	G 33r	982	478
251r		890	472
251r–v		891	474
251v–52r		910	481
252v		906, 907	465, 464
253r		950	490
253v		959	493
253v–54r		952	484
254r		952	492
254v		919	483
255r		884	469
255v–56r	G 12r	914	482
256v–57r		936	485
257r		929	487
258r		960, 975	494, 496
260r–v	G 10r–v	939	486
260v	G 10v	927	488
262v–63r		971	495
264v	G 27r–v	901	480
265v	G 25v	963	491
266r–v		946	489
267v		905	463
275r		989	432
275r–v		991	430
276v		995, 996	424, 497
283r		998	457
283v		998	122
284v–85r		1004	459
285r		1001	458

LEONARDO MANUSCRIPT FOLIO No	McMAHON PARA No. (URB)	MK/MW No
MS A		
3r		111
8v		120
10v		118, 140
26v		145
27r		58
28v		371
36r		115
37v		117
38r		124
38v	497	563
40v		565
41r–v		128
42v		566
MS B		
2v		319
3v		590
B L		
1r		650
27v		113
62r		126
113v		423, 446
114v		479
173r		600
220r		142
232v		99
250r		596
251v		638
271v		661
BN 2038		
1r		102
2r	71	524
4r	563	418
4v		558
8v	257	576
10r	815, 264	174, 560
11r	643–4	290
12v		221
13v	756	291
14r	674	297
14v	130	547
15v	622	291
16r	239, 265	195, 561
16v		541
17v	216, 252–5, 572, 98, 59	127, 397, 410, 498, 510
18r	230, 562	214, 414
18v	227, 284	210, 587
19r	30, 489	26, 132
19v	42, 30	38, 39, 52, 55, 90
20r	786	184

LEONARDO MANUSCRIPT FOLIO No	McMAHON PARA No. (URB)	MK/MW No
20v	6, 503, 335, 134	9, 222, 349, 555
21r	424	400
21v	576, 845, 846	260, 540, 549
22r	577, 595	237, 264
23r	870	548
22v	427, 236, 76	18, 202, 572
23r	44	60, 65, 119
23v		139
24r	66, 118–19	534, 559
24v	432	526
25r	47, 79	70, 72, 77, 79, 85, 86, 505
25v	238, 95	205, 522
26r	466, 83, 65, 256	171, 528, 574, 575
26v	73, 415, 75	533, 536, 537
27r	124, 122, 276	331, 395, 517, 530
27v	63, 258, 74	515, 516, 531
28r	440	527
28v	289, 290, 323, 868	312, 313, 340, 545
29r	374, 60, 554	343, 512, 573
29v	382, 400, 422–3	346, 364, 390, 396
30v–31r	282	580
31v		499
32r	750	269
33r	188, 672, 12, 443	166, 244, 511, 538, 553
33v	791, 764	179, 426
34v		601
MS C		
7v		147, 283
8v		277
14v		262
15r		143
15v		657
18r		288
21r		272
27v		123
C A		
10va/37r		633
28rв/80r		636
39ve/110v		637
45va/124v		176,361
68ra/189r		664
68vb/190v		606
76ra/207r		3, 107
85va/232r		98, 103
90va/244v		652
92rb/252r		623
97va/266v		444
99va/273ir		363
101vb/278r		100
112ra/310r		518
117rb/323r		2

LEONARDO MANUSCRIPT FOLIO No	McMAHON PARA No. (URB)	MK/MW No
119va/327v		1, 4, 96, 305
126rb/348r		150, 274
132rb/365r		112
132vb/365v		241
141rb/387r		500
147rb/399r		655
154rb/417r		6
155rc/418ir		584
159rc/429r		653
176ra/480ir		
181ra/495r		180
182vc/500r		622, 627, 629, 631, 632
184vc/505v		166, 522
192ra/522r		665
199va/534v		513
203ra/543		95, 153
216vb/579r		639
221vc/591ir		146
221va/597iiv		5, 110
241rc/658r		298
247ra/669r		656
247vb/671r		621, 624, 626, 628, 630
250ra		259
252ra/680r		648
253vd/683v		14
270rc/730r		616
283ra/768r		625
309rb/847r		634
315va/867r		615
317rb/872r		619
323rb/887r		617
323va/975v		381
324r/888r		640
335va/914ir		614
345vb/949v		97, 393
354rd/980iir		449
361rb/1007r		635
371rb/1036iir		275
372va/1037v		620
391ra/1082r		612
MS D		
4v		135
6v		138
10v		136
MS E		
front cover		443
1r		663
3r		330
4r		129
6v	551	445
16r–v		125

LEONARDO MANUSCRIPT FOLIO No	McMAHON PARA No. (URB)	MK/MW No
17r	448	232
17v		151
18r	193	173
19r	843	213
19v	126	335
30v	662	300
31v	780–81	252
32r	617 (276, 284)	276, 281, 284
32v	855, 590	236, 293
36v	287	302
80r		224
80v		220
97v	103	109
MS F		
rear cover		603
18r		437
34r		134
37r		148
Forster I		
44r		384, 385
Forster II		
3r		646, 647
6r		645
43v		644
50v		368
62v		579
63r		580, 605, 610
101r		144
Forster III		
1v		643
66v		508
88r		642
88v		658
MS G		
rear cover		662
3v	598	235
6v		586
8r	70	104, 106, 519
10r–v	939, 927	486, 488
12r	914	482
16v	887	471, 473
18v	139	425
22v	473 (438)	121, 438
23r	474	439
23v	464	542
25r	64	509
25v	963	491
26r		336
27v	901	480
30v	875	476
32r		130

LEONARDO MANUSCRIPT FOLIO No	McMAHON PARA No. (URB)	MK/MW No
33r	982	478
37r		114
51r		477
53v		484
MS H		
40r		592
40v		608
41r		660
48v		609
49v		598
61r		591
63v		604
86r		155
88r		154
88v		594
98r		595
106v		659
150v		611
Codex Hammer		
4r		440
MS I		
104v		376
138v		593
MS K		
120v		116
125r		137
MS L		
79r		333
MS M		
80r		234
Madrid II		
2r		649
26r	782	253, 258
67r		12
70v		152
73r	234	193
78v	364	378
125r		188
127v	795	189
Oxford, Ashmolean Museum		
29r		588
29v		589
New York, Metropolitan Museum of Art		
Allegory of Fidelity		607
Turin		
38v		141
15576r		316

LEONARDO MANUSCRIPT FOLIO No	McMAHON PARA No. (URB)	MK/MW No
Venice, Accademia		
228/29		309
Windsor		
12304r		310, 315
12412r		447
12604r	673	244
12624v		327
12629r		190
12639r		372
12665r		583
12665v		582, 585
12698v		599
12700r		597
12700v		684
19016r		651
19038r		354
19038v		370, 373
19059r		641
19076r		654
19129r		317, 324
19130v		318
19132r		328
19133r		323
19133v		332
19134r–19135r		320, 326
19136r–19139v		321, 329
19141r		337
19150r		160
19151v		175
19152r		156

GLOSSARY OF PROBLEMATICAL TERMS

The following list is intended to give the reader of the present edition some idea of the type of problem encountered in translating Leonardo, and to provide the student who wishes to match this translation against the originals with an indication of the approach that has been adopted. The list concentrates on technical terms rather than those presenting literary problems.

accidente – literally 'accident', but Leonardo's use relates to the Aristotelian tradition, to mean the 'secondary' or 'acquired' property of something, or a specific effect, event or occurrence which affects something so that it deviates from the norm. It is translated variably in keeping with Leonardo's rather fluid use of the term. See also *prospettiva accidentale*, and *(accidentali) superfitiali*.

arte – refers to skill or a particular pursuit requiring skill, and not to 'Fine Art' in the modern sense. It was commonly coupled in the Renaissance with *scientia* or *ingegno* (see below).

arti liberali – the 'liberal arts' as defined in the classical and medieval syllabuses of education, and generally excluding the visual arts, which were often categorised as based upon mere handiwork. Leonardo was particularly concerned to establish painting as at least equal in rank to the mathematically based liberal arts (including music) and as superior to the literary arts.

astrologia – referring to both 'astronomy' and 'astrology' in their modern senses, but usually used in an approbatory sense by Leonardo to refer to scientific 'astronomy'.

attitudine – usually translated as 'posture'.

braccio (pl. *braccia*) – a standard unit of measurement (an arm's length), not entirely standardised throughout Italy, but equal in Florence to approximately 58 cm.

chiaro et scuro – the precursor of *chiaroscuro*, the term used to refer to the modelling of forms across the tonal range from white to black. The slightly archaic phrase 'lights and darks' conveys Leonardo's meaning quite accurately.

c(h)orda – used in an anatomical sense that is difficult to translate, since the substances of the nerves, tendons, ligaments and muscle fibrils were taken to be continuous. The translation as 'chords' is retained. See also *nervo*.

cima – typically a 'summit' of a mountain, but also as the 'tip' of a branch of a tree.

colore – generally as 'colour' in the common way, but also used by Leonardo to refer to what we would now call 'tone'; i.e., a point on the scale of greys between white and black.

corpo – translated as 'body', meaning not just body in the human or animal sense, but also body in the geometrical sense of something possessing three dimensions, and sometimes synonymous with mass (or even substance).

corpo ombroso – literally a 'shaded' or 'shadowy body', but used by Leonardo to refer to a body which has the potential to make primary and cast shadows under illumination. It is translated here as 'opaque body'.

dimostrare – generally translated as 'to show' or 'to display'. It often carries with it the meaning of 'to show' in the sense of 'to prove', and plays an important role in Leonardo's arguments on the basis of 'experience'.

discorso – most obviously as 'discourse', but also as 'theory', 'analysis' and 'speech'.

disegno – obviously 'drawing' or 'design', but a loaded term for a Renaissance theorist of the visual arts, meaning the supreme property of draughtsmanship as the foundation for visual merit and beauty. It is translated as 'draughtsman-ship' where appropriate.

esperientia (and variants) – literally 'experience', but used by Leonardo to signal a form of knowledge based on direct observation and, in particular instances, upon actual experiment. It is generally translated as 'experience' – occassional-ly as 'experiment' – and its particular meaning should be clear from the context in each case.

fantasia – literally 'fantasy' or 'imagination', but like *senso comune* (see below) actually referring to a localised faculty of the brain as interpreted in late-medieval theory. *Fantasia* is the faculty that has the ability to recombine images or parts of images in new compounds. It is generally translated as 'imagina-tion'. See also *imaginativa*.

figura – a term much used by Leonardo, sometimes in the literal sense of 'figure' (anatomical or geometrical), but more often to indicate the actual 'shape' or 'configuration' of a particular 'mass' or 'body' of material.

figurare – 'to portray' or 'to represent', especially in relation to the human figure and narrative painting. See also *fingere* and *ritrare*.

fingere – 'to portray' or 'to represent', especially in relation to narrative sub-jects in which a literary quality is involved. See also *figurare* and *ritrare*.

fortuna – variously as 'fortune' (the often malevolent spirit governing human affairs) and as a 'storm' in the meteorological sense (but with obvious implica-tions of the former meaning).

giudizio – 'judgement', used by Leonardo in the sense of objective accuracy and opposed to mere 'opinion'.

grazia – obviously as 'grace', but often with more far-reaching implications than our modern use of the term. It embodies a sense of individual virtue, much in the manner of the theological sense of 'grace'. It should be regarded as distinct from 'beauty', which is a more exclusively visual property.

grado – used by Leonardo to indicate a regular space or interval, and translatable variously as 'degree', 'interval', 'level', 'unit' or 'tier'.

grossezza – used in a catch-all manner by Leonardo to indicate 'size', 'largeness', 'thickness', 'breadth', 'area' (e.g., of the cross-section of a branch), and even 'circumference'. It is translated as seems most appropriate in each case.

imaginativa – 'imagination', as used by Leonardo within the context of medieval faculty psychology, but not clearly differentiated from *fantasia*. It can perform the function of a short-term memory.

impeto – translated readily as 'impetus' but carrying specific implications within medieval dynamic theory. Impetus is the quality impressed in a body which has been set in motion and governs the time–distance performance of that body. See also *percussione*.

imprensiva – apparently Leonardo's own term for a 'receptor of impressions' which he saw as a staging-house between the sensory nerves and the *senso comune* (see below). This term remains untranslated in the text.

ingegno – the precursor of our term 'genius', but meaning at this period 'innate talent' or 'brilliance of mind'. It is translated as 'talent' except where the context suggests an alternative.

invenzione – translated straightforwardly as 'invention', but having special significance in the humanist tradition as the first part of rhetoric. It conveys a sense of 'conception' or 'idea', and is an esteemed procedure.

istoria – 'history' used in a very specific sense in the Renaissance theory of art to denote 'narrative', whether religious or secular. An *istoria* was regarded as the highest and most demanding genre of painting. Also written as *storia*.

lembo – 'edge' (of a body) or 'hem' (of a garment), used as an occasional alternative to *termine* and *stremo*.

lineamenti – 'lineaments' or 'outlines', with respect to drawings, but better translated as 'contours' for seen or painted objects, since he stresses that solids do not have discernable 'outlines'. See also *termine*.

luce, lucida, lume, luminoso – together with *splendore* and *lustro* (see below) are some of the most difficult terms to handle, partly because of Leonardo's inconsistency and partly because they indicate categories specific to medieval optics. *Luce* generally refers to 'light' in the sense of the source, while *lume* usually refers to 'light' or 'illumination' as transmitted and received on a body. However, *luce* is also used as a term descriptive of part of the eye, namely the transparent, protruding, anterior surface of the eyeball (see also *popilla*). *Lucida* is used in the sense of bright or clear, but may carry the more specific implication of transparency. *Luminoso*, meaning luminous as an adjective, is often used as a noun by Leonardo to indicate a 'luminous source' in the sense of a bright body which illuminates a darker one.

lume particolare – a light from a particular or local source, and translated as 'specific light', as opposed to the *lume universale* ('universal light') of the *(h)emisfero* (the 'sky').

lustro – translated as 'lustre' and referring to the bright highlight on shiny surfaces, which, unlike the general pattern of light and shade, moves with the eye of the observer.

membra – pl. of *membro*, and commonly meaning 'limbs', but also translated as 'parts' of a body, though *membri* is generally correctly used for this sense and, e.g., for 'features' when used of a face.

misura – 'measurement' and, not infrequently, as 'proportion'.

moto loc(h)ale and *moto actionale* – used by Leonardo to refer respectively to the motion of a man or an animal from one place to another and to the motion of the limbs and parts of the body without overall change of location. They are translated respectively as 'motion of place' and 'motion by action'.

nervo – translated as 'nerve' but not clearly separable in usage from *chorda* (see above).

obietto – meaning 'object' but often used by Leonardo specifically to refer to an illuminated body opposite a *corpo*, and affecting the appearance of the *corpo* by radiance or reflection.

ombra – generally used in the obvious sense of 'shadow', but sometimes referring to the coloured reflection cast by one illuminated body on another.

ombre mezzani – translated as 'intermediate shadows'.

operatore – variously translated according to context as practitioner, painter and maker (in the sense of creator).

par(i)ete – used in an optical context not as 'wall' but as the 'plane of intersection' through the pyramidal arrangement of visual rays. It therefore corresponds to a pane of glass or the 'picture plane'.

percussione – translated readily as 'percussion', but carrying specific implications within medieval dynamic theory. Percussion is the blow that results from a moving body's 'desire' to complete the movement dictated by its 'impetus'. See also *impeto*. *Percosso* ('struck') has similar implictions.

pianta – literally 'plant' but used somewhat variably by Leonardo, in conjunction with *(h)erba* and *albero*, to refer to a plant, grass, shrub or tree. More often than not, 'tree' is meant.

popilla – literally the 'pupil' of the eye, but sometimes seeming to refer to the receptive surface of (or within) the eye. See also *luce*.

pratic(h)a – 'practice', but also used by Leonardo with implications of 'skill' and 'dexterity'. See also *arte*.

prospettiva (or *perspectiva* and variants) – 'perspective', but in the broader sense of the science of optics as a whole rather than simply as the painter's technique for the achieving of an illusion of three-dimensional space on a flat picture plane.

prospettiva accidentale and *prospettiva naturale* – as 'accidental perspective' and 'natural perspective', respectively, used by Leonardo in his later discussions of perspective to differentiate between the appearance of a construction of artificial or illusiory space on a picture plane when it is itself subject to perspectival distortion, and the way that things diminish perspectively in nature when viewed under normal circumstances.

quantità continua – literally 'continuous quantity', and translated as such, but referring specifically to the nature of all geometrical components above the size of a non-dimensional point. Thus a line is (or has) a 'continuous quantity', and stands apart from a sequence of numbers in arithmetic, which is 'discontinuous'. A 'continuous quantity' is theoretically divisible an infinte number of times.

rapresentare – 'to represent' and largely unproblematical, but not clearly differentiated from *figurare*, *fingere* and *ritrare*.

rilievo – literally as 'relief' or 'modelling', but also used to refer to sculpture or objects 'in the round' (i.e., three-dimensional).

ritrare – 'to portray', with an emphasis upon the direct copying of nature. See also *figurare*.

scientia – generally translated as 'science', but wider in scope than its present usage. It referred to a systematic body of knowledge on a theoretical base in any area of intellectual activity, rather than to the modern technical usage which implies 'science rather than art'. It is occasionally translated as 'knowledge'.

segno – as 'sign', has specific connotations within physiognomic theory, in which the 'signs' of the face provide a reading of the person's temperament.

senso comune – literally 'common sense' but actually referring to a particular component in the human mind as characterised in late-medieval faculty psychology. The *sensus communis* (Latin) was where the nerves from each of the five senses converged to be correlated. This term is rendered as *sensus communis* in the translation. See also *imprensiva*.

similitudine, simulacro, spetie – three terms all of which correspond roughly to our word 'image', but based upon a very different theory of optics and perception. According to the prevailing medieval theory, images from lit objects were transmitted across space in the form of 'invisible skins' radiating concentrically and carrying the semblance of the object to sight. *Simulacro* and *spetie* are translated as 'image' in the sense of the presence in the air, while *similtudine* is generally translated as 'semblance' to indicate the perceived match between object and transmitted image (though occasionally 'image' is more appropriate).

spirituale – literally 'pertaining to spirits', and referring to a property distinct from material substance or form, rather than 'spiritual' in the theological sense. It is translated as 'immaterial'.

storia – see *istoria*.

stremo – used in conjunction with *termine* (see below) to indicate the boundaries of bodies, and translated as 'edge'.

superfitie (superficie) – used relatively straightforwardly as 'surface', but without any implication that surface in the geometrical sense has physical existence, since it exists in two dimensions only. See also under *termine*. *Superfitiali stremi* is translated as 'outside surfaces'; and *accidentali superfitiali* as 'effects [of light] on surfaces'.

termine – used together with *superfitie* and *stremo* (see above) to denote the way in which one body borders or abuts on another. Leonardo emphasises that the point of abutment has no physical substance in its own right. *Termine* is translated as 'boundary' or less often as 'contour' (mainly with respect to sculpture), and never as 'outline'.

universale – used in a approbatory sense by Leonardo to indicate knowledge and achievement across a wide range of fields of human endeavour, rather than simply pertaining to the universe.

vedere – used very widely by Leonardo in its normal sense 'to see', but also used in his discussion of the optics of light in the sense in which one object may be said to 'see' another – or not to see, if there is another object in the

way. It has been decided not to retain this somewhat archaic and potentially misleading use of 'see' but to use 'is exposed to' or, less often, 'faces', when inanimate objects are involved.

virtù – literally 'virtue', but one of the most loaded words in the Renaissance, carrying implications of merit, power and individual worth beyond its present meaning.

virtù visiva – used by Leonardo to refer to the agent which takes up the transmitted image of objects and translates them into 'visual' form for the brain. One reasonable translation would be 'visual power', but since Leonardo uses it to refer to a specific localisation of the receptive faculty, 'seat of vision' or 'visual faculty' is used here.

voce – in addition to its obvious meaning as 'voice', Leonardo appears to use *voce* in a specifically musical context to refer to the pitch of a note.

BIBLIOGRAPHY AND ABBREVIATIONS

Abbreviations, facsimiles, transcriptions and catalogues

BL: London, British Library (Codex Arundel)
I Manoscritti e i disegni di Leonardo da Vinci. Il Codice Arundel 263, Reale Commissione Vinciana, 4 vols., Rome, 1923–30

BN 2038: Paris, Institut de France (MS Ashburnham II) ed. Ravaisson-Mollien etc. (see A to M below)

CA: Milan, Biblioteca Ambronsiana, Codice Atlantico
Il Codice Atlantico di Leonardo da Vinci nella Biblioteca Ambrosiana di Milano, ed. A. Marinoni, 12 vols., Florence, 1973–5; and *Il Codice Atlantico della Biblioteca Ambrosiana di Milano, trascrizione diplomatica e critica*, 12 vols., ed. A. Marinoni, Florence, 1975–5; and *The Codex Atlanticus of Leonardo da Vinci, a Catalogue of its Newly Restored Sheets*, ed., C. Pedretti, New York, 1978–9; and *Il Codice Atlantico di Leonardo da Vinci nella Biblioteca Ambrosiana de Milano*, ed. G. Piumati, 35 vols., Milan, 1894–1904.
Note: in each reference to the CA, the old folio nos. (as in Piumati, above) are followed by the new folio nos. following the restoration (as in Marinoni and Pedretti above)

Forster I, II and III (sometimes as SKM): London, Victoria and Albert Museum, Library
I Manoscritti e i disegni di Leonardo da Vinci. Il Codice Forster I [etc.], Reale Commissione Vinciana, 5 vols., Rome, 1930–6

Hammer (formerly Codex Leicester): Los Angeles, Armand Hammer Collection
Il Codice di Leonardo da Vinci della Biblioteca di Lord Leicester in Holkham Hall, ed. G. Calvi, Milan, 1909

Lomazzo: G. P. Lomazzo, *Trattato dell'arte della pittura, scultura ed architectura*, Milan, 1584; and *Scritti sulle arti*, ed. R. Ciardi, 2 vols., Florence, 1973–4

Madrid I and II: Biblioteca Nacional, MSS 8937 and 8936
The Manuscripts of Leonardo da Vinci at the Biblioteca Nacional of Madrid, ed. L. Reti, 5 vols., New York, 1974

McM: *Treatise on Painting by Leonardo da Vinci*, ed. and trs. A. McMahon, intro. L. Heydenreich, 2 vols., Princeton, 1956 (including a facsimile)

MSS A to M: Paris, Institut de France
Les Manuscrits de Léonard de Vinci, Manuscrit A. [etc.] de l'Institut de France, ed. C. Ravaisson-Mollien, 6 vols., Paris, 1881–91; and ed. A. Corbeau and N. de Toni, Grenoble, 1960 (MS B), 1964

(MSS C and D), 1972 (MS A); and *I Manoscritti e i disegni di Leonardo da Vinci. Il Codice A*, 2 vols., Rome, 1938; and D. Strong, *Leonardo da Vinci on the Eye*, (MS D) Ph.D. thesis, University of California, Los Angeles, 1968

Oxford: Christ Church
Drawings by Old Masters at Christ Church Oxford, ed. J. Byam Shaw, 2 vols., Oxford, 1976

Turin: Biblioteca Reale
I Manoscritti de Leonardo da Vinci. Codice sul volo degli uccelli e varie altre materie, ed. T. Sabachnikoff, G. Piumati and C. Ravaisson-Mollien, Paris, 1893; and *Codice sul volo degli uccelli. Trascrizione diplomatica e critica di A. Marinoni*, trs. C. Pedretti, New York, 1982

R: *The Literary Works of Leonardo da Vinci*, ed. J. P. Richter, 3rd ed., London and New York, 1970; and *Commentary* by C. Pedretti, 2 vols., Oxford, 1977 (containing additional texts and important textual revisions)

Urb: Vatican, Codex Urbinas Latinus 1270
See McM above; and *Leonardo da Vinci. Das Buch von der Malerei*, ed. H. Ludwig, 2 vols., Vienna, 1882

Windsor: Royal Library, Collection of Her Majesty The Queen
A catalogue of Drawings by Leonardo da Vinci in the Collection of Her Majesty the Queen at Windsor Castle, ed. K. Clark and C. Pedretti, 3 vols., London, 1968–9; and *Leonardo da Vinci. Corpus of Anatomical Studies in the Collection of her Majesty the Queen at Windsor Castle*, ed. K. Keele and C. Pedretti, 3 vols., London and New York, 1979–80; and *Leonardo da Vinci: Fragments from Windsor Castle*, ed. C. Pedretti, London, 1957

Other publications containing sources

Scritti scelti di Leonardo da Vinci, ed. A. M. Brizio, Turin 1952

Leonardo da Vinci. Scritti letterari, ed. A. Marinoni, Milan 1974

The Notebooks of Leonardo da Vinci, ed. E. MacCurdy, 2 vols., London, 1938

C. Pedretti, *Leonardo da Vinci on Painting. A Lost Book (Libro A)*, London, 1965

L. Beltrami, *Documenti e memorie riguardanti la vita e le opere di Leonardo da Vinci*, Milan 1919

G. Calvi, *I manoscritti di Leonardo da Vinci dal punto di vista cronologico storico e biografico*, Bologna, 1925.

H. Glasser, *Artists Contracts of the Early Renaissance*, New York and London, 1977

G. Sironi, *Documenti inediti per la storia della 'Vergine delle Roccie' di Leonardo da Vinci*, Milan, 1991

J. Shell and G. Sironi, transcription of the 'Lista', in *Zenale e Leonardo, tradizione e rinnovamento della pittura lombara*, ex. cat., Museo Poldi Pezzoli, Milan, 1982

A. Vezzosi (ed.), *Leonardo dopo Milano. La Madonna dei fusi* (1501), Vinci, 1982

Further reading on Leonardo as a painter and draughtsman

K. Clark, *Leonardo da Vinci*, ed. M. Kemp, London, 1988

E. H. Gombrich, various essays on Leonardo: in *Norm and Form*, London, 1966,

pp. 58–63; *The Heritage of Apelles*, Oxford, 1976, pp. 39–75; and *New Light on Old Masters*, Oxford, 1986, pp. 32–88

L. Heydenreich, *Leonardo da Vinci*, 2 vols., New York and Basel, 1974

M. Kemp, *Leonardo da Vinci. The Marvellous Works of Nature and Man*, reprinted with minor revisions, London, 1988

M. Kemp and J. Roberts, *Leonardo da Vinci. Artist, Scientist, Inventor*, with an introduction by E. H. Gombrich, and an essay by P. Steadman, London and New Haven, 1989

Leonardo. La Pittura, ed. A. Vezzosi and P. Marani, Florence, 1977

C. Pedretti, *Leonardo da Vinci: a Study in Chronology and Style*, London, 1973

A. Popham, *The Drawings of Leonardo da Vinci*, London, 1946

The Unknown Leonardo, ed. L. Reti, London, 1974

M. Rosci, *The Hidden Leonardo*, Oxford, 1978

K. Veltman, *Studies on Leonardo da Vinci I. Linear Perspective and the Visual Dimensions of Science and Art*, Munich, 1986

J. Wasserman, *Leonardo da Vinci*, New York, 1968

INDEX

actions of figures, express the motion of the mind, 144–5; recommended method of recording, 198; to be varied in narrative painting, 220; *see also* motion

Adoration of the Magi, contract for, 268

Aeolus, 237

aerial perspective: *see* perspective, aerial

age of trees, characteristics revealing, 177–9

Agostino da Pavia, 266

air, lighter nearer the earth, 82; *see also* atmosphere

allegories and emblems: Pleasure and Pain, 238–9; Envy, 239–40; Fame and Infamy, 240–1; Il Moro 241; Galeazzo, 242; of Human Misery, 243; inventions for a pageant, 242–3; Prudence and Strength, 243; Ingratitude, 243; Truth and Falsehood, 244; Liberty, 244; Hope, 246; Fidelity, 247; Regeneration, 248; Unity, 248

Amboise, Charles d', letter from L. to, 259

anamorphosis, 59–60, 219

anatomy: L. aware of as outside scope of book on painting, 6; of the eye, L.'s intention to describe, 50; of babies, 123; bones, 127, 130, 131; L.'s projected book on, 130, 135; necessary for painter to know, 130; tendons, 130; muscles 130–2; chords, 131, 132; limbs, 131, 132; behaviour of joints, 136–7; necks of animals, 137; L. hindered in, 261; L. hopes to complete in winter of 1510, 265

Anghiari, *see* Battle of

angle, mathematical definition of an, 53

ancients, 45, 49

angry figure, how to represent an, 146

animals: loss of vision and hearing in, 22; deceived by painting, 34; dust raised by running, 168; fictional, made to look natural, 224; behaviour during deluge, 235–7

Antonio, 266, 267

Apelles, 33

architecture, 21; needs draughtsmanship, 45; L. describes his competence in, 253; L. makes comparison between doctors and architects, 256; *see also* buildings

arithmetic, 10, 14, 18, 35

art, recognised by noble intellects, 15

arts: cerebral, 35; liberal, 37, 46; mechanical, 35, 46

astronomy, 14, 16, 18, 21, 33, 34; dependent on perspective, 33; and poetry, 34

Atalante (Migliorotti?), mentioned by L., 263

atmosphere, 6; in early morning, 163; effect on distinctness; 165–6; which lends grace to faces, 215

authority, versus experience 9–10; versus nature, 193–4

background, visibility of boundaries against, 65–6; effect of b. on different colours, 72;

effect on visibility, 165–6; principal element of painting, 209, 210

balance: of figures, 134–6; motion of place made by disruption of, 138–41

Bartolomeo, 266

bas relief, 40, 42; light and shade in, 42; perspective in, 42

battle, shortcomings of poet's description of, 28; vary the movements of figures in a scene representing a, 220; how to represent a, 228–33

Battle of Anghiari: memorandum of work in progress on, 264; contract for, 270–1

beauty, human, 23–4, 34, 35, 204; more attractive than ornament, 196
in nature, 28, 30

bells, sound of, 201, 222, 264

Belvedere: *see* Rome: Vatican

Benedetto, 267

birds, colours in feathers of, 71

body or bodies: shadow of, 15; as fourth principle of the science of painting, 15; a part of the function of sight, 49; angles made with their pyramids, 52–3; mathematical definition of, 53; shadow on opaque, 74; light and shade on a faceted, 91–2; every opaque b. found between two pyramids, 109; opaque, 213; 'certain b.'s [drawn] in perspective', 263

books, printed, 19

Borian, Gulielmo, 278

Boso, Gian Francesco, 263

Botticelli, Sandro, 201

boundaries, 45, 53; loss of distinctness in, 86–7; how the painter should treat, 87–8; visibility of, varies with distance, 212; *see also* outlines

branches: variety in types of, 175–6; ramification of, 175–7; 179–82; laws governing growth of, 176–7; thickness of, in relation to trunks and leaves, 177–9; effects of light on, 182; visibility of, at a distance, 186; *see also* leaves

brother(s) of Leonardo: mentioned in a letter to Ippolito d'Este, 258; beneficiaries of L.'s will, 277; Melzi's letter to, 279

buildings, visibility of at a distance, 166

canal rights, L.'s, 259, 260, 278

candlelight or lamplight, drawing by, 216

Carissimo, Alessandro, 264

Caterina, 264

cause and effect, 40

cerebral arts: *see* arts, cerebral

chiaroscuro, 15, 16; *see also* light and shade

children, how to represent young, 146

chiromancy and false physiognomy, 147

chords; in human anatomy, 130, 132

Christ Child, 264

Cimabue, 193

clouds: effect of, on light in countryside, 162; sun's effect on, 163-5

Codex Urbinas: *see* Rome: Vatican

Codice Atlantico: *see* Milan: Biblioteca Ambrosiana

colour(s): absent from sculpture, 40, 42; a part of the function of sight and of painting, 49; semblance of object's c., left in path of its rapid motion, 67; each enters eye separately, 70; simple and compound, described, 70-1; how to enhance transparent, 71; seen through coloured glass, 71; rainbow effect, 71; quality of, revealed by light, 72; which situation is best for each to be seen in, 72; mixing of, 72-3; how to combine, to give grace, 72-3; on shadow, 72-3; in lights and shadows, 74-5; how the blueness of the air arises, 81-2; boundary of one is the start of another, 86; order in which characteristics of are lost over a distance, 87; four principal parts to be considered in, 88; in derivative shadows, 110-111; in landscapes, 162; of sun, 163; in rainbow, 168; in shadows, 212; should lend grace to one another in a composition, 212; should not look joined or attached to each other, 212; matching painter's c.'s with natural c.'s, 212-213; of smoke and dust, 229; of fire at night, 238

painter' c. obtained for L. from the Ingesuati, 268; *see also* perspective of colour

competition, good for young painter, 205

composition, *see* figure composition; narrative painting

compositions, ideas for: *see* battle; deluge: Last Supper; night

Confraternity of the Immaculate Conception, *see* Milan: S. Francesco Grande

continuous quantity, 133; *see also* geometry

contracts, 268-71; dispute over *Virgin of the Rocks*, 253-5

copying, 19; *see also* imitation

Corvinus, Mathias, King of Hungary, 24-5

costume, decorum to be observed in, 152; *see also* fashion

cosmographer, cosmography, 21, 38

Count, the young, with the Cardinal of Mortaro, 264

Croysant, Guglielmo, 278

Cusano, Messer Girolamo, 260

De Ponderibus, 265

deception, paintings have power of, 19, 20, 26-7, 34

decorum, 132, 150-51, 200

deluge, how to represent the, 233-7

Demetrius (the Cynic), reference by L. to, 9

despairing figure, how to represent a, 146

devices: for warfare, 251-2; for ships, 263; 'certain, for water', 263

discontinuous quantity: *see* arithmetic

distance: a part of the function of sight and painting, 49; eye not a good judge of, 58; increases visibility of a spherical body, 66; *see also* perspective

distortion and illusion created by perspective, 58-68; 218-19

doodles, verbal, 263

draperies: folds in, 153-6, 157-8; shadow in, 153, 158; motion in, 155-6; effect of foreshortening on, 158

draughtsmanship: excellence of, 16; and sculpture, 45; as principle of painting, 45; and architecture, 45

drawing: definition of, 16; glass used in perspective, 57; from life, 130; right temperament needed to learn, 197; good masters needed, 197; from memory, 206-7; by candlelight, 216; glass for, 216; net, 216-17; first sketches for narratives, 225

dumb people, study gestures of, 144

dust 167-8, 228; raised by animals, 168, 229

ear, 14, 18; and eye compared, 19, 20-4, 26, 28, 32; loss of hearing, 21-2; *see also* painting

earth, curvature of the, 173

emblems, *see* allegories

emotion, 4; representation of, 144-50; in bystanders, 150; in narrative painting, 220; in combatants, 229; in deluge victims, 236; *see also* motions of the mind

engineering, derives from painting, 46; *see also* hydraulic engineering

Equestrian monument, to Francesco Sforza, 252-3, 255, 258; *Il Regisole*, 265

equilibrium, *see* balance

errors: not made by true masters, 44-5; of perspective made by painters, 51-2; caused by ignorance of anatomy, 130-1; correction of, in our own work, 194; of painters who do not observe decorum, 200; how to recognise in one's own and others' work 203; in repetition, 204, 220; of lighting conditions, 209

Este, Cardinal Ippolito d', letter from L. to, 258-9

Este, Isabella d', letters to, from Fra Pietro da Novellara, 271-5

experience, 49-50, 65, 66, 67, 203; versus authority, 9, 10; true sciences born of, 10; nothing achieved with certainty without, 14; common mother to sciences and arts, 52

expression, *see* emotion

eye: functions of, 16; compared to other senses, 18; and ear compared, 19, 20-4, 26, 28, 32; as window of the soul, 20. 32; praise of, 21; noblest sense, 21, 23, 26; loss of sight, 21-2; ten functions of the, 49; how it sees, 50-1, 53-4; images seen by, 50, 53, 55, 56, 235; angle of vision, 54-5; point in, towards which visual pyramids converge, 55; how to locate the point in another's, 56; not a true judge of distance, 58; images retained in e. after the act of seeing, 69; light and shade seen by e. as it moves around an opaque body, 100; sees rainbow, 168; visual power of, 172; location of determines position of the horizon, 172; can only comprehend one thing at a time, 51, 197; *see also* light; perspective

faces: loss of distinctness in features at a distance, 86; nature creates variety in, 120; proportions of, 123-5, 126; should not resemble their master, 204; how to select beautiful, 204; monstrous, 208; graceful, 215-16; should not all resemble each other, 220; *see also* emotion

Fanfoia, Il, 267

fashion, vagaries of, censured by L., 152-3

Feligne, Girolamo/Geronimo da, 263

Ferere, Messer Ambrogio, 258

figure composition, how painter should learn, 199

Fleri, Magister Spirito, 278

Florence: admired by L., 259; life led by L. in,
 273; Santa Maria Nuova, L.'s money on
 deposit at, 277–8, 279
foam, 170
foreshortening, 44, 45, 59, 88; effect on draperies
 of, 158; need to give impression of greater
 height, 218–19; how to counter natural, 219
Francesco da Corton, 278
Fulchin, Magister Cipriane, 278
funeral, L.'s, 275

Galeazzo, 266
games to exercise the judgement, 206
geometry, 88; definition of, 10, 14, 18; cerebral
 qualities of, 35; derives from painting, 46; L.
 hard at work on, in Florence, 273; see also
 angle; bodies; boundaries; line; point; surface
German assistants of L., in the Vatican, 260–61
gesture, see emotion; motion
Gherardo (di Giovanni di Miniato), the
 illuminator, 265
Giacomo Andrea (da Ferrara), 266
Gian Antonio (Boltraffio), 266
Giorgio (German ironworker), 260–1
Giovanni (German mirror-maker), 260–1
Giovanni Lombardo, 265
Giovannina, with fantastic face, 264
Giotto, 193
Giulio Tedesco, 266, 267
God, 21; speculation on nature of, 32–3
goldsmiths, 45
grace, 162, 204; colours should lend g. to one
 another in a composition, 212; lighting
 conditions which lend, 215–16; how to
 combine colours to give, 72–3
Gualtieri (Bascapè) Messer, 241
gypsy, head of a, listed by L., 263

hair, hairstyles and headgear, 225–6; list of heads
 with, 263–4
handwriting style, L.'s, 8
harmony: born of proportion, 23, 26; in painting,
 32; in music, 34, 37
heads, listed by L., 263–4
hearing, sense of, see ear
Hieronymo, Ser Raffaello, 258–9
historical painting, see narrative painting
horizon, 82, 163, 164, 165, 172–3, 218, 235
horse(s): parallel tracks made by, 55; loses
 distinctness at a distance, 85
human figure: loses distinctness at a distance, 85;
 light and shade falling on a rotating, 101; see
 also anatomy; emotion; limbs; motion
hydraulic engineering, L. describes competence
 in, 252; see also canal rights

illusion and distortion created by perspective,
 56–68, 218–19
images (seen by the eye): of lightning, 49; of a
 man seen through the eye of a needle, 86; see
 also eye; visual pyramids
imagination, 202, 222, 224; superiority of the eye
 over, 22–3
imitation of others' work: censured by L., 193–4;
 dangers of imitating a bad master, 198
impetus of falling water, 169, 235
imprensiva, 22, 23, 67, 86
Ingesuati (Compagnia degli), 268
intersection, use in perspective, 58–59; see also
 perspective
inventions, 201–2, 222, 225

iris, called the celestial rainbow, 72

Jacopo Tedesco, 267
Jean de Paris (Perréal), 265
Joditti, 267
judgement: born of good understanding, 52;
 perspective to the aid of, 58; good, directed
 by the soul, 120; painter should welcome
 others', 203
 painters', 196–7, 198, 200, 201, 202, 203; to be
 exercised regarding light and shade, 198;
 games to exercise the, 208

knowledge: mechanical and scientific, compared,
 10; great love born of thorough, 195

landscape: method of portraying, 162; use of stain
 technique to compose, 201–2
Last Supper, ideas for, 227–8
laughter, how to represent, 147–8
leaves: shadow on, 183–5; lustre on, 184;
 transparency of, 184–5; light on, 185; wind,
 effect of, on, 185–6; visibility of, at varying
 distances, 186–8
lefthandedness, L.'s, 8
Leonardo da Vinci,
 drawings by:
 Budapest, Museum of Fine Arts, Study of
 the head of a man shouting and of a
 profile, for the Battle of Anghiari, fig. 148;
 Warrior's head for the Battle of Anghiari
 fig. 6
 Florence, Uffizi, An old man and a youth
 facing one another fig. 142; Val D'Arno,
 fig. 9
 London, British Museum, 1860-6-16-99,
 Scythed chariot and armoured cars, fig. 170;
 1861-6-21-iv, Virgin and Child with a Cat,
 fig. 143
 London, National Gallery, The Virgin and
 Child with St Anne (?) and St John, fig. 103
 London, Private Collection: The Ermine as a
 Symbol of Purity, fig. 167
 New York, Metropolitan Museum, Allegory
 of the Lizard symbolising Truth, fig. 165
 Oxford, Christ Church, Allegories of
 Pleasure and Pain and of Envy, fig. 153;
 Two Allegories of Envy, fig. 154
 Paris, Louvre, Half-Length Portrait of
 Isabella d'Este fig. 175
 Turin, Biblioteca Reale, Study of a woman's
 head, for the Angel in the Virgin of the
 Rocks, fig. 45
 Venice, Accademia, Battle of horsemen and
 footsoldiers for the Battle of Anghiari,
 fig. 149; Dancing 'Nymphs', fig. 104; Study
 of human proportions in the manner of
 Vitruvius, fig. 73
 Windsor, Royal Library, 12281r, Dissection of
 the principle organs of a woman, fig. 172;
 12360, A dragon, fig. 144; 12371, Monster's
 head, fig. 8; 12388, Infernal destruction,
 fig. 5; 12401, A flood breaking into a valley
 and wind blowing away battle tents,
 fig. 151; 12409, Storm over a valley, fig. 12;
 12410, Study of peaks of mountains, fig. 117;
 12414, Study of Alpine peaks, fig. 110; 12424,
 Star of Bethlehem, fig. 2; 12495r, Five
 grotesque heads fig. 135; 12502, Head of a
 belligerent man with a lion, fig. 101; 12543,
 Study of clasped hands for the Last Supper,

fig. 147; 12551, Study for the head of St
Philip in the Last Supper, fig. 145; 12552r,
Study for St James the Greater in the *Last
Supper*, fig. 100; 12567, Study of the chest
and shoulders of an infant from front and
rear, fig. 11; 12570, Neptune with four sea-
horses, fig. 152; 12581, Pointing lady in a
landscape, fig. 7; 12596r, Nude man from the
rear, fig. 72; 12616, Study of hands for the
Adoration of the Magi, fig. 102; 12700v,
Geometrical figures and designs for
allegorical representations, fig. 162; 19017r,
Anatomy of the foot and lower leg, fig. 81
paintings by:
 Cracow Czartoryski Museum, *Cecilia
 Gallerani*, fig. 4; fig. 140 (detail)
 Florence, Uffizi, *Adoration of the Magi*, fig. 173
 London, National Gallery, *Virgin of the Rocks*,
 fig. 3, (detail of angel's head); fig. 42 (detail
 of distant mountains)
 Milan, Sta Maria della Grazie, *The Last
 Supper*, fig. 146
 Paris, Louvre, *mona Lisa*, fig. 10; *Virgin, Child
 and St Anne fig.* 174; *Virgin of the Rocks*,
 fig. 171
 L. and studio, Collection of Duke of
 Buccleuch and Queensberry, *Virgin and
 Child with a Yarn-Winder*, fig. 176
writings:
 L.'s on painting, 1, 4; projected treatises, 1;
 legacy of, 1; *Trattato della Pittura*, 1, 2 (*see also*
 Rome: Vatican, Codex Urbinas);
 contradictions in, 2; progressive publication
 of, 2; character of L.'s, 2, 5; circulation of
 L.'s, 2; anthologies of L.'s, 2–3; L.'s inability
 to complete, 6; 'On the Elements of
 Machines', 7; problems of terminology in
 translating, 7; literary style in, 7–8; unfinished
 charactder of, 8; on anatomy, 130; on the
 human figure, 264; begun in the house of
 Piero di Braccio Martelli, 264–5; on shadows,
 97, 265; descriptions, ideas for compositions
 etc., *see* individual themes
Leonardo of Cremona, 265
letters, from L., 251–61; L. not a man of, 9
liberal arts: *see* arts, liberal
life led by L. in Florence, 273
life drawing, 130, 198, 199
light(s): a part of the function of sight and of
 painting, 49; study of (L.'s paraphrase of
 Pecham's *Perspectiva communis*), 49; changes in,
 and size of the pupil, 69; reveals the quality
 of colours, 72; in the countryside, 82–3, 161–5;
 definition of, 90; equal illumination, 90;
 illumination by even, 93; greater amount
 increases luminosity of the light, 94; larger,
 casts a shorter shadow, 106; different kinds
 of, in narrative paintings, 161; effect of strong,
 162; evening provides good, 162; in cloudy
 weather good for painting, 162; on leaves, 185;
 adding intermediate and principal, 211;
 degrees of, 211; source of in painter's studio
 214, 216; *see also* lustre
light and shade, 6, 13, 15, 16, 35, 88–115; in
 sculpture, 42–3; in painting, 44; definitions of,
 88, 90; on a faceted body, 91–2; rules for
 applying, 91–2; as seen by the eye moving
 round an opaque body, 100; on a rotating
 human body, 101; how bodies accompanied
 by l. and s., differentiate their boundaries, 101;

pyramids function by means of, 111–13; in
 sunless atmosphere, 161; in the countryside,
 161; at night, 162; strong contrasts in not
 recommended, 162; in rain, 168; reflected in
 water, 171–2; on trees, 183, 189; painter should
 learn to exercise judgement regarding, 198;
 how to employ correctly in compositions,
 208; on limbs, 209; used to enhance relief,
 209–10; which lends grace to faces, 215–16; in
 a battle scene, 229; in a night scene, 238; *see
 also* light(s); lustre; shadow(s)
lightening, illusory effect of, 67
Ligny, Count Louis de, Leonardo's memorandum
 mentioning, 265
limbs: decorum in, 132; practice in drawing, 199;
 light and shade on, 209; posing of, in
 narrative composition, 222; *see also* anatomy,
 emotion, motion
line, 15, 53, 86
linear perspective, *see* perspective, linear
lists of own works, made by L., 45, 263–4
Lorenzo, 267
low relief, *see* bas relief
lustre, 95–6; colour loses, over a distance, 87

MacCurdy, Edward, 2–3
Machiavelli, Niccolò, 271
madness, L. proposes to write on, 146
Madonna, *see* Virgin
Marco (d'Oggiono), 266
Mariolo, (de'Guiscardi), Messer, 264
Marius, reference to by L., 9
Martelli, Piero di Braccio, L. begins writing in the
 house of, 264–5
Masaccio, 193
mathematics, 19, 21, 46; truth of 10; certainty of,
 49; painter needs, 205; L. absorbed by, 273;
 five terms of, 53
Mathias Corvinus, *see* Corvinus
Maturina, 277
mechanical arts: *see* arts, mechanical
'medici', L.'s reference to, 265
Medici, Giuliano de' (Il Magnifico), 265; draft of
 letter to from L., 260–1
Melzi, Giovanni Francesco, as L.'s literary
 executor, 1–2; letters to from L., 259–60; L.
 left for Rome with, 267; mentioned in L.'s
 will, 275, 277–8; letter from, to L.'s brothers,
 279
memoranda: professional, 263–6; workshop and
 household, 266–7; *see also* doodles
memory: drawing from, 206–8; cannot retain all
 nature's forms, 225
Milan: Bibiloteca Ambrosiana I, Codice Atlantico,
 4; Cathedral, letter from L. to authorities of,
 256–7; San Francesco Grande, Confraternity
 of the Immaculate Conception, 253–5, 268–9;
 Santa Maria delle Grazie, mentioned in
 memorandum by L., 265
mirror: painter's talent like a concave, 200; master
 of painters, 202; painter like a, 202; use in
 painting, 203; painter's mind like a, 205
modelling, relationship to painting and sculpture,
 45
models, clay, 45
money, pursuit of, censured by L., 194–5, 225
Monte [delle Doti], 268
Moro, Il, *see* Sforza, Ludovico
motion: a part of the function of sight, 49; object
 in rapid m. doubles its visual image, 67; of

shadows, 114–15; three kinds of, in animals, 137; force of m. to be appropriate to action, 140; of draperies, 155; correct amount of for figures to display in a composition, 201

of action, 18; different kinds of, listed, 134; bending and stretching, 135, 137

human, 4, 119, 229, 132–143; behaviour of muscles in, 130; compound, 132, 133, 220; slowness and speed, 132; can be viewed from infinite number of locations, 133; delivering a blow, 133, 141–2; twisting, 134, 135; balance in, 134–6, 138; ploughing, 142; shooting a crossbow, 142, 143; throwing, 142, 143; *see also* motion, straight; motion of action; motion of place

of place (rising, falling, going on the level), 132; made by disruption of balance, 138–141; running, 138–9; climbing, 139–40; raising, 140; jumping, 140; pushing and pulling, 140–1 straight, 132

motions of the mind, 119, 144–6, 200, 222

mottoes: *see* allegories and emblems

mountains: blueness of, 81; colour of, 83–4; visibility at a distance, 165–6; and the horizon, 172–3; shaped by rivers, 173–5; vegetation on, 175–6; drawing a mountain facing the sun, 213; collapse of, 233–4

movement: *see* actions; motion

muscles in sculpture, 44, 45; *see also* anatomy; motion

music, 14, 15; proportionality in, 23; impermanence of, 23–4; compared with poetry 24–37; as the sister of painting, 34; harmony and proportion in, 34; and painting, 34–7; cerebral qualities of, 35; a liberal art, 37; four part singing, 37; harmonic intervals, 37; accompaniment to painter at work, 39

mutes: *see* dumb people

narrative painting, 200; draperies should be varied in, 155; depiction of light in, 161; choosing correct viewpoint for, 217–18; tiers of figures to be avoided, 217–18; should arouse emotion, 220; opposites should be juxtaposed, 220; posing of limbs in, 220; first sketches for, 225

natural perspective, *see* perspective

nature, 16; men should rely on, 9; relationship of painting and science to, 13–14; works of, more worthy than words, 21; eye triumphs over, 21; works of, less permanent than painting, 35; cause and effect in, 40; assists sculpture with shadow and perspective, 42–3; painter to observe variety in, 119; contrives variety, 119, 120; human anatomy designed by, 132; draperies to be copied from, 153; depiction of by painter, 161–189; painters should have recourse to, 193–4; painting, daughter of, 201; painters who ignore, 201; painter should liken his mind to, 205; memory cannot retain all her forms, 225

navigation, 21

nearness, a part of the function of sight and painting, 49

necessity, 50, 127

Neptune, 237

night scene, how to represent a, 238

noses, variety in types of, 206

notebook, for recording figures from life, 198, 199

Novellara, Fra Pietro da, letters from, to Isabella d'Este, 271–5 nude figures, 'many complete' listed by L., 263

observation, to be practised by painter, 199, 201, 202

old men: how to represent, 147; 'many heads of' listed by L., 263

old women: how to represent, 147; 'many throats of', listed by L., 263

opposites, should be juxtaposed in narrative painting, 220

optics: Melzi draws little on L.'s writings on, 2; L.'s treatise on painting to include, 4; derives from painting, 46; *see also* eye; light; perspective

orator, 38; how to represent, 149–50

ornament, excesses of, censured by L., 196

Our Lady: L. lists his works depicting, 263; *see also* Virgin

outlines, 16, 86, 198, 210

pageant, inventions for a, 242–3

pain and self-preservation, 132

painter: aims of, 15; lord of all things, 32; description of work of the, 39: music accompanies, 39; interpreter between nature and art, 40; errors of perspective by, 51–2; should avoid lines around bodies, 53; should prefer simple above compound perspective, 60; should dress his figure in lighter colours, 72; how painters should put perspective of colour into practice, 78; should make boundaries less discernible over a distance 86–7; how he should paint boundaries that are near, 87; to observe variety in nature, 119; should avoid monstrous proportions, 119; should avoid reproducing own features, 120, 204; needs to know anatomy, 130; reproved for studying on feast days, 195; should make their works attractive, 195–6; who will not work well for little recompense, 196; as judge of own and others' work, 196–7; should learn diligence before speedy execution, 197; advice for the young, 197–200; how he should learn figure composition, 199; should study proportions other than canonical, 199; should be universal, 199, 201–2; should observe mens' actions, 201; who ignores nature, 201; should observe natural forms, 202; should be solitary, 202, 205; like a mirror, 202; should learn perspective, 203; choice of company, 205; needs mathematics, 205; should liken his mind to nature, 205; should exercise his imagination in the dark, 224

painting: as sole imitator of nature, 13; not numbered among the sciences, 13; definition of the science of, 15–16, 18; composed of outlines and shading, 16; and philosophy, 18; compared with poetry, 19, 20–23, 24, 26, 28, 32–4, 37, 46; an inimitable science, 19–20; ability to deceive, 19, 20, 26–7, 28; superiority of, 20; compared to music, 23–4, 34–7; not dependent on other sciences, 33; and natural philosophy, 34; music as the sister of, 34; permanence of, 35; religious images, 35; likenesses preserved by, 35; and liberal arts, 35, 37; compared with sculpture, 38, 46; colour in, 42; role of light and shade in, 44; relationship of modelling to, 45; and

draughtsmanship, 45; a divine science, 45–6; characters and numerals invented by, 46; a liberal art, 46; includes seven of the ten functions of the eye, 49; invention of, 193; history of, 193; everything a subject for, 201; nature's daughter, 201; like a mirror, 202; L. describes competence in, 252; memo on techniques, 265

paper: tinted, to be used in notebooks, 199; memo on how to make coated, 265

paragone, 6, 8

Passion, cast of a narrative depicting the, listed by L., 264

Pavia, *Il Regisole* at, 265

pebbles and sand in water, 169, 171–2

Pecham, John, *Perspectiva communis*, 4–5, 49

Pedreti, Carlo, 2, 8

percussion: of wind on trees, 185; of waves, 234–5

perspective, 21, 35, 194, 199; Melzi draws little on L.'s writings on, 2; not dealt with in Codex Urbinas, 4; central to optical foundation of painting, 4; L.'s ideas on p. change, 5; few surviving texts on linear p., 6; early drafts on, 8; born of arithmetic and geometry, 14; and astronomy, 16, 18; definition of three kinds of, 16, 18; daughter of painting, 18; necessary to astronomy, 33; effects of in sculpture, 40, 43, 44; to be preferred above all other disciplines, 49; painters' errors of, 51–2; the guide and gateway of sound theory, 52; definition of, 52–3; principle of 53–8; distortion and illusion created by, 58–68, 218–19; use of intersection in 58–9; problems of natural and accidental, 58–9; viewing distance 59, 61–3; definition of natural, 59; simple preferable to compound, 60; definition and cause of accidental, 60–1; to be taught to the young painter, 197, 203; finding correct viewing point for, 219; 'certain bodies [drawn in]' listed by L., 263

aerial, 42, 80–1; *see also* perspective of disappearance

of colour, 52, 70–84, 165, 212; definition, 16; absent from sculpture, 40; in painting, 42

of disappearance, 53, 85, 163, 165–6, 229; definition of, 16; absent from sculpture, 42

of line: definition, 16; *see also* perspective; perspective of size

linear, 57; *see also* perspective; perspective of size

of size, 52–69, 77; fixed viewing point not necessary for, 59; *see also* perspective; perspective, linear

petition of L. and de Predis, concerning the *Virgin of the Rocks*, 253–5

philosopher(s), 38; who would pluck out his eyes, 22; who have given away their riches, 195

philosophy: and painting, 18; and poetry, 34

physiognomy, *see* faces

physiognomy, false, and chiromancy, 147

physiology: of sight, 50–1, 53–4, of the pupil, 51, 68–9, 70

Piacenza: Cathedral, letter from L. to the authorities, 257–8

Piero, 266

plantlife and vegetation affected by different soil conditions, 175

plants, branching systems of, included in Codex Urbinas, 4

poetry: compared with painting, 19, 20–3, 24, 26,

28, 32–4, 37, 46; compared with music, 24–37; and moral philosophy, 34; borrows from other sciences, 37–8

point: mathematical definition of, 14, 53, 88; as principle of the science of painting, 15; everything reduced to a p. in the eye, 50; p. in eye to which visual pyramids converge, 55; how to locate the p. in another's eye, 56; things seen do not converge to a mathematical p., 65–6

portraits: painters of, not skilled in narrative composition, 200; aid to drawing, 206; best light for painting, 215

position, a part of the function of sight and painting, 49

posture, 144

Poussin, Nicolas, 2; Figures in the act of throwing, engraving based on Nicolas Poussin's illustration for Leonardo's text (Urb 106r) from Leonardo da Vinci, *Traité de la peinture*, ed. R. du Fresne Paris, 1651, fig. 1

practice, 51, 52, 200

Predis, Ambrogio da, letter from, with L., to Ludovico Sforza, 253–5

profiles, method of recording, 206

proportion, 6; L.'s intention to write about, 119; to be taught to the young painter, 197, 203

of human limbs, 119; Vitruvius on, 120–22; ideal, 122; babies, 122–3; changes in from birth to mankind, 122–3; faces, 123–5, 126; arm and hand, 125–6, 127; leg and foot, 126–7, 128; effect of bending joints on, 127–8; changes when body position is altered, 128; men of various shapes may still be in p., 199

musical, 34

proportionality, 23, 26

Pulisena, 267

pupil, 51, 55, 68; every part of p. has visual power, 65–6; changes in size of, 69; why a large p. sees objects as larger, 69; images entering do not fuse together, 70

pyramid, visual: *see* visual pyramid

pyramids: every opaque body found between two, 109; light and shade function by means of, 111–13

quantity, continuous: *see* continuous quantity

quantity, discontinuous: *see* arithmetic

radiant lines: *see* visual pyramids

rain, 168

rainbow, 71; iris called the celestial r., 72; colours of, 168

rays: *see* visual pyramids

reflection: one's own in another's eye, 56; of objects in water, 169–70

Regisole, Il, 265

relationship, L.'s working, with Germans in Vatican, 260–1

relief: in sculpture, 39–40; in painting, 44; discrepancy in appearance of, between natural and painted objects, 63–5; little effect of when sun in the west, 163; how to enhance impression of, with light and shade, 209; *see also* bas-relief

religious paintings, power of, 35

repetition, censured by L., 204, 220

reproduction of own features censured, 120, 204

rest, a part of the function of sight, 49

Richter, Jean-Paul, 2–3
rivers, create the shape of mountains, 173–5
Robertet, Florimond de, 273
Rome: Vatican, Leonardo's lodgings in, 260–1, 265; Codex Urbinas, 1, 2, 4, 8
Romena, Ser Giovanni de, 271
Rubens, Peter Paul, *The Fight for the Standard*, after Leonardo's *Battle of Anghiari* (Paris, Louvre), fig. 150
rules, 10, 45, 52

Salai, Giacomo, 260, 266, 267, 273, 277
San Severino, Galeazzo da, 266
Sapin, Johan, 277
science: nature of true s., 10, 13, 14; as daughter of nature, 13; definition of, 13–14; definition of mathematical, 14; which is the most useful, 19; imitable and immutable, 19–20; nobility of, 32–3; whether mechanical or cerebral, 35; practice needs s., 51; and practice, 52, 200
sculpture, 19; compared with painting, 38–46; description of sculptor's work, 38–9; lacks colour, 40, 42; effects of illumination on, 42–3; use of shadows in, 42–3; representation of muscles in 44, 45; relationship of modelling to, 45; and draughtsmanship, 45; L. describes competence in, 252; L.'s interest in project in bronze for Piacenza Cathedral, 257–8; cast of a narrative depicting the Passion, listed by L., 264
sea: colour of, 170; and the horizon, 172–3
senses, 10, 14, 18, 23, 26; *see also* ear; eye; smell; taste; touch
sensus communis, 14, 19, 20, 22, 23, 51
Sforza, Gian Galleazzo Maria, allegory of, 243
Sforza, Ludovico (Il Moro), Duke of Bari, later Milan, allegory of, in the guise of Good Fortune, 241; letters to, from L., 251–6
shade: *see* shadow
shadow(s): as second principle of the science of painting, 15; a part of the function of sight and of painting, 49; of object close to light, 66; colours in, 72–3; that take on the blue colour of the sphere, 82; in the countryside, 82–3; brightness of sphere increases with absence of, 95; definition of, 97–8; original, 97; derived, 97; L.'s proposed writings on shadows, 97; primitive, 98; cast, 98; integral and separate, 98–9; intermediate, 100; whether primitive is darker than derivative, 101–2; proportions of primitive and derivative, 103; cast by an opaque body between equal lights, 103; derivative shadow, 103–4; derivative and augmented, 104; three configurations for, 104–5; shapes of derived, 105; straight and oblique impact made by derivative, 106; shorter cast by larger light, 106; derivative on bodies in a room with a single window, 108–9; definition of simple and compound, 109–10; compound derivative, 110; colour in derivative, 110–11; motions of 114–15; in draperies, 158; in the countryside, 161–2; early morning, 163; made by clouds, 165; of smoke clouds, 167; made by bridges, 170; on leaves, 183–5; original and derived, 210; adding intermediate and principle, 211; degrees of, 211; should not be sharply bounded, 211; testing colour balance in, 212; should have varied outline, 212; drawn by candlelight, 216

shape, a part of the function of sight, 49
sight: angle of, 54–5, 85; *see also* eye; physiology of sight
size, objects appear larger at midnight than midday, 69; *see also* perspective
sketching: *see* drawing
sky, how its blue arises, 81
smell, 14–15, 18, 21
smoke, 71, 166–7; visibility of, 57, 167, 229
soul, 49; seeks to reproduce the body it resides in, 120
stains on walls, 201–2, 222
studio: the painter's source of light in, 214, 216; moveable chest in, 216
study, programme of young painter's, 197–200
sun, effect when in the west, 163; and clouds, 163–5; effect on smoke and dust of, 167–8; and rain, 168; and rainbow, 168
surface, as third principle of the science of painting, 15; mathematical definition of, 53; shiny; conceals true colour, 72; illumination of a surface, 90
surveying, memorandum mentioning tools for, 265
symbolism, *see* allegories and emblems

talent, 200
taste, sense of, 15, 18
Tommaso, Maestro, 266, 267
touch, 15, 18
trees, 6; natural proportionality disrupted, 119; colour of, in fine weather, 162; visibility of, at a distance, 166; effect of wind on, 168; growth of, 175–182; variety of colours of different t.'s, 182, light and shade on, 183, 189; *see also* age of trees; branches; leaves

universality, 199, 201–2

vegetation, *see* plantlife
vibration, makes object appear doubled up, 87
Vilanis, Battista de, 277, 278
Virgin, Child, St Anne and Lamb, lost work described by Fra Pietro da Novellara, 273
Virgin and Child with a Yarn-Winder described by Fra Pietro da Novellara, 273–4
Virgin of the Rocks dispute over commission for, 253–5; contract for 268–9
vision: *see* eye
visual power: of painting, 26–7, 28; of the eye, 50, 88, 172; resides in the pupil, 65
visual pyramids, 16, 50, 51, 52–5, 56, 57, 58, 60
visual rays, 14, 16, 18; colour carried by, 70
Vitruvius, measurements of a man given by, 120–22

warfare, inventions for, 251–2
water, objects in air that are seen through w. appear out of position, 66; colour of, 169; images reflected in, 169–70; light and shade reflected in, 171–2; certain devices for, listed by L., 263; *see also* deluge; foam; hydraulic engineering; rivers; sea; waves
waves, 169, 234–5
weapons, 251–2
weather conditions, effect of on light and colour in landscapes, 2; *see also* atmosphere
weeping, how to represent, 147–8
weight: *see* balance
will, L.'s, 275, 277–8

wind, depiction of, 168; effect on trees and leaves of, 185–6
windows in painter's studio, 214, 216
Witelo, 265

women, how to represent, 147; decorum in representation of, 152

Zati, Marco, 271